Herausgegeben von / edited by
Wilbirg Brainin-Donnenberg, Michael Loebenstein

Österreichisches Filmmuseum
SYNEMA – Gesellschaft für Film und Medien

A book by SYNEMA ☰ Publikationen
Gustav Deutsch
Volume 11 of FilmmuseumSynemaPublikationen

SYNEMA – Gesellschaft für Film und Medien
Neubaugasse 36/1/1/1
A-1070 Wien

Design, Layout: Karl Ulbl
Mitarbeit / *Assistant*: Iris Buchholz
Grafisches Konzept der Buchreihe / *Design concept of the book series*: Gabi Adebisi-Schuster
Lektorat und Korrektur (deutsch): Hina Berau, Alexander Horwath
Proof reading (english): Kellie Rife, Natascha Unkart
Übersetzungen / *Translations*: Hina Berau, Eve Heller, Petra Metelko, Kellie Rife, Renée von Paschen,
Natascha Unkart (siehe Seite / *see page* 252)
Anhang / *Appendix*: Wilbirg Brainin-Donnenberg, Michael Loebenstein,
unter Mitarbeit von / *with the aid of* Daniela Praher
Abbildungen / *Illustrations*: Gustav Deutsch, Hendrik Ewert, Hans Labler, Michael Loebenstein,
Rick Prelinger, Hanna Schimek, Burkhard Stangl, Stephan Wyckoff (siehe Seite / *see page* 251)
Kadervergrößerungen / *frame enlargements*: Georg Wasner
Videostills: Gustav Deutsch, Michael Loebenstein, Manfred Neuwirth

Cover: *Taschenkino* © Hans Labler, 1995

Printed by: REMAprint
Printed and published in Vienna, Austria

ISBN 978-3-901644-30-6

Dieses Buch entstand mit Unterstützung von / *this book was supported by*

Österreichisches Filmmuseum (Austrian Film Museum) and SYNEMA – Society for Film & Media are supported by
BM:UKK – Abteilung VI/3 FILM and by Kulturabteilung der Stadt Wien.

Inhalt / Content

Vorwort / Preface

Filmemacher. (Bilder-)Monteur. Forscher. Architekt. Volksbildner. Museumsmacher. Bandleader. Das sind nur sieben von vielen Bezeichnungen für Gustav Deutschs Tätigkeit, denen Sie bei der Lektüre dieses Buchs begegnen werden. Oder vielleicht genügt auch, was ein junger Kurator, Sergio Fant, 2004 als Einleitung zu einer Deutsch-Lecture in Amsterdam formuliert hat: „Welcome Gustav Deutsch: The Master."

Der vorliegende Band verdankt sich, in vielerlei Hinsicht, jahrzehntelangen Freundschafts- und Arbeitsbeziehungen. Gustav Deutsch ist nicht nur für uns beide über viele Jahre hinweg Inspiration, Lehrer und Diskussionspartner gewesen. Arbeit und Leben bilden bei ihm kein Gegensatzpaar, beidem gilt die gleiche kritische Neugier, ein Sinn für Konzeptuelles, ein Gespür für und ein Interesse an Strukturen, Mustern, eine Lust am Erproben neuartiger Ideen. Sein umfangreiches filmisches Werk, dem dieser Band hauptsächlich gilt, illustriert diesen Zugang zur Welt: Kollektive Videoarbeit, struktureller Super-8-Film, Film- und Videotagebuch, Dokumentar- und Spielfilm bilden keine lineare künstlerische Entwicklungsgeschichte, sondern wechseln einander ab. International weithin bekannt wurde Deutsch durch seine Arbeit mit Found Footage, vor allem durch sein mehrteiliges Opus Magnum *Film ist*. Seinen Strategien

Filmmaker, assembler of images, researcher, architect, public educator and band leader. Those are only a few of the many designations that Gustav Deutsch's activities include; you will stumble across more of them while reading this book. However, it might also suffice to quote what curator Sergio Fant said when introducing the artist's lecture in Amsterdam in 2004: "Welcome Gustav Deutsch: The Master."

In many respects, the present volume is due to long-standing ties of friendship and collaborative experiences. Over the years Deutsch has been an inspiration, a teacher and an important interlocutor for us. In his case, work and life are not in opposition to each other; he invests both with the same critical curiosity, a sense for the conceptual, a searching interest in structures and patterns, a delight in trying out new ideas. His rich moving-image oeuvre forms the center of this book, and it is illustrative of his approach to the world. Collective video pieces, structural Super-8 filmmaking, diary films and videos, documentary and fictional projects, these are not elements in a linear, progressive development; rather they take turns in Deutsch's career. Internationally, he became widely known through his work with found footage, primarily his multipart magnum opus *Film ist*. Consequently, his strategies of reappropriation, redefinition and

der Wiederaneignung, Umdeutung und Umformung historischen Filmmaterials gilt damit auch ein Großteil der Beiträge dieses Buchs. In ihnen kulminieren die unterschiedlichen Interessen des Künstlers, hier führt er gesellschaftliche und politische Kritik, formale Analyse und synästhetischen Anspruch zusammen. Zu all dem gesellt sich ein reiches Schaffen in anderen Bereichen der Kunst – Installationen, Fotoarbeiten, architektonische Projekte, Konzerte, Symposien, selbst ein „Musical" erscheint (spät) im Werk.

Gustav Deutschs Werk zeichnet sich durch ein subtiles Spiel aus Differenz und Wiederholung aus. Dem möchte dieses Buch inhaltlich und in seinem formalen Aufbau Rechnung tragen: Motive, Werkperioden, künstlerische Verfahren und Lesarten bestimmter Filme tauchen an unterschiedlichen Stellen, von verschiedenen Standpunkten aus betrachtet, immer wieder auf. Wir sind stolz darauf, dass wir für diese erste monografische Publikation über Deutsch viele renommierte AutorInnen gewonnen haben, die in unterschiedlichen Disziplinen und Kontexten seine Arbeit kennen und schätzen gelernt haben: Archivare, FilmwissenschafterInnen, Museumskuratoren, ein Musiker und eine Psychoanalytikerin. Unser Ansinnen war es, das Deutsch-Universum zugleich breit und spezi-

reshaping of historical film materials are a major topic in several contributions to this book. The praxis of found footage filmmaking is a culmination of the artist's diverse interests, the place where his social and political commentary, as well as his formal analysis and synaesthetic approach, come together. In addition, he has created a rich oeuvre in other sectors of art and culture—installations, photographic and architectural projects, concerts, symposia; even a "musical" has recently appeared among his works.

All of Gustav Deutsch's work is distinguished by a subtle interplay of difference and repetition. This publication attempts to reflect that characteristic both structurally and in terms of content. Certain motifs, cycles or artistic methods in Deutsch's films reappear at various moments throughout the book and are treated from different points of view. We have gathered together several esteemed colleagues, who have come to appreciate Deutsch's work via their own specific disciplines and through different contexts, including archivists, film scholars, museum curators, a musician and a psychoanalyst. It is our intention to chart "Gustav Deutsch's universe" in a manner both specific and wide-ranging. The appendix, a rich collection of facts and information on Deutsch's life and work, is

fisch zu kartografieren; als „Legende" haben wir daher auch einen ausführlichen Anhang mit Daten zu Leben und Werk des Künstlers zusammengestellt.

Unser Dank gilt allen AutorInnen sowie Alexander Horwath in doppelter Weise als Autor und für seine kritischen Anmerkungen; Karl Ulbl für seine Geduld und die künstlerische Sorgfalt, mit der er dieses Buch aus einem Fundus an Texten, Bildern und Ideen komponiert hat, sowie den ÜbersetzerInnen der Texte. Wir freuen uns sehr, in diesem Band auch zwei neue, grafische Arbeiten Gustav Deutschs und Hanna Schimeks, seiner langjährigen Partnerin, präsentieren zu können. Beide haben uns in der Vorbereitung und der Herstellung des Buchs tatkräftig unterstützt, wir danken ihnen ganz besonders.

Wilbirg Brainin-Donnenberg,
Michael Loebenstein,
Jänner 2009

meant to function as a "legend" in this cartographic endeavour.

Our thanks are due to all contributors and translators, to Alexander Horwath, both for his essay and his critical remarks, and to Karl Ulbl for his patience and diligence in composing this book from a plethora of texts, images and ideas. We are especially delighted to present two new graphic works in this volume, created respectively by Gustav Deutsch and Hanna Schimek, his long time companion. Both Gustav and Hanna actively supported us in the preparation and production of the book; we owe them our deepest gratitude.

Wilbirg Brainin-Donnenberg,
Michael Loebenstein,
January 2009

Gustav Deutsch steht Modell für Hanna Schimeks Foto- und Buchprojekt *Aufsicht*
Gustav Deutsch models for Hanna Schimek's photo series and publication Aufsicht (1998)

Wilbirg Brainin-Donnenberg

Filme wie Häuser
Gustav Deutsch: Filmemacher und Architekt

Films like Houses
Gustav Deutsch: Filmmaker and Architect

Es ist immer wieder der Raum, der uns in den Arbeiten Gustav Deutschs begegnet. Der Raum und der Versuch des Filmemachers – und Architekten –, darin zu Rande zu kommen, die behutsame Annäherung, der Weg, die Methode.

In der Serie *Filme aus Niederösterreich* (1981–82) streift er gemeinsam mit seinem Kollegen Ernst Kopper über Land und Leute und öffnet unsere Augen für das spezifisch Nichtstädtische dieser Region nördlich von Wien, die Sonntag für Sonntag Zweitwohnsitz und Ausflugsziel tausender Wiener Familien ist.[1]

In *Augenzeugen der Fremde* (1993) wirft er seinen Blick auf die marokkanische Oase Figuig. Doch er nimmt dabei eher die Rolle des Landvermessers ein als die eines Kameramanns. Er platziert die Kamera an bestimmten Orten und lässt sie laufen, statt „mit seinem europäischen Gesicht" dahinter zu stehen. In der Folge sehen wir das Wandern der Schatten und ungestörte Innen- und Außenräume.[2]

Befragt nach der Genese von *Welt Spiegel Kino* (2005) spricht Deutsch von seiner elektrisierenden Erstbegegnung mit einem historischen

Time and again it is space that confronts us in the works of Gustav Deutsch—space and the attempt of a filmmaker and architect to come to terms with it: a careful approach, a path, a method.

In the series *Filme aus Niederösterreich* [*Films from Lower Austria*] (1981–82), he wanders with colleague Ernst Kopper throughout the countryside north of Austria's capital, a traditional destination of Sunday excursions and weekend-home to thousands of Viennese families. He opens our eyes to the specifically non-urban nature of the region.[1]

In *Augenzeugen der Fremde* [*Eyewitnesses in Foreign Countries*] (1993), he turns his attention to the Moroccan oasis of Figuig. But he assumes the role of a land surveyor rather than that of a filmmaker. He sets his camera up and lets the film roll instead of glueing his "European eyes" to the viewfinder. In turn we are able to observe wandering shadows and undisturbed interior and exterior spaces.[2]

When Deutsch speaks about the original idea behind *Welt Spiegel Kino* [*World Mirror Cinema*]

1) In seinem Beitrag auf S. 49–62 beschäftigt sich Wolfgang Kos mit dem „Ethos des Ephemeren" in der Arbeit von Deutsch.

2) In seinem Gespräch mit Scott MacDonald, erfahren wir von Gustav Deutsch mehr zum Konzept und zur Realisierung von *Augenzeugen der Fremde*, S. 63–95.

1) In his essay on pp. 49 Wolfgang Kos deals with the "ethos of the ephemeral" in Deutsch's work.

2) Gustav Deutsch supplies some background on the concept and realization of *Eyewitnesses in Foreign Countries* in his conversation with Scott MacDonald, pp. 63.

9

Anfangs- und Endstills von /
First and last shot of
G.D. Architekt (1994)

Filmfund: ein langer Schwenk über die breite Hauptstraße Pesar Basar in Surabaya, und mittendrin, für einen Augenblick, ein Kino, das zu diesem Zeitpunkt (1929) Fritz Langs *Siegfried* spielt. Gustav Deutsch will diese Straße überqueren, in dieses Kino hineingehen und mit den drachenaffinen Indonesiern beim nibelungischen Drachentöten zusehen. Förderungen für dieses Vorhaben gibt es erst, wenn die räumlichen Bezüge lokaler werden. Deutsch sucht sich einen zweiten auf Film gebannten Kinovorplatz in Porto und einen dritten in Wien-Erdberg und schafft damit *Welt Spiegel Kino*.[3]

In *G.D. Architekt* (1994), gemeinsam mit Hanna Schimek, seiner langjährigen Gefährtin im Leben und in der Kunst, werden zwei Hochhäuser gesprengt. Der Staub der ersten Explosion ist so intensiv, dass die zweite Detonation gar nicht mehr auf den Film kommt. Im Vordergrund, bewegungslos im Halbprofil: Gustav Deutsch, er sieht nicht hin bei dieser „Hinrichtung der Häuser". Die entstandene Baulücke wird nach und nach zu dem werden, was Deutsch Jahre später in einer weiteren Gemeinschaftsarbeit mit Hanna Schimek aufmerksam

(2006), he recalls an electrifying encounter in an archive where he viewed historical footage of a long pan, made in 1929, across the broad main street of Pesar Basar in Surabaya: He caught a glimpse of a movie house that was showing Fritz Lang's *Siegfried*. He felt the urge to cross that very street and enter the cinema, to watch the slaying of the Nibelung dragon in company with the Indonesian descendants of a different dragon tradition. This impulse received financial support only after a more domestic connection was established: Deutsch discovered more footage capturing public places in front of movie houses, one in Porto and the other in Erdberg, Vienna. The three scenes enabled him to create *Welt Spiegel Kino*.[3]

In 1994 he made a Super-8 film entitled *G.D. Architekt* with Hanna Schimek, his longstanding partner in life and art: Two high-rises are to be demolished. The dust of the first explosion is so intense that the second detonation is not registered on film. The motionless semi-profile of Gustav Deutsch is seen in the foreground—he does not turn to view this 'execution of the buildings'. The empty lot that results from the demolition becomes the eventual theme of a

3) Nico de Klerk, S. 113–122, und Tom Gunning, S. 163–180, behandeln sehr detailliert Gustav Deutschs Einsatz von „orphan films" und die Art und Weise, wie er aus Found Footage neue Bedeutung extrahiert.

3) Nico de Klerk, pp. 113, and Tom Gunning, pp. 163, discuss in detail Deutsch's use of "orphan films" and his way of extracting new meaning from found footage.

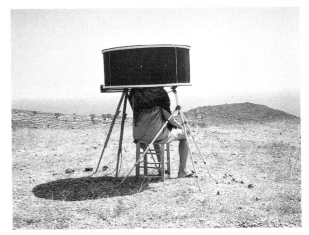

Camera-Obscura-Modell / *Model for a* camera obscura,
mit / *with* Christina dePian, Sfenduri, Aegina (2002)

betrachtet: *Terrain Vague* (1996), die Nicht-Orte
des urbanen Raums.

Bezeichnend für die Behutsamkeit des Filme-
machers Gustav Deutsch ist seine Ehrfurcht vor
dem unermesslichen Terrain, der *agorá*, das die
Endlichkeit eines, seines Werks umgibt. Doch
womit stattet sich der Architekt aus, der diese
unendliche Weite „bebauen" will? Er braucht
Pläne, Modelle, Werkzeuge und ein Team, dem
er vertrauen kann, denn seine Ausbildung hat
ihn gelehrt, dass vor allem die Zusammenar-
beit funktionieren muss, „sonst wird das Haus
nicht gut..." Zugleich muss er während der ge-
samten Bauaufgabe danach trachten, den Status
des Gesamtplaners zu erhalten. Für Deutsch ist
es wichtig, auch bei den größeren, aufwändige-
ren und arbeitsteiligeren Filmen die „Generalli-
nie" bis in die letzten Verästelungen durchzu-
führen, bis zur Gestaltung des Pressefolders.
*God is in the detail – Mies van der Rohe antwortet
Frank Lloyd Wright* lautet der Titel eines unrea-
lisierten Deutsch-Films. Das betreffende Zitat
wird verschiedentlich Gustave Flaubert, Mies
van der Rohe, Michelangelo und Aby Warburg
zugeschrieben – und gerade letzterem fühlt sich
Gustav Deutsch sehr nahe, wie etwa seine
gemeinsamen Arbeiten mit Hanna Schimek
zum „Atlas"-Motiv belegen.

work to which he dedicates special attention
years later with Schimek: *Terrain Vague* (1996),
the non-places of urban space.

Deutsch's reverence for the immeasurable
terrain, for the *agorá* which circumscribes the
finitude of each work, is illustrative of his cau-
tion as a filmmaker. Yet how does the architect
equip himself in order to build on this endless
expanse? He needs plans, models, tools—and
he needs a team that he can trust. His training
has taught him that each endeavor is a matter of
successful collaboration, otherwise "the build-
ing will not be sound..." At the same time, he as-
sumes the role of a general contractor for the
duration of the construction job: Deutsch finds
it important to maintain control over each phase
of production down to the last detail, even on
larger, more time-consuming projects that in-
volve a more complex division of labor. He will
even turn his attention to the press kit for a
given project. *God is in the detail. Mies van der
Rohe antwortet Frank Lloyd Wright* [*Mies van der
Rohe answers Frank Lloyd Wright*] is the title of a
short film yet to be realized by Deutsch. The

11

Im Idealfall folgt daraus ein produktives Wechselspiel: Individuelle Gesamtplanung *und* enge Zusammenarbeit mit anderen. Deutsch wichtigste Komplizin ist Hanna Schimek. Die Rollenverteilung zwischen den beiden sei mittlerweile so eingespielt, dass es kaum noch der Worte bedarf. So wie Schimek ihn bei seinen Projekten mit ihren Erfahrungen und ihrer speziellen Ausbildung als Malerin, grafische Künstlerin und Fotografin unterstützt, findet Gustav Deutsch seine Funktion in ihren vielfältigen künstlerischen Arbeiten. Die ausgewiesenen „gemeinsamen Projekte" haben über die Jahre eine zusätzliche Dimension gewonnen: konsensuale Produktivität.

Geprägt durch die sozialen und politischen Bewegungen der 1970er Jahre, interessierte sich Deutsch schon während seines Architekturstudiums vor allem für Gruppenprojekte. Er war immer wieder Teil eines Teams – in der Zusammenarbeit mit dem Architekten Ernst Kopper, dann in der Wiener Medienwerkstatt, aber auch im Rahmen der interdisziplinären und internationalen Künstlergruppe „Der Blaue Kompressor". Seit Ende der 1990er Jahre pflegt er eine weitere Form von *teamwork*: mit jenen KomponistInnen und MusikerInnen, die in zahlrei-

4) Auf S. 195–200 beschreibt Burkhard Stangl diese Zusammenarbeiten aus der Sicht des Musikers.

statement quoted is variously attributed to several artists including Gustav Flaubert, Mies van der Rohe, and Michelangelo and it is highly relevant to Gustav Deutsch. It is no coincidence that he feels kindred to Aby Warburg (who also made extensive use of it), as is evident in the collaborative "Atlas" projects undertaken by Deutsch and Schimek.

The ideal case scenario consists of a productive interplay between individual control *and* close collaboration with others. Deutsch's most important accomplice is Hanna Schimek. The roles they assume are so well practiced by now that they hardly need language to communicate the work at hand. Just as she contributes her experience and unique knowledge as a painter, graphic artist and photographer to his undertakings, he contributes his talents to her multifaceted art works. Over the years select, collaborative projects have gained a further dimension: consensual productivity.

Deutsch was already largely interested in collaborative work during the early days of his architectural studies, as influenced by the social and political movements of the 1970s. Time and again he was part of a team—in his efforts with Ernst Kopper, as a member of Vienna's "Medienwerkstatt," and in the interdisciplinary framework of the international art group "Der Blaue

chen Arbeitsschritten Tonspuren zu seinen Filmen produzieren.[4]

Der kurze Weg zur Lösung ist ein seltener, nicht planbarer Glücksfall. Planbar ist hingegen der Weg der kleinen Schritte. Dass Deutsch diesem Vorgehen anhängt, verdankt sich ebenfalls seiner Architektenausbildung: Die Architektur hat bereits Jahrhunderte von *trial and error* hinter sich, während die junge Filmkunst gerade ihren ersten Hunderter feiern konnte. Auch als Künstler entzieht sich Gustav Deutsch in keiner Phase der scheinbaren Mühseligkeit von Ingenieursarbeit. Es ist immer zuerst die Struktur einer Idee, die Deutsch gefangen nimmt. Daran arbeitet er, diese Struktur skizziert er immer wieder, dreht sie und wendet sie, so wie das Architekten früher mit ihren Plänen am Reißbrett getan haben (und heute in ihren 3D-Programmen am Computer). Seine Projekte sind akribisch vorbereitet, im Detail kalkuliert und beispielhaft dokumentiert. Die Kleinteiligkeit seiner Arbeitsweise bringt ihn einem Thema solange näher, bis aus der Quantität der zunächst unübersehbaren Einzelschritte die neue Qualität entsteht, die er für ausreichend erachtet. Der Weg dorthin kann Jahre dauern, wiederholte Finanzierungsversuche und andere, neue Zugänge erfordern. Ungeduld ist in Gustav Deutschs Welt keine Kategorie.

Kompressor." Since the end of the 1990s, he has also been in steady collaboration with composers and musicians, developing the soundtracks for his films through a complex process of artistic exchanges.[4]

Finding a quick solution to a problem is an unpredictable stroke of luck. What can be planned, however, is a path consisting of many small steps. Deutsch's working method is also influenced by his training as an architect: a discipline informed by centuries of trial and error in contrast to the relatively young art of cinema which only recently celebrated its centennial year. The artist Gustav Deutsch does not shy away from what seems like a laborious work of engineering. He is always initially captivated by the structure of an idea. He works the concept, sketching its structure and continually turning it over in his mind, much like an architect who drafts a design on a drawing board of old (or maps it via a contemporary, 3-D computer program). His projects are meticulously prepared, calculated down to the detail and thoroughly documented. The multi-faceted nature of his creative process brings him incrementally closer to a theme: from the vast, almost unmanageable quantity of individual steps a new quality can

4) On pp. 195, Burkhard Stangl describes these collaborations from the musician's point of view.

13

G. Deutsch & Gavrillos Michalis, bei der Besprechung der Pläne für die Camera Obscura, auf der Fähre zwischen Piraeus und Aegina / *discussing conceptual work for the camera obscura on a ferryboat between Piraeus and Aegina* (2003)

G. Deutsch & Franz Berzl, bei der Arbeit an den Plänen zu den Filmsets für / *drawing plans for the film sets of Visions of Reality*, Aegina (2005)

ensue, which will finally satisfy him. Reaching his goal might take several years and require repeated funding efforts or new methods of approach. Impatience is not a viable category in the world of Gustav Deutsch.

This process is especially evident in the long phases of archival research that Deutsch undertakes with Hanna Schimek and with the support of many film archivists. He explains that if one day a wondrous digital software emerged that could pull footage he described from the archives of the world and conjure it to appear at his editing table, he would immediately cease his search for *objets trouvés*. If the protracted labor of rummaging for footage and all the work and communication involved in the process were no longer an option—if the *footage* were no longer *found* but rather available *on-demand*—, he would have to shift his artistic endeavor to some other terrain. No architect wants to live in a prefabricated home.

If one charts individual works by Gustav Deutsch on a timeline, the abundant sum of his 'building activity' becomes apparent in light of specific chapters and turning points The 'construction sites' have expanded and the buildings have noticeably grown in height with seeming single-mindedness. With his transition from

Besonders deutlich wird dies in den langen Phasen der Archiv(film)recherche, die er mit Hanna Schimek und im Austausch mit vielen Filmarchivaren betreibt. Sollte es jemals die digitale Wundersoftware geben, die Filmausschnitte nach Wunsch und speziellen Stichworten aus den Archiven der Welt auf Gustav Deutschs Schnittplatz zaubert, dann würde er seine Arbeit mit *objets trouveés* sofort einstellen. Wenn ihm das langwierige Stöbern und die damit verbundenen Arbeitsschritte und Kom-

munikationsprozesse nicht mehr ermöglicht werden, wenn die *footage* nicht mehr gesucht und gefunden werden kann, weil sie immer schon da ist, *on demand*, müsste Deutsch sein künstlerisches Betätigungsfeld verändern. Kein Architekt will in einem Fertigteilhaus wohnen.

Trägt man die einzelnen Arbeiten von Gustav Deutsch auf einer Zeitachse auf, dann werden gewisse Abschnitte und Zäsuren in seiner „Bautätigkeit" erkennbar. Scheinbar zielstrebig haben sich die Bauplätze vergrößert, und auch die Gebäude selbst sind höher geworden. Mit seiner Wendung vom Kurzfilm zum „abendfüllenden" Format hat er ein neues Publikum erreicht, ohne sein altes zu verlieren. Sein mittlerweile auch international gefestigter Ruf als „vielförmiger" Künstler hat ihm nicht nur zahlreiche Auszeichnungen und Festivalauftritte, sondern auch diverse kommissionierte Projekte für Ausstellungen beschert. Zum Beispiel die DVD-Installation *Tatort Migration 1–10* (2005), die dem Sonntagabend-Familienfernsehritus *Tatort* das Migrationsthema so eindringlich extrahiert, als wäre es immer schon, für alle sichtbar, im Zentrum gestanden. Einmal mehr unterstützt hier der Architekt den Filmemacher: Das Raumprogramm der Installation besteht aus mehreren, vom Publikum benützbaren Heimkinos, in

short to feature length films he has gained a new audience without losing the old. His international reputation as a multi-talented artist has not only generated numerous awards and festival invitations but has also lead to several commissioned projects. In one such work he utilized the Sunday evening television program "Tatort" ("Crime Scene"), a veritable institution in Germany and Austria, extracting the theme of migration for a DVD installation entitled *Tatort Migration 1–10* (2005). His presentation made the theme appear as if it had always been central to the original TV show and had always been apparent to its audience. The architect once again complemented the filmmaker: His spatial concept for the installation involved several home entertainment units complete with sofas and screens, presenting footage of select episodes from the series in such a ubiquitous manner that the audience effortlessly recognized how it had been socialized between the 1970s and 1990s.[5]

Each new work appears to be consistent with efforts of the past. The results are scalable. And yet we continually are given to understand more precisely, more clearly and with growing urgency, what is crucial to Gustav Deutsch. At the 1995 premiere of *Taschenkino [Pocket Cinema]*,

5) Stefan Grissemann writes about *Tatort Migration* and other Deutsch installations in his essay on pp. 19.

15

denen die eigene Sozialisation (Deutschland und Österreich in den 1970er, 1980er, 1990er Jahren) mühelos wiedererkannt werden kann.[5]

Jede neue Arbeit verhält sich konsistent zum Vorangegangenen. Das Ergebnis ist skalierbar. Und doch erfahren wir immer mehr, immer genauer und dringender, worum es Deutsch geht. Als wir uns beispielsweise 1995 in der Uraufführung von *Taschenkino* nach und nach 100 Miniprojektoren vor Augen hielten, um uns mit „Lebensrhythmus", „Naturgesetzen", „Aus der Ewigkeit" und 97 anderen Grundbegriffen des Films vertraut zu machen, waren wir nicht mehr Publikum des Gustav Deutsch. Im kleinsten vorstellbaren Kinoraum recherchierten wir mit ihm gemeinsam, wie in einem anonymen Archiv. Wir betrachteten, bewerteten, wir entschieden, wir wählten aus.

Hatte der Beginn von Deutschs zentralem Zyklus – *Film ist. 1–6* (1998), auch wenn er mit einem apologetischen „wird fortgesetzt" endet – aufgrund seiner Konzentration auf den Filmapparat („Bewegung und Zeit", „Material" usw.) noch manche im Publikum überrascht oder ratlos zurückgelassen, fanden sich beim nächsten Teil – *Film ist. 7–12* (2002), ebenfalls mit einem „to be continued" als kleiner Teil eines großen

for example, the spectators were given 100 mini-projectors to hold before their eyes, to acquaint themselves with 'Rhythm of Life,' 'Movements,' 'Natural Laws,' 'From Eternity,' and 97 other basic themes of cinema. In that situation we were no longer simply an audience to Gustav Deutsch. In the tiniest movie house imaginable, we joined a collaborative research project, like in an anonymous archive. We viewed, judged and decided—we chose.

While the first part of Deutsch's central cycle —*Film ist. 1–6* (1998)—ended with an apologetic "to be continued," it left part of its audience surprised or at loss due to its focus on the film apparatus ('Movement and Time,' 'Material' etc.). The second part—*Film ist. 7–12* (2002, and still 'to be continued')—won over new converts given its reference to emotionally loaded experiences associated with cinema ('Comic,' 'Magic,' 'Conquest' etc.). Their hopes for another installment would not be frustrated. Episode 13, *Film ist. a girl & a gun* (2009), is dedicated to two notorious motifs which are at the heart of narrative cinema if you believe Godard or D.W. Griffith. Gustav Deutsch has begun to stake out his claim on the territory more amply, and his survey is yielding ever more lucid results.[6]

In 2002 Deutsch created a 'Panorama-Space' in the Vienna Künstlerhaus which surrounded

5) Stefan Grissemann behandelt u.a. *Tatort Migration* und Installationen von Deutsch in seinem Essay, S. 19–48.

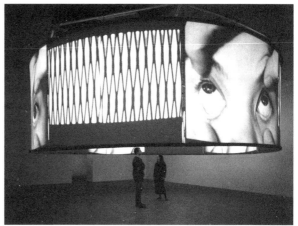

Taschenkino, Eva Spiesberger, Filmhauskino Wien (1995)
Film ist. 1–12, DVD installation, Künstlerhaus Wien (2002)

Ganzen begreifbar – dank der Bezugnahme auf emotionell besetzte Kinoerfahrungen („Komisch", „Magie", „Eroberung" usw.) schon wesentlich mehr, die ungeduldig auf einen dritten hofften. Sie wurden nicht enttäuscht. *Film ist.*, Folge 13 (2009), ist jenen berühmten Topoi gewidmet, die – glaubt man Jean-Luc Godard oder D.W. Griffith – das Herz des Erzählkinos bilden: *a girl and a gun.* Gustav Deutsch hat begonnen, das Terrain großräumiger abzustecken, und die Ergebnisse seiner Vermessungsarbeit werden immer deutlicher.[6]

2002 gestaltet der Architekt, der Raumgestalter Gustav Deutsch im Wiener Künstlerhaus einen Panorama-Raum, in dem uns *Film ist.* umgibt – ein begehbares Rund voller in Endlosschleifen projizierter Bilder… (ebenfalls)… *to be continued*… bis wir sonnengeblendet in das Dunkel der Camera Obscura in Perdika auf der griechischen Insel Aegina treten, die die zwei Architekten Deutsch und Berzl („on one of the most dramatic locations of any artwork in history…", so der Architekturkritiker und Fotograf Sam Lubell) gebaut haben.[7] Nachdem sich unser

6) In diesem Buch wird Gustav Deutschs jüngster Film von Tom Gunning, Michael Loebenstein, S. 181–194, und Beate Hofstadler, S. 201–207, behandelt.

7) Siehe auch Alexander Horwaths Essay „Kino(s) der Geschichte", S. 123–143.

us with *Film ist.*—a walk-able round with endless, projected loops of film, also '…*to be continued*…' Fast forward a year ahead in time to the instant we are blinded by the sun on entering the dark space of a camera obscura built by the architects Deutsch and Berzl in Perdika on the Greek island of Aegina—"one of the most

6) Gustav Deutsch's most recent film is discussed by Tom Gunning, Michael Loebenstein, pp. 181, and Beate Hofstadler, pp. 201.

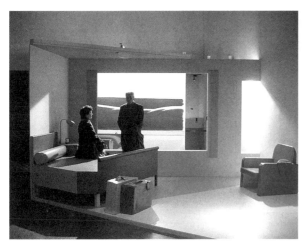

Auge an die Dunkelheit gewöhnt hat, werden wir mit den strahlendsten Umkehrbildern der Ägäis belohnt. Der uns umgebende Raum, das Meer, die Sonne, die Felsen sind ins Innere eingedrungen, hinein in das Dunkle, wo wir körperlos warten, bis wir endlich sehen...

Zum Beispiel *Visions of Reality*. Gestützt auf die *footage* von 15 Gemälden des Malers Edward Hopper,[8] unternimmt Deutsch den Versuch, die Zwischen-Räume dieser Bilder mit narrativem Material auszugießen. Dieses (Film-)Werk wird noch längere Zeit *under construction* sein, aber im Dezember 2008 hat Deutsch bereits zehn dieser Bilder maßstabsgerecht in 3D nachgebaut, das Gemälde *Western Motel* sogar als 1:1-Modell. Man kann hineingehen, sich auf das ewig faltenlose Hotelbett setzen und durch das Fenster das altbekannte Auto betrachten, aber auch die fremde Welt, die außerhalb des Rahmens liegt. Wir sind angelangt. Gustav Deutsch hat uns etwas gebaut und wir sitzen drin.

8) Für mehr Details zu Deutschs „Hopper-Projekt", siehe Michael Loebensteins „Conditio humana".

dramatic locations of any artwork in history," according to the critic and photographer Sam Lubell. After our eyes have adjusted to the dark we are rewarded with the most radiant, inverted images of the Aegean.[7] The surrounding ocean, the sun and the cliffs have penetrated into the dark where we wait—disembodied—till we finally come to see...

Visions of Reality, for instance. Visions sparked by a new type of 'footage': fifteen paintings by Edward Hopper.[8] Deutsch endeavors to fill the space created between these paintings with narrative material. This work will still be ‚under construction' for some time, but as of December 2008 the architect had already transformed ten of Hopper's images into three-dimensional models true to scale. The painting *Western Motel* has been recreated as a life-size model. We can actually go inside, sit down on the permanently wrinkle-free bed and stare out the window at that familiar car—but we can also see our strange world outside the frame. We have arrived. Gustav Deutsch has built us something, and we can sit inside.

7) See also Alexander Horwath's essay "Cinema(s) de l'histoire", pp. 123.

8) For a closer look at Deutsch's 'Hopper project', see Michael Loebenstein's "Conditio humana".

Stefan Grissemann

Kontextwechsel

Zur Arbeit des Bildermonteurs und Filmforschers Gustav Deutsch

Change of Context

Gustav Deutsch: Researcher of Film and Assembler of Images

Ereignisse, die mit freiem Auge auszumachen sind, stehen im Ruf erhöhter Glaubwürdigkeit. Sie genießen eine gewisse Zweifelsfreiheit, sogar im Kino, wo sie nachweislich nicht mehr als Licht und Schatten, strategisch arrangierte Geisterspiele sind. Davon lebt die Illusionsmaschine Kino, diesen Fehler im System macht sich die Filmkunst zunutze. Sehen heißt glauben, auch wenn Glauben, wie man sagt, das Gegenteil von Wissen ist, so wird ihm doch die Fähigkeit zugeschrieben, sprichwörtlich Berge zu versetzen, mindestens aber: sich über die Gesetze der Schwerkraft und der Logik hinweg zu setzen. An den schönen Lügen der Kinematografie mit ihren übermenschlichen Körpereinsätzen, spektakulären Zufällen und unwahrscheinlichen Triumphen wird eisern festgehalten, weil sie nicht einfach nur behauptet werden, sondern sehr konkret *zu sehen*, also auch *zu glauben* sind. Die affektive Wirksamkeit des Kinos ergibt sich anschließend aus dem Umstand, dass die Widersprüche seiner Angebote erst für Aufwühlung sorgen, sich aber endlich doch – gegen alle Widrigkeiten – jedes Mal wieder befriedigend auflösen lassen. So wird die Utopie einer leicht fassbaren harmonischen Menschheitsgeschichte spielerisch nachgestellt, in der jedem Schreckensszenario schon sein positives Gegenbild eingeschrieben ist: Die inszenierte Materialver-

Events discerned by the naked eye are attributed with heightened credibility. They enjoy a certain freedom of doubt even at the cinema, where they evidently consist of nothing more than light and shadow, a strategically arranged dance of ghosts. The machine of cinematic illusion feeds off this fact, its art exploiting this very glitch in the system. Seeing is believing and even though faith is said to be the opposite of knowledge, it is literally attributed with the ability to move mountains, or at least, to move beyond laws of gravity and logic. The beautiful lies of cinema, with its superhuman stunts, spectacular coincidences and unlikely triumphs, are stubbornly held on to—not simply because these lies are asserted, but because they are *to be seen* and therefore *believed*. The affective potency of cinema is a consequence of the fact that the contradictions of its offerings initially produce turmoil, but ultimately and against all odds, are always gratifyingly resolved. Utopia is thus playfully adapted to a readily comprehensible, harmonious history of mankind, in which every horror scenario is inscribed with its affirmative opposite: The staged material destruction so tenaciously pursued by a film industry bent on terror and apocalypse since its earliest endeavors, morphs into art productions on the screen for all to see. And every dramatic defeat turns

19

nichtung, an der die – von Terror und Apokalypse abhängige – Filmindustrie seit ihren frühesten Bemühungen so beharrlich arbeitet, verwandelt sich auf der Leinwand, vor aller Augen, in Kunstproduktion und jede dramatische Niederlage in einen Sieg über die farblose Vernunft. Das Kino: ein Umspannwerk.

Der Wiener Filmemacher Gustav Deutsch weiß die ästhetischen und ideologischen Paradoxien seines Mediums sehr zu schätzen. Sie sind sein Spielfeld. Er liebt die fundamentale Wahrheit im Kern der Schimäre ebenso wie die falschen Bewegungen des Dokumentarischen. Man kann vor den Visionen, die das Kino bietet, die Augen nicht verschließen. Im fünften Kapitel der von Gustav Deutsch kunstvoll arrangierten Materialsammlung *Film ist.* blickt man in die lichtbestrahlten Pupillen anonymer Testpersonen, hat hypnotisch kreisende Spiralmuster wie aus Duchamps *Anémic Cinéma* vor Augen und eine Einstellung in Superzeitlupe, die den tödlichen Biss einer Schlange in den Nacken einer Ratte detailliert. Der Blick auf das Schreckensbild ist unabwendbar; der Voyeur, der naturgemäß nicht anders kann, als sein Angstbegehren auszukosten, ist Opfer der eigenen Schaulust, zugleich Profiteur seiner Panik. Er ist den blutleeren Filmfieberträumen ausgeliefert, die man für ihn präpariert hat, nur wird

into a victory over bland reason. Cinema is a transformation station.

Viennese filmmaker Gustav Deutsch values the aesthetic and ideological paradoxes of his medium. They constitute his field of play. He loves the fundamental truth at the heart of the chimera as well as the false moves of the documentary. One cannot close one's eyes to the visions offered by cinema. In the fifth chapter of *Film ist.*, Deutsch's artfully arranged collection of footage, we look into the irradiated pupils of anonymous test subjects while a hypnotic, spiral pattern reminiscent of Duchamp's *Anemic Cinema* spins before our eyes and a super slow motion shot graphically details the deadly attack of a snake biting the neck of a rat. The gaze cannot be averted from the terrifying image. The voyeur who by nature cannot resist his craving for fear is a victim of visual pleasure and simultaneously profits from his panic. He is subject to the bloodless, feverish dreams prepared for him—only no actual poison is delivered with the fatal snake bite. There is an unwritten agreement that the viewer will leave the cinema possibly in a state of shock, certainly agitated, but on the whole safe and sound.

Gustav Deutsch spends a good deal of time in the dark, sitting at editing tables, withdrawn into the interiors of institutions he frequents

ihm beim Nackenbiss kein Gift verabreicht. Er wird das Kino, so die Verabredung, vielleicht schockiert, sicher bewegt, aber im Ganzen wohlbehalten wieder verlassen.

Gustav Deutsch verbringt viel Zeit in dunklen Räumen: an Schneidetischen, zurückgezogen ins Innere jener Institutionen, die er im Rahmen seiner Recherchereisen aufsucht. Routiniert hantiert er an den Bildermaschinen, an der Seite seiner Partnerin Hanna Schimek, mit Filmstreifen, Metallscheiben, Schiebereglern. In Filmarchiven und Kinematheken arbeitet er sich durch den längst unüberblickbaren Bestand an historischen Bewegungsbildern, lässt sie vor und zurück fahren, um sie auf brauchbare Einstellungen hin abzutasten. Während ihrer Sichtungen bringen Deutsch und Schimek Erinnerungsstützen in Form schnell hingeworfener Zeichnungen zu Papier, Storyboards gewissermaßen, die ihnen helfen, gefundenes Material später erneut zu identifizieren. Das ist Teil ihrer Arbeit: Sie suchen vergessene, verwaiste Filme nach Augenblicken ab, die es hervorzuheben, in Evidenz zu halten gilt. Sie überprüfen wissenschaftliche Filme auf skandalöse, mehrdeutige Bilder und folgen den exaltierten Gesten jener Phantome, die in den flammenden Melodramen, somnambulen Schauergeschichten und absurden Komödien der frühen und klassischen Kinoära auftauchen.

within the framework of his extensive research. He routinely operates the flatbed at the side of his partner Hanna Schimek, well practiced at handling strips of film, editing table plates and controls. He works his way through the immense holdings of film archives and cinematheques, scanning historical moving images, forwarding and rewinding the material in search of suitable shots. During their sessions, Deutsch and Schimek use memory aids in the form of

Deutsch mag es, mit Listen, Zahlen und Kaderplänen zu operieren, die eigene Arbeit zu ordnen, in Kapitel und Subkapitel einzuteilen. Als Künstler ist er systematisch. Das Poetische seines Zugriffs bleibt davon unbeschädigt. Das Mathematische und das Magische, zwei Grundbedingungen des Kinos, bilden in der Filmarbeit des Gustav Deutsch nicht einfach deren Pole, sondern ganz explizit das Zentrum seines Schaffens. Das Kino ist eine aus der Technik geborene Kunst, deren regelmäßiger Puls ohne die Präzision ihrer Maschinen nicht herzustellen wäre. Das ist die eine Seite.

Das Kino ist keine Erfindung der Menschen, meint Gustav Deutsch. Das ist die andere Seite. Sie kompliziert und bereichert die Dinge. Die Geschichte des Mediums reicht tatsächlich weit zurück, in eine Zeit, die lange vor dem Auftauchen des Homo erectus und dessen Laufbildphantasien liegt: bis zur ersten natürlichen Camera Obscura nämlich, in der ein dünner Lichtstrahl ein verdrehtes Bild der Außenwelt an eine dunkle Höhlenwand geworfen hat. Die Jagd nach dem Kern, dem Wesen der bewegten Welt-Abbilder ist Deutschs Lebensprojekt. Na-

quick sketches and storyboards which will help them identify the footage at a later date. This is a central part of their work: They search orphaned and forgotten films for instants worthy of being brought back into evidence. They scrutinize scientific films for scandalous, ambiguous images and pursue the exalted gestures of filmic phantoms in flaming melodramas, somnambulistic horror stories and absurd comedies that surface in the early and classical era of cinema.

Deutsch likes to use lists, numbers and scores to organize his work into chapters and sub-chapters. As an artist, he is systematic. The poetic nature of his intervention remains unscathed by his rigor. The mathematical and the magical, two fundamental conditions of cinema, do not simply constitute poles in the film work of Gustav Deutsch, but are explicitly central to its production. Cinema is an art form born of technology, its steady pulse cannot be produced without the precision of its machinery. This is one side of the story.

According to Gustav Deutsch, cinema is not a human invention—that is the other side of the story. This premise complicates and enriches the matter. The history of the medium actually reaches far back in time, long before the appearance of Homo Erectus and his moving picture fantasies—to an original, naturally occurring,

turgewalten, Sonnenlichtspiele, Mondphasen, Gewitter und Sternenfunkeln betrachtet er als vorfilmische Phänomene, er spricht vom „Projektionsraum Himmel". Seit den frühen 1980er Jahren arbeitet Deutsch nicht nur an Videos und Filmen, sondern auch an interdisziplinären Kunst- und Installationsprojekten zur Phänomenologie des Kinos, an Filmtrailern, DVDs und interaktiven Multimediaunternehmungen, an Forschungs- und Ausstellungsarbeiten sowie performativen Filmformaten. Gern bearbeitet er Projekte erst für den Kinosaal, dann für den Museumsraum und anschließend weiter für elektronische Bildträger; ein stark erweiterter Filmbegriff ist ihm eigen. Für Gustav Deutsch ist *cinema* anders als *expanded* nicht zu denken.

Adria

Die Spezialisierung Deutschs auf die Arbeit mit gefundenem Filmmaterial findet erst in den neunziger Jahren statt; in den ersten Arbeiten seiner Video- und Filmografie ist davon noch nicht viel zu spüren. Erst 1989 vollzieht er seinen Quantensprung auf dem Weg zum Found-Footage-Stilisten. Eine „Schule des Sehens" nennt Deutsch 1989 seine Arbeit *Adria – Urlaubsfilme 1954–68*: Von den Dokumentarkonventionen seiner frühen Filme emanzipiert er sich mit *Adria* nachhaltig, schlägt damit einen ersten entschei-

camera obscura that hosted a thin beam of light which threw an inverted image of the outside world onto a wall inside a dark cave. The hunt for the core, the essence of motion picture representations of the world is the life work of Gustav Deutsch. He views forces of nature, the play of sunlight, phases of the moon, lightning and starlight as pre-cinematic phenomena and speaks of the sky as a 'projection space.' Since the early 1980s, Deutsch not only works on videos and films but also on interdisciplinary art and installation projects in relation to the phenomenology of cinema, as well as film trailers, DVDs and interactive, multi-media endeavors, research and exhibition works and film performances. He enjoys working on projects initially intended for the screen, adapting them for museum spaces, and finally for digital recordings: his is a significantly enlarged concept of film. Gustav Deutsch cannot consider *cinema* other than *expanded*.

Adria

Deutsch's specialization in terms of found footage commences as late as the 1990s—an interest not really palpable in the prior works of his video and film œuvre. His first quantum leap on the path of becoming a found footage stylist occurs in 1989. He calls the film *Adria* a

23

denden Haken. Zwar erscheint der Film, gemessen an der Leichtigkeit späterer Deutsch-Arbeiten, ein wenig spröde, aber er gewährt doch bereits Einblicke in die ironische Ordnungslust dieses Filmemachers: *Adria* versammelt alte Amateuraufnahmen vom Strandurlaub. Dabei legt Deutsch eine kollektive Ästhetik des Hobbyfilms bloß, macht deren kleinste gemeinsame Nenner kenntlich. Man filmt Wegweiser und Straßenschilder (Caorle! Jesolo!), den Wellengang des Meeres, Schwenks nach rechts über vollbesetzte Strände und Stadtansichten – und nach links über Strandlandschaften und venezianische Häuserfronten. Mit der Kamera werden die Silhouetten der Architektur nachgezeichnet. Man grüßt und grinst neckisch, winkt schadenfroh den Daheimgebliebenen vom Strand, vom Markt und vom Hotelbalkon aus zu, man albert im Sand und im flachen Wasser oder schreitet per Regieanweisung stocksteif auf das Objektiv zu: vorgestanzte Posen des privaten Glücks. *Adria* ist ein stummer Film, ganz konzentriert auf die entrückten Erinnerungen enthemmter Pauschaltouristen. Deutschs Liebe zu atmosphärischen elektronischen Soundtracks wird sich erst gegen Ende der Dekade ausbilden: Vor allem seine beiden großen Unternehmungen *Film ist. 7–12* (2002) und *Welt Spiegel Kino* (2005) profitieren von den subtilen nicht-illustra-

School of Seeing. He effectively emancipates himself from the documentary conventions of his early films with *Adria*, thereby abruptly changing gears. In comparison to the lightness of later works by Deutsch, *Adria* can seem somewhat belabored, yet it provides insight into the ironic pleasure of this filmmaker's pursuit of order. *Adria* collects shots from old amateur movies of beach vacations. Deutsch exposes the collective aesthetic of the hobby film, acquaints us with its lowest common denominator. Shots include signs and guideposts (Caorle! Jesolo!), ocean waves, pans from left to right across densely populated beaches and city-scapes—and pans from the right across beachscapes and Venetian house fronts. The camera delineates silhouettes of architecture. People greet and grin whimsically, waving spitefully at those stuck at home—from the beach, in the marketplace and from the hotel balcony; they play foolishly in the sand and shallow waters, and walk woodenly toward the lens in obedience to the cameraperson's direction: prescribed poses of private joy. *Adria* is a silent film, entirely concentrated on the distant memories of budget tourists freed of inhibitions. Deutsch's love of atmospheric, electronic soundtracks would only come into play at the end of the decade. His two larger undertakings, *Film ist. 7–12* (2002) and *Welt Spiegel*

tiven Scores, mit denen Musiker wie Christian Fennesz, Burkhard Stangl, Werner Dafeldecker und Martin Siewert die gefundenen Bilder konfrontieren. Die Assemblage *Adria* weist dennoch bereits deutlich in die Zukunft ihres Regisseurs. In der kurzen letzten Episode bekundet Deutsch erstmals sein dringendes Interesse an den Launen der Materialoberflächen, mit denen er arbeitet; eine Montage aus Ferienszenen auf auslaufendem, gelochtem Film steht programmatisch am Ende von *Adria*. In *Film ist. 4. Material* führt Deutsch acht Jahre später bekritzelte, verfärbte und fleckige Filmkader einer brasilianischen Telenovela vor. Die Bilder verschwinden hinter ihren Schäden, ihren Narben und Blessuren, in einem Tanz der Fehlerstellen, der Abfall- und Endfilmstreifen. Auf einem Flohmarkt in Sao Paolo, so die bizarre Vorgeschichte der Laufbilderbeschädigung, hat der Filmemacher dieses Material gefunden, das in zweifacher Hinsicht bereits bearbeitet war: einmal durch den Lichtbestimmer, der seine Notizen in einzelne Kader geritzt hatte, zum zweiten durch die Putzfrau des Verkäufers, die mit der herumliegenden Filmspule achtlos dessen Badezimmerfliesen gereinigt hatte. Die Flecken stammten also, wie Deutsch ironisch erläuterte, tatsächlich von einer „Brazilian soap".

Kino [World Mirror Cinema] (2005) especially profit from a subtle, non-illustrative score with which musicians like Christian Fennesz, Burkhard Stangl, Werner Dafeldecker and Martin Siewert confront the found images. The assemblage of *Adria* nonetheless clearly indicates the artistic future of its creator. In the last, brief episode Deutsch first manifests a pressing interest in the fanciful material surfaces he is working with: A montage of vacation scenes from end reels perforated with holes programmatically unfolds at the conclusion of *Adria*. Eight years later, in *Film ist. 4. Material*, Deutsch presents film frames inscribed with scribbles, faded and spotted, of a Brazilian Telenova. The images recede behind a dance of scars and blisters, of strained emulsion. The bizarre story of these damaged images has it that the filmmaker found the material at a flea market in São Paolo where it lay in wait, having gone through a two-fold process of preparation: It first passed through the hands of a lab timer who scratched his technical notes into single frames of the material; the reel was then found lying around by the merchant's cleaning lady who used it to scrub bath-

*Non, je ne regrette rien /
Der Himmel über Paris* (1988)

Frühe Werke

In Österreichs erstaunlich vielseitiger Found-Footage-Szene nimmt Gustav Deutsch, bei aller Wertschätzung, die er in der Kollegenschaft genießt, seit jeher eine Außenseiterposition ein: Seine Filme sind weniger ekstatisch als jene Peter Tscherkasskys, weniger privat als die Arbeiten Gabriele Mathes' und weniger „marktgängig" als die Produktionen Martin Arnolds, sie sind systematischer geformt als die Bildereruptionen des Thomas Draschan und lange nicht so obsessiv wie die Fieberträume des Eigenbrötlers Dietmar Brehm. Deutsch lädt die Bilder, die er findet und einsetzt, weder sinnlich noch psychologisch über Gebühr auf, arbeitet an ihnen in einem viel umfassenderen Sinn; er führt sie als Prototypen ihrer Gattung vor, als hervorgehobene „Ansichten", als reflexive Objekte, an denen etwas deutlich wird: der Eigensinn des Mediums an sich.

Um zu einem Film wie *Adria* zu kommen (und von dort aus weiter zu seinem Chef d'œuvre *Film ist.*), muss Gustav Deutsch zunächst eine erhebliche künstlerische Wegstrecke zurücklegen. Als Videodokumentarist im Umkreis der politisierten Medienwerkstatt Wien erlebt er um 1980 seine Initiation. In den Arbeiten *Asuma* (1982) und *Wossea Mtotom* (1984) dokumentiert Deutsch, in Co-Regie mit den Wiekumentiert Deutsch, in Co-Regie mit den Wie-

room tiles. Deutsch ironically points out that its spots indeed originate from a "Brazilian soap."

Early Works

Within the context of Austria's remarkably multi-faceted found footage film scene, Gustav Deutsch is esteemed by his colleagues while enjoying the position of an outsider. His films are less ecstatic than those of Peter Tscherkassky, less private than works by Gabriele Mathes, and less 'marketable' than Martin Arnold's productions; they are more systematically formed than Thomas Draschan's imagistic eruptions and far less obsessive than the feverish 1982 'dreamworks' created by maverick Dietmar Brehm. Deutsch does not charge the images that he finds and implements with undue sensual or psychological qualities. Instead he works on them in a far more comprehensive sense. He exhibits them as prototypes of a genre, as accentuated 'views', as reflexive objects through which something is made clear: the idiosyncratic nature of the medium itself.

Before he is able to arrive at a film like *Adria* (and proceed from there to his chef d'œuvre *Film ist.*), Deutsch first has to travel a considerable artistic distance. He is initiated as a video documentarian around 1980 in the politicised environment of the Vienna Medienwerkstatt.

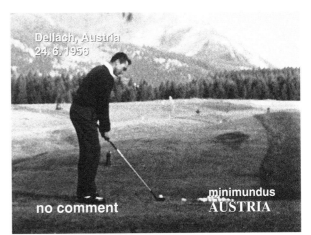

no comment – minimundus Austria (1996)

ner Videoaktivisten Gerda Lampalzer und Manfred Neuwirth, zwei Kunstprojekte, die in Zusammenarbeit mit behinderten Künstlern entstanden sind. Die beiden Filme sind von großer Offenheit, nicht pädagogisch, kommen ohne Kommentar aus.

Dennoch schlägt der Filmemacher Gustav Deutsch bald andere Richtungen ein. Er fasst das Laufbild experimentell auf und beginnt, idiosynkratische Super-8-Kurzfilme zu erarbeiten, deren Titel auf die Bereiche Pop und Politik verweisen: *Non, je ne regrette rien* (1988) etwa oder *Prince Albert fährt vorbei* (1988). Seine Lust am konzeptuellen Spiel wächst über die Jahre merklich. In *Sa. 29. Juni / Arctic Circle* (1990) würdigt Deutsch die Schmalspur-Filmidee zweier Ehepaare auf der Autoreise zum Nordkap: Sie posieren in jeder Szene mit dem Kalenderblatt des jeweiligen Tages – Reiseerinnerungen aus den Sixties, aus einer Zeit vor der einblendbaren Digitaldatumsanzeige. Das Blatt mit der Nummer 29 halten die Reisenden frierend vor ein Straßenschild mit der Aufschrift „Polarsirkel – Arctic Circle".

Österreichisches Amateurmaterial aus den fünfziger Jahren kommt in *no comment – minimundus Austria* (1996) zum Einsatz: Freizeit-, Land- und Bauernleben, Umzüge, Segnungen und Paraden, Bootsfahrten und Sportspiele und

In *Asuma* (1982) and *Wossea Mtotom* (1984), co-directed with Viennese video activists Gerda Lampalzer and Manfred Neuwirth he documents two art projects, that were organized in collaboration with handicapped artists. Both pieces possess a generous candor, avoid pedagogy and succeed without the use of commentary.

Nevertheless, the filmmaker Gustav Deutsch soon strikes out in other directions. He conceives moving images in an experimental manner and begins to work on idiosyncratic, Super-8 short films with titles that refer to pop culture and politics: *Non, je ne regrette rien* (1988) and *Prince Albert fährt vorbei [Prince Albert Passes By]* (1988). His pleasure with conceptual play grows noticeably in the ensuing years. With *Sa. 29. Juni / Arctic Circle [Sat., 29th of June / Arctic Circle]* (1990), Deutsch honors an amateur film project carried out by two married couples on the road to the North Pole. They pose in each scene with a page from the current calendar day, capturing travel memories from the Sixties, before the advent of digital timekeeping. In front of a sign marked 'Polarsirkel—Arctic Circle' the travelers—visibly freezing by now—hold a page with the

Hundebabys werden im Stil unkommentierter Fernsehnachrichten, nur mit Insert versehen (etwa: „Velden, Austria. 22.7.1956"), hintereinander gesetzt und von Deutsch bewusst unauthentisch nachvertont.

Der strukturalistische Tagebuchfilm ist um 1990 eines der bestimmenden Formate Deutschs: *Welt / Zeit 25812 min*, entstanden in Co-Regie mit Ernst M. Kopper, zeichnet eine 18-tägige Weltreise durch zehn Millionenstädte in 35 Filmminuten auf. Die Kamera schießt ein schwarzweißes Bild pro Minute – im Flugzeug, im Koffer, in Hotelzimmern, vor Skylines. Nacht und Tag wechseln einander gleichförmig ab. Man blickt aus Fenstern auf Autobahnen und Innenhöfe, in Zimmer und Flughafenkabinen – und immer wieder lange ins Schwarze. Filmische Alltagsverdichtungen bieten auch die beiden *Minutentagebücher* (1989 und 1992), die je einen Tag lang ein Bild pro Minute aus dem Leben des Gustav D. aufzeichnen. Tagesabläufe sind potenzielle Endlosschleifen: Wiederholungen, Kreisbewegungen. In der Sahara-Oase Figuig realisiert Deutsch 1988 und 1990 zwei strukturalistische Experimente: *360° v.l.n.r. tägl. 1.1.–31.1.1988* besteht aus 31 wackeligen 360-Grad-Schwenks, von denen Deutsch an jedem Tage einen dreht, den ganzen Januar 1988 über. Deutsch ist ein Essentialist des Kinos wie der

number '29.' Austrian amateur footage from the Fifties is employed in *no comment—minimundus Austria* (1996). In a style reminiscent of late night news images without commentary, one scene after another is presented, depicting farm life, processions, blessings, parades, boat excursions, sporting events and puppy shows, aided only by title inserts (i.e. "Velden, Austria. 22.7.1956") and post-dubbed with an obviously inauthentic soundtrack by Deutsch.

The structural diary film is a form that becomes decisive for Deutsch around 1990: *Welt / Zeit 25812 min [World / Time 25812 min]* was co-directed with Ernst M. Kopper and depicts an 18-day world tour of ten mega-cities in 35 film minutes. The camera shoots one black and white image per minute—in an airplane, in a suitcase, in hotel rooms, and of skylines. Day and night steadily alternate. One looks out of windows at highways and inner courtyards, into rooms and airplane cabins; and recurringly, into the darkness. Filmic compression of the everyday is also presented in the two films *Minutentagebücher* (1989 and 1992), each rendering one image per minute from a day in the life of Gustav Deutsch. Daily occurrences are potentially infinite loops constituted by repetitions and circular motions. In 1988 and 1990, Deutsch realizes two structural experiments in the

Welt/Zeit – 25812min (1990)

Kanadier Michael Snow: Geduldig erkundet er simple Standardbewegungen. Für den Film *100 Schritte tägl. 1.1. – 31.1.1990* legt er täglich, wieder einen Monat lang, im Januar 1990 mit der Super-8-Kamera 100 Schritte zurück.

Porträts sind eine Seitenlinie in Deutschs Filmografie, aber auch dabei interessiert ihn das Strukturelle, das Allgemeine mehr als das Individuelle. In den frühen 1990er Jahren ist es vor allem die Künstlerin Hanna Schimek, die von Deutsch in ironischen Kurzfilmen beobachtet wird (und auch als Koautorin dieser Filme auftritt). Die kleine Super-8-Serie *H. isst Tiere* dokumentiert scherzhaft den Wiederholungsakt der Nahrungsaufnahme von Schokolade- und Marzipantieren. Seit 1985 realisiert Deutsch viele seiner Projekte gemeinsam mit Schimek; sie arbeiten vor allem auch im Rahmen der umfassenden, oft monatelangen Filmrecherchen in aller Welt zusammen.

Augenzeugen der Fremde

Die strenge Ordnung in Deutschs Filmen kann nicht ausgeblendet werden; ihre Strukturen bleiben jeweils offensichtlich. Gemeinsam mit dem Marokkaner Mostafa Tabbou dreht Deutsch 1993 in Figuig und Wien den Essayfilm *Augenzeugen der Fremde*: Er besteht aus genau 600 Einstellungen zu je drei Sekunden – die allerdings

Saharan oasis of Figuig: *360° v.l.n.r. tägl. 1.1.–31.1.1988* consists of 31 wobbly, 360-degree pans. Deutsch shot one each day for the entire month of January 1988. He is an essentialist of the cinema like Canadian Michael Snow, patiently exploring simple, standard movements. For the film *100 Schritte tägl. 1.1.–31.1.1990*, Deutsch took 100 steps every day in January of 1990, walking backwards with a Super-8 camera in tow.

Portraits occupy a sideline in Deutsch's filmography, but even these are more concerned with the structural and universal than the individual. In the early 1990s Deutsch mainly works with the artist Hanna Schimek, producing short, ironic films in which she is the protagonist as well as the co-author. The Super-8 series *H. isst Tiere* [*H. Eats Animals*] playfully documents the repetitive act of consuming chocolate and marzipan confections in the shapes of animals. Deutsch has been producing many of his projects in collaboration with Schimek since 1985—but first and foremost, they travel the world together undertaking extensive film research, often for months at a time.

Eyewitnesses in Foreign Countries

The strict order adhered to in Deutsch's films cannot be overlooked—their structure remains

Augenzeugen der Fremde (1993)

zu Zehner- und Zwanzigerblöcken pro Motiv, also zu 30- bis 60-sekündigen Szenen zusammengefasst sind, was den Film deutlich ruhiger erscheinen lässt, als man bei einer solchen Vorgabe vermuten würde. Zwei Filmemacher blicken in die Fremde: ein Europäer in Afrika und ein Afrikaner in Europa. Jeder von ihnen dreht 300 Einstellungen, so ist der Film auch im Großen symmetrisch gebaut. Der von Deutsch fotografierte afrikanische Teil des Films steht in fast spiegelbildlichem Gegensatz zu der von Tabbou umgesetzten Wiener Hälfte: Hitze gegen Kälte, Licht gegen Dunkelheit, Profi- gegen Amateurfilmemacher. Nur in einem sehen sich Deutsch und Tabbou geeint: in der Distanz, die sie zur Welt halten, die sie filmen. Auf die Fremde kann man nur aus der Ferne blicken. Kühl komponiert Deutsch im ersten Teil des Films Landschafts- und Architekturbilder, fotografiert die Welt durch Fenster, die im Cinema-Scope-Format in die Wände gebaut sind, und zeigt die alltägliche Routine in der Oase Figuig: die Arbeit von Männern und Frauen, ein Schlachthaus, eine Schmiede, eine Baustelle, das weiche Licht Nordafrikas. Mostafa Tabbou dagegen zeichnet im zweiten Filmteil vor allem Dunkelheit auf: das Grau und Schwarz des Wiener Winters. Er beginnt seine Erkundung der Stadt mit zarten Lichtreflexen, Funkenschlägen

readily apparent. In 1993, Deutsch directs an essay film in Vienna and Figuig with Moroccan Mostafa Tabbou, entitled *Augenzeugen der Fremde [Eyewitnesses in Foreign Countries]*. It consists of exactly 600 shots lasting three seconds each—albeit appearing in blocks of ten to twenty images per motif and thus organized into scenes lasting 30 to 60 seconds which lend the film a much calmer quality than one might expect under the technical circumstances. Two film-

31

in undurchdringlicher Finsternis. Er filmt nebelige Waldlandschaften, Schönbrunn im Schnee, das Lusthaus und die Prater Hauptallee, Stadtautobahnen und Freizeitwintersportler. Tabbou zeigt seine Schauplätze erst von außen, aus einigem Abstand, um danach selbst in sie „einzusteigen": die Rolltreppen zu benutzen, mit dem Aufzug in die Tiefe zu fahren, Innenräume zu erkunden, hinter die Fassaden frei stehender Gebäude zu blicken. (Drei Jahre später wird Gustav Deutsch ein weiteres Projekt mit Mostafa Tabbou realisieren: In dem sarkastischen Polittraktat *Mariage blanc* von 1996 stellt sich Tabbou in allen Sprachen der damaligen Europäischen Union einer potenziellen Partnerin für eine Papierehe im Asylland seiner Wahl vor.)

Film spricht viele Sprachen

Mitte der 1990er Jahre hat Deutsch sein Programm gefunden. Er holt Filme aus Mülleimern, kauft sie Flohmarkthändlern auf Verdacht ab oder hebt sie unter Schneidetischen auf. Es gehe ihm darum, „unbeachtete und ungeliebte Filme vor dem Vergessen zu retten", erläutert er trocken. Aber die Kino-Archäologie allein genügt ihm nicht. Er zielt aufs Wesentliche. In den Straßen von Casablanca findet Deutsch bei einem Spaziergang 39 verstreute Filmstücke eines verschrammten, verschmutz-

makers gaze on foreign territory: one is a European in Africa, the other an African in Europe. Each directs exactly 300 shots, additionally providing the film with symmetry in its overall structure. The African part directed by Deutsch inversely mirrors the Viennese part realized by Tabbou: heat versus cold, light versus darkness, professional versus amateur filmmaker. Deutsch and Tabbou only seem akin in terms of the distance they keep to the world they are shooting: One can only view the foreign from afar. Deutsch coolly composes images of landscape and architecture in the first part of the film, shooting through windows with dimensions reminiscent of the CinemaScope aspect ratio, showing everyday routines at the oasis of Figuig: men and women at work, a slaughterhouse, a blacksmith's forge, a construction site, the soft light of North Africa. In contrast, Mostafa Tabbou predominantly depicts darkness in the second half of the film: the grey and black tones of winter in Vienna. He commences his investigation of the city with delicate light refractions, sparks in the impenetrable darkness. He films foggy forest landscapes, the palace of Schönbrunn in the snow, the Lusthaus, the main Prater alley, city highways, and sports enthusiasts. Tabbou first undertakes exterior shots of his settings, assuming a certain distance before

ten, aber immer noch irreal bunten indischen Unterhaltungsfilms: die offenbar beim Transport verloren gegangene Rolle eines Hindi-Musicals mit singender junger Frau in einer Kutsche und an einem öffentlichen Swimmingpool, mit Motorradfahrer und abreißender Barszene. Deutsch sammelt die Filmsplitter ein und montiert 21 der gefundenen Fragmente 1995 zu einem 60-Sekunden-Trailer für das Wiener Filmfestival Viennale. Er nennt das Werk *Film / Spricht / Viele / Sprachen*. Die vier Begriffe des Titels blitzen kaum wahrnehmbar zwischen den Bildern auf, Perforation und Lichttonspur des Originalfilms bleiben im Blickfeld: trotz seiner Kürze ein Hauptwerk in der Werkliste des Bildermonteurs Gustav Deutsch.

Gefundenes Filmmaterial, wie Deutsch es versteht, muss nicht unbedingt vorführbar sein; es muss, solange man von seiner Existenz oder wenigstens seiner Idee weiß, nicht einmal auffindbar sein. Deutschs dokumentarische Erzählung *K & K & K* (1999) beispielsweise ist eine filmische Paradoxie: ein selbst gedrehter Found-Footage-Film, ein cleveres Spiel mit verschwundenem oder nie belichtetem Material. Die Videoarbeit ist dem Wiener Avantgardefilmpionier Kurt Kren gewidmet und versteht sich als eine Art doppelter Erinnerungsfilm: Deutsch denkt mit dem Material, das er an einem Mitt-

he gradually 'steps into' the scene, riding on escalators, taking elevators to descend into the depths, exploring interiors and looking behind the facades of free-standing buildings. (Three years later Deutsch will realize another project with Mostafa Tabbou: a sarcastic political tract entitled *Mariage blanc*. Tabbou introduces himself to a potential wife in the film—in all the current languages of the European Union, in pursuit of a paper marriage that would enable him to take refuge in a country of his choice.)

Film speaks many languages

By the mid-1990s, Deutsch has established his agenda. He picks films out of the garbage, buys footage from flea market merchants on the suspicion they may be of interest, and retrieves outtakes from under editing tables. His concern is to "rescue ignored and unloved films from being forgotten," as he dryly explains. But an archeological pursuit of film in itself is inadequate to him. He aims for its essence. On a walk through the streets of Casablanca, Deutsch finds 39 scattered pieces of film from a scarred and soiled, yet still unbelievably colorful Indian entertainment film. The reel from a Hindi musical must have been lost in transport and includes a young woman singing in a coach and at a public pool, with a man on a motorcycle, and in a

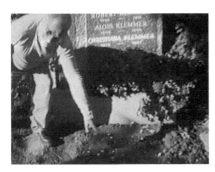

woch im August des Jahres 1997 buchstäblich aus der Hüfte gedreht hat, an seinen Freund Kren zurück, der sich darin seinerseits an seinen Freund Robert Klemmer erinnert. Schon darin spiegelt sich das Wesen der Arbeit mit gefundenem Filmmaterial: Sie ist nichts anderes als re-kontextualisierte Erinnerung. *K & K & K* bezieht sich jedoch ganz explizit auf einen Film, der nicht mehr verfügbar ist, nur als Beschreibung, als Konzept existiert – auf Krens *Klemmer und Klemmer verlassen die Welt* von 1971. Damals hatte Kren das Begräbnis des 33jährig verstorbenen Malers Klemmer mitgefilmt, war dabei jedoch auf technische Probleme gestoßen: Der Film verhakte sich im Inneren seiner Kamera, blieb stecken. Kren entnahm den defekten Film, warf ihn ins offene Grab seines Freundes – und bestattete seinen „Klemmer" gemeinsam mit dem anderen Klemmer. In seiner Filmografie führte Kurt Kren die Arbeit, schon ihrer Geschichte wegen, weiter an. Deutschs *K & K & K* nimmt die Episode wieder auf – im Tonfall eines minimalistischen Roadmovies und eines zweifachen Epitaphs. (Zum Zeitpunkt der Filmveröffentlichung 1999 lebt auch Kurt Kren nicht mehr.) Deutsch holt Kren im Café Jelinek ab, spaziert mit ihm die Otto-Bauer-Gasse hoch, fährt mit ihm U-Bahn Richtung Innenstadt. Im Café Alt Wien hängt ein Bild, das Kren Deutsch zeigen

bar scene that breaks off abruptly. Deutsch gathers the splinters of film and in 1995 edits twenty-one of the found fragments into a 60 second trailer for the Viennese International Film Festival, the Viennale. He entitles the work *Film / Spricht / Viele / Sprachen [Film / Speaks / Many / Languages]*. The four words of the title flash almost imperceptibly between the images while the perforations and optical track of the original film remain in view. Despite its brevity, this is a major film in the list of works by 'image assembler' Gustav Deutsch.

Found footage as conceived by Gustav Deutsch does not necessarily have to be presentable. As long as the fact of its existence or at least its premise is known, it does not even have to be available. Deutsch's documentary narrative *K & K & K* (1999) is an example of a filmic paradox. It cleverly plays with the concept of the found footage film, with film material that disappeared, or was actually never exposed. The video project is dedicated to Viennese avant-garde film pioneer Kurt Kren, and can be understood as a kind of two-fold film of remembrance. Deutsch thinks back upon his friend using material he literally shot from the hip on a Wednesday in August of 1997, showing Kren remembering his friend Robert Klemmer. The essence of working with found footage is

will: Hoch oben an der Wand findet sich ein vom Rauch vergilbtes Klemmer-Gemälde, das den Maler selbst mit dem Szenewirt Kurt Kalb zeigt. Klemmer, den Kren einen „Saufkumpan" nennt, blickt posthum aus seinem eigenen Bild, das an der Wand des Alt Wien unbeachtet verfällt, in Deutschs Videokamera. Mit dem Taxi machen sich Kren und Deutsch auf, Klemmers Grab zu suchen, das erst nach längerer Recherche am Dornbacher Friedhof zu finden ist: Gruppe 42, 5. Reihe, 3. Grab. Kren fotografiert Deutsch und denkt amüsiert über den eigenen Tod nach. Es mache ihm, anders als früher, keinen großen Spaß mehr, auf Friedhöfen „herumzulatschen", lacht er, da man eh „selber schon so nah dran" sei. „Der gemalte Doppelgänger auf den Bildern des Lebenden wurde ein gefilmter Doppelgänger des abgelichteten Toten", philosophiert Deutsch als Erzähler aus dem Off noch – und betont damit die vielfach selbstreferenzielle Anlage seines Films.

Performances und Installationen

Deutsch denkt das Kino weit über dessen traditionelle Grenzen hinaus: Für sein interaktives *Taschenkino* lässt er 1995 100 Spielzeugfilmbetrachter, so genannte Microviewer, im Zuschauerraum kreisen, auf denen je eine kurze Filmschleife zu sehen ist: das Auge eines Pferds, die

already reflected in the very concept of the project: It is nothing other than the re-contextualizing of memory. However *K&K&K* explicitly refers to a film that is no longer available, existing solely as a description, as a mere idea: Kren's *Klemmer und Klemmer verlassen die Welt [Klemmer and Klemmer depart the world]*, from 1971. While filming the funeral of the painter Martin Klemmer who had died at the age of 33, Kren had run into technical difficulties. The film got jammed in his camera and stopped dead in its tracks. Kren threw the defective film into his friend's open grave—and buried his 'Klemmer' together with his friend ['Klemmer' is a German word for something that gets stuck]. Kren persisted in listing this work in his filmography, precisely because of the history it encapsulated. Deutsch's *K&K&K* returns to the episode, embodying the cadence of a minimalistic road movie and dual epitaph (Kren was no longer alive at the film's premiere in 1999): Deutsch picks Kren up at Café Jelinek. They walk up the Otto-Bauer-Gasse, catching a subway headed for the center of town. Kren wants to show Deutsch a picture at Café Alt Wien. High up on the wall hangs a painting by Klemmer, yellowed by smoke and time, depicting himself. Klemmer, who is referred to by Kren as a drinking pal, gazes posthumously from his own painting that is quietly

Taschenkino – der Katalog (1995)

Ohren eines Esels, der Schwanz eines Zebras, Blitze, Feuer, Wolken, Wasseroberflächen. Ein Kreisel, eine Schaukel. Schwenks seit- und auf- und abwärts. Kurze Bewegungsabläufe, Zurücklegung knapper Wegstrecken. Alltagsarbeiten, Routinehandbewegungen, Sport und Musikerzeugung. Rituelle Handlungen, ein Kuss, ein Shakehands, gedrehte Daumen und übereinander geschlagene Beine.

Über Formfragen vergisst Gustav Deutsch die ideologiekritische Grundlagenforschung nicht. Seine zehnteilige Kunstinstallation *Tatort Migration* (2005) ist eine Analyse der Thematisierung des „Fremden" in der deutschsprachigen Krimifernsehserie *Tatort*. Deutsch stellt Geschichten von Abschiebung, Menschenhandel und Alltagsrassismus nebeneinander – und führt so die Migration als ein Zentralthema auch in der Populärkultur vor. Mit demselben Sujet ist auch Deutschs und Schimeks Beitrag zu *The Mozart Minute* (2006), einer Filmrolle mit Arbeiten zum Jubiläumsjahr des Komponisten, befasst. *Die Mozarts* nimmt den Namen des Komponisten touristisch. Eine Reihe barock kostümierter Konzertkartenverkäufer, strate-

disintegrating on the wall at Alt Wien, looking directly into Deutsch's video camera. Kren and Deutsch take off by taxi, in search of Klemmer's grave which they find at the Dornbacher cemetery after extensive research: Group 42, row 5, lot 3. Kren photographs Deutsch and thinks bemusedly about his own death. He comments that it's not much fun anymore "to stomp around" in graveyards like in the olden days, laughing and adding, "now that it's almost one's own turn." Deutsch philosophizes off-screen, "the painted doppelganger depicted in the images of the living became a doppelganger of the filmed dead," his words stressing the multi-faceted, self-referential approach of his film.

Performances and Installations

Deutsch thinks of cinema far beyond its traditional boundaries. In 1995 he circulates 100 toy movie-viewers or 'micro-viewers' among the audience for his interactive *Taschenkino (Pocket Cinema)* project. Each device runs a short strip of film displaying individual motifs: the eye of a horse, the ears of a donkey, the tail of a zebra, lightning, fire, clouds, bodies of water; a spinning top, a swing; pans and tilts; brief movements, the walking of short distances; everyday tasks, routine hand gestures, sports and music making;

Tatort Migration 1–10,
Kölnischer Kunstverein (2005)

gisch vor der Wiener Staatsoper, dem Burggarten, vor dem Stephansdom und dem Burgtheater platziert, stellt sich, mit Blick in die Kamera, mit einem jeweils halb fingierten Namen vor: mit dem eigenen Vornamen und dem Nachnamen des berühmten Komponisten. Die Familie Mozart, die Deutsch und Schimek ironisch (und dokumentarisch) präsentieren, ist eine Gesellschaft der Migranten, die sich ihren Unterhalt damit verdient, Mozart-Konzertkarten an Passanten zu vermitteln.

Zarah Leander singt, Marlene Dietrich streitet, zwei Männer halten dubiose Reden: Zwischen 1931 und 1937 sind die vier Tonfilmfundstücke entstanden, die Gustav Deutsch in seiner Installation *Film ist. Stimme und Gesang* (2004) auf vier monumentale Bildschirme setzt. Auf einem der Monitore spricht NS-Propagandaminister Joseph Goebbels zum Volk, in einem Dokument aus dem Frühjahr 1933. Ihm gegenüber: ein deutscher Röntgentonfilm von 1937, in dem durchleuchtete sprechende Köpfe ihr prosaisches Inneres, bewegliche Knochen, Knorpel und Röhren, preisgeben. Sprechapparate sind sie beide: Goebbels stellt „soziale Erlösung" in Aussicht und „eine Revolution von unabsehbaren Ausmaßen"; der gläserne Mann vis-à-vis ist weniger konkret; er sagt bloß Vokale, Wochentage und Monate auf, monoton, seltsam träu-

ritualistic events, a kiss, the shaking of hands, the twiddling of thumbs and the crossing of legs.

His concern with form does not move Gustav Deutsch to neglect his critical preoccupation with political ideology. His ten-part installation, *Tatort Migration 1–10* (2005), analyses the framing of the 'foreigner' in the German television crime drama series *Tatort*. Deutsch places stories of deportation, human trafficking and everyday racism side by side, exhibiting immigration as a theme central to popular culture. The same subject is at work in the contribution Deutsch and Schimek made to *Die Mozart-Minute [The Mozart Minute]* (2006), a film reel comprised of works undertaken in honor of the composer's 250th birthday. *Die Mozarts [The Mozarts]* interprets the name of the composer touristically. A series of concert ticket agents professionally clad in Baroque costumes strategically place themselves in front of tourist sites: the Vienna Opera, the Burggarten, St. Stephen's Cathedral and the Burgtheater. They introduce themselves to the camera using half fictional names, combining their own surname with the family name of the famous composer. The Mozart family as presented by Deutsch/Schimek is constituted by a society of immigrants who earn their living by brokering tickets for Mozart concerts to passersby.

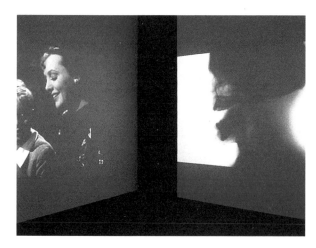

Film ist. Stimme und Gesang,
ZKM, Karlsruhe (2004/05)

Zarah Leander sings, Marlene Dietrich fights, two men hold dubious speeches: four remarkable sound film fragments created between 1931 and 1937. Deutsch integrates them in an installation entitled *Film ist. Stimme und Gesang [Voice and Song]* (2004), presenting them on four monumental screens. On one monitor Nazi propaganda minister Joseph Goebbels speaks to 'the masses' in archival footage from the Spring of 1933. Facing him stands a monitor displaying a German x-ray film from 1937 in which irradiated talking heads reveal their prosaic interior of moving bones, cartilage, and windpipes. Both are depictions of a talking apparatus: Goebbels announces the promise of "social redemption" and a "revolution of unforeseeable dimensions." The x-rayed man on the other screen is less concrete—he simply recites vowels, days and months in a strangely dreamy and monotone manner, as if under hypnosis. His leaden vocal tone has an associative ring reminiscent of wartime newsreels and movies of the Third Reich. The installation is to be understood as part of the project *Film ist.*, currently constituted by 240 minutes of film and two works for museum exhibition spaces.

Film ist.

Deutsch cares little for heavily quoted and canonized films. The material used for both of his

merisch, wie hypnotisiert. In dem blechernen Klang seiner Stimme schwingt assoziativ der Klang der Kriegswochenschauen und der Spielfilme des Dritten Reichs mit. Die Installation ist als Teil des Projekts *Film ist.* zu verstehen, das derzeit aus 240 Minuten Film und zwei Arbeiten für den Museumsraum besteht.

Film ist.

Am Zitieren kanonisierter Kinoarbeiten liegt Gustav Deutsch wenig. Das Material für seine beiden „Tableaufilme", die er *Film ist. 1–6* (1998) und *Film ist. 7–12* (2002) genannt hat, stammt aus weit gehend unbekannten Quellen: Es geht Deutsch nicht um Film*geschichts*-, sondern um Film*wesens*forschung – darin aber ganz explizit „nicht um filmwissenschaftliche Theoriebildung", sondern um „eine persönliche filmkünstlerische Annäherung". Die Standortbestimmung ist entscheidend: Zu oft wurde Deutschs Form der Auseinandersetzung mit dem Kino als akademisch missverstanden. Die ersten zwölf Teile seines Langzeitprojekts kreisen um die „Geburtsstätten des Films", das wissenschaftliche Labor und den Jahrmarkt – also einerseits um

Lehr- und technische Versuchsfilme, andererseits um Slapstick und Spektakelkino, um Melodramen und Kolonialismusfilme. Die *Film ist.*-Reihe entsteht in Kooperation und Koproduktion mit jenen europäischen Filmarchiven und -museen, die Deutsch mit Material und Nutzungsrechten versorgen. *Film ist.* sei ein „Buch der Träume", schreibt Tom Gunning, ein Akt der Kunst und der freien Assoziation.

In *Film ist.* verlaufen anfangs alle Bewegungen von rechts nach links, Deutschs alte Lust an der Kombination sehr ähnlicher, serieller Einstellungen – siehe *Adria* – schlägt hier noch einmal durch. Aber *Film ist.* will viel mehr vom Kino als bloße strukturelle Vergleichbarkeit. Die Produktion ist auch ein synthetischer Erzählfilm: Deutsch konstruiert Geschichten, die in den gefundenen Bildern eigentlich nicht vorgesehen waren. Der Reiz, der im einen Film ausgeübt wird, erfährt seine Reaktion in einem anderen. Auf den „kosmischen" Einsatz des Lichts verweist der Filmemacher unentwegt. Es flackert nervös im Menschenauge, das gespenstisch die Leinwand füllt, es strahlt vom Himmel herab und übersetzt sich in Funkenflug und Feuerwände: Das Licht, wie es im Kino erscheint, ist eine Naturgewalt. Das Feuer gehört zu Deutschs favorisierten Filmmotiven, weil es sich nicht nur mit dem Themenkomplex des Kino-

"tableau films," which he entitled *Film ist. 1–6* (1998) and *Film ist. 7–12* (2002), largely derive from unknown sources: Deutsch is not concerned with film *historical* research, he wants to research the *essence* of film. He is explicitly uninterested in the cultivation of a film historical theory, rather pursuing a personal approach. The positioning of Deutsch's work is decisive. The form his debate with cinema takes is all too often misunderstood as academic. The first twelve parts of the long-term project circle between the two 'birthplaces of film'—the scientific laboratory and the amusement park. On the one hand Deutsch uses educational and scientific test films, and on the other, he focuses on slapstick and spectacular movies, melodramas and colonialist films. The *Film ist.* series is produced in cooperation with European archives and museums that provide Deutsch with footage and copyrights. *Film ist.* is a "book of dreams" according to Tom Gunning, an artistic act and an act of free association.

Initially each action in *Film ist.* moves across the screen from right to left—Deutsch's pleasure in combining similar shots in a series (see *Adria)* surfaces once again. But *Film ist.* demands much more of cinema than mere structural comparability. The production is also a synthetic narrative: Deutsch creates stories that were never

lichts verbinden lässt, sondern auch mit jenem des filmmateriellen Verfalls. Mit einem Diktum Gustav Mahlers hat Deutsch 1999 eine seiner kleinen Arbeiten betitelt: *Tradition ist die Weitergabe des Feuers und nicht die Anbetung der Asche* besteht aus spektakulären Bildern verschmolzener Nitrocellulose; hinter einer Wand aus Flecken und Kratzern kann man Aufnahmen eines brennenden Hochhauses erkennen, blutrot gefärbt und von Christian Fennesz mit elektronischem Geräuschmaterial begleitet.

In Filmbildern von der Vermessung der Körperfunktionen eines Tenors findet Deutsch im dritten Kapitel von *Film ist.* zu einem anderen Generalthema: zu den bizarren Wechselwirkungen von Wissenschaft und Kunst. Eine Frau tritt auf, verkabelt wie eine Selbstmordattentäterin. Die Maschinenmenschen, die Deutsch zeigt, erscheinen vermessen und durchleuchtet wie der Röntgenschädel der anonymen Sprechtestperson, willenlos wie die Crash-Test-Puppen in den Zeitlupestudien der Firma Daimler-Benz. Über die Jahre scheint Gustav Deutschs Arbeitsweise nur noch aufwändiger geworden zu sein: Auszüge aus rund 70 Filmen finden sich in den Teilen eins bis sechs; die Episoden sieben bis zwölf greifen bereits auf 190 Filme zurück. Deutsch schwelgt in surrealistischen Schnittfolgen, nicht mehr allerdings, um die Bourgeoisie

meant to be told in the original footage. Stimulus in one film finds response in another. The filmmaker perpetually refers to the "cosmic" action of light. It nervously flickers in the human eye, it hauntingly fills the screen, it pours down from the heavens and is translated into flying sparks and walls of fire: Light as it appears in cinema is a force of nature. Fire is one of Deutsch's favorite film motifs, not only because it dovetails with a host of ideas relating to light in cinema, but also because it is connected to the idea of filmic decay. Deutsch entitled a short work from 1999 with a dictum articulated by Gustav Mahler: *Tradition ist die Weitergabe des Feuers und nicht die Anbetung der Asche* [*Tradition is the Handing on of Fire, not the Worship of Ashes*]. It consists of spectacular images of molten nitrate film. Behind a wall of spots and scratches one glimpses shots of a burning high-rise, tinted red and accompanied by electronic sound composed by Christian Fennesz.

Film images showing the measurement of a tenor's physical capabilities lead Deutsch to another essential theme presented in the third chapter of *Film ist.*: the bizarre reciprocity of science and art. A woman appears, wired with cables like a suicide bomber. Deutsch presents mechanical figures that appear measured and transparent, like the anonymous speaker in the

 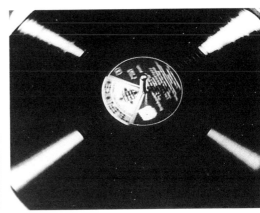

zu irritieren, sondern um die ungeheuerliche Manipulationsmacht des Kinos zu demonstrieren: Hinter jeder Bürgerwohnungstür kann sich das offene Meer verbergen, ein orientalischer Markt oder eine bedrohte Stummfilmheldin. Der Titel der siebenten Eintragung in Deutschs Buch der Träume ist in der Vielfalt seiner Bedeutungen zu lesen: „Komisch", das muss hier „spaßig" *und* „befremdlich" meinen. Die Montage rekonstruiert eine unter Beobachtung stehende Welt: Von einer Felswand aus nimmt ein Mann via Fernglas ein Boot in den Blick, dessen Mannschaft selbst gerade eine Tänzerin observiert. Anderswo zeichnet sich eine kriminelle Geschichte ab; man wird Zeuge von Ermittlung, Übergriff und Flucht, aber die Erzählung verdichtet sich nie, findet keine Logik, steigert sich bloß zur Raserei und bleibt für alle Lesarten offen: eine narrative Kapsel aus Slapstick, Thriller, Western und desaströsem *chase film*.

Klassisch surrealistisch setzt Kapitel 9.3, Stichwort „Eroberung", ein: mit dem Einbruch des Animalischen in den Bürgersalon. Raubtiere dringen in die Villa vor und vertreiben die parfümierte weiße Gesellschaft aus ihrem Paradies. So bearbeitet Deutsch den kolonialistischen Blick im frühen Kino: Im ethnografischen Film wird das „Wilde" für die Kamera inszeniert – nackte Tänzerinnen, perplexe Schwarze, grim-

x-ray film, or helpless, like crash test mannequins in slow motion studies by Daimler-Benz. Deutsch's working method seems only to have gotten more elaborate over the years. Excerpts from approximately 70 films are to be found in *Film ist. 1–6* while episodes 7–12 resort to 190 films. Deutsch revels in surrealist sequences, not to irritate the Bourgeoisie but rather to demonstrate the enormous, manipulative power of cinema—the open sea, an oriental marketplace or a silent film heroine in distress might be lurking behind any front door. Multiple meaning is legible in the title of the seventh entry in Deutsch's book of dreams: "Komisch" in German can connote both 'funny' *and* 'strange.' The montage reconstructs a world under surveillance. A man with binoculars standing on a cliff has a boat in his sights while the crew on board is watching a female dancer. Somewhere else, a crime is unfolding. We are witness to an inquest, an assault and an escape while the whole story never quite coalesces and finds no rationale, instead escalating into a mania open to interpretation: a narrative encapsulating slapstick, thriller, Western and a disastrous chase.

Classical surrealism takes hold in chapter 9.3 with the keyword "Eroberung" [conquest], as the bourgeois living room is invaded by the

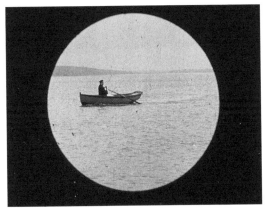

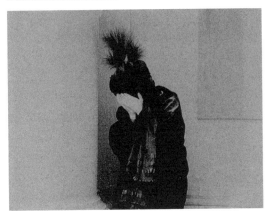

Welt Spiegel Kino / Episode 1,
Kinematograf Theater Erdberg 1912 (2005)

mig starrende Buschmänner. Der Zynismus des „Ersteweltkinos" wird in der Zusammenschau evident: Erst untersucht ein filmender Ethnograf die Piercings eines Afrikaners, dann wird ins Maul eines toten Nilpferds geschaut. Die Assoziationskette führt von hier aus logisch in den Krieg, zu den für die Kamera inszenierten Schlachtenordnungen, zur militärischen Selbstdarstellung einer mit Freude in den Ersten Weltkrieg ziehenden Gesellschaft: Aus allen Rohren wird gefeuert. Zum Männerstolz über die reglementierte Vernichtungsarbeit kommt das Leiden der Frauen: Das Kino-Arsenal des Melodramatischen wird in Episode elf vermessen. Die Stummfilmdiven leiden Hände ringend und mit vor Schmerz verzerrten Gesichtern, Pistolen werden in Anschlag gebracht, Männer dringen in die Schlafzimmer wehrloser Frauen vor, es werden Ringe angesteckt, Dolche hervorgezogen und Gift vergossen über die Filme, die Räume und die Zeiten hinweg.

Welt Spiegel Kino
Ein weiteres seiner vielen *works-in-progress* – und eines seiner zentralen Werke – hat Gustav

animal kingdom. Predatory animals storm the villa and banish its perfumed white society from their paradise. This is how Deutsch works the colonialist gaze of early cinema: The savage world is staged for the camera in ethnographic films showing naked dancers, perplexed blacks, grimly scowling bushmen. The cynicism of first world cinema is made evident in the synopsis. First, a filmmaking ethnographer examines the piercings of an African, then we look inside the mouth of a dead rhinoceros. Subsequently the series of associations logically proceeds to war, from battle movements directed for the camera to the military self-portrayal of a society joyously entering into World War I. Old cannons are fired. Male pride in the regimented labor of destruction is coupled with the suffering of women. The cinematic arsenal of melodrama is surveyed in episode 11. Silent film divas with distorted expressions wring their hands in anguish, pistols are drawn, men force their way into the bedrooms of helpless women, rings are put on fingers, knives are drawn, poison pours over the films, across space and time.

World Mirror Cinema
In 2005 Gustav Deutsch introduces yet another of his many works-in-progress: *Welt Spiegel Kino [World Mirror Cinema]* is a central work, con-

Deutsch 2005 mit dem 90minütigen Dreiteiler *Welt Spiegel Kino* vorgestellt. Im Wien des Jahres 1912 stand an der Ecke Schlachthausgasse und Erdbergstraße das „Kinematograf Theater", ein Vorstadt-Lichtspielhaus: Eine historische Dokumentarfilmszene vom Leben auf dem Boulevard vor diesem Theater bildet den Ausgangspunkt des ersten Teils in *Welt Spiegel Kino*. Selbstreflexive Versuchsanordnungen sind Deutschs Spezialität: Er dringt, während er die Bilder verlangsamt und auf verschwindende Details in der dokumentarischen Massenszene zufährt, so tief in sein Material, dass es sich wie von selbst zu fiktionalisieren scheint. Deutsch wählt einzelne anonyme Figuren aus der Menge – und ordnet diesen mit anderen gefundenen Filmfragmenten imaginäre Hintergrundgeschichten, Rückblenden, Phantastereien zu. Die kunstlosen Bilder von der Straße werden assoziativ mit der Kinofiktion verschnitten, beginnen ein geheimnisvolles Eigenleben zu führen: Die Welt spiegelt sich im Kino.

Zwei weitere Episoden, die erneut auf simplen Schwenks über das Straßentreiben vor grossen Kinohäusern basieren, folgen auf das Wiener Segment: eine im Juli 1929 gedrehte Szene aus Surabaya im ehemaligen Niederländisch-Indien (wo man ausgerechnet Fritz Langs *Nibelungen* und den Lon Chaney-Krimi *The Unholy*

sisting of three parts with a running time of 90 minutes. In the Vienna of 1912, the "Kinematograf Theater" stood at the corner of Schlachthausgasse and Erdbergstrasse, a cinema on the edge of town. An historical documentary film scene of street life in front of this theater unfolds and provides the point of departure for the first part of the film. Self-reflexive experimental settings are Deutsch's specialty: He penetrates deeply into the material, slowing down the footage and moving in on minute details in the archival crowd scene. At this point the material appears to become fictionalized of its own accord. Deutsch chooses anonymous individual figures from the crowd and combines them with other found film fragments, rendering imaginary background stories, flashbacks, and fantasies. Artless images of the street take on a mysterious life of their own: The world is mirrored in cinema.

Two further episodes are based on straightforward pans across bustling streets in front of big movie houses, and follow upon the Vienna segment. One scene, dating from 1929, was shot in the former Dutch Indies city of Surabaya where Fritz Lang's *Nibelungen* and the Lon Chaney detective story *The Unholy Three* were being presented. The other scene is from Porto, in the year of 1930. Deutsch digs deep into the

45

Three zeigt) und eine aus Porto anno 1930. Indem sich Deutsch – sowohl in seiner verschachtelnden Montage als auch ganz buchstäblich in der Eindringung ins grobe Korn seiner Einstellungen (das Bild drohe sich „im Schwirren der Filmkörnung aufzulösen", schreibt Tom Gunning über *Welt Spiegel Kino*) – tief in die Bildschichten gräbt, vollzieht er den kontrollierten Sturz ins Bodenlose des narrativen Kinos: Alles scheint mit allem in Zusammenhang zu stehen und einen irrlichternden filmischen Raum zu produzieren, in dem das Fiktive vom Dokumentarischen bald nicht mehr zu unterscheiden ist. *Welt Spiegel Kino*, schreibt Gustav Deutsch, präsentiere „(Kino)Geschichte(n), wie wir sie in Filmarchiven finden: sprunghaft, zufällig und überraschend". – Das Haus, in dem 1912, wie Deutsch zeigt, ein in Dänemark produzierter Film mit dem deutschen Verleihtitel *Die schwarze Kappe* lief, steht übrigens noch: An seiner Fassade leuchten heute die neongrünen Lichter eines Wettcafés.

In seiner Kunst ergründet Deutsch die Fundamente des Filmischen unaufhörlich, seit knapp 30 Jahren und gegenwärtig intensiver denn je.

layers of the images through a densely interwoven montage coupled with a literal penetration into the material's graininess ("the image threatening to resolve itself into the swarm of film grain," writes Tom Gunning on *Welt Spiegel Kino)*. He thereby executes a controlled fall into the bottomless nature of narrative cinema: Everything appears to be interrelated, producing an uncanny filmic space in which the fictional and the documentary soon become indistinguishable from one another. According to Deutsch, *Welt Spiegel Kino* presents "(cinema) history the way we find it in the film archives: volatile, haphazard and surprising." The Vienna building which in 1912 played host to a Danish film entitled *The Black Cap* still exists, by the way. But it is no longer a movie theater: the green neon lights of a gambling café now glow on its façade.

Deutsch has ceaselessly fathomed the depths of fundamental filmic principles in his art over the course of almost thirty years, and he continues to do so more intensively than ever. His definitions and shorthand formulas of film are apparent maneuvers. He realizes that the mercurial movie mysteries fluctuating between evidence and phantasm are not to be conclusively resolved. Unable to solve the unanswerable, he strives for a specificity of inquiry, for an artisti-

Welt Spiegel Kino / Episode 3,
Cinema São Mamede Infesta, Porto 1930 (2005)

Die Definitionen und Kino-Kurzformeln, die er anbietet, sind Scheinmanöver. Er weiß, dass die Mysterien der zwischen Evidenz und Phantasma changierenden Laufbildkunst nicht endgültig zu klären sind. So bemüht er sich – Antworten notgedrungen schuldig bleibend – um die Präzisierung seiner Fragen, um lustvolle künstlerische Zuspitzung (und Vorführung) der tausend Finten eines Mediums, dem wir uns, wider besseres Wissen, sehlüstern und gutgläubig immer wieder anvertrauen. Der umfassende, lexikografische Zugriff des Filmforschers hat, so gesehen, System. Deutsch schließt in seiner Arbeit nichts kategorisch aus, keine Bildersorte hat bei ihm Vorrang – und alles, auch das scheinbar „Wertlose", Anspruch auf kritische Durchleuchtung: zufällig Gefundenes und selbst Inszeniertes, laienhafte und professionelle Darstellungen, *early cinema* und spätes Filmtheater, Fernsehen und Kino, „Kunst" und „Kitsch". In der nicht wertenden Präsentation der Filmfundstücke, in der Verschiebung des Blicks von der größeren Erzählung zu den visuellen Details wird etwas sichtbar, sind Entdeckungen zu machen. Darauf legt Gustav Deutsch größten Wert: zu bezeugen, dass kühne visuelle Lösungen filmischer Grundprobleme insbesondere dann zustande kommen, wenn sie (wie im wissenschaftlichen Film) ohne eigentliche Kunst-

cally relished focus upon (and presentation of) the thousand tricks of a medium that we trust time and again, even though we know better. Seen in this light, the comprehensive, lexicographical approach of the researcher is fully logical. Deutsch does not categorically reject anything in his work—no type of image receives priority in his mind—and everything, even apparently "worthless" material, requires thorough illumination, whether it is found by coincidence, or is directed by the artist, whether it is amateur or professional performance, early cinema, or the latest theatrical releases, television or cinema, 'art' or 'kitsch.' In a non-judgmental presentation of found footage, in redirecting the gaze from a master narrative to visual details—something becomes visible, discoveries are made. Gustav Deutsch attaches great importance to showing how audacious visual solutions of essential filmic problems may arise, as in scientific films, beyond the laborious effort of art; and inversely, how the dramatic mannerisms of high art accelerate the involuntary self-exposure of its authors—and then again, how much of the world and time is preserved and

anstrengung erarbeitet werden; und umgekehrt: zu zeigen, wie die dramatischen Manierismen der Hochkultur die unfreiwillige Selbstentblössung ihrer Autoren noch beschleunigen – und wie viel Welt und Zeit im fragilen Material der Filme selbst aufbewahrt, dokumentiert sind. Am Schneidetisch hat der Kino-Rechercheur somit tatsächlich seinen Platz, nur dort ist er dem Objekt seiner Fahndungen wirklich nahe, nur dort nimmt die großenteils immaterielle Filmkunst physisch Gestalt an. Sehen heißt berühren. Film ist: eine Fotoserie und eine Lichtmaschine.

documented in the fragile material of film itself. In this sense, the researcher Deutsch is in perfect place at the editing table—only here is he truly intimate with the object of his discoveries, here where the primarily immaterial art of film takes on physical form. Seeing means touching. Film is: a series of photographs and a light machine.

Wolfgang Kos

Ethos des Ephemeren

Zur volksbildnerischen Methodik von Gustav Deutsch

Ethos of the Ephemeral

Gustav Deutsch's Educational Methods

„Ich liebe das Ungeliebte.
Und ich liebe das Retten und das Finden".
Gustav Deutsch, 1998

"I love that which is unloved.
And I love finding and saving things."
Gustav Deutsch, 1998

Gesamtkultur

Materialien zur Gesamtkultur, 1–100. So der Titel einer 1993 vorgelegten Mappe, in der medienübergreifende Aktivitäten der späten 1980er und frühen 1990er Jahre dokumentiert sind, an denen auch Gustav Deutsch als Mitglied der internationalen Künstlergruppe „Der blaue Kompressor" beteiligt war: eine Flut von Spuren, Bildzeichen, Diagrammen, Plänen und Dokumenten von Grenzgängen aller Art. Damit verwoben war ein gemeinsam mit Hanna Schimek unter dem Label *Die Kunst der Reise* betriebenes grenzüberschreitendes Langzeitprojekt, das sich mit vielstimmiger Neugier der mikrotopografischen Feldforschung widmete, mit besonderer Aufmerksamkeit für interkulturellen Austausch jenseits plakativer Multikulti-Begeisterung.

„Gesamtkultur" – ein Schlüsselbegriff für die Arbeit von Gustav Deutsch. Damit ist keineswegs jene „Idee des Gesamtkunstwerks" gemeint, die seit Richard Wagner durch die Kulturgeschichte geistert und mit Totalitätsanspruch auf eine Zusammenführung und Verschmelzung aller Künste zielt. Zwar steht auch der für den „Blauen Kompressor" und Gustav Deutsch

Macroculture

Materialien zur Gesamtkultur, 1–100 [Materials on Macroculture, 1–100] is the title of a 1993 artist's book comprising multimedia activities from the late 1980s and early 1990s, in which Gustav Deutsch took part as a member of the international group of artists named "Der Blaue Kompressor"—a flood of traces, pictographs, diagrams, plans and documents of all sorts of interdisciplinary ventures. It involved a long-term interdisciplinary project with Hanna Schimek entitled *Die Kunst der Reise [The Art of Travelling]*, which is dedicated to micro-topographical field research with a special emphasis on intercultural exchange beyond superficial multicultural enthusiasm.

'Macroculture' is a key term in describing Gustav Deutsch's work. It decidedly does not refer to the notion of the *'Gesamtkunstwerk,'* such has been in the air since Richard Wagner's operas, aiming at synthesizing all of the arts as a totality. As a programmatic concept in the work of Deutsch an "Der Blaue Kompressor" macroculture indicates and all-encompassing perspective. But it abstains from the pathos of

49

Der Blaue Kompressor – Floating and Stomping Company, Wiltz, Luxemburg (1984)
v.l.n.r. / *f.l.t.r.:* Wolfgang Herburger, Belinda Loe, Joseph Pletsch, Christina dePian, Herbert Kerschbaum, Herbert Maly, Hanna Schimek, Luitgard Eisenmeier, Gustav Deutsch, Georges Moes, Kim Hogben, Karl Bloyer

Gustav Deutsch, Mostafa Tabbou, Hanna Schimek in Figuig (1992)

programmatische Gesamtkultur-Begriff für All-
umfassendes, aber verzichtet wird auf Entgren-
zungspathos, okkupierende Intention und Er-
oberungsgestus. Im Zentrum steht eine dem
Pathos misstrauende, generalistische, anti-dis-
kriminatorische Haltung, die alles einschließt,
aber nichts ausschließt, nur weil es unbedeutend
oder irrelevant erscheinen mag. Auch was nicht
zusammengehört, wird verknüpft, ohne dass
deshalb eine stringentes Ganzes entstehen muss.
Dieses „sanfte Prinzip" ist Adalbert Stifter näher
als James Joyce, Bodo Hell näher als Walter Kem-
powski, James Benning näher als Alain Resnais.

Finden und Zerstäuben

Peripheral Vision hieß eine 1992 erschienene, vom
New Yorker Radikalmusiker Elliott Sharp kom-
pilierte Langspielplatte mit hyperurbanen Stü-
cken der Noise-Szene aus der Lower East Side.
Der Titel wies darauf hin, dass aus den Augen-
winkeln Dinge zu erkennen sind, die verborgen
bleiben, wenn man nur nach vorne schaut: eine
Metapher für die Erweiterung des kanonisier-
ten ästhetischen Materials in Richtung Krach,
Kakophonie und Zufall. Elliott Sharp sprach von
einer „Zerstäubung" der Wirklichkeit, um dieser
auf die Spur zu kommen.

Von einer Methode des permanenten Fin-
dens und Zerstäubens des Gefundenen kann

dissolving boundaries, grandstanding intentions,
and gestures of conquest. Instead, it is centered
on a more generalized, anti-discriminatory ap-
proach, which distrusts pathos, includes every-
thing and excludes nothing simply because it
might appear insignificant or irrelevant. What-
ever does not belong together is nevertheless in-
terconnected, even though it may not comprise
a stringent entity. This 'non-invasive' principle is
closer to Adalbert Stifter than James Joyce; closer
to Bodo Hell than Walter Kempowski; and
closer to James Benning than Alain Resnais.

Finding and Atomizing

Peripheral Vision is the name of a record of
hyper-urban tracks from the Noise scene in the
Lower East Side compiled in 1992 by the radical
New York musician Elliott Sharp. The title indi-
cates that things can be detected in the corner of
one's eye, which would have remained hidden,
if one had only looked straight ahead—a
metaphor for the expansion of the canonized
aesthetic material in terms of noise, cacophony
and coincidence. Elliott Sharp spoke of "atom-
izing" reality in order to get closer to it.

With concern to Gustav Deutsch, one can
speak of a method of 'continually finding and
atomizing things.' Even the most ephemeral
material is seriously considered for research and

51

Die Kunst der Reise – Die Athen Konferenz (1995)
Rituale (1982)

any field whatsoever may be of interest. That which is 'invisible,' or buried, is painstakingly uncovered, and any trace, no matter how negligible, may give rise to a macro perspective of social and cultural phenomena. The body language and attire (under special consideration of the handbags) of older church-going ladies in the Lower Austrian Weinviertel region in the early 1980s serve to indicate the varying speeds of modernization in rural areas (*Rituale*). It is decisive that the 'macrocultural' particles of reality remain in flux. This is a nomadic process, which can only function if the ideal of complete openness is embedded in a precisely encoded classification system.

When Deutsch is in need of directions, he prefers to put up his own signs. And when he no longer needs them, he takes them down again, since he wishes to leave as few traces as possible in the terrain he has passed through. The wandering artist Hamish Fulton, who has followed trails, such as "A Ten Day Circular Walk from Furkapass," aims to "leave no footprints." Deutsch's manipulation of original film footage also remains fleeting, like that of a *flâneur*, even though he edits with painstaking care.

The "Art of Travelling"—whether it be in reality or at the editing table—involves selecting a few routes from the infinite number of those

man bei Gustav Deutsch sprechen. Auch Ephemeres wird als Forschungsmaterial ernst genommen, jede Abzweigung kann interessant sein, „Unsichtbares" und Verschüttetes wird in skrupulöser Feinarbeit freigelegt und jede noch so unscheinbare Spur kann Anlass sein für eine makroperspektivische Betrachtung gesellschaftlicher und kultureller Phänomene. Die Kleidung und Körpersprache (unter besonderer Berücksichtigung der Handtasche) von älteren Kirchgängerinnen im Weinviertel der frühen 1980er Jahre dient als Indikator für unterschied-

liche Geschwindigkeiten bei der Modernisierung des ländlichen Raums (*Rituale*). Entscheidend ist, dass die „gesamtkulturellen" Realitätspartikel nicht definitiv fixiert werden, sondern in der Schwebe bleiben: ein nomadisches Verfahren, das aber nur funktionieren kann, wenn das Ideal einer Offenheit in alle Richtungen in ein präzise kodiertes Ordnungssystem eingebettet ist.

Wo Gustav Deutsch Wegweiser braucht, stellt er sie selber auf. Und wenn er sie nicht mehr braucht, räumt er sie wieder weg, denn im durchquerten Gelände sollen möglichst wenig Eingriffe zurückbleiben. Der Wanderkünstler Hamish Fulton, der sich Routen wie „A Ten Day Circular Walk From Furkapass" auferlegte, nannte als Vorbedingung, „nicht zu viele Fußspuren zu hinterlassen". Auch Deutschs Operationen am Bild-Rohmaterial bleiben, obwohl bei der Montage mit Eselsgeduld getüftelt wird, flüchtig und flaneurhaft.

Die „Kunst der Reise" – ob real oder am Filmschneidetisch – besteht darin, aus der Unendlichkeit möglicher Routen einige wenige auszuwählen und diese dann mit akribischer Energie, strengem Reglement und penibler Protokollierung zu begehen. Das Verhältnis von Aufwand und Ergebnis kann bei Gustav Deutsch von absurd anmutendem Ungleichgewicht sein.

available, and pursuing them with unrelenting energy, strict routine and an exact protocol. The relationship between input and output may become absurdly imbalanced in the case of Gustav Deutsch. This 'love of detours' (*Umwegigkeit*: a term supposedly used by Heimito von Doderer) and the paradoxical contrast between vagabondage and strict formalism culminates in the added value that gives rise to great works of art from seemingly worthless materials. And it bestows Gustav Deutsch's films with a poetical touch far beyond their epistemological value.

Adria, Originalfilme mit Markierungen / *original footage with markings*

Internationaler Sendeschluss (1992)

Diese „Umwegigkeit" (ein Begriff, den Heimito von Doderer verwendet haben soll) und der paradoxe Kontrast zwischen Vagabondage und strengem Formalismus bringen jenen Mehrwert, der erst aus scheinbar wertlosem Kleinzeug große Kunst macht. Und der den Werken von Gustav Deutsch über ihren Erkenntniswert hinaus poetischen Sog gibt.

Sammeln und Zeigen

1997 fand im Münchner Haus der Kunst unter dem Titel *Deep Storage. Arsenale der Erinnerung* eine Ausstellung zum Thema Sammeln, Speichern und Archivieren in der Kunst statt, mit Werken so unterschiedlicher Künstler wie Bernd und Hilla Becher, Hanne Darboven oder Paul McCarthy. Im Katalog beschreibt Kurator Matthias Winzen das Sammeln als anthropologische Konstante: „Sammeln trägt Sinn, Ordnung, Begrenzung, Zusammenhang und Erklärung in das Zerstreute, Zufällige und Bedrohliche hinein." Einige dieser Aspekte lassen sich auch Gustav Deutschs Arbeit zuordnen, zum Beispiel die unermüdliche Suche nach Zusammenhängen im akkumulierten Material oder die Vermeidung von Entropie durch strikt durchgehaltene Sortierungs- und Klassifizierungsregeln. Die als wesentlich beschriebene Kausalität zwischen Sammeln und Angstbewältigung jedoch

Collecting and Exhibiting

In 1997 an exhibition on the topic of collecting, storage and archiving took place in Munich's Haus der Kunst under the title of *Deep Storage: Arsenale der Erinnerung* with works by widely different artists, such as Bernd and Hilla Becher, Hanne Darboven and Paul McCarthy. In the catalogue, curator Matthias Winzen describes collecting as an anthropological constant: "Collecting provides meaning, order, limitations, connections and explanations for that which is scattered, coincidental or threatening." Some of these aspects can be attributed to Gustav Deutsch's work, for example an untiring search for connections in the accumulated footage, or avoiding entropy by means of strict sorting and classification rules. However, the basic causality between collecting and overcoming fear doesn't apply in his case. His effort to establish connections does not seem to be laden with any phobias or panic-stricken fantasies of order. It is not desperation which drives him (the attempt to fend off what cannot be controlled), but the delight in playing games of association.

Gustav Deutsch is a collector with lightweight baggage, not a pack rat. He is a mediator and a provider. Collecting is not a purpose in itself for him, but a precondition for the analysis and passing on of material. Sorting and clas-

Tatort Migration 1–10 (2005)

prallt ab. Denn das Bestreben, Zusammen-hänge zu organisieren, scheint unbelastet zu sein von Angstphobien und panischen Ord-nungsphantasien. Nicht die verzweifelte Ban-nung und Abwehr des Unkontrollierbaren treibt den Künstler an, sondern die Freude am assoziativen Spiel.

Gustav Deutsch ist ein Sammler mit leich-tem Gepäck, kein Ansammler. Ein Zwischen-träger und Weitergeber. Sammeln ist nicht Selbstzweck, sondern Vorbedingung für die Analyse und Vermittlung des Materials. Indem die Bilder geordnet werden, werden sie erst sichtbar. Manchmal genügt es, Vergleichbares aneinander zu reihen, zum Beispiel Aus-schnitte aus allen *Tatort*-Folgen, in denen Zuwanderer Handlungsträger sind (*Tatort Migration*, 2005). Oder *Internationaler Sende-schluss* (1992) eine „Videoarbeit zur Phäno-menologie des Fernsehens": eine Collage mit internationale Beispielen für das patriotische Design, mit dem staatliche TV-Stationen einst ihr Programm beendeten. Indem Deutsch von der scheinbar irrelevanten Frage ausgeht, ob der Wind, der die Nationalfahnen feierlich bauscht, von links weht (wie in Norwegen oder Kuwait) oder von rechts, schärft er den Blick auf die Konstruktion von nationalen Identitäten.

sifying images makes them visible. Sometimes it is sufficient to edit comparable footage into a se-ries, for example all the scenes from a long-run-ning television show in which migrants figure as protagonists or antagonists (*Tatort Migration*). Or *Internationaler Sendeschluß [International End of Broadcast]*, a "Video on the Phenomenology of Television," which brings together interna-tional samples of the patriotic designs that state-owned TV stations use to sign off their pro-grams. By focusing on whether the wind blowing the national flags comes from the right or the left (such as Norway or Kuwait), Gustav Deutsch hones our senses for the construction of national identities.

Normality

Sometimes it even suffices to wait and see what happens in front of the camera. Sociocultural contexts can be found anywhere. Rituals in rural Lower Austria: Sunday—old men in hats in front of the church. Phlegmatic brass-band music. Young women in fancy dresses from the town department store. Older women wearing head-scarves, their backs bent in submission. A pho-tographer in white pants and a handsome jacket. Young parents with a buggy. Or the first of May—open collars, over-aged party members, empty slogans: "Social democracy secures wel-

Normalität

Manchmal reicht es sogar, darauf zu warten, was sich vor der Kamera abspielt. Soziokulturelle Kontexte finden sich überall. Rituale im ländlichen Niederösterreich, Sonntag vor der Kirche: Alte Männer mit Hut. Phlegmatische Blasmusik. Junge Frauen mit festlichem Kostüm aus dem Stadtkaufhaus. Die älteren mit Kopftuch, demütig eingeknickt. Ein Fotograf mit weißer Hose und fescher Jacke. Jungeltern mit Buggy. Oder am 1. Mai: Offene Hemdkrägen, überaltertes Parteivolk, Parolen mit Leerlauf: „SPÖ sichert Wohlstand und Fortschritt". Aus dem zufällig Registrierten lassen sich Wählerstromanalysen hochrechnen. Und Zeithistoriker, die Bilder zumeist nur zur Illustration von quellenmäßig gesicherten Inhalten einsetzen, könnten lernen, wie man aus dem Habitus von Menschen soziologische Tiefenströme herauslesen kann. Sofern man bereit ist, geduldig zu schauen.

Die Partikel der Welt, wie Gustav Deutsch sie sammelt, ergeben eine Art kontemplatives Lehrmittelkabinett mit Zufallsgenerator – der Künstler und Filmemacher als Volksbildner mit offenem Angebot, der viele didaktische Tricks auf Lager hat. Zum Beispiel die Hürde der scheinbaren Langeweile, wodurch erst jene leeren Räume entstehen, die für konzentriertes Dechiffrieren

fare and progress." Voter transition analyses can be extrapolated from that which is registered by chance. And contemporary historians, who usually employ images only for the purpose of illustrating facts upheld by official sources, might learn how to read sociological trends according to the appearance and mannerisms of people, in as far as they have the patience to observe them.

The bits and pieces of the world as collected by Gustav Deutsch turn into a kind of contemplative cabinet of teaching material, generated by coincidence. The artist and filmmaker as a public educator with an open curriculum and all sorts of didactic tricks up his sleeve—when, for example, the hurdle of apparent boredom gives rise to those empty spaces that are indispensable for concentrated decoding. Christoph Huber has described Gustav Deutsch's editing techniques as a "perfect suspense machine, born of repetition and differentiation." Or the strategy of deceleration perfected by the "image choreographer" Deutsch in *Welt Spiegel Kino*, where the most banal details come to life and register as sensations—normality as a grand opera.

A penchant for sorting things according to ordinal numbers is not only a question of style; it is subtle didactics intended to hone our analytical skills and render the method of classification

Rituale (1982)

unabdingbar sind. Als „perfekte Suspense-Maschine, gebaut aus Wiederholung und Differenz", beschreibt Christoph Huber die Montagetechnik von Gustav Deutsch. Oder die Strategie der Verlangsamung, die der Bilder-Choreograph in *Welt Spiegel Kino* zur Perfektion gebracht hat, wodurch banalste Details zum Leben erwachen und zu Sensationen werden – Normalität als große Oper.

Auch der Hang zum Sortieren mittels Ordnungszahlen ist nicht bloß Stilmittel, sondern subtile Didaktik, um die analytische Aufmerksamkeit zu schärfen und die Methoden der Ordnung transparent zu machen. So wird verhindert, dass sich allzu vordergründige, schnell entzifferbare Zusammenhänge ergeben und der filmische Fleckerlteppich zur nostalgischen Idylle wird, die Episodenstruktur zur Rhapsodie. Ein zwischengeschaltetes „2.1" dient einerseits der Versachlichung des Materials, andererseits der Abstrahierung. „Mit den Unterkapiteln deute ich an", so Deutsch in einem Interview, „dass diese Sortierung nach außen hin offen ist". Tatsächlich hat das Systematisieren etwas latent Instabiles, trotz einer gewissen Unerbittlichkeit und Obsessivität des Ordnens. Grundsätzlich sind alle Subteile austauschbar, und das Nummernsystem kann ebenso ins Unendliche führen wie versacken. Aber immer freut man sich,

more transparent. This helps prevent superficial, quickly decoded connections from being established, where the patchwork of film becomes a nostalgic idyll, or episodic structure becomes a rhapsody. The intermediate "2.1" serves a double purpose: objectification of the footage, and abstraction. Deutsch has stated in an interview: "The subchapters indicate that the classification remains open to more." In actual fact, systematic classification is latently instable, despite a certain implacability and obsession with the act of sorting things. Basically, all components are interchangeable, and the numerical system can either lead to infinity or a dead end. However, we are always pleased to see the mark of progress, like a milestone along the road.

Collective achievements

When working with the historical remnants of daily routine, there is a great temptation to overemphasize their curiosity value. In Deutsch's case, comical sequences and unintentional peculiarities can be found, however they are not used against their original authors. In the compilation film *Adria*, where travelogues made by

wenn wieder eine Wegmarke kommt, wie Kilometersteine entlang einer Straße.

Kollektive Leistungen

Bei der Arbeit mit historischen Alltagsresten ist die Versuchung groß, das kuriose Potenzial des Materials auszureizen. Auch bei Deutsch finden sich komische Sequenzen und unfreiwillige Merkwürdigkeiten, doch diese werden nicht gegen ihre Urheber verwendet. Beim Kompilationsfilm *Adria*, bei dem Reisefilme von Touristen aus den 1950er und 1960er Jahren als archäologisches Material dienen, fehlt jene Verachtung der Spezies Tourist, an der „kulturkritische" Intellektuelle seit Jahrzehnten ihren Spaß haben.

Die Freude der Filmenden, endlich ans Meer reisen zu können, bleibt immer spürbar. Eine Vielzahl von Faktoren trug dazu bei, dass sich um 1960 der Reiseradius erweiterte: der Anstieg von Einkommen und Lebensstandard, die beginnende Massenmotorisierung oder der zunehmende Prestigedruck, den Urlaub für Fernreisen – vorerst vor allem an die Adria – zu nutzen. Dabei spielten moderne „Werkzeuge" eine große Rolle, ob Campingkocher oder Schmalfilmkamera.

Es sind also Bildzeugnisse von Pionieren, die Deutsch behutsam sortiert. Indem er den privaten Filmen vergleichbare Standard-Sequenzen

tourists in the 1950s and 1960s serve as archeological finds, there is no apparent scorn of the species of tourist that "culturally critical" intellectuals have been joking about for decades. The filmmakers' pleasure in finally being able to travel to the sea is always tangible. Many factors contributed to the expanding radius of holiday trips around 1960: the increasing income and standards of living, the beginning mass motorization, and the increasing peer pressure to spend one's holidays abroad—particularly on the Adriatic Sea. Modern "gadgets" played a great role in this context, whether camping stoves or cine cameras.

It is these images created by pioneers that Deutsch is carefully sorting. By assembling comparable standard sequences from private films (e.g., frontal or side-window scenes shot from a moving vehicle, the play of waves, or the view of the coast), he makes it clear how much of our daily media consumption is based on a standard repertoire of "subconsciously acquired" images and points of view. The cues for the "touristic gaze" are based on visual traditions from the romantic era, and the aesthetic rules for the selection of motifs and image composition have been perpetuated and perfected from medium to medium over the last 200 years. We all know intuitively, which images and memories corre-

Adria (1989)

entnimmt (z.B. horizontale und vertikale Kameraschwenks, Spiel der Wellen oder Blick auf die Küste), um Regelmäßigkeiten herauszuarbeiten, macht er deutlich, wie sehr alltäglicher Mediengebrauch auf einem normierten Repertoire von unbewusst „gelernten" Bildern und Blicken beruht. Die Regieanweisungen des touristischen Schauens gehen auf die Romantik zurück, die ästhetischen Reglements für Motivwahl und Bildaufbau haben sich seit nunmehr 200 Jahren von Medium zu Medium perpetuiert und perfektioniert. Wir alle wissen intuitiv, welche Blicke und Bilderinnerungen dem jeweiligen landschaftlichen Kontext entsprechen. Es handelt sich dabei um gesellschaftliche Vereinbarungen mit großer Aussagekraft. Als das Künstlerduo Peter Fischli / David Weiss um 1990 tausende populäre und durch tausendfache Wiederholung entleerte touristische Bildmotive (Schispur im Schneefeld, Pyramide mit Palme, Fischerboot bei Sonnenuntergang etc.) nachfotografierte, war diese Nahführung von Kunst und Kitsch einerseits eine Provokation, andererseits eine Ehrenrettung. Durchaus mit Respekt sprachen die Künstler vom besonderen Wert „mittlerer Bilder". Um solche handelt es sich auch bei den Adriafilmen. Indem sie Gustav Deutsch als Lehrmaterial für eine Schule des Sehens verwendet, erinnert er daran, dass sie

spond with the landscapes in question. This involves social consensus and has a great impact. When the artists Peter Fischli & David Weiss photographed thousands of popular but overtaxed views and images (ski tracks in the snow, pyramids with palm trees, fishing boats at sunset, etc.) around 1990, this combination of art and kitsch constituted both a provocation and a reinstatement of dignity. The artists spoke with respect of the special value of "average images." The films of the Adriatic Sea also comprise such images. By using them as teaching material for a 'school of seeing,' Gustav Deutsch reminds us that they indicate a collective cultural achievement on account of their normality and calculability.

Respect

It is a sign of consequence and respect that Gustav Deutsch tried to desubjectify his perspective and keep his distance when shooting the film *Augenzeugen der Fremde* [*Eyewitnesses in Foreign Countries*] at a Moroccan oasis he had known for years. For instance, he decided against 'seeking the action' in his viewfinder. He let the camera film 'blindly,' by simply

59

gerade in ihrer Normalität und Berechenbarkeit auf eine kollektive Kulturleistung verweisen.

RESPEKT

Es zeugt von konsequentem Respekt, wenn Gustav Deutsch bei den Dreharbeiten zum Film *Augenzeugen der Fremde* (1993) in einem ihm seit vielen Jahren bekannten marokkanischen Oasenort versuchte, seinen Blick zu entsubjektivieren und Distanz zu halten. Das geschah beispielsweise dadurch, dass der Filmemacher die Vorgänge nicht im Sucher auswählte, sondern sie von der Kamera „blind" abfilmen ließ, indem er diese einfach auf den Boden stellte. Denn: „Eigentlich wollte ich in Figuig nie filmen oder fotografieren".

Die wichtigste Vorkehrung, um kulturimperialistische Blickregie nicht zum „Seelenräuber" werden zu lassen und tief sitzenden Fernwehbildern ihre imaginative Macht zu nehmen, war hier einmal mehr eine rigide Versuchsanordnung. Strenge formale Vorgaben – vorbestimmte Tageszeiten (das Wandern der Schatten!), Strukturvorgaben wie „600 mal 3 Sekunden", thematische Anordnung der Einstellungen („...Auftritte / Akteure / Handlungen / Drehen / Gehen / Fahren..."), dienen dazu, Distanz zu halten, um ein „authentisches Filmprojekt" herstellen zu können. Nicht durch persönliche Ein-

setting it on the ground: "Actually I never intended to film or photograph in Figuig."

A strict routine was once again the most important precaution for not becoming a "soul thief" through culturally imperialistic cinematography, and for keeping in check the imaginative power inherent in the visual culture of 'wanderlust.' Strict formal boundaries—predetermined times of day (the progression of shadows!); structural guidelines, such as "600 x 30 seconds;" and the thematic order of shots ("appearances / actors / plots / turning / walking / driving") all serve to keep a distance and enable an "authentic film project" to come into being. Authenticity was not to be attained as a result of personal involvement, but through avoiding or excluding it.

Another idea was to creatively involve Mostafa Tabbou, a yearlong friend without any film experience. In turn, Tabbou, who is named as co-author, filmed places and scenes in Vienna that were 'foreign' to him, however his work was based on Gustav Deutsch's concepts. This part of the film may not have the same stringency as the Moroccan part, yet it takes on great moral-symbolical meaning. With the exchange of roles, Deutsch indicates that cooperation on an equal basis between cultures means foregoing certain things as a final consequence.

Augenzeugen der Fremde (1993)

schreibungen wird Authentizität angestrebt, sondern durch deren Behinderung und Aussparung.

Dazu kam als weitere Konzeptidee die kreative Einbeziehung von Mostafa Tabbou, einem langjährigen Freund ohne Filmerfahrung. Reziprok filmte Tabbou, der als Co-Autor genannt wird, Orte und Szenen im für ihn „fremden" Wien, allerdings auf der Basis von Vorgaben von Gustav Deutsch. Dieser Teil des Films hat vielleicht nicht dieselbe Stringenz wie die Marokko-Montage, aber er hat große moralisch-symbolische Bedeutung. Denn mit dem Rollentausch weist Deutsch darauf hin, dass Zusammenarbeit auf gleicher Augenhöhe und Vermittlung zwischen den Kulturen in letzter Konsequenz Verzicht bedeuten muss. Der von Selbstbeschränkungen geprägte Film *Augenzeugen der Fremde* war also eine Art Exerzitium mit dem Ziel einer Deprogrammierung vorfixierter Einstellungen. Schon bei vielen „Kunst der Reise"-Projekten waren die Begegnungen mit dem Fremden von Vorsicht, Respekt, Gewissenhaftigkeit und einer defensiven Grundhaltung geprägt.

Bezeichnend ist, dass das Filmprojekt, das als subtile Kritik eines zu kurz gedachten Interkulturalismus interpretiert werden kann, auf Skepsis stieß, als es 1992 zwecks Förderung beim Ministerium für Unterricht und Kunst eingereicht

Marked by self-restrictions, the film has thus become an exercise with the goal of deprogramming fixed ideas. In all of the *Art of Travelling* projects, foreign encounters have been characterized by care, respect, conscientiousness and a defensive attitude.

It is characteristic that the film project, which can be interpreted as subtle critique of an overly limited interculturalism, met with skepticism when it was submitted for a grant to the Austrian

wurde. Ein Juror fragte, ob durch den Film „nicht nur neue Klischees" entstünden. Gustav Deutsch nahm die Beinahe-Ablehnung zum Anlass für einen Aufsatz in einem Band der Reihe „Maghreb-Studien", der das Marokkobild der Deutschen und das Deutschlandbild der Marokkaner behandelt. In diesem stellt er seine Strukturprinzipien ausführlich dar und spricht von einem „Versuch über das gegenseitige Verständnis zweier Menschen verschiedener Herkunft". Der Abschnitt über Deutschs ersten Aufenthalt im Oasenort, bei dem er 1981 den jungen Berber und späteren Filmpartner Mostafa als Rezeptionisten im Hotel „Sahara" kennen gelernt hat, trägt den Titel „Über den Zufall als Ursache und eine Freundschaft als Voraussetzung". Die Filmreise nach Wien zwölf Jahre später war die erste Europareise von Mostafa Tabbou, indirekt finanziert aus den Mitteln der österreichischen Filmförderung. Nach Ablauf seines Visums kehrte er zurück nach Marokko. Erstmals gezeigt wurde der Film im Rahmen eines Deutsch-Marokkanischen Symposiums in Rabat.

Ministry of Education and the Arts in 1992. One juror asked whether "anything other than new clichés" would result from the film. Gustav Deutsch found this close shave with rejection called for an essay in a volume of the series *Maghreb-Studien*, which deals with the image that German-speaking people have of Morocco and vice versa. In it he elaborates his structural principles in detail and speaks of an "attempt to find a mutual understanding between two people of different origins." The part about Deutsch's first trip to Figuig, where he met the young Berber Mostafa (who later became his film partner) as the receptionist in the Hotel Sahara in 1981, is entitled "About Coincidence as Cause and Friendship as Precondition." The film trip to Vienna twelve years later was Mostafa Tabbou's first trip to Europe, indirectly financed by Austrian film subsidy money. After his visa expired, he returned to Morocco. The film was premiered in the scope of a German-Moroccan symposium in Rabat.

Scott MacDonald

Gespräch mit Gustav Deutsch (Teil 1)
A Conversation with Gustav Deutsch (part 1)

Gustav Deutsch, Scott MacDonald, New York (2008)

Der folgende Text ist die gekürzte Fassung eines längeren Interviews, das wir im Rahmen des *Orphan Film Symposium 2008* in New York begonnen haben. Gustav Deutsch und ich trafen uns, um über sein bemerkenswertes Projekt *Film ist.* zu sprechen. In den folgenden Monaten habe ich seine Filme genau untersucht und ihm regelmäßig Fragen dazu gestellt. Er hat mir die Antworten per Email geschickt. Dieser elektronische Austausch wurde mit einer bearbeiteten Transkription des früheren Gesprächs kombiniert. Deutsch erhielt eine weitere Bearbeitung des Interviews und weitere Fragen. Er beantwortete die neuen Fragen, nahm Korrekturen vor und retournierte mir das Interview. Bis August 2008 habe ich es weiter überarbeitet. Die vorliegende Version behandelt jene Aspekte, die meine KollegInnen in diesem Band detaillierter untersuchen, nur am Rande.

MacDonald: „Recycled Cinema" – das Aufgreifen von altem Filmmaterial, um es durch Rekontextualisierung zu etwas Neuem zu machen – ist zur vorherrschenden Tendenz im Avantgardefilm der letzten zwanzig Jahre geworden. Heute gibt es viele verschiedene Arten des filmischen „Recycling". Mich interessiert, wie Sie zu dieser Arbeitsweise und überhaupt zum Film gekommen sind.

What follows is an abbreviated version of a longer interview that was begun during the 2008 Orphan Film Symposium in New York, when Deutsch and I met to record a conversation about his remarkable *Film ist.* project. In the months that followed, I explored his films and periodically sent him questions about them; he emailed answers to my questions. These web interchanges were combined with the edited transcript of the earlier conversation, and an edited version of the longer interview was returned to Deutsch, along with still further questions. Deutsch answered the new questions, made

63

Adria (1989)

Deutsch: Das Resultat meiner ersten Arbeit mit Found Footage war *Adria*, den ich 1989 fertig gestellt habe. Ich verwendete Amateurfilmmaterial, das im Zeitraum 1954 bis 1968 an der Adria aufgenommen worden war.

MacDonald: Wie sind Sie an diese Amateurfilme herangekommen? Waren das Menschen, die Sie gekannt haben? Oder haben Sie per Inserat um „Spenden" gebeten?

Deutsch: Ich habe Freunde gefragt, einige Filme auf dem Flohmarkt gekauft und auch ein Inserat in einer Gratiszeitung aufgegeben, die in allen Bezirken Wiens verteilt wird.

MacDonald: Haben Sie die interessantesten Szenen aus den gesammelten Amateurfilmen ausgewählt und sie dann Kategorien zugeordnet?

Deutsch: Die erste Entscheidung, die ich getroffen habe, war, nur Filme zu sammeln, die an der Adria gedreht worden waren. Dafür hatte ich mehrere Gründe. Nach dem Krieg, als es sich die Menschen zum ersten Mal wieder leisten konnten, Urlaub im Ausland zu machen, war die Adriaküste das Hauptreiseziel – nicht nur für Österreicher. (Meine eigene Familie hat sechsmal Urlaub in Lignano gemacht.) Es war

corrections, and returned the interview to me. I continued to revise it through August, 2008. In this version of our extended conversation I have tried to avoid aspects of Deutsch's career that my colleagues, in this volume, have engaged in detail.

MacDonald: Recycled cinema, taking old film material and making it new by placing it into a new context, has become the most pervasive tendency in avant-garde film over the last twenty years or so, and there are now many different approaches to cinematic "recycling." I'm curious about how you came to work in this way and how you got into filmmaking in the first place?

Deutsch: My first work with found footage resulted in *Adria – Urlaubsfilme 1954–1968 (Film— Schule des Sehens 1)*, which was finished in 1990. It used home movies shot on the Adriatic Sea during the period from 1954 till 1968.

MacDonald: How did you get hold of the home movies you used? Were these people you knew, or did you advertise for donations?

Deutsch: I asked friends of mine; I bought some films at a flea market, and I put an ad in a free local newspaper that was distributed in all districts of Vienna.

MacDonald: Did you choose a set of the most interesting excerpts from the home movies you

auch das erste Mal, dass Filmemachen – auf 8mm – für die breite Masse möglich und erschwinglich war.

Beim Anschauen dieser Amateurfilme habe ich viel darüber gelernt, wie die Menschen die Welt sehen, wie Menschen auf die Kamera reagieren und welche Macht in dieser Apparatur liegt. Weil all diese Filme an den gleichen Orten gedreht worden waren, von Familien in der gleichen Situation, mit dem gleichen sozialen Status, waren sie im Grunde alle gleich. Man muss auch bedenken, dass das vor der allgemeinen Verbreitung des Fernsehens war, das heißt die Filmemacher waren nicht vom Fernsehen beeinflusst. Ihre filmische Praxis war bestimmt durch ihre frühere fotografische Praxis.

MacDonald: Hatten Sie vor diesem Projekt Filme gemacht?

Deutsch: Ich habe Architektur studiert. Ich bin Architekt, habe aber während meines jahrelangen Architekturstudiums auch fotografiert und gefilmt – auf Super-8. Das waren gewissermaßen Tagebuchfilme.

MacDonald: Wurden diese Filme öffentlich gezeigt?

Deutsch: Sie sind in einem Zeitraum von zehn Jahren entstanden, und ich habe sie in den frühen 1990er Jahren dreimal in Programmkinos in und um Wien gezeigt. Sie waren Teil der Retro-

collected and then put them into categories?

Deutsch: The first decision I made was to collect only films shot on the Adriatic Sea. I had several reasons for this. It was the first time after the war that people could afford holidays abroad, and a main destination for Austrians and many others was the Adriatic coast (my family spent six holidays in Lignano). It was also the first time that 8mm filmmaking was available and affordable for the masses.

Watching those home movies, I learned a lot about how people view the world, how people react towards the camera, and what kind of power is embedded in this instrument. Because all these films were shot in the same places and by families in similar situations and with the same social status, they were essentially identical. Also, remember, this is before television was widely available, so the filmmakers were not influenced by television; their filmic practice derived from their earlier photographic praxis.

MacDonald: Had you made films before this project?

Deutsch: I studied architecture; I'm an architect, though I was also photographing and filming during the years of my architectural studies. I filmed in Super-8 and made, let's say, diary films.

MacDonald: Did you show them publicly?

65

Prince Albert fährt vorbei (1988)

spektive meiner Super-8-Arbeiten. Das Programm hatte den Titel „Drei Minuten aus der Ewigkeit" und enthielt auch die Filme *Sa. 29. Juni / Arctic Circle* (1990), *Non, je ne regrette rien* (1988), *H. isst Tiere* (1991–1993), *Minuten-Tagebuch / Das Blaue Zimmer – 48 Std* (1989), *Kurzer unruhiger Schlaf* (1989), *Drei Minuten aus der Ewigkeit / Feuer* (1986) und *Meer* (1986). Vier meiner frühen Super-8-Filme wurden auf 16mm transferiert und auf Festivals gezeigt, z.B. in Rotterdam: *Prince Albert fährt vorbei* (1988), *Kristallnacht / Maingas* (1989), *Non, je ne regrette rien* und *Sa. 29. Juni / Arctic Circle*.

Eine Zeit lang war ich Mitglied eines Wiener Medienkollektivs, der Medienwerkstatt, die 1978 gegründet wurde und immer noch existiert. Nach meinem Studium wollte ich nicht sofort als Architekt in einem Büro arbeiten, ich wollte etwas Anderes machen. 1981 bin ich zur Medienwerkstatt gestoßen, durch ein Gemeinschaftsprojekt mit einem anderen Architekten, Ernst Kopper. Er hatte mit drei Architekten ein Land-Kollektiv gegründet und um Förderung für ein alternatives Medienprojekt angesucht, in dem das Leben am Land thematisiert wurde.

Deutsch: I presented these films—shot over a period of ten years—three times in art house cinemas in and around Vienna during the early 1990s, as part of a retrospective of my Super-8 filmmaking. The program was entitled "Drei Minuten aus der Ewigkeit" ["Three Minutes from Eternity"] and included my *Sat., 29th of June / Arctic Circle* (1990), *Non, je ne regrette rien* (1988), *H. isst Tiere* (1991–1993), *Minuten-Tagebuch / Das Blaue Zimmer-48Std* (1989), *Kurzer unruhiger Schlaf* (1989), *Drei Minuten aus der Ewigkeit / Feuer* (1986), and *Meer* (1986). Four of my early Super-8 films were transferred to 16mm, and these were shown in festivals, including the Rotterdam International Film Festival: *Prince Albert fährt vorbei* (1988), *Kristallnacht / Maingas* (1989), *Non, je ne regrette rien*, and *Sat., 29th of June / Arctic Circle*.

For a time I was a member of the Viennese media collective, Medienwerkstatt, which was founded in 1978. It still exists. After my studies I didn't want to immediately go to work as an architect in a company; I wanted to do something different. I began working with Medienwerkstatt in 1981, on a collaborative project with another architect—Ernst Kopper—who had founded a collective with three other architects. They had applied for a grant for an alternative media project focusing on life in the countryside.

Sa. 29. Juni / Arctic Circle (1990)

Meine architektonischen Studien hatten alle mit Raumpolitik zu tun. Ich hatte bereits als Student in dieser Gegend von Österreich – dem Weinviertel – gearbeitet, auch als Erntehelfer, und kannte dort einige Leute. Ernst hat das alles gewusst und auch, dass ich mich für Fotografie und Film interessierte. Er fragte mich, ob ich das Projekt mit ihm machen wolle (als er die Finanzierung endlich beisammen hatte, waren die anderen Kollegen schon wieder abgesprungen), und ich sagte zu.

Wir haben zwei Jahre zusammengearbeitet und in dieser Zeit das kulturelle Verhalten und die Rituale der Leute am Land während eines ganzen Jahres auf Video aufgezeichnet. Wir haben alle Feste besucht, alle Schuleröffnungen, Straßeneinweihungen usw. Wir haben fünf Videofilme gemacht, darunter *Rituale* (1982) und *Fulkur* (1982), die beide noch immer von der Medienwerkstatt verliehen werden.

Für uns war kollaborative Arbeit damals eine politische Sache, Kollaboration nicht nur unter Künstlern, sondern mit den Leuten aus den Orten, wo wir gefilmt haben. Nachdem wir die fünf Videofilme geschnitten hatten, sind wir wieder aufs Land zurück, diesmal mit einem Bus, der mit drei Fernsehmonitoren ausgerüstet war. Wir haben die Filme auf Marktplätzen gezeigt und in Lokalen und anderen öffentlichen

Rituale (1982)
Fulkur (1982)
Wossea Mtotom (1984)

All my studies in architecture had been involved with the politics of space. Also, I'd already been working in this region of Austria (the Weinviertel) as an architecture student and knew people in the area. I had also participated in the harvest as a worker. Ernst knew all this, and he also knew that I was interested in photography and film. He asked me if I would like to carry out this project with him (by the time he got the money for it, his other colleagues had left the collective). I agreed.

We worked together for two years, shooting video, and recording the cultural behavior and rituals of people in the countryside during the cycle of a year. We visited all the feasts and all openings of schools and roads and whatever. We made five video films, including *Rituale* (1982), and *Fulkur* (1982), both of them still distributed by the Medienwerkstatt.

In those days, we saw collaborative work as political, as collaboration not only among artists, but with the people in the areas where we filmed. So after we had edited the five films, we went to the countryside again, this time with a bus equipped with three television monitors. We showed the films in marketplaces and in pubs, and other community spaces, and had discussions with the local people.

After awhile I was fully engaged with this

Räumen, und haben mit der lokalen Bevölkerung diskutiert.

Nach einiger Zeit war ich mit meiner Arbeit immer stärker bei der Medienwerkstatt involviert. Zusammen mit Manfred Neuwirth und Gerda Lampalzer, zwei Mitgliedern der Gruppe, habe ich ein Video realisiert, das viel auf Festivals gezeigt wurde und in Montpellier einen Preis erhielt: *Asuma* (1982), über geistig behinderte Menschen, die mit Künstlern zusammenarbeiteten. Diese Künstler waren vom „Centre de Réadaptation" in Capellen, Luxemburg, gefragt worden, ob sie mit Klienten arbeiten wollten, die nicht in reguläre Werkstätten integriert werden konnten. Die Künstler entschieden sich dafür, gemeinsam mit den Klienten Musikinstrumente zu produzieren. Ich hörte von diesem Projekt und beschloss, eine Dokumentation darüber zu drehen.

Später bin ich Teil dieser Künstlergruppe geworden, die immer noch existiert: „Der Blaue Kompressor Floating & Stomping Company". Zusammen haben wir in Luxemburg, als Nachfolgeprojekt, einen öffentlichen Garten gebaut, und ich habe gemeinsam mit Manfred und Gerda ein Video über dieses Gartenprojekt gemacht, *Wossea Mtotom* (1984), das ebenfalls auf Festivals lief. Meine Videos drehten sich immer um künstlerisches Arbeiten in einem sozialen

work at Medienwerkstatt. Together with Manfred Neuwirth and Gerda Lampalzer—members of the group—I completed a video film that was widely shown in festivals and won a prize at a festival in Montpellier, France: *Asuma* (1982). It was about mentally challenged people working in collaboration with artists. The artists were asked by the Center for Readaptation in Capellen, Luxembourg to work with those clients who could not be integrated into regular workshops. The artists decided to create musical instruments with the clients. I heard about this project and decided to do a documentary.

Later I became part of this art group—it still exists: "Der Blaue Kompressor Floating & Stomping Company." As a follow-up project we built a public garden in Luxemburg, and together with Manfred and Gerda I shot a video about this garden project: *Wossea Mtotom* (1984), which also toured in festivals. My video work was all about working with art in a social context; it was only later on, with *Adria*, that I started to focus on film.

MacDonald: How did the unusual organization of *Adria* develop?

Deutsch: First, I looked carefully at the home movies I had collected, without any structure in mind. Then I decided to categorize the films into "actions," meaning the activities of the film-

Kontext. Erst später, mit *Adria*, habe ich begonnen, mich auf Film zu konzentrieren.

MacDonald: Wie hat sich die ungewöhnliche Struktur von *Adria* entwickelt?

Deutsch: Zuerst habe ich – ohne mir strukturelle Gedanken zu machen – die Amateurfilme, die ich gesammelt hatte, ganz genau angesehen. Dann bin ich dazu übergegangen, die Filme zu kategorisieren – nach „Aktionen", d.h. den Aktivitäten der Filmemacher, als sie diese Filme drehten, und „Reaktionen", also den Reaktionen der Menschen vor der Kamera. Dann habe ich eine detailliertere formale Organisation entwickelt, der ich ganz genau gefolgt bin. Die Entscheidung, solche formalen Kategorien zu setzen, entsprach der Absicht, die Amateurfilme nicht so sehr als individuelle Produkte bestimmter Familien zu sehen, sondern als Zeugnisse einer größeren sozialen Gruppe zu einem bestimmten historischen Zeitpunkt.

Ich habe einige erstaunliche Dinge herausgefunden. Zum Beispiel werden siebzig bis achtzig Prozent aller Schwenks von links nach rechts gemacht. Ich bin mir nicht sicher, was das zu bedeuten hat, ob es mit der Tatsache zu tun hat, dass wir von links nach rechts schreiben, oder damit, dass wir in der nördlichen Hemisphäre leben: Die Drehung des Wassers, wenn es durch den Abfluss fließt, verläuft in unserer Hemisphäre im

makers as they made the films; and "reactions," meaning the reactions of the people in front of the camera. Then I devised a more detailed formal organization that I followed very carefully. The decision to make such formal categories derived from my attempt to see the home movies not so much as the individual products of particular families, but as records of a particular social group at a specific historical moment.

I discovered some astonishing things. For example, seventy or eighty percent of all pans are made from the left to the right. I'm not sure what this means, whether it has to do with the fact that we write from left to right or whether it has to do with our being in the northern hemisphere: the spin of the water as it leaves the basin moves clockwise in this hemisphere. But what I was most interested in was what people do with the camera, and what the camera does with them. If you just take a position in your surrounding and make a circular pan, you reveal yourself as the center of the world. If you are chasing something with a pan, you are a hunter: the camera becomes the gun. If you're just strolling around with the camera searching for something and don't find it, that reveals a lot about, let's say, your insecurity at the moment. One can clearly see that some of those who are shooting the films are more inventive than

Adria (1989)

Uhrzeigersinn. Am meisten hat mich interessiert, was Menschen mit der Kamera tun und was die Kamera mit ihnen macht. Wenn man einfach eine Position in der Umgebung einnimmt und einen Rundumschwenk macht, dann zeigt man sich damit als Zentrum der Welt, in der man sich befindet. Wenn man etwas mit einem Schwenk verfolgt, ist man ein Jäger: Die Kamera wird zur Waffe. Wenn man nur mit der Kamera herumstreift und etwas sucht und nicht findet, dann verrät das eine Menge, z.B. über die eigene Unentschlossenheit in diesem Moment. Man kann deutlich sehen, dass einige dieser Filmemacher einfallsreicher sind als andere, und dass sie durch die Praxis lernen. Was sie über das Filmen hinaus lernen, ist Sehen, und das gab mir die Idee für den Untertitel: *Film – Schule des Sehens.*

Auch das, was die Menschen *vor* der Kamera anstellten, war sehr aufschlussreich. Diese Menschen sind schon oft vor der Kamera gestanden; sie wissen, wie man für ein Foto posiert. Aber jetzt erkennen sie, dass sie Bewegung zeigen müssen, sie spüren die Verpflichtung zur ‚Aktion': Sie bewegen sich für die Kamera, sie spielen kleine Szenen, sie reagieren aggressiv, sie verstecken sich, etc. Film war zu dieser Zeit nicht billig, und alle wussten das, daher fühlten sich die ‚Darsteller' dazu verpflichtet, unmittelbar und theatralisch zu reagieren.

others, and that they learn by doing. What they learn besides filming is *seeing*, and this gave the idea to the subtitle: *Film—Schule des Sehens* ("Film—School of Seeing").

Also, what people did in front of the camera was revealing about them. These people had been in front of photo cameras many times. They knew how to pose for a photograph. But now they understood they had to show motion; they felt obliged to do some "action": they

71

Das war der Anfang meines Interesses an Found Footage, es hat mir viel über meine eigenen Kino-Interessen erzählt, und darüber, was ich als Filmemacher tun wollte.

MacDonald: Ihre Herangehensweise ist das Gegenteil von dem, was Péter Forgács macht: Er vertieft sich in die jeweilige Familiensituation und erforscht sie.

Deutsch: Ja. Als Filmemacher, der mit Amateurfilmen arbeitet, hatte ich schon das Gefühl, sehr vorsichtig sein zu müssen: Das waren Filme, die niemals für eine öffentliche Vorführung gedacht waren. Ich hatte also eine Art Verantwortungsgefühl den Menschen gegenüber, die die Filme gemacht haben. Ich wollte mich nicht über sie lustig machen, und ich wollte sie nicht in irgendeiner Weise bloßstellen. Péter Forgács gelingt es wunderbar, diesen beiden ethischen Fallen zu entgehen.

Es war sehr wichtig für mich, dass – soweit das möglich war – die Familien, die die Filme gedreht hatten, auch bei der Premiere anwesend waren (bei einigen Filmen wusste ich natürlich nicht, von wem sie stammten). Ich dachte mir, es wäre wichtig für sie, zu sehen, dass das, was sie – oder ihre Eltern – vor dreißig, vierzig Jahren gemacht hatten, nicht nur von privatem Interesse war.

MacDonald: Erinnern Sie sich an ihre Reaktionen?

walked for the camera, they performed little scenes, they reacted aggressively, they hid, et cetera. Everyone knew that film was not cheap in those days, which is why the performers felt they had to respond quickly and dramatically.

This was the beginning of my interest in found footage, and it told me a lot about my own interests in film and what I wanted to do as a filmmaker.

MacDonald: Your approach is the inverse of what Péter Forgács does: he dives into the particular family situation and explores it.

Deutsch: Yes. I did feel that as a filmmaker working with home movies, I had to be very careful: these were films that were never supposed to be shown in public, so I felt a responsibility to the people who made them. I didn't want to make fun of them, and I didn't want to expose them in a way that they wouldn't have liked. Péter Forgács manages to avoid both of these ethical dangers perfectly.

It was very important for me to have the families that shot the films at the premiere (of course that was not entirely possible, because I didn't know who made some of the films). I thought it was important for them to see that what they had done—or what their parents had done, thirty, forty years ago—was of more than private interest.

Deutsch: Sie sagten, dass es eine völlig neue Erfahrung für sie war, *ihre* Filme durch *meine* Augen und zusammen mit den Filmen anderer Familien zu sehen.

MacDonald: Kapitel 2.3 erinnert oft an die frühen Lumière-Filme, die von Booten aus gefilmt wurden, z.B. von Gondeln in Venedig.

Deutsch: Ja, die Lumière-Schwenks waren ein Bezugspunkt für mich, vor allem weil der erste Film, der aus einem bewegten Fahrzeug gedreht wurde – oder jedenfalls *einer* der ersten Filme, nämlich *Venise, panorama du Grand Canal pris d'un bateau* (1896) – von einer Gondel aus gedreht worden war.

MacDonald: Ich habe *Welt/Zeit* (1990) gesehen, bevor ich eine Beschreibung davon gelesen hatte, und er erinnerte mich an Kubelkas *Adebar* und *Schwechater*. Es schien so, als hätten Sie sich dazu entschieden, nur einige der Kader auf dem Filmstreifen zu verwenden. Als ich dann die Beschreibung las, verstand ich den Film natürlich ganz anders. Aber es interessiert mich trotzdem, etwas über Ihre Beziehung zu Ihren Wiener Kollegen zu erfahren. Könnten Sie etwas über Ihr Verhältnis zu Kubelka erzählen? Kren? Martin Arnold? Andere Wiener Filmemacher?

Deutsch: Ich hatte das Glück, Kurt Kren in seinen letzten Jahren regelmäßig zu treffen, da er in der Nähe meiner Wohnung in Wien lebte. Ich

MacDonald: Was their response memorable?

Deutsch: They said that seeing *their* films through *my* eyes and with the films from other families created a completely new experience for them.

MacDonald: Section 2.3 is often reminiscent of the early Lumière films shot from boats, including gondolas in Venice.

Deutsch: Yes, the Lumière pans were a reference, especially because the first film shot from a moving vehicle—or at least one of the first films: *Venice, panorama du Grand Canal pris d'un bateau* (1896)—was made from a gondola.

MacDonald: I looked at *Welt/Zeit [World/Time]* (1990) before I read a description of it, and it reminded me of Kubelka's *Adebar* and *Schwechater* because of what appeared to be a decision to use only some of the frames available on the filmstrip. Of course, once I read the description, I had quite a different sense of the film. But I am curious about your relation to your Viennese fellow filmmakers. Could you talk a bit about your relations with Kubelka? Kren? Martin Arnold? Other Viennese filmmakers?

Deutsch: I had the chance to meet Kurt Kren frequently in his last years, as he lived close to my home in Vienna. I am a great admirer of his work and of Kurt's very individual, analytic, conceptual, and, at the same time, poetic way of filmmaking, I liked him as a person, and I am

73

bin ein großer Bewunderer seines Werks und seiner sehr individuellen, analytischen, konzeptuellen und gleichzeitig poetischen Art und Weise, Filme zu machen. Ich mochte ihn als Mensch und ich bin froh, dass ich die Gelegenheit hatte, ihn näher kennenzulernen.

Peter Kubelka ist das, was ich einen „Meister" nennen würde. Sein Werk ist essentiell für jeden, der sich dafür interessiert, was Film ist und was Film nicht ist. Er ist in seiner Arbeit und in seinen Urteilen über die Arbeit anderer ein „Fundamentalist". Ich habe seine Vorlesungen immer genossen. Ich hatte die Gelegenheit, mit ihm zusammenzusitzen, einige Gläser trockenen Weißwein zu trinken und über Film und die Welt zu reden.

Martin Arnold und Peter Tscherkassky sind gute Freunde von mir. Abgesehen von ihrer großartigen Arbeit als Film- und Videomacher, ist es mir sehr wichtig, dass sie in Wien leben und da sind, wenn ich mich unterhalten will, nicht nur über unsere künstlerische Arbeit.

MacDonald: Ist die Kamera in *Welt/Zeit* während der ganzen 18 Tage der Reise durchgehend gelaufen?

Deutsch: Das Konzept des Films war von mir, aber Ernst Kopper – der Architekt und Freund, mit dem ich die zuvor erwähnten Videoarbeiten gemacht hatte – hat gedreht. Er plante eine

happy that I had the chance to know him.

Peter Kubelka is what I would call a "master"; his work is essential for everybody who is interested in what film is and what it is not. He is a "fundamentalist" in his work and in his judgments about the work of others. I always enjoy his lectures. I've had the chance to sit and drink some glasses of nice dry white wine with him, and discuss film and the world.

Martin Arnold and Peter Tscherkassky are good friends of mine. Aside from the great work they do as film- and videomakers, it is very important to me that they live in Vienna and are there when I want to talk, and not only about our work as artists.

MacDonald: Was the camera in *Welt/Zeit* running continually during the entire eighteen days of the trip?

Deutsch: The concept for the film was mine, but it was shot by Ernst Kopper, the architect and friend with whom I made the video works I spoke of earlier. He was planning to make a world-trip, an excursion of architects around the world, and he agreed to carry out the project. The idea was to have the camera—a Nizo Super-8—running during the entire trip, whether it was in the suitcase or out. When it was outside of the suitcase, he positioned the camera in hotel rooms, in front of TV sets, took

Welt/Zeit – 25812min (1990)

Weltreise, eine Exkursion von Architekten rund um die Welt, und er erklärte sich dazu bereit, das Projekt durchzuführen. Die Idee war, dass die Kamera – eine Nizo Super-8 – während der gesamten Reise Aufnahmen machen sollte, egal ob sie eingepackt war oder nicht. Wenn sie ausgepackt war, stellte er die Kamera in den jeweiligen Hotelzimmern auf, z.B. vor den Fernsehgeräten; er nahm sie auf Busreisen mit, ins Flugzeug usw. Der automatische Auslöser war auf einen Kader pro Minute eingestellt.

MacDonald: *Welt / Zeit* wirkt wie ein Vorbote von *Film ist.* in dem Sinn, wie er die Reise der *Kamera* dokumentiert, die sich von Ernst Koppers Reiseerfahrung unterscheidet. Die Kamera „erzählt" vom Leben der Kamera während einer bestimmten Zeitspanne – vergleichbar mit der Art und Weise, in der *Film ist.* vom Frühen Kino „erzählt".

Deutsch: Ich wollte die Kamera zu einem Instrument der objektiven Beobachtung machen. Die Kamera zeichnet auf, was auch immer sich vor ihr befindet. Ernst bestimmte die Orte und Zeitpunkte der Beobachtung, und dann hat die Kamera ihre Arbeit getan. Sie hat das Fernsehprogramm im Hotelzimmer in Tokyo aufgenommen, das keiner angeschaut hat, einen Baum im Garten eines Hotels in Kyoto während eines heftigen Regenschauers, eine Kreuzung in Taipeh

it with him on bus trips, in airplanes. The timer was set to take one frame per minute.

MacDonald: *Welt/Zeit* seems like a premonition of *Film ist.* in the sense that it documents the trip *of the camera*, which is different from the way your friend experienced that trip. The camera "speaks about" the life of the camera during a particular period—in much the way that in *Film ist.* early films "speak about" early cinema.

Deutsch: I wanted to turn the camera into an

während einer ganzen Nacht, ein Gewitter, das sich auf der Fassade eines Hochhauses in Chicago spiegelt. Es ist der konzeptuellste meiner Filme: Ich habe wie ein Wissenschafter agiert, der ein Experiment aufbaut und neugierig ist, welche Ergebnisse daraus resultieren.

MacDonald: *Augenzeugen der Fremde* (1993) ist ein elegantes und bezauberndes Experiment zur Frage der Repräsentation und Vergleichbarkeit von Orten. Wie kam es zu dieser Zusammenarbeit mit Mostafa Tabbou? Und wo liegt Figuig?

Deutsch: Figuig liegt an der Grenze zwischen Algerien und Marokko. In den späten 1980er und frühen 1990er Jahren haben Hanna Schimek (meine Lebens- und künstlerische Partnerin) und ich fast jedes Jahr drei Monate dort verbracht. 1981 war ich schon einmal allein an diesem Ort, während meiner Reise durch den Maghreb. Ich war mit öffentlichen Verkehrsmitteln unterwegs, und damals hat die Grenzpolizei in Oujda, einem Grenzort im Norden Marokkos, Touristen ohne Auto nicht gestattet, nach Algerien einzureisen. Sie haben mir gesagt, die einzige Chance, über die Grenze zu kommen, sei, in die Sahara hinunter zu reisen und dort zu Fuß die Grenze in Figuig zu überqueren. Das habe ich dann getan und mich sofort in diese Oase verliebt. Da sie von den „normalen" Touristenpfaden weit entfernt ist und Touristen

instrument for objective observation. The camera records whatever is in front of it. Ernst chose the positions and times of the observation, and then the camera did the job: it recorded a TV program in a hotel room in Tokyo that nobody was watching, a tree in the garden of a Hotel in Kyoto during a heavy rain, an intersection in Taipei through a whole night, a thunderstorm reflected in the glass front of a Chicago skyscraper. It is the most conceptual of my films: I acted like a scientist who sets up an experiment and is curious about the results.

MacDonald: *Augenzeugen der Fremde [Eyewitnesses in Foreign Countries]* (1980) is an elegant and engaging experiment in representing and comparing places. How did your collaboration with Mostafa Tabbou come about? And where is Figuig?

Deutsch: Figuig is on the border between Algeria and Morocco. In the late 1980s and early 1990s, Hanna Schimek, my companion in life and art and I spent three months there almost every year. I'd been to this place alone in 1981, during a journey through the Maghreb. I'd been travelling on public transportation, and in those days the border police in Oujda—a border town in North Morocco—didn't allow tourists without a car to enter Algeria. They told me that the only chance to cross the border was to go down

nichts Spezielles bieten kann, hatte sie ihre uralte Kultur beibehalten – Architektur, Bewässerungssystem, Lebensstil...

Mostafa Tabbou hat im Hotel Sahara gearbeitet, einem sehr kleinen und einfachen Hotel, in dem ich während meines ersten Aufenthaltes einmal übernachtete, und dann wieder mit Hanna bei unseren späteren Besuchen. Wir freundeten uns mit ihm an.

MacDonald: Wie haben Sie die genaue Form dieser Zusammenarbeit festgelegt?

Deutsch: Mostafa hatte noch nie zuvor gefilmt – es gibt in seiner Sprache (Berber) gar keine Bezeichnung für Film –, also habe ich mir eine Struktur ausgedacht, die erstens nicht zuviel von ihm verlangen würde und zweitens mein eigenes „normales" Verhalten in Figuig nicht verändern würde, samt meiner Weigerung, irgendwelche mir unbekannte Menschen mit der Filmoder Fotokamera „abzuschießen". Hanna und ich hatten das Gefühl, dass eine Kamera vor dem Gesicht eines Touristen einerseits ein Schild und andererseits eine Waffe ist. Sie ist ein Instrument der Abwehr und der Aggression. Der Unterschied zwischen einem Gewehr und einer Kamera ist letztendlich nur eine Frage der Fortdauer der Existenz des „Opfers". Das Motiv und die Haltung des „Jägers" ist die gleiche.

Ich habe das Projekt begonnen, indem ich

to the Sahara desert and cross the border on foot in Figuig. This was what I did, and I immediately fell in love with this oasis. Being far away from the "normal" tourist routes, and having nothing special to offer to tourists, it had kept its age-old culture, architecture, water system, way of life...

Mostafa Tabbou was working in the Hotel Sahara, a very small and simple hotel where I stayed for one night on that original trip and then again with Hanna on later visits. He became a friend of ours.

MacDonald: How did you decide on the precise nature of this collaboration?

Deutsch: Mostafa had never filmed before—actually, there is no name for film in his language (Berber)—so I thought about a structure that, a) would not demand too much from him, and b) that would not change my "normal" behavior in Figuig, including my decision not to "shoot" any unknown people with a film or with a photo camera. Hanna and I felt that a camera in front of the face of a tourist is on the one hand a shield and on the other, a weapon. It's an instrument of defense and of aggression. The difference between a gun and a camera is ultimately only a question of the "victim's" continued existence. The motive and the attitude of the "hunter" is the same.

Mostafa eine Fotokamera schickte. Das war zwei Jahre, bevor wir zu drehen anfingen (ich habe das „Opfer" sozusagen bewaffnet). Und ich traf für mich selbst die Entscheidung, beim Filmen in Figuig nie durch den Sucher zu schauen und nie den Auslöser „im richtigen Moment" zu drücken.

Das formale Konzept des Films bestand darin, „verlängerte Ansichten" in der Dauer von drei Sekunden aufzunehmen – um eine künstlerische Einheit zu schaffen zwischen dem Teil, den Mostafa aufnehmen würde, und dem, was ich aufnehmen würde. Ich entschied mich dazu, meine Aufnahmen in Zehnergruppen zu organisieren, und Mostafa organisierte seine in Zwanzigergruppen – das entsprach seiner Idee, mit den zweiten zehn Aufnahmen überall dort „einzutreten", wo er zunächst, von „außen", die ersten zehn gefilmt hatte. Für meinen Teil legte ich bei jeder Aufnahme fest, wie lange die Kamera „arbeiten" sollte, und innerhalb dieser Zeitspanne wurde die zweite Zeituhr aktiv. Sie startete und stoppte die Kamera in vorher festgelegten Intervallen. In dreißig Sekunden Film sehen wir so entweder einen Tag, eine Stunde oder eine Minute, die vergeht, in Drei-Sekunden-Intervallen. Manchmal saß ich neben der Kamera, manchmal stellte ich die Kamera auf und ging weg.

I set the project in motion by sending Mostafa a photo camera; this was two years before we started filming (I was arming the "victim"), and made the decision for my part, to shoot in Figuig without looking through the camera, and without pushing the trigger at the "right moment."

The formal concept of the film was to shoot "prolonged views," in lengths of three seconds—to create an artistic unity between the part Mostafa would shoot and what I would shoot. I decided to organize my shots in groups of ten and Mostafa decided to organize his in groups of twenty—according to his idea to "enter," during the second ten shots, what he had first filmed from the "outside" in the first ten. For my part, I decided for each shot how long the camera should "work" and within this time-span the second timer started and stopped the camera at prearranged intervals. In thirty seconds of film, therefore, we see either one day, one hour, or one minute passing by, in three-second intervals. Sometimes I was sitting beside the camera; sometimes I set the camera up and left.

In Figuig, Mostafa was only present during my shooting when he helped me to get in contact with people I wanted to film, or when I filmed him. In Vienna, Mostafa decided when and how often he wanted to shoot; he told me

Augenzeugen der Fremde (1993)

In Figuig war Mostafa nur dann beim Filmen anwesend, wenn er mich bei der Kontaktaufnahme mit Leuten unterstützte, die ich filmen wollte, oder wenn ich ihn filmte. In Wien entschied Mostafa, wann und wie oft er filmen wollte. Er erzählte mir, was er während seiner Expeditionen mit der Fotokamera gesehen hatte und filmen wollte, und ich begleitete ihn bei den ersten Aufnahmen. Später ging er dann alleine. Manchmal hatte er viele Aufnahmen gemacht, dann selektierten wir im Nachhinein die zehn, die im Film zu sehen sind. Für den Ton gingen wir ein zweites Mal, und ich nahm Ton an den Orten auf, an denen er gefilmt hatte.

MacDonald: Was, glauben Sie, haben Sie bei diesem Projekt gelernt?

Deutsch: Das ist nicht einfach zu beantworten. Manchmal habe ich einen ganzen Tag nur an einem Fleck verbracht. Während die Kamera ihrer Arbeit nachging, hatte ich viel Zeit, genau zu beobachten, was geschah – oder besser gesagt, was *nicht* geschah. Es war ein Geduldspiel. Vielleicht lernte ich auch, darauf zu verzichten, das Exotische, Andersartige, Fremdartige nur aus Neugier und der visueller Reize wegen abzubilden. Vielleicht habe ich gelernt, dass dieser Ort, aufgrund seiner beschränkten Ressourcen und der Eindeutigkeit seiner Regeln und Vorschriften, ein Modell für die „Welt" ist. Aber

what he had seen during his expeditions with the photo camera and wanted to film, and I accompanied him for the first shootings. Later he went alone. Sometimes he made many shots, then afterwards we selected the ten which are shown in the film. For the sound we went a second time and I recorded sound at the spots where he had filmed.

MacDonald: What do you think you learned by doing this project?

Mariage blanc (1996)

diese Erfahrung könnte ich auch in einem kleinen Dorf in den österreichischen Alpen machen. Ich war übrigens überrascht, als ich in einigen Kaffeehäusern in Figuig Bilder von schneebedeckten Bergen und Almhütten sah. Soviel zum „Exotischen"!

1995 habe ich einen anderen Film mit Mostafa gemacht, einen Beitrag zu dem Kompilationsfilm *Alien/Nation*, der von Sixpackfilm initiiert wurde. Mostafa und ich haben uns in einem Hotel in Casablanca getroffen und ein „matchmaker video" gedreht, in dem Mostafa in allen Sprachen der Europäischen Union den folgenden Satz spricht: „Mein Name ist Mostafa Tabbou; ich bin 30 Jahre alt; ich lebe in Marokko und möchte eine österreichische (deutsche/britische/französische ...) Frau heiraten." Der Film endet mit der Angabe seiner Adresse und seiner Telefonnummer.

Es war für ihn nicht notwendig, die Frau zu heiraten, die ihn nach Europa brachte. Sie lebten sechs Jahre lang zusammen und er erhielt die niederländische Staatsbürgerschaft. Danach arrangierte seine Familie eine Heirat mit einer Marokkanerin, und seit 2004 leben sie zusammen in Herzogenbosch. 2006 haben sie ein kleines Mädchen bekommen.

MacDonald: Wie hat die Arbeit an *Film ist.* begonnen?

Deutsch: That's not easy to answer. Sometimes I spent a full day in one spot. While the camera did its job, I had the chance to observe very carefully what was happening—or more precisely, *not* happening. It was an exercise in patience. Maybe I learned to abstain from depicting the exotic, the alien, the foreign just out of curiosity and for visual sensation. Maybe I learned that this place, because of its limited resources and the clarity of its rules and regulations, is a model for the "world." But this lesson could be learned in a small village in the Alpine mountains in Austria as well. In fact, I was surprised to see in some coffeehouses in Figuig paintings of snowy mountains and Alpine huts. So much for "exotic!"

In 1995, I made another film with Mostafa, as a contribution to a compilation reel initiated by Sixpackfilm, entitled *Alien/Nation*. Mostafa and I met at a hotel in Casablanca and shot a matchmaker video, in which Mostafa speaks the following sentence in all the languages of the European Union: "My name is Mostafa Tabbou; I am 30 years old; I live in Morocco; and I want to marry an Austrian (German/English/French...) woman." The film ended with his address and telephone number.

It was not necessary for him to marry the woman who brought him to Europe; they lived

Deutsch: *Film ist.* begann 1995, als auf der ganzen Welt 100 Jahre Kino gefeiert wurden. Zunächst habe ich einige berühmte Zitate über Film gesammelt, zum Beispiel Sam Fullers „Ein Film ist wie ein Schlachtfeld." oder Jean-Luc Godards „Film ist die Wahrheit vierundzwanzigmal in der Sekunde." Ich habe eine Liste solcher Definitionen angelegt und einige eigene hinzugefügt. Aber mehr und mehr dachte ich mir, wie seltsam es ist, dass die Menschen das Medium in einem Satz definieren wollen – obwohl diese Statements natürlich eine Menge über die betreffenden Leute und ihr jeweiliges Werk aussagen. Für mich war es interessanter, eine Liste zu haben als einen einzelnen Satz. 1996 habe ich für die Viennale mithilfe meiner Liste einen Trailer gemacht: *Film ist mehr als Film.*

MacDonald: Als ich zum ersten Mal *Film ist.* sah, habe ich versucht, eine einfache Idee, den einen grundlegenden Gedanken zu finden, der alle Kapitel zusammenhält, aber alle schienen sich aufzufächern, sich zu öffnen, statt sich auf das Thema einzuengen. Es ist so, als würde man sich fragen: „Was zum Teufel ist eigentlich Film?!"

Deutsch: Das Hauptinteresse bestand für mich – und besteht immer noch – darin, den Film über sich selbst sprechen zu lassen, mit seinen eigenen Mitteln und seiner eigenen Geschichte, und nicht zu versuchen, das zu kommentieren oder

together for six years and he got the Dutch citizenship. Afterward, his family arranged a marriage with a Moroccan woman, and since 2004 they've lived together in Herzogenbosch. In 2006 they had a little girl.

MacDonald: How did *Film ist.* begin?

Deutsch: *Film ist.* began in 1995, the year everybody around the world was celebrating one hundred years of cinema. I started by writing down some famous quotations about film, like Sam Fuller's "Film is a battlefield" or Jean-Luc Godard's "Film is the truth twenty-four times a second." I made a list of quotes and added some of my own. But more and more, I thought how strange it is that people try to define the medium in one sentence—though it does say a lot about the people who make these statements, and about their own work. For me it was more interesting to have a list than a single phrase. In 1996, I made a trailer for the Vienna International Film Festival with my list: *Film ist mehr als Film [Film Is More Than Film].*

MacDonald: When I was first looking at *Film ist.*, I was trying to find one simple idea that was holding each section together, but they all seem to open out, rather than focus in. It's as if you're asking, "What the hell *is* film?!"

Deutsch: The main interest for me was, and still is, to let film speak for itself with its own means

diese Mittel und diese Geschichte zu erklären. Natürlich kann ein Film, der „Film ist." heißt, *niemals* fertig sein. Es wird immer etwas geben, wofür es sich eher lohnt, zwei oder drei Jahre damit zu verbringen; das ist die durchschnittliche Zeit, die ich für die Arbeit an jedem Teil von *Film ist.* bisher aufgewendet habe.

MacDonald: Hat sich *Film ist.* Kapitel nach Kapitel entwickelt? Haben Sie darüber spekuliert, wie die ersten sechs Teile aussehen würden?

Deutsch: Die allererste Idee drehte sich um Fiktion und *non-fiction* – Filme, die gemacht wurden, um Informationen zu sammeln, und Filme, die zur Unterhaltung gemacht wurden. Aber das habe ich sehr bald fallengelassen, weil ich eigentlich überhaupt nicht zwischen Fiktion und Nicht-Fiktion unterscheide.

MacDonald: Meinen Sie das in bezug auf das Frühe Kino oder Film an sich?

Deutsch: Bis zu einem gewissen Maß ganz allgemein, aber besonders, was das Frühe Kino betrifft. Am Anfang wollte ich den Film gar nicht in Kapitel unterteilen. Ich wollte alles mit allem kombinieren, habe mich dann aber dagegen entschieden. Ich konzentrierte mich stattdessen auf die „Geburtsstätten" des Films. Die erste Geburtsstätte war das wissenschaftliche Labor. Film wurde vor allem von Wissenschaftern entwickelt, als Instrument für die Forschung. Die

and history, not to try to comment on or explain those means and that history. I try to speak with film about film. Of course, a film called "Film ist." can *never* be finished: there will always be something more worth focusing on for two or three years, the normal period of time that I spend working on each chapter of *Film ist.*

MacDonald: Did *Film ist.* evolve one chapter at a time? Did you conjecture what the first six parts would be?

Deutsch: The very first idea had to do with fiction/nonfiction—films made to gather information and films made for entertainment—but I very quickly forgot that because I don't actually distinguish at all between fiction and nonfiction.

MacDonald: Do you mean in early film, or in film altogether?

Deutsch: To a certain extent in general, but especially in early film.

Also, at the beginning I didn't want to separate the film into sections; I wanted to combine everything together, but I decided against this too. I came up with the idea of focusing on the birthplaces of film. The first birthplace was a scientific laboratory; film was mostly developed by scientists as an instrument for research. The second birthplace was the fairground, "fairground" meaning all sorts of theatrical entertainment.

Film ist. Ein Instrument (1998)
Film ist. Bewegung und Zeit (1998)

zweite Geburtsstätte war der Jahrmarkt – „Jahrmarkt" meint hier alle Arten von theatralischer Unterhaltung. Das erlaubte mir, das Material einzuteilen, indem ich fragte, was gehört zum Labor und was ist mit dem Jahrmarkt verbunden? Ich hatte gleich am Anfang entschieden, dass der erste Teil sechs Kapitel haben sollte, aber ich hätte leicht zehn machen können.

MacDonald: Stammt das gesamte Material in den ersten sechs Kapiteln von *Film ist.* aus wissenschaftlichen Filmen?

Deutsch: Das ganze Material hat mit Labors zu tun, aber es ist nicht notwendigerweise nur aus wissenschaftlichen Filmen entnommen. Die Filme mit den Auto-Crash-Tests sind zum Beispiel von Mercedes. Im Kapitel „Material" verwendete ich einen Film, den ich auf einem Flohmarkt in São Paulo gekauft hatte, Filmmaterial aus einer brasilianischen Telenovela, das hergestellt worden war, um Filter und Helligkeitswerte im Kopierlabor bestimmen zu können. Es waren zwei Kader aus jeder Einstellung dieser Seifenoper; auf einem Kader waren die geschriebenen Anweisungen eines Laborangestellten, was man mit der Einstellung tun solle. Dieses Material ist in „Material", weil es direkt aus einem Labor kam, wo jemand damit arbeitete, und *auch*, weil es noch in einem anderen Sinn als „Material" verwendet wurde. Der Mann, der

This allowed me to divide the material by asking, what is connected to the lab and what is connected to the fairground? I decided in advance on six chapters for the first part, but could easily have made ten.

MacDonald: Is all the material included in the first six chapters of *Film ist.* from science films?

Deutsch: All the material has to do with laboratories, but it's not specifically from scientific films. The films of the car crash tests, for example,

Film ist. Material (1998)

are from Mercedes. In "Material" I used a film I bought at a flea market in São Paulo, footage from a Brazilian telenovela that had been used to distinguish the filters and exposure times in a laboratory. There were two frames from each shot of this soap opera, in which there were indications written by a man from the lab about what to do with the shot. This material is in "Material" because it came directly from a laboratory where somebody was working with it and *also* because it was used as "material" in a different sense. The man who sold me the film told me that his cleaning lady had used it to clean the floor tiles in his bathroom: she would stick the broom into the mass of film, then into the Brazilian soap, and scrub the floor tiles. Like the man in the lab, she left a layer of traces on the filmstrip.

So to get back to your question, not all of what you see in *Film ist. 1–6* is scientific film, but it all has to do, more or less, with laboratories of one kind or another.

MacDonald: *Film ist. 1–6* is different from *Film ist. 7–12*, and not just in the general sense you've mentioned: that is, in their representing the two birthplaces of cinema. The material in chapters 1 to 6 seems to come from a wider time span than the material included in chapters 7 to 12. Is this simply because the more you worked with

mir den Film verkaufte, hat mir erzählt, dass seine Putzfrau den Film dazu verwendete, die Bodenfliesen im Klo zu reinigen: Sie steckte den Besen in den Kern, den „Bobby" des Films, dann in brasilianische Seife und schrubbte die Bodenfliesen. Wie der Angestellte im Labor hinterließ sie Spuren auf dem Filmstreifen.

Um also auf Ihre Frage zurückzukommen: Nicht alles, was man in *Film ist. 1–6* sieht, ist wissenschaftlicher Film, aber es hat alles mehr oder

weniger mit Labors der einen oder anderen Art zu tun.

MacDonald: *Film ist. 1–6* unterscheidet sich von *Film ist. 7–12* nicht nur in dem allgemeinen Sinn, den Sie erwähnt haben – was die Repräsentation der beiden Geburtsstätten des Kinos betrifft. Das Material in den Kapiteln 1 bis 6 scheint aus einer größeren Zeitspanne zu stammen als das Material, das in den Kapiteln 7 bis 12 verwendet wird. Hat das einfach damit zu tun, dass Sie sich mehr und mehr für das Frühe Kino interessierten, je länger Sie mit Found Footage gearbeitet haben?

Deutsch: Ja, das war einer der Gründe. Der andere war, dass es aus dem Bereich des Frühen Kinos viel mehr verfügbares Material für die „Jahrmarkt"-Kapitel gab: komische Filme, Märchen, Panoramen und frühe Filmdramen wie die Diva-Filme aus Italien. Außerdem erhielt ich nach *Film ist. 1–6* das Angebot vom Nederlands Filmmuseum, mit der dortigen „Bits & Pieces"-Sammlung zu arbeiten, die zu einer meiner Hauptquellen wurde.

MacDonald: Sie haben erwähnt, dass sie auf Flohmärkte gehen und dort Material kaufen, aber es ist auch offensichtlich, dass Sie viel Zeit in Archiven verbringen.

Deutsch: Die Art von Recherche, die ich durchführe, hängt vom Ausgangspunkt ab. Eine Weise, mich meinem Thema anzunähern, ist,

found film, the more interested you became in early cinema?

Deutsch: Yes, that was one reason. The other was that there was much more material available from early cinema for the "fairground" chapters: comic films, fairytales, panoramas, and early film dramas, like the diva films from Italy. Plus, after *Film ist. 1–6* I received an offer from the Nederlands Filmmuseum [the national film archive in the Netherlands, Ed. note] to work with their "Bits & Pieces" collection, which became one of my main sources.

MacDonald: You mentioned going to flea markets and buying material, but it's also clear that you spend a lot of time in archives.

Deutsch: The kind of research I do depends on what the starting point is. One way to approach my subject is to read something, to research the subject, to go to museums to find film material relating to this subject, to have an idea of how to use this material, and to make something out of it.

My second approach was/is to just be alert when I'm in labs or walking in the street. I collect films. For example, on the street where I live in Vienna, there is a big lab, and the trash cans are put outside each night. I pass by and take a look, and if I find something, I take it with me.

darüber zu lesen, zu recherchieren, in Museen zu gehen, um Filmmaterial zu finden, das sich mit diesem Thema beschäftigt – um eine Vorstellung davon zu kriegen, wie sich dieses Material einsetzen lässt, was sich daraus machen lässt.

Mein zweiter Ansatz war und ist es, schlichtweg aufmerksam zu sein, wenn ich in Kopierwerken bin oder durch die Straßen gehe. Ich sammle Filme. Zum Beispiel gibt es in der Straße, in der ich in Wien wohne, ein großes Labor, und jede Nacht werden die Mülleimer nach draußen gestellt. Ich gehe vorbei und schaue mir das genau an, und wenn ich etwas finde, nehme ich es mit.

Es gibt noch eine dritte Methode. Ich fange mit einer thematischen Idee an, zu der ich gerne arbeiten würde. Ich versuche, mich in meiner Recherchetätigkeit auf jene Archive zu beschränken, mit denen ich bereits Erfahrung gesammelt habe, und wo ich weiß, dass die Archivare gerne mit mir zusammenarbeiten. Ich kann das normale Archivsystem nicht benutzen: Archive kategorisieren ja meistens alles nach Titel, Autor, Jahr. Ich halte hingegen Ausschau nach spezifischen Szenen: jemand, der eine Tür schließt, jemand, der Stiegen hinaufsteigt, jemand, der einen Brief liest... Ich muss mich also verständlich machen gegenüber Menschen, die selber Unmengen an Filmen gesehen haben und

I also use a third approach. I begin with an idea about what I would like to work on. I try to restrict my field of research to archives where I've had some experience, and where the archivists are willing to cooperate with me. I cannot use the normal archive system; archives usually work by title, by author, by year. What I'm looking for is special scenes and particular actions: somebody closing a door, somebody climbing up a staircase, somebody reading a letter... I have to make myself understandable to people who have seen a lot of films and "have the archive in their heads," people like Nico de Klerk and Mark-Paul Meyer from the Nederlands Filmmuseum. I tell them what kinds of things I'm looking for and they find what they can: because of their hard work, Hanna and I can go to their archives for two or three weeks and watch film eight hours a day.

MacDonald: As you worked on *Film ist.*, to what extent were you thinking about earlier filmmakers who have worked with found footage?

Deutsch: When I give lectures with these films, I often say whom I had in mind, or to whom I'm dedicating a screening. For example, in section 1.5 of "Bewegung und Zeit / movement and time" I use shots of the famous Tacoma Bridge, the same footage Bruce Conner used in *A Movie* (1958). The second section of "Material," where I use the

Film ist. Bewegung und Zeit (1998)

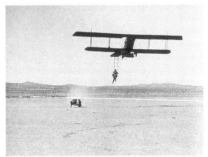

Film ist. Komisch (2002)

„das Archiv im Kopf haben", Menschen wie Nico de Klerk und Mark-Paul Meyer vom Nederlands Filmmuseum. Ich sage ihnen, was ich genau suche, und sie finden, was ihnen möglich ist. Aufgrund dieser intensiven Vorarbeit können Hanna und ich dann in diese Archive fahren und dort zwei oder drei Wochen lang acht Stunden am Tag Filme sichten.

MacDonald: In welchem Ausmaß haben Sie an frühere Filmemacher und deren Umgang mit Found Footage gedacht, als Sie an *Film ist.* gearbeitet haben?

Deutsch: Wenn ich Vorlesungen zu und mit diesen Filmen halte, sage ich oft, an wen ich dabei gedacht habe oder wem ich die Vorführung widme. Zum Beispiel verwende ich in Kapitel 1.5 von „Bewegung und Zeit" Einstellungen der berühmten, schwankenden Tacoma-Brücke; das

footage of the Brazilian telenovela, is dedicated to Stan Brakhage, because of his work on the film strip in *Mothlight* (1963), a key film for me.

The last section of *Film ist.,* "Ein Spiegel /a mirror," where this actor goes through a whole repertoire of expressions, is from a German Democratic Republic film; it's intercut with the audience of a cinema where you can see the projector beam behind them. When I was editing this, I had in mind a sentence from Peter Kubelka, "Film is destroyed by actors," and I often make this connection when I lecture.

And the sequence in "Ein Augenblick / a blink of an eye," where the eye is cut out, is for me a reference to *Un chien andalou* (1929, by Luis Buñuel and Salvador Dali).

But I never start with the idea of making a reference to the work of other filmmakers,

gleiche Material hat Bruce Conner in *A Movie* (1958) verwendet. Der zweite Abschnitt von „Material", wo ich das Filmstück der brasilianischen Telenovela verwende, ist Stan Brakhage gewidmet, wegen seiner Bearbeitung des Filmstreifens in *Mothlight* (1963), der ein Schlüsselfilm für mich ist.

Das letzte Kapitel von *Film ist., „Ein Spiegel"*, wo der Schauspieler sein ganzes Repertoire an Gesichtsausdrücken durchspielt, stammt aus einem DDR-Film; es ist unterschnitten mit den Aufnahmen eines Publikums im Kino, wo man den Lichtkegel des Projektors hinter den Leuten sieht. Als ich das geschnitten habe, hatte ich einen Satz von Peter Kubelka im Hinterkopf: „Der Film wird von den Schauspielern vernichtet." Ich stelle diese Verbindung oft her, wenn ich eine Vorlesung halte.

Und die Sequenz in „Ein Augenblick", wo das Auge herausgeschnitten wird, ist für mich eine Referenz auf *Un chien andalou* (1929, Luis Buñuel und Salvador Dalí).

Dieser Verweis auf andere Filmemacher ist aber niemals mein Ausgangspunkt, obwohl es mir klar ist, dass für viele Betrachter meine Bildwelt andere Filme evoziert, nicht nur Avantgardefilme. Zum Beispiel die Sequenz gegen Ende des Abschnitts 7.3 in „Komisch", wo das Flugzeug in den Senkflug geht und einen Mann auf-

though it is often clear to me that for many viewers my imagery will evoke other films, and not only avant-garde and experimental films. For example, the sequence near the end of section 7.3 of "Komisch/comic," where the plane flies down and picks up the man, certainly suggests the famous sequence from Hitchcock's *North by Northwest* (1959) where Cary Grant is attacked by the plane.

MacDonald: You mentioned Bruce Conner's *A Movie*. Conner died recently. He was very important in American culture, in both avant-garde and pop culture. Your chase sequence in 7.3 seems closely related to a sequence in Conner's *A Movie*. How important was Conner for you?

Deutsch: I am a great admirer of Bruce Conner's work, and *A Movie* especially was important for me. I also admire the work of Morgan Fisher—another key film for me was his *Standard Gauge* (1984).

But in general I don't have "favorite" filmmakers, and some of the most important influences don't come from filmmaking at all. Aby Warburg's Mnemosyne Atlas, for example, was and still is very important for me.

MacDonald: Generally, unlike Bill Morrison and Gianikian and Ricci Lucchi, you don't seem particularly interested in film's *physical* decay. Indeed, while you do sometimes use decayed im-

Tradition ist die Weitergabe des Feuers und nicht die Anbetung der Asche (1999)

greift – das suggeriert sicherlich die berühmte Szene aus dem Hitchcock-Film *North by Northwest* (1959), in der Cary Grant von einem Flugzeug attackiert wird.

MacDonald: Sie haben *A Movie* von Bruce Conner erwähnt, der vor kurzem gestorben ist. Er war sehr wichtig für die amerikanische Kultur, für die Avantgarde wie für die Popkultur. Ihre Jagdsequenzen in 7.3 scheinen eng verwandt zu sein mit einer Szene aus *A Movie*. Wie wichtig war Conner für Sie?

Deutsch: Ich bin ein großer Bewunderer seines Werks, und *A Movie* war für mich besonders wichtig. Ich bewundere auch die Arbeit von Morgan Fisher, sein *Standard Gauge* (1984) war ein weiterer Schlüsselfilm für mich.

Aber an sich habe ich keine „Lieblings-Filmemacher", einige meiner wichtigsten Einflüsse kommen gar nicht vom Filmemachen. Aby Warburgs Mnemosyne-Atlas zum Beispiel war und ist für mich immer noch ganz zentral.

MacDonald: Sie scheinen überhaupt, anders als Bill Morrison oder Yervant Gianikian und Angela Ricci Lucchi, nicht so sehr am physischen Verfall des Filmmaterials interessiert zu sein. Obwohl Sie manchmal beschädigtes Bildmaterial verwenden, scheint es Ihnen eher darum zu gehen, wie sehr das Frühe Kino noch immer zu uns sprechen kann – wenn auch auf eine an-

agery, you seem more interested in the degree to which early cinema can still communicate to us, albeit in a different manner than its creators originally might have hoped it would communicate.

Deutsch: I used decayed images in three chapters of *Film ist.*, "Magie / magic," and in *Film ist.*, "Material." But I didn't want to dedicate a whole chapter to this subject.

In the trailer I made for the Filmarchiv Austria—*Tradition is the Handing on of Fire, not the*

dere Art und Weise, als es die Urheber ursprünglich intendiert hatten.

Deutsch: Ich habe beschädigte Bilder in drei Kapiteln von *Film ist.* „Magie" verwendet und auch in „Material". Aber ich wollte der Thematik kein ganzes Kapitel widmen.

Im Trailer, den ich für das Filmarchiv Austria gemacht habe – *Tradition ist die Weitergabe des Feuers, nicht die Anbetung der Asche* (1999) – ist der Verfall des Filmmaterials das wichtigste Sujet. Indem jeder Kader zwölfmal dupliziert wurde und diese Zwölf-Kader-Bilder dann durch Überblendungen verbunden wurden, habe ich versucht, die Beschädigungen „pulsieren" zu lassen. Beschädigte Bilder sind immer schön. Während unserer Recherchen halten Hanna und ich den Film oft am Schneidetisch an und betrachten einzelne Filmkader so, als ob wir Gemälde anschauen würden.

Aber wie Sie richtig sagen, ich bin in erster Linie daran interessiert, verborgene Schätze des Frühen Kinos aufzuspüren und diesen Bildern und Geschichten neue Bedeutung einzuflößen, indem ich Bilder und Szenen miteinander kombiniere, die niemals für solche Verbindungen gedacht waren.

MacDonald: Könnten Sie darüber sprechen, wie der Soundtrack für *Film ist.* entstanden ist?

Deutsch: Ich habe einen befreundeten Musik-

Worship of Ashes (1999), the decay of the film stock is the main subject. By duplicating each frame twelve times, and having these twelve frames overlapping each other by fading in and fading out, I tried to let the decayed images "pulsate." Decayed images are always beautiful, and often during our research Hanna and I stop the film on the editing table and look at single frames as if we were looking at paintings.

But as you say, I am primarily interested in detecting hidden treasures of early cinematography, and in bringing new meaning to the images and stories by combining images and scenes that were never meant to be combined.

MacDonald: Could you talk a bit about how the soundtrack for *Film ist.* evolved?

Deutsch: I asked a music-curator friend, Werner Korn, to suggest contemporary musicians working in the field of electronic music. I wanted to have a contemporary soundtrack, and I wanted to work with musicians who knew each other and had worked together. We chose four: Burkhard Stangl, Christian Fennesz, Martin Siewert and Werner Dafeldecker. Christian and Burkhard already had experience with film music. The musicians got all the material on video—more than twelve hours of it!—and we asked them to improvise and create sounds while watching this material. They

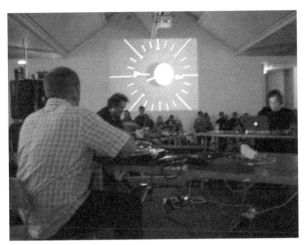

Film ist. 1–12, Live Act
mit / *with* Werner Dafeldecker, Christian Fennesz,
Martin Siewert, Burkhard Stangl,
Dundee Contemporary Arts, 19.10.2003

kurator, Werner Korn, gefragt, ob er mir zeitgenössische Musiker empfehlen könnte, die auf dem Gebiet der elektronischen Musik arbeiten. Ich wollte einen zeitgemäßen Soundtrack haben und mit Musikern arbeiten, die sich schon kannten und auch bereits zusammengearbeitet hatten. Wir haben vier ausgewählt: Burkhard Stangl, Christian Fennesz, Martin Siewert und Werner Dafeldecker. Christian und Burkhard hatten schon Erfahrung mit Filmmusik. Die Musiker erhielten das gesamte Material auf Video – das waren mehr als 12 Stunden! – und wir haben sie gebeten, zu improvisieren oder Sounds zu kreieren, während sie das Material ansahen. Sie wurden nicht gebeten, Musik für spezielle Szenen zu machen, sondern nur auf die Bilder zu reagieren. Das Material, das sie produzierten, wurde in einer Ton-Bank auf dem AVID abgelegt, parallel zur Bilder-Bank.

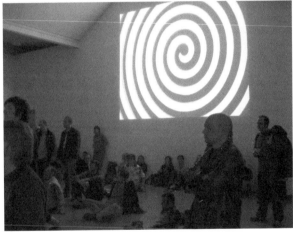

Ich kann mir nicht vorstellen, ohne Ton zu schneiden. Wenn ich damit beginne, eine Sequenz zu schneiden, wähle ich ein Musikstück aus, das mit den Bildern zu funktionieren scheint. Manchmal habe ich die Sounds geloopt, manchmal überlappt. Sobald ich mit dem Schnitt einer Sequenz fertig war, habe ich die Musiker gefragt, ob sie vorbeikommen und anschauen würden, was ich gemacht hatte. Dann haben sie die geschnittenen Sequenzen samt

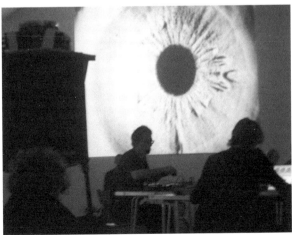

Film / Spricht / Viele / Sprachen,
Fundstückoriginal vom / *original footage found on*
Blvd. Sidi Mohammed ben Abdallah, Casablanca

Sound bekommen und wiederum an der Musik gearbeitet, unabhängig davon, ob die Originalmusik ihre eigene oder die eines anderen Musikers war. Sie sind Sampling gewohnt. Am Ende hat jeder von ihnen an einem ganzen Kapitel gearbeitet, eines wurde kollektiv erarbeitet und eines wurde so belassen wie es war. Christian Fennesz hat den End-Mix gemacht.

Später hatten wir mit dem Film eine Reihe von Live-Konzerten, auch mit dem Originalmaterial der mitwirkenden Archive und mit der DVD-Version von *Film ist.* Damit haben wir verschiedene Arten von Publikum ansprechen können.

MacDonald: Ein anderer Found-Footage-Film, *Film / Spricht / Viele / Sprachen* (1995), ist sehr kurz und erstaunlich dicht: Er versammelt mimische und körperliche Gesten aus dem Bollywoodfilm, den Sie hier verwenden, zwei Untertitel-Ebenen, sowie die Stimmen von der Tonspur, die Abbildung der Tonspur selbst, die Nummern am Rand des Filmstreifens...

Angesichts der Geschichte des Materials, aus dem Sie diesen kleinen Film gemacht haben, suggeriert der Titel auch die verschiedenen Arten, wie ein und derselbe Filmstreifen in verschiedenen Kulturen zu verschiedenen Zeiten als Big-Budget-Unterhaltung, als Mist oder als Teil eines anderen Films funktionieren kann.

Deutsch: Es gibt eine Anekdote zu diesem Film.

were not asked to make music for special scenes, but just to react to the images. The material they produced was organized in a sound library on the AVID, parallel to the image library.

I cannot imagine editing without sound. Whenever I started to edit a sequence, I chose a piece of music that seemed to work with the images. Sometimes I looped the sounds, sometimes I overlapped them. When I finished the editing of a sequence, I asked the musicians to come see and hear what I had done. They would get the edited sequences back with sound, and work on the music again, regardless of whether the original music was their own, or another musician's. They're used to working with sampling. In the end each of them worked on a whole chapter; one was done collectively; and one was left as it was. The final mixing was done by Christian Fennesz.

Later, we had a series of live music performances with the film, and with original material from the cooperating Archives, and with the DVD version of *Film ist.* This allowed us to reach a variety of audiences.

MacDonald: Another found footage work, *Film / Spricht / Viele / Sprachen [Film / Speaks / Many / Languages]* (1995), is very short and remarkably dense: it includes facial and hand gestures by the characters in the Bollywood film you recycle,

Scott MacDonald

Ich machte im Herbst 1991 auf dem Boulevard Sidi Mohamed Ben Abdallah in Casablanca einen Spaziergang. Es hatte geregnet, und ich versuchte, den Wasserlachen auf dem Gehsteig auszuweichen. In einer dieser Wasserlachen sah ich ein Stück 35mm-Film. In einer anderen – noch ein Stück. Nach fünf Wasserlachen entschloss ich mich dazu, sie zu sammeln. Auf mehreren hundert Metern fand ich 39 Stücke. Wahrscheinlich hat ein Kurier, der den Film transportierte, eine Rolle verloren.

Im Hotel trocknete ich die Stücke, und als ich wieder in Wien war, realisierte ich, dass sie aus einem Bollywoodfilm mit französischen und arabischen Untertiteln stammten. Ich wusste nicht, was ich mit dem Material anfangen sollte und legte es beiseite. Die Gelegenheit, damit zu arbeiten, kam dann 1995, als ich gefragt wurde, meinen ersten Trailer für die Viennale zu machen. Zuerst habe ich die Stücke nach den Hauptschauplätzen geordnet: eine Pferdekutsche, ein Swimming Pool, eine Tankstelle und eine Bar. 21 der 39 Stücke waren an diesen Schauplätzen gedreht worden. Dann arrangierte ich die 21 Stücke anhand der vier Schauplätze und der Geschichten, die dort erzählt wurden. Die Themen waren: Liebe, Eifersucht, Verbrechen und Geschäftsleben.

Ich habe die Länge der Filmstücke beibehal-

two levels of subtitling, plus the voices on the soundtrack and the visualization of the soundtrack itself, the numbers on the edge of the filmstrip...

Given the history of the material you worked with in this little film, the title also suggests the various ways in which, in different cultures at different times, the same bit of film material can function as big-budget entertainment, as junk, as part of a different film.

Deutsch: There's a story behind *Film / Spricht / Viele / Sprachen*. I was walking on the Boulevard Sidi Mohamed Ben Abdallah in Casablanca, in autumn 1991. It had rained, and I tried to avoid stepping into the puddles on the sidewalk. In one of these puddles I saw a piece of 35mm film. In the next one—another piece. After five puddles, I decided to collect them. In several hundred meters I found thirty-nine pieces. I guessed that a courier transporting a film had lost a reel.

Back in the hotel I dried the pieces, and back in Vienna I realised that they were from a Bollywood film, with French and Arabic subtitles. I didn't know what to do with this material and put it away. The opportunity to use it came in 1995, when I was asked to make my first trailer for the Viennale. First, I ordered the pieces according to the four main locations where they were shot: a horse carriage, a swimming pool, a

ten, so wie ich sie gefunden hatte, und zwischen die Stücke habe ich jeweils einen monochromen Filmkader montiert – so wie ein Restaurator an einem zerstörten Fresko arbeitet, indem er neutrales Material zwischen die gefundenen Bildteile fügt. Für jeden der vier Schauplätze habe ich eine Farbe ausgewählt: Orange, Türkis, Violett und Blau. Und in jeden dieser einzelnen Farbkader habe ich ein Wort eingesetzt: „FILM", „SPRICHT", „VIELE", „SPRACHEN." Ich wollte die filmischen Fragmente als Objekte präsentieren, mit all ihren Beschädigungen, mit der sichtbaren Tonspur und den sichtbaren Perforationslöchern. Ich wollte zeigen, dass viele Geschichten und viele Arten von Geschichten in solchen gefundenen Filmstücken verborgen sind.

gas station, and a bar. Twenty-one of the thirty-nine pieces were shot on these locations. Then I arranged the twenty-one pieces using these four locations according to the story embedded in each. The themes of the stories were: love, jealousy, crime, and business.

I kept the lengths of the pieces of film as I found them, and between the pieces I put one frame of monochrome color, the way a restorer would work on a destroyed fresco, putting some neutral material in between the found images. For each of the four locations I chose a color: orange, turquoise, violet, blue; and in each of these individual colored frames I included a word: "FILM," "SPEAKS," "MANY," "LANGUAGES." I decided to show the film fragments as objects, with all their damage, and with the soundtrack and the sprocket holes visible. I wanted to demonstrate that many stories, and many kinds of stories, are embedded in such pieces of found footage.

Gustav Deutsch, Hanna Schimek

Lichtbilder

Installationen und performative Arbeiten

Light Images

Installations and performances

Parallel zu den linearen filmischen Arbeiten schafft Gustav Deutsch installative und performative Arbeiten für den Ausstellungsraum. Dafür entwickelt er dem jeweiligen Thema entsprechende Formate und ortspezifische räumliche Lösungen. Sind es beim – anlässlich von „100 Jahre Kino" entwickelten – *Taschenkino* hundert Super-8 Filmbetrachter, die er im Publikum kreisen lässt, so ist es bei *Film ist. 1–12* ein auf das präkinematografische Zoetrop referierender Projektionszylinder. *Tatort Migration* nimmt mit zehn Heimkino-Boxen auf die intime Atmosphäre des Fernsehens Bezug.

Sowohl für den Ausstellungs- als auch für den öffentlichen Raum gestalten Gustav Deutsch und Hanna Schimek Lichtinstallationen und arbeiten seit 2003 am Projekt *Licht | Bild*, dessen Kern ein Bilderatlas zum Thema Licht darstellt, der im Sinne des *Mnemosyne Atlas* von Aby Warburg Aufnahmen aus unterschiedlichen Gebieten der Kunst- und Wissenschaftsgeschichte sowie eigene Aufnahmen in einen Dialog treten lässt. *Licht | Bild* ist auch das Thema der von Deutsch und Schimek gegründeten und geleiteten Aegina Akademie, einem Forum der Kunst und Wissenschaft. In Zusammenarbeit mit dem Architekten Franz Berzl entstand im Rahmen dieses Forums das Camera-Obscura-Gebäude in Aegina.

Parallel to his linear cinematographic work, Gustav Deutsch creates installations and performances for exhibition spaces. To this end, he develops corresponding formats and spatial solutions for each topic. For his *Taschenkino*— developed especially for the Centenary of Cinema, he lets one hundred Super-8 'microviewers' circle in the audience. And for *Film ist. 1–12* he uses a projection cylinder, reminiscent of the pre-cinematographic zoetrope. *Tatort Migration* makes use of ten Home Cinema boxes in reference to the more intimate atmosphere of watching television.

Gustav Deutsch and Hanna Schimek design light installations for exhibitions, as well as public spaces. Since 2003 they have been working on the project *Light | Images*, the core of which is a pictorial atlas on the subject of light, a dialogue among photos from greatly varying fields of art and science history and their own photos, similar to Aby Warburg's *Mnemosyne Atlas*. *Light | Images* is also the theme of the Aegina Academy, an art and science forum founded and directed by Deutsch and Schimek. In cooperation with architect Franz Berzl, the camera obscura building on the Island of Aegina came into being in the scope of this forum.

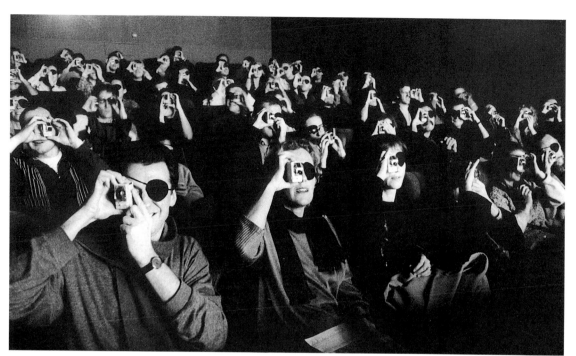

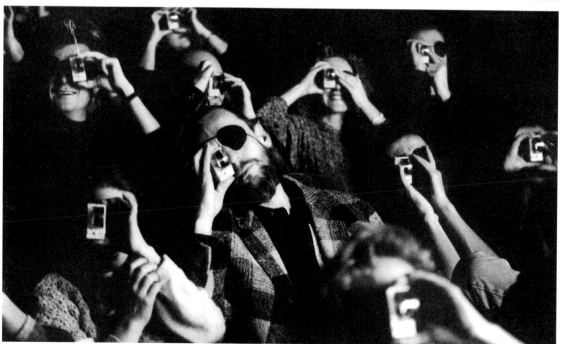

Taschenkino, Interaktive Filmvorführung / *interactive film screening*; Filmhauskino, Wien

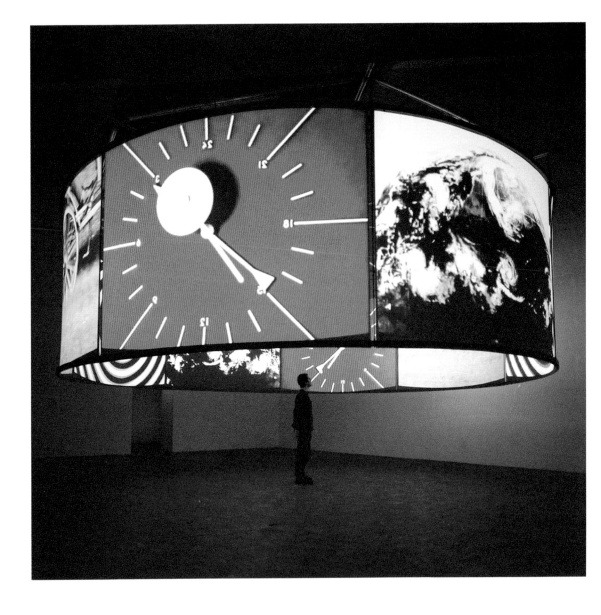

Film ist. 1–12, 8 channel DVD installation; Künstlerhaus Wien © Hans Labler

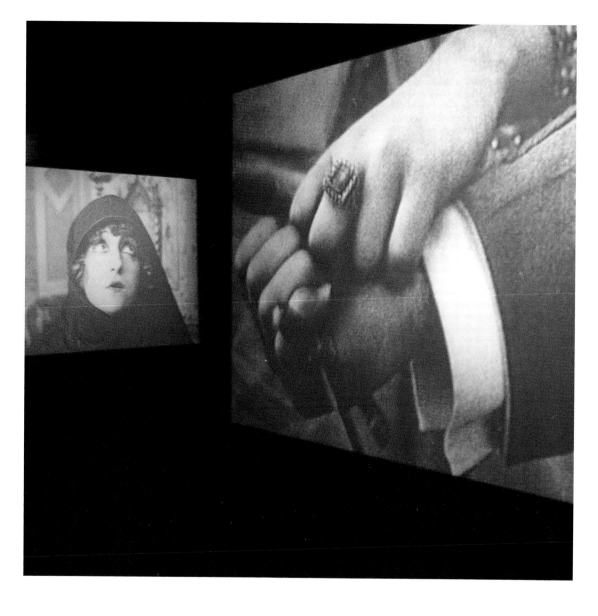

Film ist. 1–12, 8 channel DVD installation; Galeria Solar, Vila do Conde

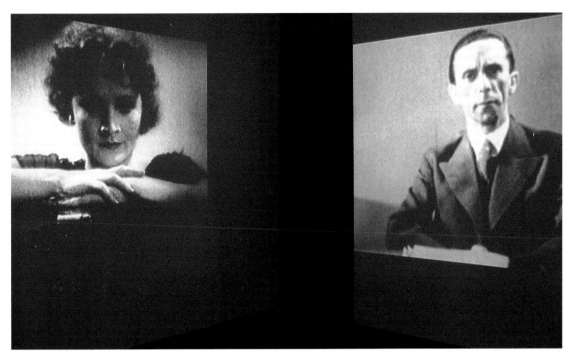

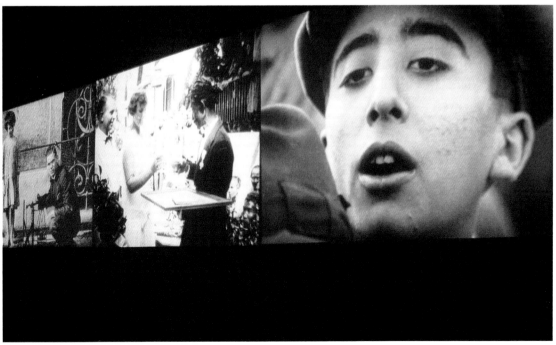

Film ist. Stimme und Gesang, 4 channel DVD installation; ZKM, Karlsruhe (oben/*top*), *Welt Spiegel Kino – Tryptichon;* Galeria Solar, Vila do Conde

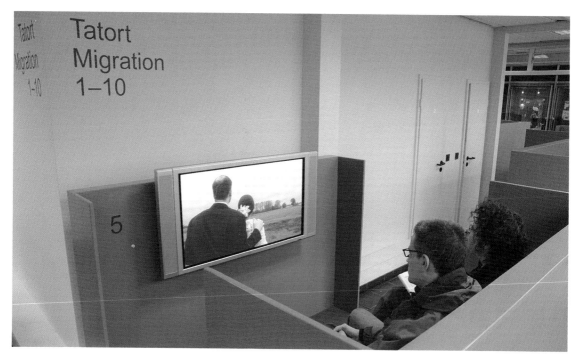

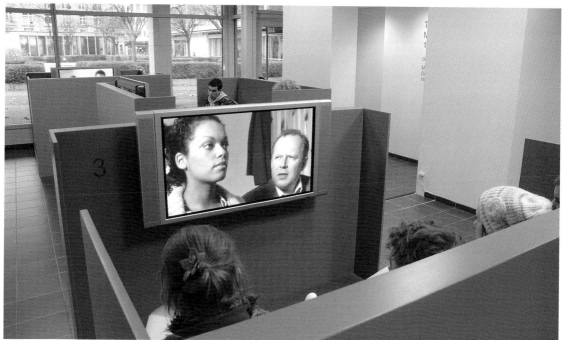

Tatort Migration 1–10, 10 channel DVD installation; Kölnischer Kunstverein © Kölnischer Kunstverein

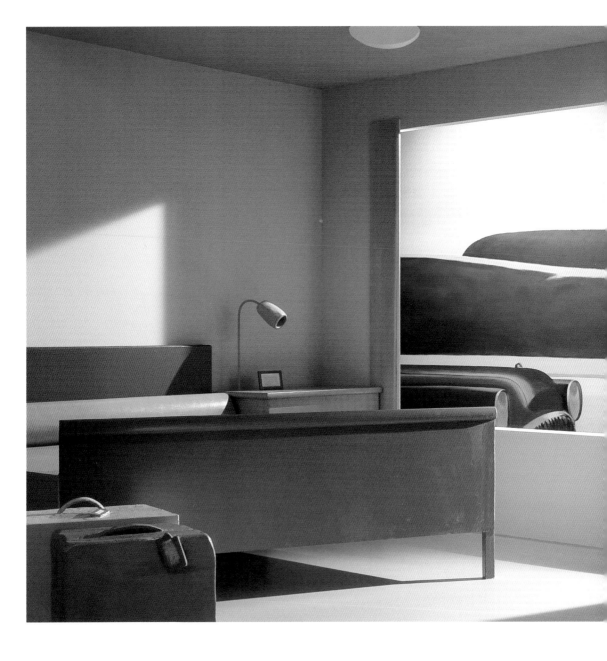

Wednesday, 28 August 1957, 6 p.m., Pacific Palisades, Multimedia installation; Kunsthalle Wien © Stephan Wyckoff

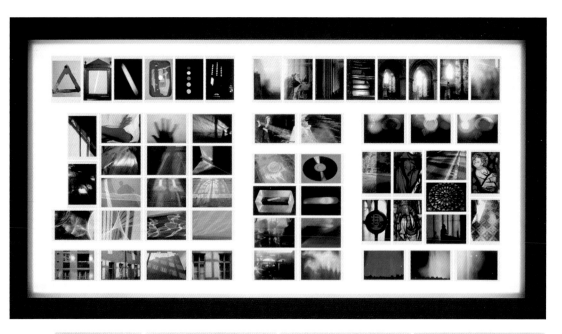

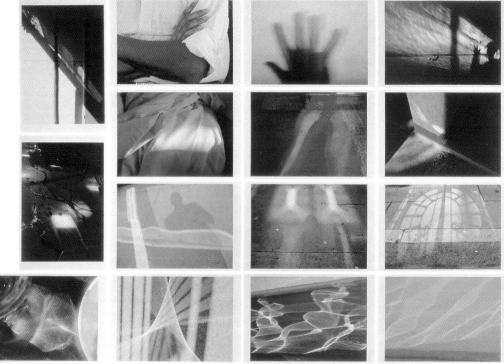

Licht | Bild | Realität – Atlas, Gustav Deutsch, Hanna Schimek; Lentos Museum, Linz

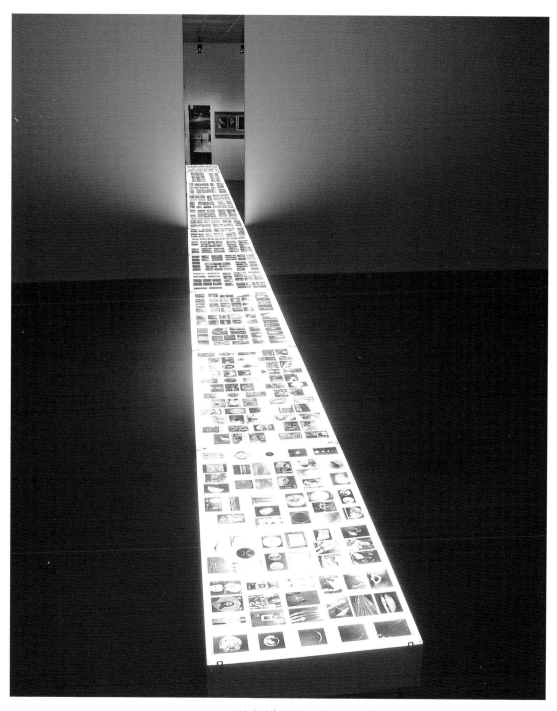

Licht | Bild | Realität – Atlas, Gustav Deutsch, Hanna Schimek; Lentos Museum, Linz

Light Columns – a reconstruction of the Apollo Temple of ancient Aegina by light, Gustav Deutsch, Hanna Schimek, Franz Berzl; Aegina, © Franz Berzl

5th Decree of 22nd January 1828, Lichtinstallation / *light installation*, Gustav Deutsch, Hanna Schimek; Markellos Tower, Aegina © Hans Labler

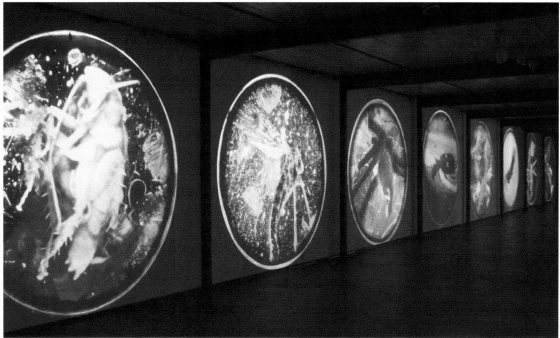

Licht | Bild | Illusion – Atlas, 26 Panoramas, Gustav Deutsch, Hanna Schimek; Kunsthalle Wien – project space

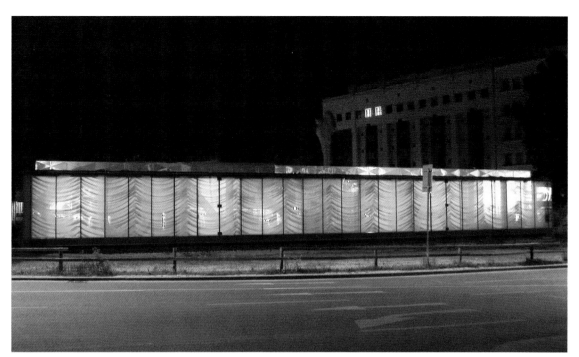

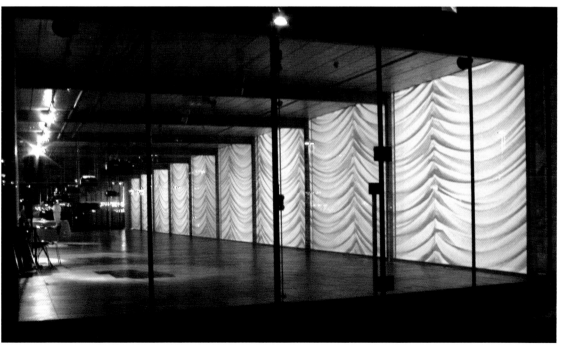

Licht | Bild | Illusion – Atlas, 26 Panoramas, Gustav Deutsch, Hanna Schimek; Kunsthalle Wien – project space

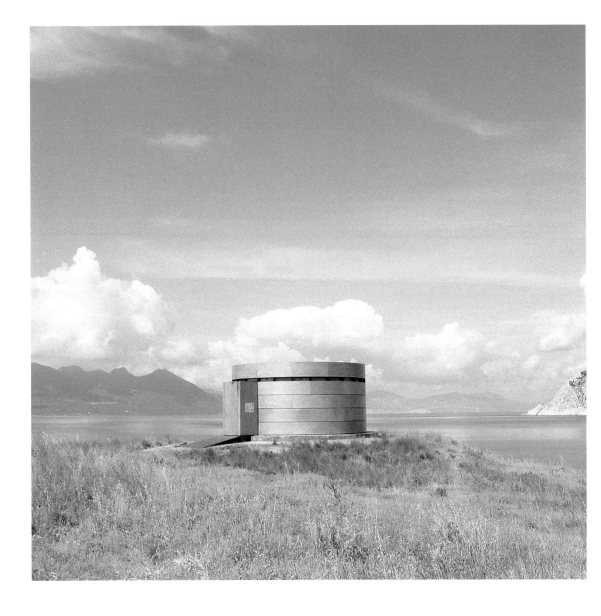

Camera Obscura Building, Gustav Deutsch, Franz Berzl; Perdika, Aegina

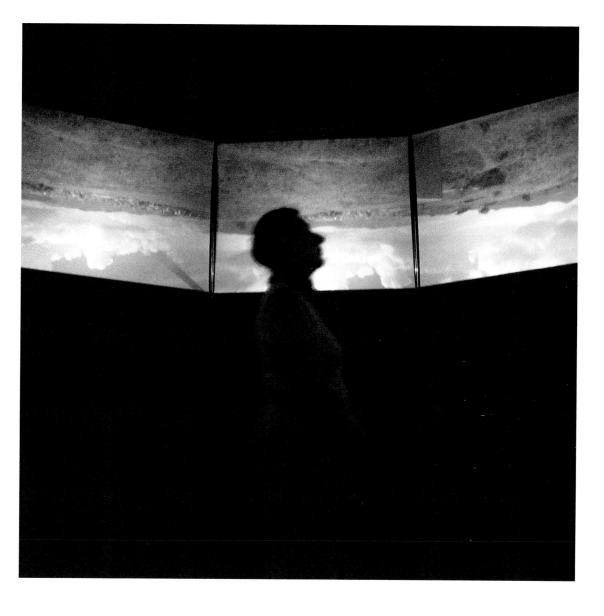

Camera Obscura Building, Gustav Deutsch, Franz Berzl; Perdika, Aegina

Alpenglühen / 10000 Watt, Lichtinstallation / *light installation*, Gustav Deutsch, Hanna Schimek; Silvretta, Bielerhöhe

Nico de Klerk

Entwurf eines Heims

„Orphan films" im Werk von Gustav Deutsch

Designing a Home

Orphan films in the work of Gustav Deutsch

Als Filmemacher ohne Kamera hat sich Gustav Deutsch nur in einem einzigen Fall mit Material beschäftigt, das buchstäblich *gefunden* war. Grundsätzlich arbeitet er mit Bildern, die er und seine Recherche-Partnerin Hanna Schimek sorgfältig aus den Sammlungen öffentlicher und privater Filmarchive ausgewählt haben. Tatsächlich, so konstatiert Deutsch, hätte er sein Œuvre niemals ohne die Hilfe und das Wissen jener Archive erschaffen können, die die von ihm wiederverwendeten Filme gesichert oder zumindest aufbewahrt haben. Das ist zweifellos einer der Gründe dafür, dass das meiste Material, das er aus Archiven selektiert, unter die Kategorie der „Orphan Films" fällt. – Man zapft das Gedächtnis des Archivars nicht deshalb an, weil man Kanonisiertes will, sondern weil man nach unbekannten, unbeachteten, unerwarteten Filmen sucht.

„Orphan film" – „verwaister" Film – ist ein Begriff, der sich in letzter Zeit in filmhistorischen und archivarischen Kreisen allgemein durchgesetzt hat. Grob gesprochen, bezeichnet er Filme (bzw. Produktions- und Präsentationskontexte), die vernachlässigt worden sind, entweder aus Mangel an Interesse oder weil sie keinen praktischen, kommerziellen oder ideellen Wert zu haben schienen. Amateurfilme, Lehrfilme und wissenschaftliche Filme fallen in diese

As a filmmaker without a camera, Gustav Deutsch has dealt in one case only with footage that was quite literally found. As a rule, he works with images that he and his research partner Hanna Schimek have carefully selected from the collections of film archives, both private and public. Indeed, as Deutsch has stated, he couldn't have made his œuvre without the help and knowledge of archives that have preserved, or at least stored, the films he re-uses. Undoubtedly that is one reason why most of the materials he culls from archives can be said to fall under the category of orphan films; one picks the archivist's brain for the unknown, unappreciated, unexpected films, not for the canon.

'Orphan film' is a term that has recently come into general use in film historical and archival circles. It roughly denotes films, or their technologies of production and exhibition, that have been neglected through lack of interest, promise or practical value. Home movies, educational or scientific films come readily to mind here, as well as other works shown outside the regular venues; but trailers, commercials, newsreels, if not all elements that belonged to the programme of shorts of the mainstreamcinema show, share a similar fate. Furthermore, the term has been strongly identified, notably in the U.S., with matters of copyright, more particularly

Kategorie, aber auch andere Arbeiten, die abseits oder am Rande des regulären Kinobetriebs existieren, teilen das Schicksal der Waisen: Trailer, Werbespots, Wochenschauen, wenn nicht überhaupt all jene kurzen Formate, die einst Teil einer gewöhnlichen Kinovorstellung waren. Darüber hinaus wird der Begriff (vor allem in den USA) im engen Zusammenhang mit Fragen des Copyrights gesehen, genauer gesagt: mit dem Status eines Films, dessen Urheberrechtsschutz abgelaufen ist oder dessen Rechtsinhaber (seine „Eltern") nicht gefunden werden können. In dieser Betrachtungsweise steckt implizit auch das Plädoyer für eine lebendige „Public Domain", die die Erhaltung und Präsentation solchen Materials erlaubt.[1]

Respektlosigkeit

Der moderne Found-Footage-Film hat sich (manchmal unwissentlich) als starkes Argument für die Vitalität dieser Domäne erwiesen, indem er das Potential von Filmen demonstrierte. Eines der frühesten Beispiele, Bruce Conners *A Movie* (1958), gab bereits die Richtung vor, gerade weil der Filmemacher – nachdem ihm klar geworden war, dass die Ausschnitte aus

with a film's unprotected status when its copyright has expired and/or when its copyright owners (its 'parents') cannot be traced. Implicit in this concern is a plea for 'a vital public domain' that allows the preservation and presentation of such materials.[1]

Irreverence

The modern found footage film has shown itself, sometimes unwittingly, to be a strong advocate for the vitality and liveliness of that domain by showcasing the potential of films that have fallen from the mainstream. In fact, one of the earliest examples, *A Movie* (1958) set the pace, precisely because filmmaker Bruce Conner had no choice but to resort to materials now called orphaned after he had learned that the clips from the Hollywood features he would have preferred to re-use were far beyond his economic means. But the options open to Conner, to wit condensed reduction prints of B-movies and newsreels as well as other films for private consumption, could never be mere functional equivalents, lacking as they did the very cultural references that fascinated him. Almost inevitably, then, *A Movie* and many found footage

1) Dan Streible, „The Role of Orphan Films in the 21st Century Archive", in: *Cinema Journal*, 46:3, Spring 2007, S. 124–128.

1) Dan Streible, "The Role of Orphan Films in the 21st Century Archive", in: *Cinema Journal*, 46:3, Spring 2007, pp. 124–128.

A Movie (Bruce Conner, 1958)
Film ist. (1998, 2002, 2009)

Hollywoodspielfilmen, die er ursprünglich verwenden wollte, seine finanziellen Möglichkeiten bei weitem überschritten hätten – keine andere Wahl hatte, als auf Material zurückzugreifen, das heute als „verwaist" bezeichnet wird. Die Möglichkeiten, die Conner offen standen – Reduktionskopien von B-Movies und Wochenschauen sowie andere Filme für den privaten Gebrauch – konnten nicht einfach als funktionale Äquivalente fungieren, da ihnen gerade jene kulturellen Referenzen fehlten, die ihn faszinierten. Fast zwangsläufig machen sich also *A Movie* und viele folgende Found-Footage-Filme über das Mainstream-Kino und die Mainstream-Kultur im Allgemeinen lustig. Das ist gar nicht so sehr eine Frage der bewusst eingenommenen kritischen Haltung – *A Movie* ist sicher nicht *nur* kritisch gegenüber den „dunklen Jahrzehnten"[2], in denen er entstand. Es ist eher das Resultat eines spezifischen Umgangs mit „Orphan"-Filmen, der diese gezielt als Objekte von großer kultureller und sozialer Bedeutung behandelt; sie rechtfertigen unsere Aufmerksamkeit nicht

films in its wake cock a snook at mainstream film and culture. This is not so much a matter of taking up a critical stance—certainly *A Movie* is not *merely* critical of the 'dark ages'[2] in which it originated. Rather, it is the result of the deliberate treatment of orphaned materials as objects of great cultural or social significance, equally worthy of our attention as more obvious icons such as mainstream Hollywood films. For instance, the films of Péter Forgács or Peter Delpeut, on mid-twentieth century home movies and silent films from the 1910s respectively, testify to both the richness and expressiveness of these materials and to the work that has been done to reveal that eloquence. I venture that this 'archaeological' inclination is what distinguishes modern found footage films from older compilation films. In the latter, images were compiled and juxtaposed in order to establish new connections and new meanings; here, editing played a most crucial role. In modern found footage films the focus is, rather, on the materials' intrinsic qualities; hence the importance of more 'invasive' measures such as

2) Der Begriff ist entnommen aus: Marty Jezer, *The Dark Ages: Life in the United States 1945–1960*, Boston 1982. Er bezeichnet die Nachkriegsära in Amerika bis circa 1960, in der politischer, sozialer und kultureller Konformismus durch eine antikommunistische Politik und die Macht des korporativen Kapitalismus vehement forciert wurde.

2) The term is taken from: Marty Jezer, *The Dark Ages: Life in the United States 1945–1960*, Boston 1982. It denotes the postwar era in America until circa 1960, when conformism in political, social, and cultural matters was most emphatically enforced by a politics of anticommunism and the power of corporate capitalism.

weniger als andere, offensichtlichere Ikonen wie jene des Hollywoodkinos. Die Filme von Péter Forgács oder Peter Delpeut über Amateurfilme aus der Mitte des 20. Jahrhunderts bzw. Stummfilme aus den 1910er Jahren bezeugen etwa die Vielfältigkeit und Ausdruckskraft dieser Materialien sowie der Arbeit, die geleistet wurde, um diese Eloquenz zu enthüllen.

Ich wage zu behaupten, dass gerade diese „archäologische" Tendenz den modernen Found-Footage-Film vom älteren Modell des Kompilationsfilms unterscheidet. Im letzteren Fall werden Bilder kompiliert und nebeneinander gestellt, um neue Verbindungen und Bedeutungen zu etablieren; die entscheidende Rolle spielt hier der Schnitt. Im modernen Found-Footage-Film hingegen liegt der Fokus eher auf den intrinsischen Qualitäten der verwendeten Materialien; damit gewinnen „invasivere" Methoden an Bedeutung – Zeitlupe, Zooms oder Kolorierungen. Beide Filmtypen suchen gewissermaßen nach Dingen und Eigenschaften, die die Bilder nicht oder nicht unmittelbar preisgeben. Kompilationsfilme tendieren jedoch dazu, das *Erschaffen* in den Mittelpunkt zu stellen; man könnte sagen, sie sind alchemistisch. Found-Footage-Filme dagegen tendieren zum Modus der *Entdeckung*: Sie sind analytisch. Das Werk von Gustav Deutsch scheint Eigenschaften

slow motion, zooming or coloring. Both can be said to be in search of things the images cannot or do not immediately reveal. But compilation films tend to focus on creation—they are, one might say, alchemical, whereas found footage films tend to focus on discovery—they are analytical. Gustav Deutsch's work nevertheless appears to share characteristics with both types. They do not just take the spectator on a voyage of discovery, they also treat him to something new, albeit with a twist. The sheer amount of orphaned material that has found its way into his films has, in my view, contributed to their double edged nature.

On the one hand, then, his films increasingly and manifestly pry into the hidden treasures of the materials he has gathered. By juxtaposition; by slowing down, interrupting or reversing their movement; by eliding frames; by zooming in; by looping; or by adding music and other sounds Deutsch allows, nay invites the spectator to inspect the material, almost the way he himself has. Therefore we, like him, see things we may never have been aware of before. To accomplish this, orphan films, because of their very unfamiliarity, are the perfect material. With their often curious genres, scenes, styles and techniques, preoccupations and affections, the spectator can be expected to sit up and be

beider Typen zu vereinen. Seine Filme nehmen den Betrachter nicht nur auf eine Entdeckungsreise mit, sie führen ihm auch etwas Neues vor – allerdings mit überraschenden Wendungen. Die schiere Menge „verwaisten" Materials, das Eingang in seine Filme gefunden hat, trägt meiner Meinung nach zu ihrer doppelten Natur bei.

Deutschs Werke untersuchen also einerseits (ganz manifest und in wachsendem Ausmaß) die verborgenen Schätze, die in den von ihm gesammelten Filmen schlummern. Durch Gegenüberstellung, durch Verlangsamung, Unterbrechung oder Umkehr ihrer Bewegung, durch das Auslassen von Kadern, durch Hineinzoomen, Looping oder das Hinzufügen von Musik und Geräuschen lädt Deutsch den Betrachter dazu ein, das Material genau zu inspizieren – fast so, wie er es zuvor selbst getan hat. Aus diesem Grund sehen wir, wie er selbst, Dinge, die wir bis dahin vielleicht nie bewusst wahrgenommen haben. Dafür sind „orphan films" gerade wegen ihrer Unvertrautheit das perfekte Material. Die oft kuriosen Genres, Szenen, Stile und Techniken, Themen und Gefühlslagen, mit denen sie sich beschäftigen, fesseln die Aufmerksamkeit des Betrachters. In seinen Filmen hat es Deutsch allerdings geschafft, diese Materialien ununterscheidbar zu machen von jenen, die bekannter sind oder als historisch wertvoller erachtet

more readily intrigued. Yet, in his films Deutsch has managed to make these materials indistinguishable from those that are better known or considered more important historically. As he has exploited, from *Film ist.* onwards, the enormous variety of orphan films—it's not just home movies or newsreels anymore—his films have come to reflect the gamut of archival materials. Consequently, home movies rub shoulders with the first Lumière films, a classic of the silent avant-garde blends in with early farce. All these materials find themselves in a democratic mix, having undergone the same 'analytical' treatment. In brief, Deutsch strips the films he re-uses of film history as we know it.

There is a sense of irreverence here, a trait, incidentally, that Deutsch shares with Bruce Conner: both can make do with whatever is available to them. Deutsch, leaning toward a more comically cavalier approach, professes, for example, that each of the two series of *Film ist.*, *1–6* and *7–12*, deals with an important setting (the lab, the theatre), and function (instruction, entertainment) of cinema. But more than once he flouts historical fact by showing that any kind of film can fit the bill of the episodes into which he has subdivided the series. *Film ist. 1–6*, for example, contains many excerpts of films that are obviously scientific or educational, yet

117

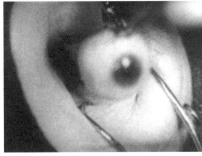

werden. Beginnend mit *Film ist.*, hat er zunächst die große Vielfalt der „orphan films" genützt; mittlerweile reflektieren seine Filme aber die ganze Bandbreite von Archivmaterialien. Folglich stehen Amateurfilme dicht neben den ersten Lumière-Filmen, ein Klassiker der Avantgarde Seite an Seite mit einer frühen Burleske. Alle diese Elemente kommen in einem demokratischen Mix zusammen, und alle wurden derselben „analytischen" Behandlung unterzogen. Deutsch löst also die Filme, die er wiederverwendet, von einer Filmgeschichte, wie sie uns vertraut ist.

Diese Respektlosigkeit ist ein Wesenszug von Gustav Deutschs Werk, den er übrigens mit Bruce Conner teilt: Beide können mit dem auskommen, was ihnen zugänglich ist. Deutsch, einem eher komischen, unverkrampften Vorgehen zugetan, behauptet zum Beispiel, dass sich jede seiner zwei *Film ist.*-Serien (*1–6* und *7–12*), mit einem wichtigen Schauplatz des Kinos (Labor bzw. Theater) und mit einer seiner Funktionen (Instruktion bzw. Unterhaltung) beschäftigt. Aber mehr als einmal setzt er sich über historische Fakten hinweg, indem er jedwede Art von Film zeigt, die gerade in das jeweilige Kapitel passen könnte. *Film ist. 1–6* enthält zum Beispiel zahlreiche Ausschnitte aus Filmen, die offensichtlich wissenschaftliche Filme oder Lehr-

there are others that are less so, and some clearly not at all. Also, in both series we see him juxtaposing material in identical ways (e.g., in 5.4 he mixes up the views of various cameras the way he does written messages among various readers in 10.3). In other words, to make his point, whether it's about film being, say, instrumental or comical, he doesn't necessarily need science films or comedies. Gustav Deutsch can pick the right clip from the wrong film.

Performance

On the other hand, Deutsch's more recent work goes beyond an analysis of found footage; beyond Tom Gunning's characterization of it as a 'primer' of cinema's possibilities.[3] The reason is that he takes more and more care of the way the materials are being arranged. The two series of *Film ist.* point up the difference. In the first series editing was mostly a matter of—not seldom witty—juxtaposition (e.g. an image of a finger pushing a button followed by a lightning-streaked sky, complete with thunderclap). In the second, the editing is more varied and complex; elsewhere I have called some of its patterns 'cognitive editing,' as Deutsch's sequencing of

3) Tom Gunning, "FILM IST. A primer for a visual world" (www.sixpackfilm.com/archive/texte/01_filmvideo/filmis t_gunningE.html)

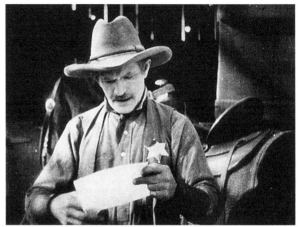

Film ist. Schrift und Sprache (2002)

filme sind; aber es gibt auch andere, auf die das weniger oder überhaupt nicht zutrifft. Wir sehen auch, dass er in beiden Serien Materialien in identischer Manier kombiniert (zum Beispiel bringt er in 5.4 verschiedene Kameraperspektiven auf die gleiche Art und Weise durcheinander wie die Schriftstücke, die in 10.3 von verschiedenen Personen gelesen werden). Anders gesagt: Um sein jeweiliges Argument durchzuziehen – z.B. dass Film „ein Instrument" oder „komisch" sei –, benötigt er nicht unbedingt wissenschaftliche Filme oder Komödien. Gustav Deutsch kann im falschen Film den richtigen Ausschnitt finden.

Performance

Auf der anderen Seite gehen Deutschs neuere Arbeiten über die Analyse von Found Footage und die Herstellung einer „Fibel" der Möglichkeiten des Kinos (Tom Gunning)[3] hinaus. Der Grund dafür ist, dass er sich mehr und mehr damit beschäftigt, wie die Materialien arrangiert werden. Die beiden Serien von *Film ist.* zeigen diese Differenz. Im ersten Film war der Schnitt vor allem eine Frage der – nicht selten witzigen – Gegenüberstellung. Im zweiten ist der Schnitt variantenreicher und komplexer. An

materials in a number of instances is suggestive of tracing thought processes.[4] That is to say, one image motivates a subsequent one that represents a memory, fantasy, wish, association or other mental image, rather than create some sort of continuity or contrast.

This way of editing is not meant to create new meanings, but to recreate experiences. Of

3) Tom Gunning, „Film ist. Eine Fibel für eine sichtbare Welt", in: *Stadtkino Zeitung* Nr. 379, April 2002

4) Nico de Klerk, "Enter the dragon: Gustav Deutsch's *Welt Spiegel Kino* #2" (unpublished manuscript, 2005)

119

einer anderen Stelle habe ich einige dieser Muster „kognitives Editing" genannt, da Deutschs Sequenzierung der Materialien oftmals dem Nachzeichnen gedanklicher Prozesse ähnelt.[4] D.h. ein Bild motiviert das folgende, das eher für eine Erinnerung, eine Phantasie, einen Wunsch, eine Assoziation oder ein anderes mentales Bild einsteht, als irgendeine Kontinuität oder einen Kontrast zu begründen.

Diese Art des Schnitts zielt nicht auf die Erschaffung neuer Bedeutungen ab, sondern auf die Wiederherstellung von Erfahrungen. Auch das ist natürlich eng mit Deutschs Verwendung von „Orphan"-Materialien verbunden. Wir haben heute keine Vorstellung davon und kaum eine Erinnerung mehr daran, welche Reaktionen diese Filme hervorgerufen haben; nicht nur hinsichtlich des Weltwissens, auf das sie sich bezogen haben, sondern auch, was die ihnen eingeschriebene Kinoerfahrung betrifft. Die Ironie von Gustav Deutschs Werk liegt also darin, dass er – nachdem er seine Materialien ihrer „filmhistorischen Relevanz" entkleidet hat – einen Eindruck ihrer Historizität evoziert. Das heißt: Vorschläge darüber zu machen, welche Wirkungen sie beim zeitgenössischen Publikum ausgelöst haben könnten, unbeeindruckt von den Monu-

course, this, too, is intimately related to his use of orphan materials. After all, we, today, have no idea, and hardly a memory, of the type of responses elicited by these materials—some of which date back over a 100 years, not only in terms of the world knowledge they appealed to, but also in terms of cinematic experience. The irony, then, of his work is that, after having removed his materials' film historical importance, he proposes to evoke a sense of history, viz. what their impact or significance might have been for contemporary audiences, unbothered by the landmarks erected by historians of early cinema. To this end, his editing brings together, as in the old programme format, disparate genres and scenes. Hence he can make us see, for instance, that exotic travelogues, colonial propaganda *and* fashion films have an intriguing common feature: the anthropometric gaze (*Film ist.* 9.3); or how the story of Fritz Lang's *Siegfrieds Tod*, by elaborating on the image of the dragon, could have been appropriated by cinema audiences in late-colonial Surabaya (*Welt Spiegel Kino,* Episode 2). His sequencing of the materials, then, increasingly and more systematically reflects the point of view of spectators—first of all himself. Because Deutsch is no film historian, nor does he claim to be one. I'm sure his films would never have

4) „Enter the dragon: Gustav Deutsch's *Welt Spiegel Kino* #2", unpubliziertes Manuskript, 2005

Film ist. Eroberung (2002)
Welt Spiegel Kino / Episode 2 (2005)

menten und Wegmarken, die die Historiker des frühen Kinos errichtet haben. In diesem Sinne bringt seine Schnittarbeit – wie in den alten Programmformaten des Kinos – disparate Genres und Szenen einander nahe. Er ermöglicht uns etwa, zu sehen, dass der exotische Reisebericht, die koloniale Propaganda und der Modefilm ein faszinierendes gemeinsames Merkmal besitzen: den anthropometrischen Blick (*Film ist.* 9.3); oder wie sich das Kinopublikum im spät-kolonialistischen Surabaya die Geschichte von Fritz Langs *Siegfrieds Tod*, aus der Deutsch das Bild des Kampfs mit dem Drachen entnimmt, angeeignet haben könnte (*Welt Spiegel Kino,* Episode 2). Seine Sequenzierung der Materialien reflektiert demnach immer mehr und immer systematischer den Standpunkt der Betrachter – und zu allererst seinen eigenen. Denn Deutsch ist kein Filmgeschichtsschreiber und behauptet auch nicht, einer zu sein. Ich bin sicher, dass seine Filme nie so ausgesehen hätten wie sie es tun, wenn er ausgebildeter Filmhistoriker gewesen wäre; er wäre sich mit all seinem Wissen selbst im Weg gestanden.

Letztlich ist das, was seine Filme mit den „verwaisten" Materialien anstellen, nicht nur eine Wiederverwendung. Der ehemalige Architekt Gustav Deutsch baut für sie ein Haus, ein wahrhaftiges, lebendiges Heim, das den Bildern

looked the way they do had he been a trained film historian; he would have been fooled too much by what he knew.

Finally, his films do not just re-use orphaned materials. Gustav Deutsch, former architect, is building a home for them, a veritable, living home, that avoids assigning the images to a fixed place in film history. His films are in no way mausoleums. That makes them examples *par excellence* of what I call 'recombinant

keinen fixen Platz in der Filmgeschichte zuweist. Seine Filme sind alles andere als Mausoleen. Das macht sie zu Paradebeispielen einer Vorgehensweise, die ich „rekombinatorisches Programmieren" nenne. Zugegeben – der Begriff ist tautologisch, da Programmieren ganz wesentlich eine Assemblage heterogener Attraktionen gemäß funktioneller oder narrativer Prinzipien ist: Die konstitutiven Elemente eines Programms nehmen einen Platz ein, belegen eine bestimmte Position im Ablauf, während homogenisierende Aspekte wie das Herkunftsland, das Produktionsstudio, usw. in den Hintergrund treten. Performative Qualitäten triumphieren über ökonomische oder nationale Kategorien. Und das ist genau, worum es in Deutschs Entwurf geht. – Sein Werk ist nicht nur eine Rekombination diverser Materialien, mit dem Zweck, uns sehen zu lehren. Es geht darüber hinaus. Die Bausteine der episodischen Struktur, mit der er – seit *Adria* und dem Nicht-Found-Footage-Projekt *Taschenkino* – bevorzugt arbeitet, bewahren in ihrer Aufführung den demokratischen Geist seines Werks, indem sie selber rekombiniert werden können. Jedes Screening kann eine neue Abfolge unterschiedlicher Episoden sein, aus unterschiedlichen Filmen, in unterschiedlicher Reihenfolge.

Gustav Deutsch lehrt uns, selber zu sehen.

programming.' Admittedly, the term is tautological, as programming is essentially the assembling of heterogeneous attractions according to functional or narrative principles; a programme's constitutive elements fill a slot, occupy a sequential position, while disregarding homogenizing aspects such as country of origin, studio, etc. Performative qualities, in other words, prevail over productional trademarks. And that is precisely what Deutsch's design is all about. Not only does his work recombine the diverse materials of often unknown origins in order to make us see, but it doesn't stop there. The building blocks of the episodic structure in which he prefers to work ever since *Adria – Urlaubsfilme 1954–1968* and the non-found footage project *Taschenkino* retain the democratic relish of his work in its performance, by allowing it to be recombined itself. Every screening can be a different line-up of different episodes, from different films, in a different order.

Gustav Deutsch makes us see for ourselves.

Alexander Horwath

Kino(s) der Geschichte

Dunkle Kammern, sprechende Objekte, mehr als Filme. Gustav Deutsch als Museumsmacher

Cinéma(s) de l'histoire

Dark Rooms, Speaking Objects, More than Film: Gustav Deutsch as a Museum Maker

Im Rahmen des Europäischen Kulturprojekts *Light / Image / Reality* wurde 2003 auf der griechischen Insel Aegina ein Camera-Obscura-Gebäude errichtet. Verantwortlich dafür waren Gustav Deutsch (Idee / Konzept), Franz Berzl (Architektur) und Gavrilos Michalis (Realisation). Es ist ein zylindrisches Gebäude mit zwölf kleinen, gleichmäßig im Kreis verteilten Öffnungen. Durch die Öffnungen fällt das von der Umgebung reflektierte Licht ins Innere des Gebäudes, und zwar auf zwölf von der Decke hängende, ebenfalls im Kreis angeordnete Leinwände. Diese natürliche Projektion ergibt ein zwölfteiliges panoramatisches Abbild der Umgebung, auf dem Kopf stehend und seitenverkehrt. Das Gebäude wurde auf dem Fundament einer deutschen Flakstellung aus dem Zweiten Weltkrieg errichtet und besteht aus einer Stahlkonstruktion mit Holzverkleidung. Es ist das erste Camera-Obscura-Gebäude in Griechenland, und das erste weltweit, das ein panoramatisches Abbild erzeugt. Matthias Boeckl schreibt darüber: „Nicht nur die kopfstehende Welt, auch das Zugangsritual durch eine Schleuse zur Außenwelt vermitteln das Gefühl einer ,anderen' Welt, die aber doch noch die unsere ist."

Die ,andere' Welt, die aber doch noch die unsere ist, findet sich auch im Kino ein. Was hier gese-

In the course of the European Cultural Project *Light / Image / Reality*, a camera obscura was built on the Greek Island of Aegina in 2003. Those responsible were Gustav Deutsch (idea / concept), Franz Berzl (architecture) and Gavrilos Michalis (realization). It is a cylindrical building with twelve small openings evenly allocated on its perimeter. When they are opened, the light from the surroundings is reflected in the building onto twelve screens, which are suspended from the ceiling in a circle. These natural projections result in a twelve-part panoramic view of the surroundings, mirror-inverted and upside down. The building was erected on the foundation of a German anti-aircraft gun emplacement from World War II and is a steel construction with wooden paneling. It is the first camera obscura building in Greece and the first in the world to project a panoramic view. Matthias Boeckl writes: "The upside-down world, as well as the ritual entrance through a chute or gateway from the outside world, gives you the feeling of 'another' world, which is actually still our own."

The 'other' world, which is actually still our own, also finds its way into the cinema. What is seen there has, however, passed through more than one dark room. We may consider the camera obscura a lost utopia of the medium of film;

123

Camera Obscura, Aegina (2003)

hen wird, hat allerdings mehr als eine dunkle Kammer durchlaufen.

Man kann die Camera Obscura als eine ver-schüttete Utopie des Mediums Film betrachten: ein Raum, der zugleich Kamera, Labor und Kino ist; ein Raum, in dem Aufnahme, Entwick-lung, Kopierung und Projektion in Echtzeit – oder besser: in Lichtgeschwindigkeit – zusam-menfallen. Man kann aber auch, in umgekehr-ter Richtung und im Sinne Bazins, das Medium Film als das historisch letzte und am weitesten ausgreifende jener Aufzeichnungs- bzw. Reprä-sentationssysteme verstehen, die so wie die Camera Obscura mit der Wirklichkeit noch durch physikalisch gesicherte Kontakte – durch echte Schleusen zur Außenwelt – verbunden sind. Systeme der Darstellung also, in denen die Wirklichkeit ihren Auftritt nicht nur in Anfüh-rungszeichen hat.

Die Arbeit des Künstlers, Filmemachers und Camera-Obscura-Entwerfers Gustav Deutsch gilt solchen Systemen und ihren Schleusen, den Zonen des Kontakts zwischen zwei ‚Welten‘ oder Wirklichkeiten, die keinesfalls gegeneinan-der ausgespielt oder scharf getrennt werden

a room that is simultaneously a camera, a labo-ratory and a cinema; a room where filming, development, printing and projection take place simultaneously—at the speed of light. On the other hand (and inspired by Bazin), we may also consider the film medium the historically last and most advanced of those recording or repre-sentational systems, which are still linked with reality through physical contact, such as the camera obscura—real gateways to the outside world. That is, systems of representation, in which reality doesn't just appear in quotation marks.

The work of the artist, filmmaker and camera obscura designer Gustav Deutsch deals with such systems and gateways; the zones of contact between two 'worlds' or realities, which should by no means be played against each other or separated entirely from one another. 'Our' world takes a deep interest in the 'other' and vice versa; each of them is a part of the other. Deutsch's preferred term for the 'other' world (which is nevertheless still ours) is *film*. In the titles of three of his works, he uses the formulation *Film is.* and puts a dot in place of the numerous his-torical, contemporary or future definitions (or 'reductions') of the medium of film. The dot, or the period, comprises several meanings or move-ments in one small space. Firstly, a full stop, or

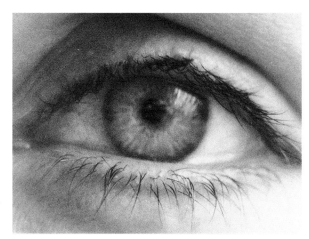

Film ist mehr als Film (1996)

dürfen: ‚Unsere' und die ‚andere' Welt nehmen großen Anteil aneinander, sind jeweils Teil voneinander. Deutschs bevorzugter Begriff für die ‚andere' Welt (die aber doch noch die unsere ist) ist *Film*. Im Titel dreier seiner Werke gebraucht er die Formulierung *Film ist.* und setzt damit einen Punkt an die Stelle der zahllosen Definitionen bzw. Engführungen des Mediums Film, die es gibt, gegeben hat und noch geben wird. Dieses Satzzeichen, der Punkt, versammelt mehrere Bewegungen auf engstem Raum. Erstens: eine Schließung oder einen Beschluss, der besagt, dass Film existiert – unabhängig von den einzelnen Definitionen und Gebräuchen, die die Menschheit davon macht. „Es gibt die ‚andere' Welt." Zweitens: eine Wertung, die aus der ehernen Härte und Knappheit der Formulierung spricht, das Pathos der Evidenz. „Es ist eine großartige Welt." Drittens: eine explosionsartige Öffnung in alle erdenklichen Richtungen, das paradoxe Gegenstück zur ersten Bewegung. Der Punkt ist kein Ende. Er ist selbst eine Schleuse, ein überwindbarer Widerstand, durch den all die Erfahrungen, Erwartungen und Potentiale strömen, die vom Wort *Film* und vom Faktum der tatsächlichen, außersprachlichen Existenz des Films ausgelöst werden. „Film ist unendlich, und unendlich vieles. Film spricht viele Sprachen. Film ist mehr als Film."

the decision that film exists—independent of the individual definitions and uses that humanity makes of it. *"There is 'another' world."* Secondly, a valuation, which lies in the reverent brevity of the formulation, the pathos of evidence: *"It is a wonderful world."* Thirdly, an explosive opening up in all directions, the paradoxical counterpart to the first movement. The dot is infinite. It provides its own gateway, a resistance to be overcome, to be flooded by all the experiences, expectations and potential that the word 'film' (and the fact of the actual, extra-linguistic existence of film) has released. *"Film is infinite, and infinitely meaningful. Film speaks many languages. Film is more than film."*

It is that 'more than' which suggests some of Gustav Deutsch's major interests, as well as the characteristic convergence of scholarly and artistic processes in his work; scholarly work that is conscious of its aesthetical and poetic elements, and art that strives to be seen as explanatory, enlightening and clarifying.

The 'more than' is, for example, that of the psychoanalyst or poet, who recombines the frag-

125

Film ist. Licht und Schatten (1998)

Darin, im ‚mehr-als‘, klingen wesentliche Inte-
ressen von Gustav Deutsch an, und auch das
ihm und seiner Arbeit eigene Zusammenflie-
ßen von wissenschaftlichen und künstlerischen
Verfahren; einer Wissenschaft, die sich ihrer äs-
thetischen, poetischen Anteile bewusst ist, und
einer Kunstpraxis, die danach trachtet, erklä-
rend, aufklärend, klärend zu sein.

Das ‚mehr-als‘ ist z.B. jenes des Psychoanaly-
tikers oder Dichters, der das ihm vorliegende,
meist fragmentarische Begriffsmaterial in eine
neue Reihenfolge bringt bzw. einen anderen
Rhythmus und Klang darin entdeckt. Die auf
vorliegendem Filmmaterial basierenden Werke
von Deutsch sind mit diesen Aktivitäten ver-
wandt. Bilder, die scheinbar (zumindest was ihre
Herkunft betrifft) nichts oder wenig miteinander
zu tun haben, ‚nicht zusammengehören‘, wer-
den verglichen, verknotet, als zusammengehö-
rig erachtet. Es sind oft äußerliche Entsprechun-
gen, formale Korrespondenzen, versteckte An-
schlüsse, die zu einer solchen Montage führen.
Erst dann wird, wie bei der Traumarbeit oder
einem Rebus, ein dritter (oder sechster) Sinn er-
kennbar. Zum Beispiel in den Nachtversen von

mentary material available to him in a new man-
ner, or discovers a new rhythm and sound in it.
Deutsch's found footage films are all related to
such activities. Images, which seemingly have
nothing or little to do with each other (in terms
of origin), or 'don't belong together,' are com-
pared, interlaced and considered related. Therè
are often external correlations, formal corre-
spondences, or hidden connections, which lead
to such sequencing. Only then is a third (or
sixth) sense recognizable, like in a dream or a
rebus. For example in the night verses of *Film ist.
2.2*, which are accompanied by a barking dog:
shadow figures made by hands; the moon be-
hind the passing clouds; a spotlight illuminating
a storm-stricken town; a full-frame shot of the
moon; moths in a light; space—the final fron-
tier; a lunar eclipse; a human eye—the pupil
responding to light and dark; and finally, a circu-
lar accumulation of bacteria around a pool
of light. All of life, inside and outside of the
cinema, is based on 'phototactic behavior.'

Gustav Deutsch's 'more than' is also the pri-
mary motivation behind a certain tendency in
cultural studies, investigating historical artifacts
in order to decipher the forces, potentials, and
power relations at work in a given society—as
well as making them useful for the present. A
further example from *Film ist.* illustrates how

Film ist. Licht und Schatten (1998)

Film ist. 2.2, die von Hundegebell begleitet sind: das Schattenspiel der Hände; der Mond hinter vorbeiziehenden Wolken; ein Scheinwerferkegel streicht über das sturmumtoste Dorf; bildfüllend der Mond; Motten im Licht; das Weltall – unendliche Weiten; eine Mondfinsternis; ein menschliches Auge – die Pupille reagiert auf dunkel und hell; und schließlich eine lichtkreisförmige Akkumulation von Bakterien – alles Leben, im Kino oder außerhalb, beruht auf „phototaktischem Verhalten".

Gustav Deutschs ,mehr-als' ist aber auch die Antriebskraft einer kulturwissenschaftlichen Praxis, deren Umgang mit historischen Artefakten prononciert auf Erkenntnisse über die Gesellschaft und die in ihr wirkenden Kräfte, Machtverhältnisse und Möglichkeiten abzielt. Ein weiteres Beispiel aus *Film ist.* zeigt, wie sich am kleinen, scheinbar beliebigen Filmfundobjekt größere Strukturen ablesen lassen. Dieses kurze Dreckstück von Film, das im vierten Kapitel von *Film ist.* zum Einsatz kommt, hatte Deutsch auf einem brasilianischen Flohmarkt erworben: ein von Putzmittel zerfressener Teststreifen, der je zwei Kader aus sämtlichen Szenen einer melodramatischen Kino- oder Telenovela enthält. Mit diesem Streifen wurden später, im Zuge einer praktischen Umwertung durch eine Putzfrau, Böden geschrubbt. Die

larger structures can be recognized in small, seemingly arbitrary finds of film footage. The dirty, trashy piece of film, which appears in chapter 4 of *Film ist.*, was acquired by Deutsch at a flea market in Brazil. A test strip damaged by cleaning agents, it contains two frames each of all scenes of a movie or TV melodrama. At some later point in time, a cleaning lady had used this old film strip to clean floors with, as a practical means of recycling materials. Here a psychoanalytical perspective goes hand in hand with the sociological reading. The test strip still carries within itself the narrative neurosis and ideological preoccupations of the dominant film industry, but it also exemplifies an opposing force. In artistic terms, it is an experimental film, which—as each scene is reduced to two frames—ridicules the ideological essence of its origin and gives birth to a different, dynamic beauty. And it is an 'experimental film' in practical terms, which—due to the specific material properties of the emulsion coating—brings to light its own surprising cleansing effect in the hands of a cleaning person. This naturally also ruined it. The fact that the cleaning lady, who

psychoanalytische Perspektive geht hier Hand in Hand mit einer soziologischen Lesart. Dem Teststreifen sind noch ganz deutlich die Erzählneurose und Ideologieproduktion des dominanten Kinos eingeschrieben, gleichzeitig aber trägt er die Kunde gegenläufiger Energien in die Welt hinaus: Er ist im künstlerischen Sinn des Wortes ein Experimentalfilm, der – dank der Verkürzung auf zwei Kader pro Szene – das Ideologische seiner Herkunft lächerlich macht und eine andere, dynamische Schönheit gebiert; und er ist im praktischen Wortsinn ein ‚Experimentalfilm‘, der – dank spezifischer materieller Eigenschaften der Emulsionsschicht – in den Händen einer Reinigungskraft seine eigene, überraschende Reinigungskraft beweist. An dieser geht er freilich auch zuschanden. Dass ihn eine Person benutzt hat, die selbst zum (potentiellen) Publikum der ursprünglichen Seifenoper zählte, macht die Sache noch schillernder.

Das aufrührerische Lied von „Ton Steine Scherben" aus dem Jahr 1969 lautete so: „Macht kaputt, was euch kaputt macht". Wenn man also der Meinung ist (wie viele Menschen um 1969), dass Fernsehserien und Melodramen ihr Publikum zu „passiven Opfern" der herrschenden Ideologie und also kaputt machen, dann vertritt die brasilianische Putzfrau einen Augenblick lang die Idee des emanzipatorischen Gegenschlags.

used it, was also—potentially—part of the mass audience that watched the original soap opera, makes the whole story even more scintillating.

"Macht kaputt, was Euch kaputt macht" ("Destroy whatever's destroying you.") was the title of a rebellious 1969 song by the German band Ton Steine Scherben. If one assumes (like many people did in 1969) that film and TV melodramas are 'destroying' their audiences by turning them into 'passive victims' of the dominant ideology, then the Brazilian cleaning lady represents the concept of an emancipatory counterstrike. Even if one believes (as do many contemporary scholars of film and cultural studies) that the audiences of such soap operas have access to various strategies of subversion and revaluation, and should not only be seen as victims, the film as a cleaning article represents a nice allegory of such a revaluation strategy. This proves more difficult, however, when we speculate about the results of the cleaning process in question. Is the floor perfectly clean, does the home sparkle when the owner comes back from her daily shopping spree? Her gem of a cleaning lady has bettered her own record. At the very least, she deserves an extra tip, or at friendly pat on the shoulder. Did the filmstrip serve to stabilize the social system for a second time around? Did the cleaning lady outdo

Auch wenn man der Meinung ist (wie viele Film- und Kulturwissenschaftler heutzutage), dass das Publikum solcher Filme und Serien über diverse Subversions- und Umwertungsstrategien verfügt und sich also keineswegs nur in der Opferrolle befindet, lässt sich der Putzfilm noch als schöne Allegorie dieser Umwertungsstrategien begreifen. Schwierig wird es erst dann, wenn man – naturgemäß spekulativ – das Ergebnis des Putzvorgangs genauer betrachtet: Der Boden ist perfekt gereinigt, die Wohnung blitzt und strahlt, die Hausherrin kommt vom nachmittäglichen Schaufensterbummel nach Hause. Ihre „Perle" hat sich selbst übertroffen, dafür ist ihr ein kleines Trinkgeld gewiss, oder wenigstens ein freundliches Schulterklopfen. Hat der Filmstreifen hier also zum zweiten Mal ein bestehendes System nur stabilisiert? Hat sich die Putzfrau mit seiner Hilfe gleich doppelt selber betrogen, im Glauben, sie könne über sich hinauswachsen – zuerst, als sie durch ihn von der ,anderen Welt' träumte, vor der Leinwand oder dem Fernsehschirm; und dann, als sie durch ihn zur Übererfüllung einer jener Vorgaben gelangte, die für die Erhaltung der Herr-und-Knecht-Dynamik grundlegend sind? Die Sache könnte sich aber auch viel schlichter verhalten: Hat der Filmstreifen nicht einfach das Seine dazu beigetragen, dass eine Person mit hohem

herself with the help of it, or did she do herself in—in the belief she could do better work? First, when she dreamt of 'another world' while watching the original film on the screen, and then when she used the material residue of that film to improve her own work, maintaining the master and servant relationship in the process? Or could it be a lot less sophisticated? Didn't the filmstrip simply contribute to helping a person with high professional standards master a particularly difficult task—giving her a real degree of satisfaction?

It's not a coincidence that at the end of such a chain of thoughts, more questions have come to light than answers. The clarifying and enlightening aspects of Gustav Deutsch's artistic practice should not be confused with solutions, answers or conclusions. What his work results in are insights into the multi-faceted relationship between 'our' and the 'other' world. History is engraved into the reality of the images and objects that surround us, just like in the case of the camera obscura on Aegina, built on the foundation of an old German anti-aircraft gun emplacement. 'Our history' and 'our lives' are also depicted in film images, and inscribed on the filmstrip itself, but in order to illuminate all of their contradictions and social dimensions (no

Berufsethos eine besonders schwierige Herausforderung bewältigen konnte? Dass sie zu einer Qualitätssteigerung ihrer Arbeit gelangte – und darin echte Befriedigung fand?

Es ist kein Zufall, dass am Ende solcher Gedankenketten eher Fragen als Antworten stehen. Das Klärende, Aufklärende von Gustav Deutschs Kunstpraxis darf nicht mit Lösungen, Auflösungen oder dem Ziehen einer Summe verwechselt werden. Was sein Werk hervorbringt, sind Einsichten in das vielfach verspiegelte Verhältnis zwischen ‚unserer' und der ‚anderen' Welt. In die Bild- und Dingwirklichkeit, die uns umgeben, ist Geschichte eingeprägt; so wie im Fall der Camera Obscura von Aegina, erbaut auf dem Fundament einer deutschen Flakstellung. Auch in den Bildern des Films, und auf den Filmstreifen selbst, zeichnet sich ‚unsere' Geschichte, ‚unser' Leben ab, aber um es in all seinen Widersprüchen hervorzutreiben (egal ob in künstlerischer oder wissenschaftlicher Absicht), bedarf es anderer Arbeitsweisen als dem heute weithin gebräuchlichen Absurfen, Anzapfen und Kombinieren der im digitalen Raum angeblich „unbegrenzt" vorhandenen Bilder. Es braucht z.B. eine willentliche Verlangsamung, Begrenzung und ‚Vermühseligung' der Arbeit, um Situationen zu schaffen, in denen die „Widerständigkeit der Gegenstände"

matter whether it be for an artistic or a scholarly purpose), working methods are required other than the currently widespread surfing, downloading and revamping of the supposedly 'unlimited' reservoir of images available in the digital world. What is needed, for example, is a premeditated approach that slows down the work, makes it more arduous and limits its scope—in order to create situations, where the "resistance of objects" (Helmut Lethen) manifests itself and the objects themselves become articulate.

Deutsch's 'visits to the archives'—since the beginning of his work on *Film ist.*—not only serve to reclaim hundreds and thousands of stored filmstrips and images from earlier times, but also to recapture these kinds of situations. His repeated trips from film archive to film archive, his communication with the archivists about their potential and actual holdings, his long viewing sessions at the editing tables on site, his vast notes or visual transcriptions of these viewing sessions (mostly in the form of sketches made together with Hanna Schimek) and the retranslation of those notes into a first draft of the film—all these activities are attempts to measure and experience the 'inherent meaning' of the original film footage, in order not to make things simpler (for himself) than

(Helmut Lethen) erfahrbar ist und die Gegen-
stände selbst aussagekräftig werden können.

Deutschs ‚Gang ins Archiv' – seit Beginn der
Arbeit an *Film ist.* – dient nicht nur der Rückge-
winnung hunderter, tausender abgelagerter
Filmstücke und Bilder aus früheren Zeiten, son-
dern auch der Rückgewinnung derartiger Situa-
tionen. Die mehrmalige Fahrt von Filmarchiv
zu Filmarchiv, die Kommunikation mit den Ar-
chivaren über ihre potentiellen und tatsächli-
chen Bestände, die monatelange Sichtungsar-
beit an Schneidetischen vor Ort, die aberwit-
zige Mitschrift bzw. visuelle Transkription dieser
Sichtungen – vor allem in Form von Skizzen, die
in gemeinsamer Arbeit mit Hanna Schimek ent-
stehen – und die Rückübersetzung dieser Notate
in einen Werkentwurf, all diese Aktivitäten sind
Versuche, das ‚Eigengewicht' der verwendeten
Filmgegenstände zu ermessen, (sich) die Dinge
nicht leichter zu machen als sie ihrer Entste-
hung und Bedeutung nach sind. Entsprechende
Arbeitsweisen lassen sich in Deutschs und
Schimeks künstlerischer Biografie weit zurück-
verfolgen, zumindest bis in die 1980er Jahre (per-
formative Erforschungen der Wüste; das fünf-
jährige „Anlegen eines öffentlichen Gartens
nach künstlerischen Gesichtspunkten und sol-
chen der Benutzbarkeit"; Projekte unter dem
Titel *Die Kunst der Reise*; usw.).

they are in the context of their genesis and their
meaning. Corresponding working methods can
be traced way back to Deutsch and Schimek's
artistic biography, at least until the 1980s (perfor-
mative research in the desert; the five-year proj-
ect of *"Planning a public garden in keeping with
artistic and usability criteria;"* projects entitled
The Art of Travelling, etc.)

The dual evidence of film lies in its function
as a vehicle for the photographic images cap-
tured in it, as well as its inherent function as
a 'material witness,' which carries with it the
history of its use. At first it would appear com-
pletely logical that this dual function can be bet-
ter recognized and studied in an archive (on the
editing table, in one's hands or under a magni-
fying glass) than in a museum (in an exhibition,
in the cinema, during projection). According to
this logic, Deutsch's visits to the archives are a

Die doppelte Evidenz des Films beruht auf der Zeugnisfunktion der auf ihm festgehaltenen fotografischen *Bilder* und auf seiner eigenen ‚Zeugenschaft' als *Material*, das die Geschichte(n) seines bisherigen Gebrauchs in sich trägt. Es erscheint zunächst ganz logisch, dass diese ‚Zweiseitigkeit' im Archiv (am Schneidetisch, in der Hand, mit der Lupe) besser erkannt und studiert werden kann als im Museum (in der Ausstellung, im Kino, in der Illusion der Projektion). Gemäß dieser Logik ist Deutschs Schritt ins Archiv ein Fortschritt. Zum Beispiel gegenüber dem bekannten Topos vom Künstler, der eine Museumsausstellung besucht, um sich für seine eigene Arbeit von den Werken der Alten inspirieren zu lassen – dieser Künstler bleibt in hohem Ausmaß auf der Ebene der Bilder, ihrer Wahrnehmung, ihrer ästhetischen Traditionen; im Archiv würde er, zusammen mit den Restauratoren, Provenienzforschern und Katalog-Abteilungen, viel mehr über die materielle, kontextuelle, ‚rückseitige' Geschichte der betreffenden Werke erfahren. Dazu kommt, dass im Museum üblicherweise ‚Museumsstücke' zur Ansicht gelangen, also nur der ‚herausragende', relativ enge Ausschnitt aus den Gesamtbeständen, der mit den jeweils herrschenden kunstgeschichtlichen und ästhetischen Prämissen korreliert. Im Archiv findet sich hingegen immer

mark of progress, e.g. in contrast to the well-known notion of the artist, who goes to a museum exhibition to find inspiration in the masterpieces of the past. Such an artist will mainly adhere to the surface of these images, their perception and their aesthetical traditions. In an archive, assisted by the restorers, researchers and cataloguers, he or she would find out much more about the material and contextual history (the 'verso side') of the works in question. In addition, museums usually exhibit 'museum pieces,' meaning a relatively narrow, 'outstanding' portion of the complete inventory—that which correlates with the aesthetical and art-historical premises, which are prevalent at a given time. In the archives, on the other hand, there is always more—'more than' the canon, more than can be found hanging on the walls or than is regularly screened in cinemas or film museums. This is also where the proverbial 're-venge of the archive' comes in—not only in that trivial sense, in which a journalist sometimes exposes someone's lies or schemes to the public by confronting them with contradictory or incriminating images or statements from the archives. The return of long-forgotten, cobweb-ridden, non-canonical artifacts can also be characterized in a more positive sense—as the potency of artifacts to be uncovered as *alternatives*.

Recherche für / *Research for Film ist. a girl & a gun*,
Nederlands Filmmuseum (2007)

‚mehr-als': mehr als der Kanon, mehr als das, was an den Wänden hängt oder in Kinos und Filmmuseen regelmäßig gezeigt wird. Deshalb verkehrt sich die *Arche* auch sehr leicht in die *Rache* des Archivs – nicht nur in jenem trivialen Sinn, in dem Journalisten manchmal Personen des öffentlichen Interesses der Lüge oder Verschleierung überführen, indem sie sie mit widersprüchlichen oder belastenden Archivbildern und -aussagen konfrontieren. Die Wiederkehr der lange dahindämmernden, selig vergessen geglaubten, nicht-kanonischen Archivalien ist auch in einem weiteren und positiveren Sinn charakterisierbar: als die Potenz der Artefakte, sich als *Alternativen* zu entpuppen. Ihre ‚andersartige', ‚fremde' Gestalt, die sie aus der Tiefe des Historischen (aus ihrer einstigen, nunmehr historisch gewordenen ‚Normalität') mit sich bringen, widerspricht ganz von selbst der heutigen ‚Normalität' – und damit auch der Gewohnheit (bzw. Herrschaftstechnik), den jeweils aktuellen Zustand einer Gesellschaft als unausweichlichen, unveränderlichen Naturzustand auszugeben.

Um diese Potenz der Artefakte tatsächlich freizusetzen, um die Archivalien als Alternativen wiederkehren zu lassen, ist es ratsam, der mühevollen Archivarbeit einen zweiten ‚Fortschritt' folgen zu lassen: den Schritt zu einer neuen

Their 'different' or 'foreign' semblance, which derives from their former, now historical—or 'outdated'—normalcy, naturally contradicts the current 'normalcy' and thus also the custom of passing off the current state of a society as inevitable and unalterable, as a natural state.

In order to actually set free the potency of the artifacts, to enable them to reappear as alternatives, it is advisable to follow up the arduous archival work with another 'step of progress'— the step towards a genuine re-presentation of the recaptured images, offering a new view of them on the basis of the experiences made in the archives, on the editing table. It is a step back into the public sphere, to a new work of art, or simply to an exhibition, to the cinema or the museum—with the difference that the 'doublesidedness,' the dual evidence of the film now tends to be exhibited, too. In addition to the generally accepted connection with reality that the filmic or photographic images have, the 'hidden' weight of the original film footage will now also become evident, the unique history of the materials used and the historicity of the medium as a whole.

Alexander Horwath

Ansicht oder Darstellung nicht nur der wieder-
gefundenen Bilder, sondern auch der im Archiv,
am Schneidetisch gewonnenen Erfahrungen. Es
ist der Schritt zurück in die Öffentlichkeit, hin zu
einem neuen Kunstwerk, oder einfach zurück in
die Ausstellung, ins Kino, ins Museum – mit
dem Unterschied, dass nun die ‚Zweiseitigkeit'
oder doppelte Evidenz des Films tendenziell
mitausgestellt wird: dass neben dem weithin ak-
zeptierten Wirklichkeitsbezug der filmisch-foto-
grafischen Bilder auch die ‚heimliche' Ge-
schichte der verwendeten Materialien und die
Geschichtlichkeit des Mediums im Ganzen spür-
bar wird.

Gustav Deutschs Arbeiten, vor allem jene,
die mit den Worten *Film ist* beginnen, setzen
diesen Schritt selbst dort noch, wo sie unter den
archivarisch hervorgeholten Filmstücken neue
Einheiten und Sinnzusammenhänge stiften
(zum Teil auch mit Hilfe neu komponierter
Musik). Sie lassen sich weder auf geschlossene
Erzählungen reduzieren, noch auf historische
‚Beweisführungen' in der Art, in der Archivma-
terial meist verwendet wird. Wie Deutschs Film
Welt Spiegel Kino in seiner ganzen Anlage exem-
plifiziert, steht hinter jedem Bild immer noch
ein bzw. mehr-als-ein anderes Bild, und auch
dieses wird niemals das letzte oder definitive ge-
wesen sein. So ist auch das Kapitel 9 von *Film ist.,*

Gustav Deutsch's works, particularly those be-
ginning with the phrase *Film ist.*, take such a
step with ease and confidence—even in places
where they create new clusters of meaning
(with the help of newly composed music, for in-
stance). They can neither be reduced to closed
narratives, nor to the function of 'historical
proof' (a common practice whenever archival
material is being used on TV). As demonstrated
by the structure of Deutsch's film *Welt Spiegel
Kino*, there is always another or more-than-one
other image behind each image, and this will
also never be the definitive or final one. Chap-
ter 9 of *Film ist.,* for instance, reaches beyond the
sort of dry evidence that its subtitle—*Conquest*—
would seem to promise at first glance. It offers
a cultural and social-historical outline of the ex-
pansionist ideas which characterize Western
bourgeois society in the late 19th and early 20th
century, and demonstrates how film accompa-
nied, reflected and supported these ideas—from
claiming territory by various new means of
visual and material transport (train, cinema, air-
plane) to the more or less 'peaceful' incorpora-
tion, 'measuring' and exhibition of what is
deemed 'savage,' and the violent conquest of
land through war. In decisive moments, how-
ever, these passages invite a different reading.
When lions suddenly leap out of fireplaces into

das den Übertitel *Eroberung* trägt, keineswegs so ‚beweisführend', wie es auf den ersten Blick erscheinen will. Es bietet einen kultur- und sozialhistorisch schlüssigen Abriss zum Expansionsgeist der westlichen Bourgeoisie im späten 19. und frühen 20. Jahrhundert und demonstriert, wie der Film diese Haltung begleitet, wiedergibt, unterstützt – von der Inbesitznahme des Raums durch diverse neue (Blick-)Maschinen (Eisenbahn, Kino, Flugzeug), über die mehr oder weniger ‚friedliche' Eingemeindung, Abmessung und Ausstellung des oder der ‚Wilden', bis hin zur gewaltförmigen, kriegerischen Aneignung von Raum. In entscheidenden Momenten laden diese Passagen jedoch zu gegenläufiger Lektüre ein: Wenn in bürgerlichen Salons plötzlich Löwen aus dem Kamin oder eine Python aus dem Nachtkästchen schlüpfen, kann man darin die bürgerliche Angst vor dem Eindringen des Wilden ins Innerste der ‚Zivilisation' erkennen, was im Gegenblick – aus Sicht der ‚Wilden' – nur bedeutet, dass das koloniale System nun endlich zu kippen beginnt. Im filmischen und medizinischen Vermessen der Eingeborenen zeigt sich ganz buchstäblich unsere europäische Vermessenheit; aber wir haben uns offenbar ziemlich ‚vermessen', denn im Gegenzug schicken sie uns ihre tierischen Rachegeister durch den Kamin und die Nachttischlade, in die

middle-class living rooms, or a python snakes out of a night table, one can feel the fear of the bourgeois that the 'savages' might invade the innermost hearth of 'civilization.' From the perspective of the latter, of course, this means the colonial system is finally beginning to tip. The European peoples' arrogance and lack of humanity have become obvious during the passages, which show how indigenous peoples were measured and 'documented' by means of medicine and cinematography. But in Deutsch's 'utopian' selection of images, the counterattack of the 'savages' is even stronger: They are sending us their full register of animalistic revenge, via our fireplaces and night tables, into the bedrooms of our bad conscience. At the end of the sequence, the python creeps over a magnificently ornamented carpet that is going up in flames.

The proverbial "cussedness of things" would be a good metaphor for this and many other examples from the *Film ist.* series. With innumerable archival finds, and with his sparse and gentle manipulations of the footage (slow motion, reverse motion), Deutsch demonstrates how strong the 'alternative' potential of cinematic artifacts is. It only takes a nudge, and the ideas and objects recorded on film begin to work against their apparent purpose—including the

Schlaf- und Wohnzimmer unseres schlechten Gewissens. Am Ende der Sequenz schlängelt sich die Python über einen prächtig ornamentierten, in Flammen stehenden Teppich.

Das Sprichwort von der „Tücke des Objekts" wäre eine gute Metapher für dieses und viele andere Beispiele aus der *Film ist.*-Reihe. Deutsch zeigt anhand zahlloser Archivfunde bzw. durch seine ganz seltenen und sanften Eingriffe ins Material (Zeitlupe, Rücklauf), wie stark das ‚alternative' Potential der Kinoartefakte ist: wenn die darin aufgehobenen Ideen und Dinge – aber eben auch, wie im brasilianischen Putzfilm, die Filmstreifen selbst – gegen ihren scheinbaren Sinn, gegen ihre ‚Normalfunktion' tätig werden. Drei Beispiele von vielen: Kapitel 7.1, das die tückischen Objekte unmittelbar feiert (Türen, Leitern, Fahrräder, Schläuche); Abschnitt 7.4, der die Umkehrung, den Rücklauf der Zeit und die mögliche ‚Wiedergutmachung' der Geschlechtertrennung bzw. der von Mann und Frau angerichteten Zerstörungen zum Thema hat, oder das gesamte *Magie*-Kapitel – etwa der Block 8.2 mit seinen ‚Wiederauferstehungen' und der Verkündigung eines freien Changierens zwischen Tod und Leben, Himmel und Erde.

Im *Film ist.*-Projekt (und in anderen Arbeiten) verheimlicht Deutsch nicht die ‚Beschriftung',

filmstrip itself, as the example of the Brazilian cleaning lady has shown. Chapter 7.1 celebrates a whole series of 'cussed objects' (doors, ladders, bicycles, hoses); 7.4 proposes the reversal of time, of sexual difference, and of all the destruction wrought by man and woman; and chapter 8 (*Magic*) is entirely devoted to the suspension of everyday logic—most beautifully in the case of 8.2, with its 'resurrections' and its invitation to roam freely between life and death or Heaven and Earth.

In the *Film ist.* project, Deutsch never makes a secret of the various 'inscriptions' the archival footage carries, that is the extremely varying textures, the grades of color or black & white, and the degree of damage accumulated on the film. On the contrary, he exhibits them—and encourages the viewer to ponder this 'hidden weight' of the film artifacts. It is a sort of counter weight to all the representational capacities of film, to the 'real world' references that we have come to expect from film images. Whoever exhibits these 'inscriptions', opens the floodgate for one of the most beautiful dreams of film, which is usually suppressed: the dream of someday being able to tell its own story, not just the stories of the people depicted. The dream sequence in chapter 8.3 of *Film ist.* refers to this very set of circumstances. A sleeping woman is tossing around in

Film ist. Eroberung (2002)

also die extrem unterschiedlichen Texturen, Farb- bzw. Schwarzweißqualitäten und Beschädigungsgrade, die das Archivmaterial aufweist. Im Gegenteil: Er stellt sie aus. Das ist das erwähnte ,Eigengewicht' der Filmzeugnisse, eine Art Gleichgewicht zu dem, was in den jeweiligen Bildern von der Welt erzählt wird – und ebenso ,sprechend' und ,tückisch' wie diese. Wer es ausstellt, öffnet die Schleusen für einen der schönsten Träume des Mediums Film, der fast stets unterdrückt wird: *einmal die eigene Geschichte erzählen, nicht immer nur die der Menschen und Dinge im Bild!* Die Traum-Sequenz in *Film ist.* (Kapitel 8.3.) spricht genau diesen Sachverhalt an.

Eine schlafende Frau. Sie wälzt sich im Traum. Ihr und uns erscheint eine Pappmaché-Höhle, in deren Mitte Bildverlust droht. Zum Zeitpunkt, als das betreffende Nitrofilmstück im Archiv umkopiert wurde, war die Zersetzung des Materials offenbar schon weit fortgeschritten – und zwar genau an dieser Stelle. Die flackernden Bildschäden werden nun im Sekundentakt schlimmer, die Beschädigung selbst nimmt die Stelle des Bilds ein. Es ist ein aufregendes Bild, das kein Mensch je so gewollt hat; ein Bild, das der Filmstreifen im Vollzug seiner Geschichte ,von selbst', also blindlings erzeugt hat. Manche Filmarchivare nennen diese Bilder: „Blumen des Bösen". Am Höhepunkt der

her dreams. A paper-mâché cave appears to her and to us, in the middle of which the image threatens to disappear. At the time when the original piece of nitrate film was preserved in the archive, the footage had obviously already disintegrated to a good degree—exactly at this spot. The flickering damage in the frames worsens from second to second, and the damage itself takes on the place of the image. It is an exciting image that wasn't premeditated, an image the film footage produced 'by itself' in the course of its history, that is to say blindly. Some film archivists call these images the 'flowers of evil.' At the climax of the shot, and at the center of the image where the damage is now in full bloom, the paper-mâché cave turns into the horrifying maw of the devil —as if both aspects of the medium, its recto and its verso side, so to speak, were now communicating with each other, as if the images captured one hundred years ago and the damage accumulating over one hundred years were aware of each other's most intimate secrets. The floodgate enabling these two worlds to be in contact with each other would seem both allegorical and

Einstellung tritt mitten aus der (abgebildeten) Höhle und mitten aus dem blumigen (im Material erblühten) Bildschaden ein gruseliges Höllenmaul hervor – ganz so, als kommunizierten die beiden Seiten des Mediums nun miteinander, als wüssten der vor hundert Jahren entstandene Bildinhalt und der über hundert Jahre akkumulierte Filmverfallszustand die intimsten Geheimnisse voneinander. Die Schleuse, in der die zwei Welten Kontakt haben, erscheint allegorisch *und* konkret vor unseren Augen. Dazwischen sehen wir immer wieder die schlafende Frau, deren Traum in der Folge – mit Hilfe weiterer Höllenmäuler, Überblendungen und Geistererscheinungen – zu einer Fantasie des Fliegens und (sexuellen) Ausbrechens gerät; zu einer widersprüchlichen Geschichte der (Selbst)Ermächtigung durch den gewaltsamen Eingriff eines geträumten ‚Wilden‘. Der reißt die Frau aus ihrem braven Dasein und schleudert sie in den Weltenraum hoch, wo sie den herrlichen Schwebezustand der Freiheit erlebt. An dieser Stelle in Gustav Deutschs Inszenierung spielt die Frau die Rolle des Films.

„Der Rest ist Geschichte" heißt es manchmal, wenn alles gesagt scheint. Aber es ist nie alles gesagt, und der Rest ist nicht nur unendlich, unabgeschlossen, ‚to be continued‘ wie die Schlüsse

tangible, right in front of our eyes. And in-between, we keep on watching the sleeping woman, whose dream—assisted by more devil's maws, superimpositions and ghostly apparitions—turns into a fantasy of flying and (sexual) escape; a contradictory narrative of (self-) empowerment through forcible interventions by a 'dream savage.' He tears the woman out of her bourgeois existence and flings her upwards, into space, where she experiences the wonder and the glory of floating free. At this point in Gustav Deutsch's production, the woman is playing the role of the film.

"The rest is history," is what we usually say when everything that matters seems to have been said. However, it has never all been said, and the rest is not only infinite and never-ending—'to be continued,' as indicated in the endings of several films by Gustav Deutsch— but also *another* (hi)story. It is that, which has not yet been entirely illuminated and exposed or 'demystified' by scholarly practices. It doesn't yet have a name. It will only be exhibited in the museums of the future—or may already be found in the utopian, poetical, polemical 'museums' of some contemporary artists.

As cultural techniques, which stem in almost equal parts from scholarly work (the need for

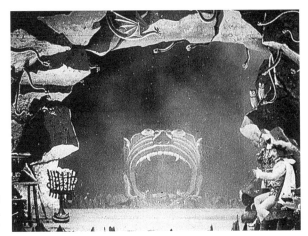

mancher Deutsch-Filme, sondern auch eine *andere* Geschichte. Das, was noch nicht ganz erhellt und sauber geschichtet und ‚entzaubert' vor uns liegt. Das, was noch keinen Namen hat. Das, was immer erst in den Museen der Zukunft erzählt wird (und so wieder eintritt ins sauber Geschichtete) – oder schon jetzt erzählt wird: in den utopischen, poetischen, polemischen ‚Museen' einiger Künstler.

Als Kulturtechniken, die zu annähernd gleichen Teilen von der Wissenschaft (dem Bedürfnis nach Entzauberung und Erkenntnis) und der Schaustellerei (dem Bedürfnis nach Vergnügen und Wiederverzauberung) herrühren, lassen sich die Medien Film und Museum – zumindest ‚experimentell' – als enge Verwandte betrachten. Beide sind Forschungsplätze und Wunderkammern zugleich, Systeme zur Aufbewahrung von Bildern der Welt und Systeme, in denen diese Bilder vorgeführt, inszeniert und interpretiert werden. Beide erschaffen einen szenischen Raum, in dem wir der Geschichte gewahr werden können; und da sie in der kapitalistischen Gesellschaft groß geworden sind, tendieren beide dazu, die eingesammelten Zeugnisse des Geschehenen als ‚Besitz' zu betrachten.

Die utopischen, poetischen, polemischen ‚Museen' einiger Filmkünstler bieten sich als demystification and knowledge) and showmanship (the need for entertainment and remystification), the media of film and the museum can be considered closely related. Both of them are simultaneously sites of research and cabinets of curiosities; systems for storing images of the world, and systems in which these images are displayed, promoted and interpreted. Both employ forms of *mise-en-scène* through which the public can experience history. And since they both came into being in a capitalist society, they both tend towards a 'proprietary' view of the collected evidence of the past. The utopian, poetical, polemical 'museums' created by some filmmakers may be seen as an alternative model. Amongst them—that is alongside the multifaceted work of Chris Marker, the short films by Bruce Conner, Dziga Vertov's 'laboratory' of cinema, the *Histoire(s) du cinéma* by Jean-Luc Godard, the unique television programs produced by Alexander Kluge, or Peter Kubelka's work, which includes filmmaking, teaching and the creation of an actual museum—the films and film-related works by Gustav Deutsch have increasingly secured their own special place.

alternatives Modell an. In ihre Reihe – das heißt z.B. neben das ausufernde, vielgliedrige Werk von Chris Marker und die kurzen Filme Bruce Conners, neben das Labor Dziga Vertovs und die *Histoire(s) du cinéma* von Jean-Luc Godard, neben Alexander Kluges Fernsehen oder die in Filmen, Vortragsereignissen und einer tatsächlichen Museumsgründung artikulierte Praxis von Peter Kubelka – tritt mehr und mehr auch das filmische und filmbezogene Schaffen von Gustav Deutsch.

Ihre ‚Kinos der Geschichte' sind sehr unterschiedliche Bauwerke und einander teilweise kritisch entgegen gesetzt. Die Archive, die sie nutzen, und die Art, in der sie das tun, um danach ihre eigenen Sammlungen anlegen zu können, sind ebenso vielfältig. Sie berufen sich teilweise auf ähnliche, zum Teil aber auf völlig verschiedene (geschichts)philosophische Traditionen; sie tun dies manchmal ganz ausdrücklich, manchmal nur implizit. Manchmal untersuchen sie das, was von den großen Namen bleibt, aber viele von ihnen tendieren zum Rest, zum Abgesonderten, denn „Verse wachsen auf dem Müll" (Anna Achmatowa), nicht in der Vitrine. All ihre ‚Museen' sind Transkriptionsvorgänge vor den Augen des Publikums; es sind keine blinden (wie so oft die Archive) und keine übermäßig geschliffenen Spiegel (wie so oft die Museen), son-

The individual 'Cinemas of History' built by these artists are greatly varying constructions, and are sometimes even critically opposed to each other. The archives they make use of, and the manner in which they do so in order to create their own collections, vary just as greatly. They often invoke similar philosophies of history, yet also quite different ones, in part. They sometimes do so explicitly and sometimes only implicitly. Sometimes they investigate what remains of the great names, but many of them tend towards the rest, to that which has been excluded, since "verses are fostered by waste" (Anna Akhmatova), and not in showcases. All of their 'museums' are processes of transcription in the public eye. They are neither blind mirrors (as archives tend to be), nor are they too highly polished ones (the way museums often function). They are "living mirrors of a new world," as Tom Gunning wrote in reference to Deutsch's *Welt Spiegel Kino*, "revealing the cinema as a play of reflections that stretches across modern life."

Some of them, such as Godard, produce obituaries for the cinema or describe how film came to be at fault in the face of real historical challenges. For example, how it became clear in 1945 that the cinema of the spectacle had failed, whereas "the poor cinema of newsreels" now "has to wash clean of all suspicion / the blood

dern „lebendige Spiegel", wie Tom Gunning über Gustav Deutschs *Welt Spiegel Kino* geschrieben hat.

Die einen, wie Jean-Luc Godard, produzieren Nachrufe aufs Kino der großen Autoren oder erzählen vom Schuldigwerden des Films im Angesicht der realen geschichtlichen Herausforderungen. Zum Beispiel wie das Erzähl- und Spektakelkino im und vor dem Zweiten Weltkrieg versagt hat und nun „das arme Kino der Wochenschauen das Blut und die Tränen von jedem Verdacht reinwaschen soll – wie man das Trottoir reinigt, wenn alles zu spät ist und die Armee schon in die Menge geschossen hat". Die anderen, wie Gustav Deutsch, zeigen, dass das arme Kino der Wochenschau-, Lehr-, Amateur- und halb zerfallenen ‚prähistorischen' Filme genauso schuldig und hilflos und begeisterungsfähig ist wie das reiche und große; und dass es sich mindestens ebenso gut – wenn nicht besser – für eine Wiederbelebung eignet, d.h. für eine Geschichtslektüre ‚gegen den Uhrzeigersinn'.

„Schwerer ist es, das Gedächtnis der Namenlosen zu ehren als das der Berühmten.", schreibt Walter Benjamin. „Dem Gedächtnis der Namenlosen ist die historische Konstruktion geweiht." Das gilt auch für die vorliegende Textkonstruktion: Es ist verführerisch, weil leichter,

and tears / just as the pavement is swept / when it's already too late / and the army has opened fire on the crowd." Others, like Gustav Deutsch, show that the ‘poor' cinema of newsreels, home movies, educational films, and half-disintegrated ‘prehistoric' films is just as helpless and at fault, as its wealthy counterpart, which lays claim to the name of ‘film history.' And that, vice versa, the poor relatives are certainly as suited for revitalization as their canonical cousins are; that is, for a ‘reverse-engineering' of history to the point where the things and ideas that have ‘survived' in our minds are joined by those that have not.

Walter Benjamin writes: "It is more arduous to honor the memory of the nameless than that of the renowned. Historical construction is dedicated to the memory of the nameless." This may also be applied to the textual construction at hand. It is tempting, because it is easier, to deal with famous works and names. Yet since then, partially as a result of Benjamin's continued presence, we have seen far more artistic and scholarly projects taking the "arduous path" than he would have anticipated when writing these last words in the year 1940.

In *Film ist. 12—Memory and Document*, there is a single shot by which an anonymous man im-

mit den berühmten Werken und Namen zu operieren. Aber mittlerweile sind, zum Teil auch inspiriert durch Benjamin selbst, viel mehr künstlerische und wissenschaftliche Projekte auf den „schwereren" Weg gebracht worden als es in seinen letzten Zeilen aus dem Jahr 1940 möglich erschien.

In *Film ist. 12 – Erinnerung und Dokument* gibt es eine einzelne Einstellung, mit der sich ein Namenloser in einer Weise verewigt, die an die Berühmten gemahnt. Ihn zu ehren – und damit auch jenen, der ihm durch seine mühevolle Archiv-, Museums- und Kunstarbeit als erster die gebührende Ehre erwies – ist das Ziel dieser Textkonstruktion.

Der namenlose Mann steht mit Kamera und Stativ im Mittelgang eines fahrenden Bahnwaggons. Er filmt, aber da ihn dabei niemand anderer filmt, ist sein Tun nur deshalb zu sehen, weil er selbst in den großen Spiegel filmt, der sich vor ihm befindet, an der Tür zum nächsten Waggon. Links fetzt ein Zugfenster an der Landschaft vorbei – der mobilisierte ‚Eisenbahnblick', der heute als wichtiger Vorreiter des Kinoblicks gilt. Doch die Draußenwelt ist zu hell, wir erkennen im Zugfensterrahmen keine Details, umso mehr, als der Filmende nun die Kamera in die Mitte ausrichtet, auf sich selbst, auf den Spiegel. Im Zuge dieser Bewegung nimmt er

mortalized himself in a fashion reminding us of the famous ones. The goal of this textual construction is to honor him—and to also honor the man, who was the first to pay tribute to him in *Film ist.* by means of painstaking work in archives, museums and art. The anonymous man is standing with a camera and a tripod in the center aisle of a moving train car. He is filming. No one else is filming him, so the only reason why we can see him at all is that he's filming the large mirror in front of himself on the door to the next train car. The landscape flies by in the left-hand window—the ‘mobilized gaze' from the train, which is today considered an important forerunner of the ‘cinematic gaze.' But the world outside is much too bright. We cannot make out any details in the pictures framed by the train window, all the more so because the filmmaker then swings the camera around to the center, directing it at himself in the mirror. In the course of this pan, he captures a third and forth type of image in his film. To the right of the door, beside the mirror, there are two gauges, instruments for the purpose of recording reality, the characteristics of which—temperature, air humidity or speed—are being translated into the movements of indicators and into the figures they indicate, that is, into geometrical, abstract and scientifically based ‘moving

eine dritte und vierte Art von Bild ins Bild und in den Themenkreis auf: Rechts von der Waggontür, gleich neben dem Spiegel, hängen zwei Messgeräte, Apparaturen der Aufzeichnung von Wirklichkeit, die deren Eigenschaften – Temperatur, Luftfeuchtigkeit oder Geschwindigkeit – in Zeigerbewegungen und angezeigte Zahlen übertragen, also in geometrisch-abstrakte und wissenschaftlich fundierte ‚Bewegtbilder'. Links von der Tür, gleich neben dem Spiegel, hängt gut erkennbar ein gemaltes Landschaftsbild, das an die Stelle des ‚wirklichen', hinter dem Zugfenster abrollenden Landschaftsbilds tritt. Letzteres zeichnet sich, weil ‚überbelichtet', nur indirekt ab – als flackernder Lichtreflex mitten im gemalten, ‚künstlichen' Bild: auf der Leinwand.

Es ist, im Ganzen genommen, ein perfektes und zugleich vollständig offenes Filmbild vom Film. Und ein Selbstbild, das dem Namenlosen zwar keinen Namen, aber ein Fortleben und einen konkreten Ort in der Welt gibt. Seines ist das kleinste, und eines der schönsten aller ‚Museen', die Filmemacher bisher errichtet haben.

pictures.' To the left of the door, beside the mirror, there is an easily recognizable landscape painting, which takes the place of the 'real' landscape rolling past the train window. Due to the light conditions in the car, the 'real image' is 'overexposed' and can only be perceived indirectly—as flickering reflections of light on the 'artificial' surface of the painting: on the screen.

As a whole, it is a perfect and completely open film image of film. An image and a self-portrait that does not attribute a name to the anonymous man, but gives him a continued existence and a concrete place in time. His is the smallest and one of the most beautiful of all 'museums' that filmmakers have yet created.

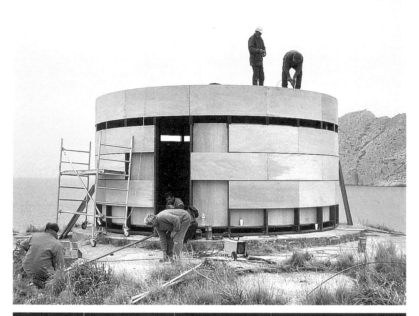

Camera Obscura, vierter Tag / *day 4*, Perdika, Aegina (2003)
Camera Obscura, neunter Tag / *day 9*

Scott MacDonald

Gespräch mit Gustav Deutsch (Teil 2)
A Conversation with Gustav Deutsch (part 2)

MacDonald: Ihre Architektenausbildung trat wieder in den Vordergrund, als Sie 2003 gemeinsam mit Franz Berzl Ihre panoramatische Camera Obscura entwarfen und bauten. Wie kam es zu diesem Projekt? Das Panorama und die Camera Obscura haben ja eine lange Tradition, aber ich glaube nicht, dass die beiden Formen schon jemals in dieser Weise miteinander kombiniert worden sind.

Deutsch: Die Camera Obscura wurde als Teil von *Light/Image – The Aegina Academy: A Forum for Art and Sciences* realisiert. Es gab zwei Phasen dieses Projekts, eine im Jahr 2003 zum Thema „Realität" und die zweite 2005 über „Illusion". Es war ein großes, von der EU finanziertes Projekt mit Partnern in Griechenland, Österreich, Deutschland, Ungarn und den Niederlanden. Hanna und ich waren die Initiatoren und künstlerischen Leiter. Es lag für uns auf der Hand, dass wir zum ersten Thema eine Camera Obscura realisieren würden, und ich hatte die Idee, ein Panorama und eine Camera Obscura im selben Gebäude zu verbinden. Ich hatte die Camera Obscura in San Francisco gesehen, aber für dieses Projekt wollte ich keine optischen Hilfsmittel verwenden – keine Optiken und keinen konkaven Projektionstisch. Ich wollte die reinste Form der Camera Obscura: ein Loch und eine Projektionsfläche in einem dunklen Raum.

MacDonald: Your architectural training came to the fore in 2003 when you and Franz Berzl designed and built your panoramic camera obscura building. How did this project come about? Of course, both the panorama and the camera obscura have long histories, but I'm not aware of any instance where the two forms have been combined in precisely this way.

Deutsch: The camera obscura was realized as part of *Light/Image—The Aegina Academy: A Forum for Art and Science.* There were two phases of the project, one in 2003 on "Reality," and the second in 2005 on "Illusion." It was a big project financed by the European Union with collaborators in Greece, Austria, Germany, Hungary, and the Netherlands. Hanna and I were the initiators and artistic directors. It seemed obvious that we should realize a camera obscura for the first theme, and I had the idea to combine a panorama and a camera obscura in the same building. I had seen the camera obscura in San Francisco, but for this project I didn't want to use any kind of optical devices—lenses or a projection table. I wanted the purest form of a camera obscura: a hole and a screen in a dark room.

We found this amazing spot on a military site on the island, with the foundation of a former concrete German gun-emplacement from World

Wir fanden einen wunderbaren Platz auf einem Militärgelände auf der Insel. Die Grundfesten stammten noch von einer deutschen Beton-Flak-Stellung aus dem Zweiten Weltkrieg. Es war exakt die richtige Dimension für das Gebäude. Wir konnten die Erlaubnis der griechischen Marine bekommen, an dieser Stelle zu bauen. Die Idee war, ein rundes Gebäude herzustellen, mit zwölf Löchern und zwölf Leinwänden, die kreisförmig von der Decke hängen. Franz Berzl hat den architektonischen Entwurf gemacht und Gavrilos Michalis, ein griechischer Künstler und Handwerker, hat das Gebäude konstruiert. Die Dimension der Löcher haben wir vor Ort durch Experimentieren festgelegt.

MacDonald: Wie zugänglich war die Camera Obscura? Wie viele Leute haben den Ort besucht?

Deutsch: Sie funktioniert immer noch, ist in einem guten Zustand und wird oft von Touristen besucht, aber auch von Schulklassen der Insel. Es hat sich eine Gruppe von Leuten gebildet, die „Freunde der Camera Obscura", die die finanziellen Mittel zur Instandhaltung aufbringt. Eine Aufsichtsperson kümmert sich darum und öffnet und schließt das Gebäude jeden Tag. Von Oktober bis April ist es ganz geschlossen. Hanna und ich streichen es einmal im Jahr neu. Wir sind eigentlich überrascht, dass es nach fünf Jah-

War II. It had exactly the dimensions necessary for the building. We succeeded in getting permission from the Greek Navy to build on this site. The idea was to have a round building with twelve holes and twelve screens hanging from the ceiling. Franz Berzl did the architectural design, and Gavrilos Michalis, a Greek artist and craftsman, constructed the building. The dimensions of the holes were decided by experimenting on the spot.

MacDonald: How accessible is the camera obscura—have many people visited the site?

Deutsch: It's still functioning; it's in good condition, and is often visited by tourists, but also by school classes from the island. A group of people—"Friends of the camera obscura"—was founded to raise the financial expenses of maintenance: a guard takes care of it, opens and closes it every day (it's closed from October until April). Hanna and I repaint it once a year.

We are astonished that the building has not been vandalized, after five years! And we are happy that the people of the island accept it. They call it "Panagitsa," which means "little chapel."

MacDonald: With *Welt Spiegel Kino* you found a new way to organize and work with early film footage. Here, each "Episode" has a predictable, or more or less predictable, overall structure,

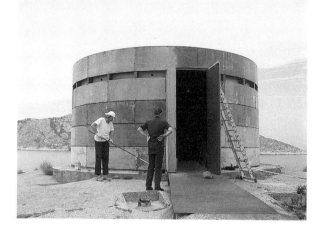

Camera Obscura, Instandhaltungsarbeiten /
maintenance work (2006)

ren noch immer nicht von Vandalen beschädigt oder zerstört worden ist! Und es freut uns, dass die Inselbevölkerung es akzeptiert. Sie nennen es „Panagitsa" – das heißt „kleine Kapelle".

MacDonald: Mit *Welt Spiegel Kino* haben Sie einen neue Weise gefunden, frühes Filmmaterial zu ordnen und damit umzugehen. Hier hat jede „Episode" eine mehr oder weniger vorhersehbare, durchgängige Struktur, innerhalb derer man ein breites Spektrum an interessanten Bildern und Sequenzen erforschen kann.

Ich sehe folgende Parameter der formalen Organisation: Erstens hat jede Episode die gleiche Länge, dreißig Minuten; zweitens beginnt jede mit allgemeinen Ansichten einer bestimmten städtischen Umgebung, in der sich ein Kino befindet, dann werden diese Ansichten wiederholt und der Fokus auf spezifische Personen gelegt, die darin vorkommen, und es wird eine Verbindung zwischen diesen Personen und anderen Artefakten aus dem Frühen Kino imaginiert; drittens konzentrieren Sie sich an einem bestimmten Punkt jeder Episode auf den Film, der im betreffenden Kino zu sehen ist. Sie zeigen Ausschnitte, die offenbar aus diesem Film stammen, *und* Sie intervenieren *innerhalb* dieser Ausschnitte durch Schnitte auf andere Filmstücke, kehren dann zum Originalfilmausschnitt zurück und schließlich wieder zur Straßenszene.

within which you are able to explore a wide range of interesting images and sequences.

I see the following organizational parameters: first, each section is the same length: thirty minutes; second, each begins with general views of a particular urban environment within which there is a movie theater, then repeats those general views while focusing in on particular characters within them and imagining a connection between each of these characters and characters within other artifacts of early cinema; third, within each section, at one point you focus in on the film playing in the local theater, present what appear to be excerpts from that specific film, *and* within *that* excerpt, intervene for a moment with a cutaway to yet another film, then return to the excerpt, then to the street scene.

Are there organizational parameters that I've not mentioned?

Deutsch: No. The only thing I would add is that I used different kinds of "gateways" to leave the street scenes and switch to other protagonists. The structure I had in mind was that of a search engine: every person in an image can be a link

147

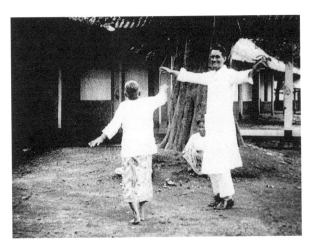

Gibt es noch weitere Parameter, die ich übersehen habe?

Deutsch: Nein. Das einzige, was ich hinzufügen würde, ist, dass ich verschiedene Arten von „Schnittstellen" benutzt habe, um die Straßenszenen zu verlassen und zu anderen Protagonisten zu wechseln. Die Struktur, die mir vorschwebte, war die einer Suchmaschine: Jede Person in einem Bild kann ein Link zu einem anderen Bild sein und von dort wieder zu einem Objekt oder einer anderen Person überleiten.

Zum Beispiel habe ich die Polizisten in Episode 2 verwendet, um zu einer Autosequenz überzugehen. Mit der Autofahrt konnte ich die ursprüngliche Straße verlassen und zu einem Passanten wechseln, der dann zum Schattenspieler wird. Mit ihm konnte ich zum Schattentheater kommen. Ein anderes Beispiel ist die Straßenbahn, in die ich „einsteige" und mit der ich zu einer anderen Station komme, wo eine Gruppe weißgekleideter Holländer aus dem Waggon aussteigt. Einer von ihnen wird zum Arzt in einer Institution für geistig behinderte Menschen, der mit einer seiner Patientinnen tanzt.

to another image, and from there to an object and to another person and so on.

In Episode 2, for example, I used the policemen to continue with a car sequence. With the car ride I could leave the original street, and meet a passerby who becomes the shadow player and with him I could move on to the shadow theater. Another example is the tram that I enter, and move on to another tram station, where a group of white dressed Dutch people leave the tram. One of them becomes the doctor in the hospital for the mentally challenged who dances with one of his female clients.

I decided to use "dream-sequences" as well, or fantasies of my protagonists, to continue with a character they imagine being or would like to become. For example, the little boy in Episode 1 who gets slapped becomes a boy in the Viennese fairground, and there he imagines becoming the strong man bending the iron. These were opportunities to include footage that I wanted to use, but could not directly link to one of the characters in the street scenes. I also decided that the fictitious characters I created could be contemporary with the street scenes, but also be the same person in the future (as, for example, the first man in Episode 1 who becomes a soldier from World War 1) or in

Ich wollte auch „Traumsequenzen" verwenden oder Fantasien meiner Protagonisten, um Anschlüsse zu Figuren zu machen, die sie gerne wären oder werden möchten. Zum Beispiel der kleine Bub in Episode 1, der geohrfeigt wird; er wird zu einem Buben im Wiener Prater und imaginiert sich dort als starker Mann, der Eisen biegen kann. Das gab mir die Möglichkeit, Material einzubeziehen, das ich zwar verwenden wollte, aber nicht unmittelbar an eine der Figuren in den Straßenszenen andocken konnte. Weiters beschloss ich, dass die fiktiven, von mir kreierten Charaktere sowohl der historischen Zeit der Straßenszenen angehören, als auch die Zukunft einer Person repräsentieren konnten (wie zum Beispiel der erste Mann in Episode 1, der ein Soldat im Ersten Weltkrieg wird) – oder ihre Vergangenheit (wie die Frauen in Episode 3, die Körbe mit Trauben auf ihren Köpfen tragen).

Ich entschied mich, alle fiktiven Porträts in Zeitlupe zu zeigen – um den Zusehern mehr Zeit zu geben, sie zu studieren – und das Bild am Ende jedes Zooms auf eine Person kurz einzufrieren; dieses Standbild wurde dann mit dem ersten Standbild des folgenden fiktiven Porträts überblendet. Das gleiche Manöver dann wieder am Ende jedes fiktiven Porträts, wenn wir in die Straßenszene zurückkehren und das Bild wieder zurückgezoomt wird.

the past (like the women in Episode 3, carrying baskets of grapes on their heads).

I decided to slow down all fictitious portraits, in order to give the audience more time to study them, and I decided to have the film frozen at the end of each zoom, and overlap this frozen image with the first frozen image of the fictitious portrait. The same technique was used at the end of each fictitious portrait and at the beginning of the zoom out.

MacDonald: What instigated this project?

Deutsch: During my research for *Film ist. 7–12*, I came across the film from Surabaya with the Cinema Apollo. That film is called *Soerabaia—Het Straatverkeer op Pasar Besar, 15ᵗʰ July 1929*. It's a film about the traffic in Surabaya. Nico de Klerk told me that this film, along with four other actualities, is the only document of a local East Indian film production in the collection of the Nederlands Filmmuseum. I was particularly struck by one 180 degree pan, filmed from the upper floor of a building on a very busy street. Right across from the camera on the other side of the street was a cinema, and one could clearly see which films were showing there: *The Un-*

MacDonald: Was war der Auslöser für dieses Projekt?

Deutsch: Während meiner Recherche für *Film ist. 7–12* habe ich einen Film aus Surabaya gefunden, der das dortige Apollo-Kino zeigt. Der Film hat den Titel *Soerabaia—Het Straatverkeer op Pasar Besar, 15. Juli 1929*. Es ist ein Film über den Straßenverkehr in Surabaya. Nico de Klerk erzählte mir, dass dieser Film zusammen mit vier anderen Artefakten das einzige Dokument einer lokalen ostindischen Filmproduktion in der Sammlung des Nederlands Filmmuseums darstellt. Ich war vor allem von einem 180-Grad-Schwenk beeindruckt, der vom oberen Stockwerk eines Gebäudes auf eine sehr belebte Straße gerichtet war. Direkt gegenüber der Kamera, auf der anderen Seite der Straße, war ein Kino, und man konnte genau erkennen, welche Filme dort gezeigt wurden: *The Unholy Three* (1925, Tod Browning) mit Lon Chaney und der erste Teil von Fritz Langs Epos *Die Nibelungen: Siegfrieds Tod* (1924).

Nun stellte sich die Frage, wie wohl die Bevölkerung von Surabaya – einer großen Stadt im damaligen Niederländisch-Ostindien, heute Indonesien – einen Film wie *Die Nibelungen* rezipierte. Welche der zahlreichen Leute, die am Apollo-Kino vorbeigingen, hatten überhaupt je dieses Kino betreten? Welche Art von Spannung

holy Three (1925, directed by Tod Browning), starring Lon Chaney, and the first part of Fritz Lang's epic *Die Nibelungen: Siegfried's Tod* (1924).

The question arose as to how a film like *Die Nibelungen* by Fritz Lang was perceived by the people of Surabaya, a major city in what was then the Dutch East Indies—nowadays Indonesia. Which of the numerous people going by the Apollo Cinema had actually ever entered this cinema? What was the nature of the tension between the masterpiece of German expressionist cinema (the heroic epic that later on the Nazis would appropriate for their ideology) and the actual conditions at the end of a century-long colonial domination? How was the myth of the dragon perceived by people engaged in an independence movement?

I decided to look for similar footage in other cities and cultures, I wanted to have Vienna as the second, and I chose Portugal as the third. Luckily I found two films in the Archives in Vienna and Lisbon picturing a movie theater with people in front of it. When it was clear that at least one of the films playing in those theaters was preserved, even as just a fragment, Hanna and I started viewing all material available from those times and places.

The task of this film was to tell fictitious stories of the people, of their lives, of the social,

herrschte zwischen diesem Meisterwerk des deutschen expressionistischen Kinos (jenem Heldenepos, das die Nationalsozialisten später für ihre Ideologie einspannten) und den realen Bedingungen am Ende einer hundertjährigen kolonialistischen Herrschaft? Wie wurde der Mythos vom Drachen wahrgenommen – von Menschen, die sich in einer Unabhängigkeitsbewegung befanden?

Ich begann, nach ähnlichem Material aus anderen Städten und Kulturen Ausschau zu halten. Ich wollte als zweite Stadt Wien haben und wählte Portugal als dritten „Schauplatz". In Archiven in Wien und Lissabon fand ich glücklicherweise zwei Filmdokumente, die ein Kino zeigten, mit Menschen davor. Als klar war, dass von den Filmen, die zu diesem Zeitpunkt in diesen Kinos liefen, zumindest einer noch erhalten war, begannen Hanna und ich, alles verfügbare Material aus dieser Zeit und von diesen Orten zu sichten.

Der Film sollte erfundene Geschichten erzählen, über die Menschen und ihr Leben, über den sozialen, kulturellen und politischen Hintergrund – unter Verwendung visueller Zeugnisse aus den jeweiligen Zeiten und Orten. Der Film fokussiert nicht auf die großen Ereignisse oder berühmte Figuren der Geschichte (obwohl auch zwei solche ins Bild gesetzt werden); es geht

cultural and political background, using visual records of the time and place. It's not the big events, the famous protagonists of History that this film is focusing on (although two of those are pictured as well); it's average individuals, daily lives, the private stories that history is actually composed of, but that are often forgotten and not respected in film.

All three countries were in a transition process at the times the films were shot. In

um durchschnittliche Menschen, alltägliches Leben, jene privaten Geschichten, aus denen die Geschichte in Wahrheit besteht, die aber oft vergessen und im Film nicht respektiert werden.

Alle drei Länder befanden sich zu der Zeit, als die Filme gedreht wurden, in einem Prozess des Übergangs. In Indonesien war das Ende der holländischen Kolonialherrschaft nahe, die österreichisch-ungarische Monarchie stand kurz vor dem Zusammenbruch und dem Eintritt in den Ersten Weltkrieg, und Portugal war am Beginn der Ära Salazar, einer Diktatur, die bis 1974 dauerte.

MacDonald: Mir fallen nur drei Beispiele ein, wo Frauen und Männer über eine lange Zeitspanne aktiv zusammengearbeitet haben: die Italiener Yervant Gianikian und Angela Ricci Lucchi; die Naturfilmer Claude Nuridsany und Marie Pérennou; und Sie und Hanna Schimek. Können Sie etwas über die Art Ihrer Zusammenarbeit erzählen?

Deutsch: Wenn wir an Filmprojekten arbeiten, dann möchte Hanna an der Recherche und Vorbereitung beteiligt sein, aber nicht am Schnittprozess teilnehmen. Wenn sie an einem Buch arbeitet, ist es genau umgekehrt. Ich arbeite mit

Indonesia the end of the Dutch colonial rule was near; the Austro-Hungarian Empire was collapsing and entering the first world war; and Portugal was just at the beginning of the dictatorship of Salazar, which lasted till 1974.

MacDonald: I only know of three instances where men and women have been active collaborators over a substantial period of time: the Italians Yervant Gianikian and Angela Ricci Lucchi; Claude Nuridsany and Marie Pérennou, the nature filmmakers; and you and Hanna Schimek. Could you talk about the nature of your collaboration?

Deutsch: When we work on film projects, Hanna wants to work on the research, but doesn't want to be involved with the editing. When she is working on a book, it's the other way around: I work with her on the research, then she takes over. In the final stage, we are "supervising artists" for each other. When I am editing a film, Hanna is my first critic; her job is to keep her distance and tell me what she sees and feels. I do the same with her work. Our finished works are separately hers and mine, though we do work closely with each other on specific phases of our projects.

Hanna has always worked with me on the research for *Film ist.*; we've developed more or less similar views about what we see. What we

ihr an der Recherche, dann übernimmt sie. In der Schlussphase sind wir jeweils „Supervising Artists" füreinander. Wenn ich einen Film schneide, ist Hanna meine erste Kritikerin. Ihre Aufgabe ist es, Abstand zu halten und mir zu sagen, was sie sieht und fühlt. Ich mache das Gleiche, was ihre Arbeit betrifft. Unsere fertiggestellten Arbeiten sind dann getrennt in ihre und meine, obwohl wir in spezifischen Phasen ganz eng zusammenarbeiten.

Von Beginn an hat Hanna mit mir an den Recherchen zu *Film ist.* gearbeitet. Wir haben ziemlich ähnliche Ansichten entwickelt über das, was wir sehen. Wichtig ist uns, dass jedes der gewählten Bilder in sich kraftvoll oder interessant sein muss. Wenn es relevant für unseren Inhalt oder Kontext, aber kein gutes Bild ist, verwenden wir es nicht.

MacDonald: Episode 1 in *Welt Spiegel Kino* endet mit einer sehr seltsamen Sequenz: eine nackte Frau und ein Mann, der sie sogar zu begraben scheint! Was können Sie mir zu diesem Material sagen?

Deutsch: Der Film stammt von der ersten österreichischen Produktionsfirma, Saturn-Film, die von 1906 bis 1911 existierte, dann wurde sie von den Behörden geschlossen. Saturn produzierte ausschließlich Filme mit erotischem Inhalt, Softpornos. Der Film, den ich verwendet habe, trägt den Titel *Das Sandbad* und zeigt eine nackte Frau, die

always understand is that any image we choose has to be powerful or interesting in itself. Even if it's relevant to the context or content we are working with, if it's not a good image, we don't use it.

MacDonald: "Episode 1" of *Welt Spiegel Kino* ends with a very strange sequence of the nude woman and the man, who seems at one point to be burying her! What can you tell me about this material?

Deutsch: This film is from the first Austrian production company, Saturn-Film; from 1906 until 1911, when they were shut down by the authorities, they produced only films with erotic content, soft-core porn. The film I used is entitled *Sandbad*, meaning "sand bath"; it shows a naked woman taking a sand bath on the outskirts of Vienna (this was a health practice, invented by Florian Berndl, the founder of the biggest open-air bath on the Danube river in Vienna—it still exists).

The man's covering the woman with sand is a metaphorical act similar to the gold rain into which Zeus transforms to impregnate Danae.

MacDonald: A more general question about the various sections of *Welt Spiegel Kino*: how much do you edit within the sequences you choose? I assume you select sequences for their interest and decide which sections are of most interest

in einem Wiener Außenbezirk ein Sandbad nimmt. Das war eine Art Gesundheitstraining, entwickelt von Florian Berndl, dem Gründer der größten Freiluftbadeanstalt an der Donau, in Wien. Es gibt diese Anlage immer noch.

Das Bedecken der Frau mit Sand durch den Mann ist eine metaphorische Handlung, ähnlich dem goldenen Regen, in den sich Zeus verwandelt, um Danae zu schwängern.

MacDonald: Eine allgemeinere Frage zu den verschiedenen Abschnitten von *Welt Spiegel Kino*: In welchem Ausmaß schneiden Sie innerhalb der ausgewählten Sequenzen? Ich nehme an, Sie wählen Sequenzen und deren Teile Ihrem Interesse entsprechend aus, aber wenn sie sich einmal für eine Passage entschieden haben, schneiden Sie dann innerhalb dieser Passage? Es gibt zum Beispiel im indonesischen Teil verschiedene Aufnahmen des Buben in der Seilbahn, während sich der Hintergrund verändert. Haben Sie diese Schnitte gemacht oder sehen wir die Originalsequenz?

Deutsch: Meistens schneide ich die Sequenzen nicht. Ich habe in der Schattentheater-Szene geschnitten, und manchmal auch dann, wenn ich mehr Einstellungen hatte, als ich verwenden wollte. Es könnte sein, dass ich die Szene geschnitten habe, die Sie erwähnen.

MacDonald: Die Absurditäten und Gesetzmäßig-

for you, but once you've chosen a passage, do you edit within that passage? For example, there are several shots of the boy on the cable car as the background changes; did you do that editing or are we seeing the original sequence?

Deutsch: Most of the time I do not edit the sequences. I did edit the shadow theater scene, and I edited sometimes when I had more scenes than I wanted to use. I may have edited the sequence you've referred to.

MacDonald: The absurdities and regularities of colonialism are a major focus in "Episode 2." In his program notes for the film in your catalogue for the film, Nico de Klerk says, "Not all colonial cinema is colonial all the time. And no colonial society is colonial all the time."

Deutsch: All the films available to me from the Nederlands Filmmuseum were made by and for colonialists, or their families back home, or their children in schools, here or there. What Nico means, I suppose, is that one should not read these films with pre-judgment only. I didn't explicitly select "colonialist moments"; there were scenes much more "colonialistic" than the ones I chose. I tried—as I did in the other two episodes as well—to select people with a certain charisma, whether they were Dutch or Indonesian. The man holding the monkey, the boy in the cable car, the shadow-puppet maker, the

Welt Spiegel Kino / Episode 2

keiten des Kolonialismus sind ein wichtiges Thema in Episode 2. In seinem Text für das Programmheft zum Film schreibt Nico de Klerk: „Nicht das ganze koloniale Kino ist die ganze Zeit kolonial. Und keine koloniale Gesellschaft ist die ganze Zeit eine koloniale Gesellschaft."

Deutsch: Alle Filme aus dem Nederlands Filmmuseum, die mir zur Verfügung standen, waren von und für Kolonialisten gemacht, oder für ihre Familien zu Hause, für ihre Kinder in der Schule, da oder dort. Ich nehme an, was Nico meint, ist, dass man diese Filme nicht nur mit Vorurteilen betrachten sollte. Ich habe nicht speziell „koloniale Momente" ausgewählt. Es gab Szenen, die sehr viel „kolonialistischer" waren als die, die ich dann ausgesucht habe. So wie in den anderen beiden Episoden habe ich hier versucht, Menschen mit einem gewissen Charisma auszuwählen, egal ob sie Holländer oder Indonesier waren. Der Mann, der den Affen hält, der Bub in der Seilbahn, der Handwerker, der die Schattenpuppen anfertigt, die drei tanzenden Mädchen, die Frau mit dem Sonnenschirm – sind das kolonialistische Momente? So wie ich den Ausdruck „kolonialistische Momente" verstehe, gibt es nur zwei davon im Film: Wenn der alte Arbeiter geehrt wird und die letzte Szene mit den Kapok-Arbeitern.

MacDonald: Haben Sie auch Bildmaterial gesucht,

das die kulturellen Praktiken Indonesiens reflektiert?

Deutsch: Ich habe nicht speziell nach solchen Bildern gesucht. Aber wie man sich vorstellen kann, waren die Dokumentationen der industrialisierten Landwirtschaft – Tabak, Kapok, Zucker, Tee, Reis – kaum auf einzelne Personen fokussiert und auch nicht sehr interessant. Als wir uns ansahen, was wir ausgewählt hatten, war ich erstaunt darüber, wie viele Tanzszenen es gab. Das waren nicht nur Aufführungen im Kontext der indonesischen Kultur, sondern auch an den Feiertagen der Holländer. Das war vielleicht typisch für die Art und Weise, in der die Holländer die indonesische Kultur in ihre eigene integrierten. Die Drachenszene zum Beispiel, die in die *Siegfried*-Szene einmontiert ist, war Teil der Feierlichkeiten für das „Huwelijksfeesten", ein niederländisches Hochzeitsfest.

MacDonald: Einmal, irgendwo in der dritten Episode, sehen wir einen Militär, der zwei Männern Orden verleiht. Wissen Sie, wer dieser Mann ist?

Deutsch: Das ist António Óscar de Fragoso Carmona, der 1926 an dem Staatsstreich von Ma-

three girls dancing, the woman with the umbrella—are these colonialist moments? As I understand the term "colonialist moment," there are only two in the film: when the old worker gets honored and the last scene with the Kapok workers.

MacDonald: Did you look for imagery that reflected Indonesian cultural practices?

Deutsch: I didn't look especially for those kinds of images. But as you might imagine, documentations of industrialized agriculture—tobacco, kapok, sugar, tea, rice—didn't focus on one person and were not very interesting. I was astonished after looking at what we selected that there were many dance sequences, performed not only in the context of Indonesian culture, but also on the holidays of the Dutch. This might have been typical of the way the Dutch integrated Indonesian culture into their own. The dragon scene that is cut into the *Siegfried* scene, for example, was part of the festivities for the "Huwelijksfeesten," a Dutch wedding celebration.

MacDonald: At one point well into the third episode, we see a military man decorating two men; do you know the identity of this man?

Deutsch: That is António Óscar de Fragoso Carmona, who in 1926 participated in the coup d´etat of Manuel de Oliveira Gomes da Costa

nuel de Oliveira Gomes da Costa teilnahm und Premierminister wurde. 1928 war er der auf Lebenszeit gewählte Präsident, aber 1932 übergab er die Macht an António de Oliveira Salazar, der bis zur Revolution 1974 als Diktator regierte. In Portugal gab es nach dem Staatsstreich das sogenannte 100-Meter-Film-Gesetz, das Kinobesitzer dazu nötigte, vor jedem ausländischen Film mindestens 100 Meter Film zu zeigen, die in Portugal produziert worden waren. Das war der Grund, warum so viele Dokumentationen über typisch portugiesische Themen gedreht wurden. (Das bot auch vielen jungen Filmemacher die erste Chance, Regie zu führen – einige von ihnen wurden später so bekannt wie Manuel de Oliveira). Deshalb sind diese Dokumentationen auch sehr gut gemacht, gut kadriert, gut ausgeleuchtet und geschnitten, im Gegensatz zu den ethnografischen Filmen aus Indonesien aus derselben Zeit.

MacDonald: Welche Anweisungen haben Sie Christian Fennesz und Burkhard Stangl für die Musik zu diesem Film gegeben?

Deutsch: Es gibt verschiedene Ebenen des Soundtracks: Originalmusik aus der Zeit und den Gegenden der drei Episoden (Wiener Volksmusik, Kronchong-Musik – eine Mischung aus indonesisch-malaysischer, portugiesischer und holländischer Musik – und Fado); dann diese gleiche

and became prime minister. In 1928 he was elected president for life, but in 1932 he gave the power to António de Oliveira Salazar, who was dictator until the 1974 revolution.

In Portugal after the coup there was the so-called law of the hundred meters of film, forcing cinema owners to show at least hundred meters of film produced in Portugal before each foreign film. This was the reason why many documentaries were produced about typically Portuguese subjects (it's also how young filmmakers—some of whom later became well known, like Manuel de Oliveira—got their first chance to direct films). And that's why these documentaries are very well made, well framed, lighted and edited, in contrast to the ethnographical films from Indonesia of the same period.

MacDonald: What directions did you give Christian Fennesz and Burkhard Stangl about the music for this film?

Deutsch: There are several levels of the soundtrack: original music from the times and places of the three episodes (Viennese folk music; Kronchong music—a blend of Indonesian/Malaysian, Portuguese and Dutch music; and Fado); this same music transcribed and interpreted by the musicians; and compositions by the musicians (themes for different groups of people in

157

Musik in der Transkription und Interpretation der Musiker; und schließlich Kompositionen der Musiker (Themen für verschiedene Personengruppen im Film). Zuletzt wurde ein belgischer Cellospieler eingeladen, zum geschnittenen Film zu improvisieren (diese kontinuierliche Tonspur wird während des Films ein- und ausgeblendet).

Bis auf diese vierte Ebene war die Vorgangsweise die gleiche wie bei *Film ist.*: Ich hatte eine Sound-Bibliothek mit der gesamten Musik auf dem Computer, platzierte die Töne während des Schnitts, diskutierte das Resultat dann mit den Musikern, überarbeitete es und ließ Christian Fennesz den End-Mix machen.

MacDonald: Mich erinnert dieses Projekt an Ken Jacobs' *Tom, Tom, the Piper's Son* (1969, 1971). War das Werk von Jacobs zentral für Ihre Überlegungen?

Deutsch: *Tom, Tom, the Piper's Son* ist ein Schlüsselfilm.

MacDonald: Wir haben vorher Péter Forgács erwähnt; kennen Sie *Dal polo all'equatore* von Gianikian und Ricci Lucchi? Ein wiederum ganz anders gearteter Found-Footage-Film über das Kino als Speerspitze des Imperialismus. Ich nehme an, Sie kennen auch Matthias Müller und seine Arbeit – der erste Teil von *Film ist. 7.1* erinnert an seine *Home Stories* (1990).

the film). Finally, a Belgian cello player was invited to improvise with the edited film (this continuous track fades in and out throughout the film).

Other than this 4th level, the procedure was the same as in *Film ist. 7–12*: I had a sound library with all the music in the computer, and I placed the sounds during the editing, then discussed the result with the musicians, revised it, and had the final mixing done by Christian Fennesz.

MacDonald: This project reminds me of Ken Jacobs' *Tom, Tom, the Piper's Son* (1969, 1971). Has Jacobs' work been important in your thinking?

Deutsch: *Tom, Tom, the Piper's Son* is a key film.

MacDonald: Do you know Gianikian and Ricci/Lucchi's *From the Pole to the Equator?*—a very different found footage film about cinema as the spearhead of empire. We mentioned Péter Forgács earlier. I assume you know Matthias Müller and his work—the early part of *Film ist. 7.1* is reminiscent of his *Home Stories* (1990).

Deutsch: I like *From the Pole to the Equator* very much. I also know *Home Stories*. I am good friends with all of these filmmakers. I include their films when I am curating programs, or giving lectures, and I invited Péter Forgács to Greece to show his *Angelos Film* (1999) as part of the *Light/Image* project Hanna and I realized in

Deutsch: Ich mag den Film von Gianikian und Ricci Lucchi sehr gerne und kenne auch *Home Stories*. Mit all diesen Filmemachern bin ich befreundet und zeige ihre Filme, wenn ich Filmprogramme kuratiere oder Vorlesungen halte. Péter Forgács habe ich nach Griechenland eingeladen, sein *Angelos' Film* (1999) war Teil des *Licht/Bild*-Projekts, das Hanna und ich in Aegina 2005 realisiert haben. Es war das erste Mal, dass die Tochter von Angelos den Film gesehen hat, und ich war sehr erfreut, sie kennenzulernen.

MacDonald: Wie *Film ist.* endet auch *Welt Spiegel Kino* mit den Worten „to be continued". Sind weitere Episoden in Vorbereitung? Um welche Gegenden der Welt wird es gehen?

Deutsch: Ich möchte weitermachen, aber mit einem anderen Aspekt des Themas, wie Kino die Welt spiegelt und umgekehrt. Zuerst muss ich allerdings die Fortsetzung von *Film ist.* fertigstellen.

MacDonald: Ich habe gehört, dass bei dieser Fortsetzung von *Film ist.* das Kinsey Institute beteiligt ist.

Deutsch: Der Fokus von *Film ist.*, Kapitel 13, ist eines der ersten und grundlegenden Themen des Kinos: die Konfrontation der Geschlechter. Für diese neue Arbeit nutze ich wieder meine ursprüngliche Zitatensammlung; der Titel ist *Film ist. a girl & a gun* – bezugnehmend auf ein

Aegina, Greece in 2005. It was the first time that the daughter of Angelos saw the film, and I was very pleased to meet her.

MacDonald: Like *Film ist.*, *Welt Spiegel Kino* ends "to be continued." Are further episodes in progress? What parts of the world are involved?

Deutsch: The idea is to continue with a different aspect of how Cinema mirrors World, and vice versa. But first, I have to finish the continuation of *Film ist.*

MacDonald: I understand that the *Film ist.* continuation involves the Kinsey Institute.

Deutsch: The focus of *Film ist.*, Chapter 13 is one of the first and primary subjects of cinema: the confrontation of the sexes. For this new work, I've gone back to my original collection of quotes; the title will be *Film ist. a girl & a gun*— referring to a quote by D.W. Griffith that was reused by Godard in one of his films. This phrase, "All you need to make a film is a girl and a gun," has raised a lot of questions in my head: what exactly could Griffith have meant? The two words are a weird combination, but they imply a lot about the confrontation of the sexes. Of course, there's a very appropriate answer from feminists, which is "All you need to stop a sexist is a girl *with* a gun."

Hanna and I were in Bloomington in December, 2007, for two weeks. They let us view the

Zitat von D. W. Griffith, das Godard in einem seiner Filme wiederverwendet hat. Diese Formulierung – „All you need to make a film is a girl and a gun" – hat in bei mir eine Menge Fragen ausgelöst: Was genau könnte Griffith damit gemeint haben? Es ist eine seltsame Kombination zweier Wörter, aber sie verraten viel über die Konfrontation der Geschlechter. Natürlich gibt es eine sehr passende Antwort von Seiten der Feministinnen: „Alles was man braucht, um einen Sexisten zu stoppen, ist ein Mädchen mit einer Waffe."

Hanna und ich waren im Dezember 2007 zwei Wochen lang im Kinsey Institute in Bloomington. Wir durften die Filmsammlung auf DVD sichten und wählten etwa 40 Filme aus, die wir dann auf einem Schneidetisch anschauen konnten. Die Sammlung ist in einem fürchterlichen Zustand; niemand hat sich um die Filme gekümmert, seit Kinsey sie gekauft oder geschenkt bekommen hatte. Die Universität stellt gewisse Geldmittel zur Verfügung, aber das Archiv ist ständig auf der Suche nach Partnern. Derzeit arbeiten sie an einem Projekt über ältere Paare, das vom Pharmakonzern Bayer finanziert wird.

Alle Filme des Kinsey Institute sind Stummfilme. Ich habe natürlich keine Vorstellung davon, wie diese Filme realiter vorgeführt wurden. Ich kann mir nicht vorstellen, wie fünf

collection on DVD and we selected about forty films, which we were able to look at on an editing table. The collection is in a terrible state; nobody has taken care of the films since they were originally bought by Kinsey or given to him. The University provides limited funding, but the archive is continually looking for partners. Right now they're working on a project on elderly couples, which is being financed by Bayer, the pharmaceutical company.

All films are silent. Of course, I have no idea how these films were really shown. I cannot imagine five men sitting in front of a screen watching a porn film in silence. I can imagine *one* man watching, but not five. I suppose the films were accompanied by music.

It was too expensive for me to make prints of the films I wanted to be able to use, especially since the films are in such bad shape, so I decided to send a cameraman from Vienna: he filmed thirty-two films in HD.

Our experience was that after three days of watching stag films, they became like objects produced on a conveyor belt. Sometimes the sex is disgusting because you have the feeling nobody is enjoying it. But I must also admit that for Hanna and me, even after watching two weeks of porn films eight hours a day, there would be a sequence that would arouse us. After awhile

Film ist. a girl & a gun (2009)

Männer vor einer Leinwand sitzen und sich in
aller Stille einen Pornofilm anschauen. Ich kann
mir einen einzelnen Mann vorstellen, aber nicht
fünf. Ich nehme an, es gab Begleitmusik zu den
Filmen.

Es war zu teuer, neue Kopien jener Filme zu
ziehen, die ich verwenden wollte, umso mehr,
als sie in so schlechtem Zustand sind. Also
schickte ich einen Kameramann aus Wien hin;
er filmte 32 Filme auf HD ab.

Wir machten die Erfahrung, dass diese Stag-
Filme nach dreitägigem Anschauen wie Objekte
vom Fließband werden. Manchmal ist der Sex
abstoßend, weil man das Gefühl hat, dass ihn
niemand genießt. Aber ich muss auch zugeben,
dass Hanna und ich, nachdem wir zwei Wochen
lang acht Stunden am Tag Pornofilme gesehen
hatten, immer noch einzelne Sequenzen sahen,
die uns erregten. Nach einer Weile glaubt man,
dass das nicht mehr möglich ist, aber erstaunli-
cherweise geschieht es doch, als Resultat einer
kleinen Bewegung im Bild, oder von etwas, das
man schwer beschreiben kann.

Eine Sache war auffällig – dass in den Porno-
filmen der 1920er Jahre, oder aus der Zeit davor,
die Körper so anders aussehen. Das merkt man
auch bei den Softpornos der Saturn-Film von
1906 oder 1908. Die Frauen sind alle nackt, und
es sind Körper, die ich von den Fotografien mei-

ner Großmutter kenne! Es war faszinierend, über diese Unterschiede nachzudenken – die Ästhetik dessen, was „sexy" ist, sieht heute vollkommen anders aus.

MacDonald: Gibt es noch etwas, das sie zu einem Ihrer Filme sagen möchten?

Deutsch: Ich glaube, es war Jean Renoir, der einmal ungefähr Folgendes gesagt hat: „Wenn ich meine Filme im Detail erklären könnte, wäre ich ein Schriftsteller." Bei keinem meiner Filme kann ich wirklich ganz genau erklären, warum ich bestimmte Einstellungen ausgewählt habe, oder warum ich bestimmte Szenen miteinander kombiniere, und was diese spezifischen Kombinationen bedeuten. Und selbst wenn ich glaube, es zu wissen, bin ich nicht sicher, ob es sinnvoll wäre, das zu erzählen, weil es wiederum andere Lesarten verhindern könnte.

you think this cannot happen, but astonishingly it does happen, as a result of some small movement or something very hard to define.

One thing that struck us is that in the porn from the 1920s and earlier, the bodies look so different. You can see this also in the soft-core films produced by Saturn Film from about 1906 to 1908. The women are all naked and these are bodies I recognize from pictures of my grandmother! The aesthetic of "sexy" is so different now, which was fascinating to realize and think about.

MacDonald: Anything further you'd like to say about any of these films?

Deutsch: I think it was Jean Renoir who once said something like, "If I could explain my films in detail, I would be a writer." With any of my films, I am really not able to explain precisely why I choose particular shots or why I combine particular film scenes, and what the meanings behind specific combinations are. And even if I think I know, I am not sure it is useful to tell, because telling might hinder other possible interpretations.

Tom Gunning

Vom Filmfossil zu einer filmischen Schöpfungsgeschichte
From Fossils of Time to a Cinematic Genesis

Gustav Deutsch's Film ist.

„Found Footage" – die Wiederverwertung vorgefundenen Filmmaterials in der Bearbeitung späterer FilmemacherInnen – bedeutete einen Markstein in der Filmtheorie und Filmproduktion. In seinem berühmten Experiment kombinierte Lev Kulešov mit seinen Studenten in den Revolutionsjahren der Sowjetunion ein und dieselbe Einstellung des Schauspielers Ivan Mosjukin (in der dieser eher neutral blickt) mit einer Reihe weiterer Aufnahmen (genannt werden meistens: ein Teller Suppe, ein totes Kleinkind und eine spärlich bekleidete Frau), um eine Palette verschiedenster Gemütsregungen zu erzeugen (als da wären: Hunger, Kummer und Lust). Das von Filmemachern und Theoretikern von Hitchcock bis Deleuze gerne zitierte Mosjukin-Experiment faszinierte und fasziniert vor allem Theorie-affine Filmemacher wie Godard, Pudovkin und Hollis Frampton – und zwar zu Recht, denn es war dazu gedacht, Filmstudenten die Logik ihres Handwerks nahe zu bringen. Für Kulešov belegte das Experiment die Macht der Montage: durch Aneinanderreihung wird Bedeutung geschaffen, filmische Einstellungen müssen folglich synthetisch gelesen werden. Für sich allein bleibt jede Aufnahme bedeutungsneutral, verstanden werden kann sie nur durch Kontextualisierung. Die Einstellung mit Mosjukin bezog ihre Bedeutung aus dem

"Found footage"—the recycling of previously shot film, reworked by later filmmakers—defined a founding moment in both film theory and filmmaking. As is well known, Lev Kuleshov and his students in the revolutionary USSR intercut the same shot of the actor Mozhukin (with a rather neutral expression) with a variety of other shots (usually described as: a bowl of soup, a dead baby and a scantily clad woman) in order to produce widely differing affects (respectively: hunger, sorrow and lust). Referenced by theorists and filmmakers from Hitchcock to Deleuze, the Mozhukin experiment has particularly fascinated theoretically inclined filmmakers such as Godard, Pudovkin, and Hollis Frampton—appropriately so, since it was designed to instruct film students in the logic of their craft. For Kuleshov the experiment demonstrated the power of editing to create meaning through juxtaposition, demonstrating that cinematic shots must be read synthetically. Each shot in isolation remains neutral in its meaning; it can only be read through contextualization. The shot of Mozhukin gained its meaning from the cut that juxtaposed it to another shot. A single shot in itself means nothing—or potentially can mean *anything*. According to Kuleshov, a film's meaning therefore comes not from the act of filming, but from the act of splicing.

163

Schnitt, der ihr eine andere Einstellung gegenüberstellte. Ein einzelnes Bild bedeutet für sich genommen nichts – oder kann potenziell *alles* bedeuten. Laut Kulešov entsteht die Bedeutung eines Films also nicht beim Filmen, sondern beim Zusammenkleben.

Ich möchte die Lektion dieses Experiments von seiner ursprünglichen Beweisabsicht weg verlagern und mich auf das Material konzentrieren, das der Transformation zugrunde liegt: die bereits existierende Aufnahme Mosjukins. Kulešov benötigte für seine Demonstration nicht unbedingt Found Footage (obwohl Berichten zufolge Rohfilm in der Sowjetunion nach der Revolution Mangelware war, sodass er sich gezwungen sah, den Ausschuss des vorrevolutionären russischen Kinos zu durchstöbern). Doch die Entscheidung zeitigte starke Wirkung. Die Verwendung des vertrauten Gesichts eines mittlerweile emigrierten Filmstars verlieh Kulešovs Experiment eine polemische Note. Der Schnitt lud nicht nur neutrales Material mit spezifischen Bedeutungen auf, er verwarf auch all die reaktionär-bourgeoisen Bedeutungen, die das vorrevolutionäre Material ursprünglich vermitteln sollte. Man könnte behaupten, dass Kulešovs ikonoklastische Hermeneutik sich auch als Macht über die Zeit manifestierte, da sie die Bedeutung eines Filmfossils mit der ex-

I want to shift the lesson of this demonstration from its intended QED about the power of montage, and focus instead on the material underlying its transformation: the preexisting shot of Mozhukin. Kuleshov's demonstration did not necessarily demand using found footage (although according to some accounts the scarcity of raw stock in the post-revolutionary USSR compelled Kuleshov to scavenge among the leavings from pre-revolutionary Russian cinema). However, the choice had strong effects. The use of the familiar face of émigré movie star Mozhukin gave Kuleshov's experiment a polemic edge. Editing not only imposed specific meanings on neutral material, but also overcame whatever reactionary bourgeois meanings the pre-revolutionary footage originally intended to convey. One could claim that Kuleshov's iconoclastic hermeneutics also asserted a power over time, overcoming a fossilized meaning with the explosive dynamics of a new cut. While Kuleshov may not have specifically seen this renewal of old material as demonstrating montage's revolutionary potential, the other major advocate and theorist of the praxis of montage in early revolutionary Russia, Esfir Shub, certainly did. In her compilation film *The Fall of the Romanov Dynasty*, Shub's montage redefined pre-revolutionary footage of the Czar's

plosiven Dynamik eines neuen Schnitts überwand. Kulešov mag diese Erneuerung alten Materials nicht speziell als Beweis für das revolutionäre Potential der Montage gesehen haben, aber Esfir Šub, die zweite große Befürworterin und Theoretikerin der Montage in den frühen Revolutionsjahren der Sowjetunion, tat es ganz gewiss. In ihrer Montage des Kompilationsfilms *Der Fall der Dynastie Romanov* (1927) vollzog sie eine Neudefinition des vorrevolutionären Filmmaterials über die Zarenfamilie und das russische Reich; in den frühen 1920er Jahren stellte sie mit ihrem Schüler Sergej Eisenstein Schnittfassungen ausländischer Filme her, um deren ideologische Botschaft zu verändern.

Während der Begriff „Found Footage" die Rolle des Zufalls – die in der surrealistischen Ästhetik gefeierte *trouvaille* – hervorhebt, veränderte die Verwendung vorgefundenen Filmmaterials meiner Ansicht nach vor allem die Temporalität des Filmbildes. Wie Robbe-Grillet einmal sagte, scheint das Kino immer im Präsens zu stehen: Wir sehen Handlungen vor uns ablaufen. Doch das Kino hat – zumindest in seinen fotografischen Aspekten – auch etwas von der Vergangenheitsform des fotografischen Bildes: die Spur des Vergangenen, die Botschaft, die laut Roland Barthes alle Fotografie verkündet – „Das ist gewesen." Das Filmbild wirkt demnach

family and the Russian empire, as did the re-editing of foreign films to change their ideological message that she undertook with her pupil Sergei Eisenstein in the early twenties.

While the term "found footage" highlights the role of chance, the lucky *trouvaille* celebrated in surrealistic aesthetics, to my mind the use of cinematic found footage primarily transformed the temporality of the cinematic image. As Robbe-Grillet once theorized, cinema seems restricted to the present tense: we see actions unfolding before us. However, cinema, at least in its photographic aspects, also partakes of the past tense of the photographic image, the trace of the past, the message that Roland Barthes claimed all photography proclaims: "This has been." The cinematic image therefore operates in two different temporalities simultaneously. On the one hand, the moving image's present tense shows actions in the course of unfolding; while on the other hand, as a photographic trace, film consists of records of past events. The context, genre and stylistics of individual films privilege one aspect over the other (even to the extent of nearly repressing, although never totally eradicating, signs of one or the other). The fictional film usually foregrounds the present tense of unfolding action with effects of anticipation, suspense, and immediate involve-

simultan in zwei Zeitlichkeiten. Einerseits zeigt das Präsens des bewegten Bildes Handlungen im Lauf ihrer Abfolge, andererseits besteht Film – als fotografische Spur – aus Aufzeichnungen vergangener Ereignisse. Kontext, Genre und Stil der einzelnen Filme privilegieren jeweils einen der beiden Aspekte (manchmal so stark, dass die Anzeichen des anderen unterdrückt, wenn auch nie zur Gänze beseitigt werden). So rückt der Spielfilm üblicherweise – mittels Antizipation, Suspense und unmittelbarer Anteilnahme – das Präsens sich entfaltender Handlungen in den Vordergrund, während der Dokumentarfilm eher zum Vergangenheitsaspekt tendiert, zur Aufzeichnung eines Geschehens, das sich bereits ereignet hat.

Das Kino der Avantgarde spielt häufig mit der Spannung zwischen diesen Modi filmischer Zeit. Wie William Wees gezeigt hat, nimmt Found Footage in Nordamerika und Europa eine zentrale Rolle im Avantgardefilm ein und stellt beinahe schon ein Genre für sich dar. Mehr als den Zufallscharakter des glücklichen Fundes unterstreicht Found Footage im Kino den Vergangenheitsaspekt der Bilder: Dieses Bild hat schon vor diesem Film existiert, für gewöhnlich in einem anderen Kontext. Experimentelle Filmemacher unterziehen das vorgefundene Material natürlich zahlreichen technischen Mani-

ment, while the documentary film tends to foreground the past tense aspect of recording an event which has already occurred.

Avant-garde or experimental cinema frequently plays on the tension between these modes of cinematic time. As William Wees has shown, in the past few decades especially, found footage has played a major role in avant-garde cinema in both North America and Europe, almost constituting a genre in itself. More than the chance-like nature of a lucky find, found footage in cinema tends to emphasize the pastness of the image: This image existed before this film, usually in a different context. Experimental filmmakers, of course, subject found footage to a range of technical manipulations and adopt a variety of tones—from the pop-art satirical collage of iconic mass cultural images by the late Bruce Conner to the utterly transformed, nearly unidentifiable, oneiric working-over of found images in the *Twilight Psalm* series of Phil Solomon (especially such films as *Walking Distance*, or *Night of the Meek*). I do not want to reduce the complexity of this cinema of appropriation to a limited number of themes, since found footage refers to material rather than final result and that result can be wide-ranging. But the use of found footage, from the experiment of Kuleshov on, brings the paradoxical nature of

pulationen und schlagen verschiedenste Tonlagen an – von der satirischen Pop Art-Collage ikonischer Bilder der Massenkultur bei Bruce Conner zur gänzlich veränderten, nahezu unidentifizierbaren und traumähnlichen Überarbeitung gefundener Bilder in Phil Solomons Serie *Twilight Psalm* (vor allem in Filmen wie *Walking Distance* oder *Night of the Meek*). Ich möchte die Komplexität dieses Kinos der Appropriation nicht auf einige wenige Themen reduzieren, da Found Footage eher das Material denn das Endresultat benennt – und das kann breit gefächert sein. Doch die Verwendung von Found Footage, angefangen bei Kulešovs Experiment, bringt die paradoxe Natur der filmischen Zeitlichkeit, ihre Verflechtung von Vergangenheit und Gegenwart auf den Punkt. Gustav Deutschs Filme haben eine große Bandbreite existierenden Materials verarbeitet, von Amateurfilmen über Lehr- und Wissenschaftsfilme bis hin zu Pornos und Spielfilmen aus dem frühen und klassischen Kino. Jeder Deutsch-Film hat seine individuelle Gestalt, und selbst innerhalb der Serie *Film ist.* sind die Variationen bemerkenswert. Doch innerhalb dieser Variationen kehrt eines immer wieder: das Nachdenken über filmische Zeit.

Das experimentelle Kino erforscht Bruchlinien, wagt sich auf trügerischen Boden und

cinematic temporality, its intertwining of effects of past and present, to a boil. The films of Gustav Deutsch have worked over a range of preexisting footage, from home movies, to educational and scientific films, to pornographic films, to fiction films from both early and classical cinema. Each film he has made has its own individuality, and even within his series *Film ist.* the variations are striking. But within these variations a meditation on cinematic time recurs.

Experimental cinema explores fault lines, slides down slippery slope, evades definition by definition. Rather than exemplifying theoretical issues of cinematic temporality, the films of Deutsch, like other found footage films, play with diverse possibilities. Therefore a critic like myself needs to avoid freezing this dynamic into a theoretical statement. But in this brief essay I want to explore the implications of Deutsch's found footage film for both temporality and the mechanics of meaning in cinema. To shift a bit from my initial focus on temporality to the more traditional semantic approach to Kuleshov's experiment, the use of footage implies a radical decontextualization and redefinition. Whatever the meaning or intention originally tied to this footage, that tie has been loosened. Kuleshov's method was to supply a *new* context, to supply a new meaning. While the avant-garde seized

entzieht sich per definitionem Definitionen. Anstatt theoretische Fragen filmischer Temporalität zu veranschaulichen, spielen Deutschs Filme, wie andere Found-Footage-Filme auch, lieber mit verschiedenen Möglichkeiten. Ein Kritiker wie ich muss es deshalb tunlichst vermeiden, diese Dynamik in einem theoretischen Statement einzufrieren. Ich möchte jedoch in diesem kurzen Essay ausloten, welche Auswirkungen Deutschs Found-Footage-Arbeit auf die Frage der Zeitlichkeit und der Bedeutungsmechanik im Kino hat. Wenn wir den Fokus noch einmal kurz von der Zeitlichkeit zur traditionellen semantischen Lesart von Kulešovs Experiment zurück verlagern, dann impliziert die Verwendung von existierendem Filmmaterial eine radikale Dekontextualisierung und Neudefinition. Egal mit welcher Bedeutung oder Absicht das Filmmaterial ursprünglich befrachtet gewesen sein mag – diese Fracht wurde gelöscht. Kulešovs Methode war es, einen *neuen* Kontext, eine neue Bedeutung zu liefern. Die Avantgarde griff das dynamische Umdeuten begierig auf, aber spätestens seit Bruce Conners Frühwerk lief diese Methode häufig auf Ambiguität und Mehrdeutigkeit hinaus. Kulešov demonstrierte seine Kontrolle über die Bedeutung, während Conner und andere das Bild in ein breites Spektrum von – politischen, sexuellen und anar-

upon this dynamic redefinition of meaning, from at least Bruce Conner's early works, this redefinition often celebrated ambiguity and equivocation. Kuleshov demonstrated his control of meaning, while Conner (and others) liberated the image into a wide range of associations—political, sexual and anarchic. Kuleshov displayed the semantic power of editing; found footage films in the late twentieth and early twenty first century rerouted this power, multiplying rather than defining it.

In the segments 1–6 of *Film ist.*, Deutsch radically separates images from the films he draws on from their original context. Since many of the films in this first part of the series are from educational or scientific films, this original exhibition context defined their original meaning. These films generally served as part of a course of instruction on such things as animal behavior, physiology or the nature of the larynx. In some avant-garde found footage films (such as the extraordinary work of Abigail Child or Leslie Thornton) scientific footage wavers between metaphor and sensational attraction as a whole new context is created. In the *Film ist. 1–6* series, one strongly senses the original purpose of pedagogy in the nature of the footage. A tone of instruction dominates: from the subject matter focused on; to composition and lighting; to the

Film ist. Ein Augenblick (1998)
Film ist. Bewegung und Zeit (1998)

chischen – Assoziationen entließen. Kulešov
zeigte die semantische Macht des Schnitts auf,
die Found-Footage-Filme im späten 20. und frü-
hen 21. Jahrhundert leiteten diese Macht um, ver-
vielfachten sie lieber, anstatt sie zu definieren.

In den Kapiteln 1 – 6 von *Film ist.* löst Gustav
Deutsch Bilder der Filme, die er verwendet, ra-
dikal aus ihrem ursprünglichen Kontext. Viele
Stücke in diesem ersten Teil der Serie stammen
aus Lehr- oder Wissenschaftsfilmen und dieser
Rezeptionskontext definierte ihre ursprüngli-
che Bedeutung. Die Filme waren zumeist Teil
von Lehrkursen zu Themen wie Tierverhalten,
Physiologie oder der Funktionsweise des Kehl-
kopfs. In einigen Found-Footage-Avantgardefil-
men (wie den außergewöhnlichen Arbeiten von
Abigail Child oder Leslie Thornton) schwankt
das wissenschaftliche Filmmaterial zwischen
Metapher und Sensation, und es wird ein voll-
ständig neuer Kontext geschaffen. In *Film ist. 1–*
6 ist der ursprüngliche pädagogische Zweck in
der Machart des Filmmaterials noch immer
stark spürbar. Der Grundton ist belehrend: an-
gefangen bei der behandelten Materie über die
Komposition und das Licht bis hin zu den beim
Drehen eingesetzten Methoden (Zeitlupe oder
Stop-Motion, Röntgenaufnahmen) und den im
Film vorgeführten wissenschaftlichen Messge-
räten. Allerdings hat Deutsch die Filme ihrer

ursprünglichen Begleitkommentare entledigt. Ohne diese beruhigenden Erklärungen wirkt ein Gutteil des Filmmaterials befremdlich, traumartig, erschreckend oder amüsant, grotesk. Die Bilder werden nicht wegen der Information, die sie enthalten, verarbeitet, sondern präsentieren sich uns in all ihrer Seltsamkeit. Deutsch ersetzt offenbar das ursprüngliche durch sein eigenes pädagogisches Projekt. Die Titel der Serie lenken unsere Aufmerksamkeit auf einen Aspekt, der den ursprünglichen Filmemachern ganz transparent erschienen sein mag, nämlich das Medium Film. Von der Funktion befreit, wissenschaftliche Daten aufzuzeichnen, offenbaren diese Filme das Wesen des Kinos als bewegtes Bild, seine Affinität zu den Bewegungen physischer Körper und wissenschaftlicher Instrumente, seine Kontrolle über die Zeit und den Sehsinn. Und wieder taucht die duale Zeitlichkeit auf. Das Gefühl der Überraschung und Entdeckung, das wir erleben, während diese Bilder vor uns tanzen, trägt stark die Zeitform des Präsens, da die Bewegung vor unseren Augen abläuft. Unsere Wahrnehmung der Bilder als Daten, ihre Rolle bei der Aufzeichnung wissenschaftlicher Vorführungen, die bereits stattgefunden haben, betont hingegen die Vergangenheit. Beide Aspekte erscheinen aus dem vertrauten Rahmen genommen: Wir sind

devices used in the shooting process (slow motion or stop motion, x-ray photography); as well as the presence in the footage of scientific instruments of measurement. Yet Deutsch has stripped these films of the explanations of physiology or psychology that originally accompanied them. Without these reassuring explanations, much of the footage seems strange, dream-like, horrifying or amusing, grotesque. Instead of being processed for the information they hold, these images confront us in all their oddness. Deutsch seems to substitute his own pedagogic project for the original one. The series' titles direct our attention to an aspect that the original filmmakers may have considered transparent: the film medium itself. Liberated from the function of simply recording scientific data, these films display the nature of cinema as a moving image, cinema's affinity with the motions of physical bodies and scientific instruments, its control of time and vision. And the dual sense of temporality returns. The sense of surprise and discovery we experience as these images pirouette before us carries a strong present tense, as the movement unfolds before us. Yet our perception of the images as data, their role in recording scientific demonstrations that had already occurred, accents the past tense. Both these aspects appear defamiliarized; we

Film ist. Ein Instrument (1998)

ebenso fasziniert (und manchmal abgestoßen) von der Bewegung der Körper wie vom wissenschaftlichen System, dem das Bild unterworfen wird.

Der wissenschaftliche Kontext eines Großteils dieser Bilder evoziert jedoch noch ein weiteres Zeitsystem. Die wissenschaftliche Darstellung trachtet danach, eine Abstraktion der Zeit zu präsentieren, in der der singuläre Moment zugunsten unveränderlicher Naturgesetze verschwindet. In den Kapiteln 1–6 von *Film ist.* bleiben die Bilder jedoch nie einfach in dieser abstrakten Zeit: Konkrete Zeit, Historizität, dringt in die Bilder ein. Die Kleidung, die die Menschen tragen, die Farbenpalette des Filmmaterials, die Ausstattung – all diese Hintergrunddetails tendieren dazu, die Bilder in einer spezifischen Zeit zu verankern, der die Filme sonst zu entkommen versuchen. Die Bedingtheit der wissenschaftlichen Demonstration, ihre Verwurzelung in bestimmten Verhaltensformen, nicht weniger als im Fall der Kleider- und Haarmode, breitet sich vor uns aus. Dennoch verschwinden die grundlegenden Gesetze von Bewegung und Physiologie nicht einfach in dieser Matrix von Zeitbezügen. Diese kontrastierenden Elemente, die abstrahierten wissenschaftlichen Gesetze und die bedingten filmischen Details, umschlingen einander und beschreiben jenen

are as fascinated (and sometimes repelled) by the motion of bodies as by the scientific regimen to which the image is subjected.

But the scientific context of much of this imagery evokes another temporal regime. Scientific demonstration strives to present an abstraction of time in which the unique moment disappears in favor of the unchanging laws of nature. However, in Sections 1–6 of *Film ist.* the images never rest simply in this abstract time. Time seeps into the images. The clothes people wear, the color of the film stock, the nature of décor — all these background details tend to anchor these images in a specific time that otherwise the films strive to evade. The contingency of the scientific demonstration, its rootedness in certain styles of behavior and attitude as much as clothing or hairstyle swims before us. And yet the fundamental laws of motion and physiology do not simply disappear into this matrix of period reference. These contrasting elements of abstracted scientific laws and contingent filmic details twine about each other, defining a *pas de deux* that seems to underlie much of *Film ist.* as a whole: an interaction between funda-

171

Pas de deux, der einem Gutteil von *Film ist.* zugrunde zu liegen scheint: eine Interaktion zwischen fundamentalen Gesetzen, Trieben und Kräften einerseits und ihren materiellen Manifestationen und individuellen Identitäten andererseits. Deutsch recycelt nicht bloß alte wissenschaftliche Filme, er zeigt das doppelte Wesen des Kinos auf: seinen Sinn für große und wiederkehrende Muster und seine Affinität zum Besonderen und Einzigartigen.

Die Kapitel 1–6 untersuchen nicht nur den wissenschaftlichen Aspekt des Kinos, sondern auch Deutschs eigenes pädagogisches Vorhaben – einen Entwurf der Grundlagen des Kinos. Der zweite Teil von *Film ist.*, Kapitel 7–12, konzentriert sich auf die historische Dimension des Kinos. Das deutsche Wort *Geschichte,* wie das französische *histoire*, bedeutet sowohl *history* als auch *story*. *Film ist. 7–12* greift den filmischen Aspekt dieser Wechselbeziehung zwischen Narrativ und Historie auf und evoziert das Erzählen von Geschichten und das Überliefern von Tradition. Wie *Film ist.* insgesamt, setzen die Kapitel 1–6 stark auf den Schnitt, manchmal wird dabei die Abfolge des Originalmaterials beibehalten, manchmal werden neue Gegenüberstellungen geschaffen. In Kapitel 1–6 erzeugt die Einstellungsfolge ein Gefühl von Rhythmus und Ablauf, während in der zweiten Serie eher die

mental laws, urges and forces, and their material manifestations and individual identities. Rather than simply recycling old scientific films, Deutsch demonstrates the double nature of cinema: its eye for general pattern and recurrence along with its affinity for the particular and unique.

Episodes 1–6 not only explore the scientific aspect of cinema, but Deutsch's own pedagogic project of laying out the fundamentals of cinema. The second group of *Film ist.*, episodes 7–12, focuses on the historical dimension of cinema. The double aspect of history explored in this section can be expressed linguistically in French and German, but unfortunately is less immediate in English. German *Geschichte,* like French *histoire*, translates as both history and story. Section 7–12 of *Film ist.* takes up the cinematic aspect of this interrelation of narrative and history, evoking the telling of stories and the carrying on of tradition. Episodes 1–6 like all of *Film ist.* rely heavily on editing, sometimes preserving the sequence of original footage, and sometimes creating new juxtapositions. In Episodes 1–6, the succession of shots convey a sense of rhythm and process, rather than the devices of suspense, mystery or comic gags that dominate the second series. The material used in Episodes 7–12 comes from a different sort of

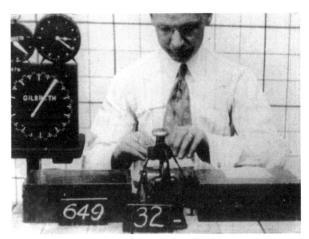

Film ist. Ein Instrument (1998)

Kunstgriffe Suspense, Geheimnis oder Slapstick dominieren. Das in Kapitel 7–12 verwendete Material gehört einem anderen Archiv an als die vorwiegend pädagogischen Filme der vorangegangenen Serie. Diese Bilder, die in erster Linie aus den Anfangsjahrzehnten der Filmgeschichte stammen, beinhalten zwar das für den frühen Film charakteristische Aktualitätenkino, eröffnen jedoch einen ganz anderen Kontext: Sie waren primär für das Publikum im Kino gedacht, sie sollten die Schaulust befriedigen, Auge und Fantasie verführen, nicht belehren. Die Bilder verfolgten keinen pädagogischen Zweck, sondern luden – als Reiseberichte oder fiktive Abenteuer – die Zuschauer in ihre filmischen Welten ein. Obwohl Deutsch diese Bilder aus ihren Originalgeschichten herausbricht, ist noch immer spürbar, dass sie Teil eines größeren Ganzen, Bruchstücke einer fehlenden Erzählung sind. Als Fragmente verweisen sie auf ungesehene, zukünftige erzählerische oder enthüllende Momente. Sie enthalten immer noch einen narrativen Wert und eine Energie, die Deutsch von ihnen ablöst, ohne sie dabei zu zerstreuen.

Somit ist nicht nur die Zeitform, die in diesem Abschnitt wirkt, eine andere, es entsteht auch eine andere Dialektik zwischen dem Vergangensein der Geschichte und der Unmittelbarkeit der Handlung. Die Bilder erscheinen

archive than the primarily educational films that appear in the earlier series. Drawn primarily from the first decades of cinema history, these images, while including the actuality footage so essential to early filmmaking, presents films from a very different exhibition context than the first series. These films were primarily intended for theatrical audiences and address the pleasures of sight, the seductions of eye and fantasy, more than the discipline of education. Rather than forming part of a pedagogic demonstration, these images invited spectators to enter their cinematic worlds, whether as travelogues or fictional adventures. Although Deutsch pries these images loose from their original stories, nonetheless one senses them as part of a larger whole, fragments of an absent story. As fragments they refer to unseen future moments of narrative or revelation. Even separated from their original context, these images still have a narrative valence and momentum, an energy Deutsch abstracts from them, but does not dissipate.

Thus not only does a different sort of time operate in this section, but it creates a different

173

älter, sprich, historischer: Wir sehen ihren antiquierten Stil nicht nur in Mode und Ausstattung, sondern auch in den filmischen Mitteln und im Schauspiel. Die Historizität des Kinos entfaltet sich vor unseren Augen. Dennoch erkennen wir mitten in diesem starken Vergangenheitsgefühl auch eine emotionale Intensität, eine fesselnde Darstellung dramatischer Situationen, die uns neugierig macht auf das Folgende – eine Hauptantriebsfeder des narrativen Films, die Frage: Was passiert als nächstes? Deutsch nutzt diese Energie und untergräbt sie zugleich, er enthält uns die erwartete Befriedigung einer narrativen Auflösung vor, indem er die Geschichte unterbricht oder unsere Neugier auf andere Bilder lenkt. Wie Kulešov schreibt Deutsch die Bedeutung einer Einstellung mithilfe der darauf folgenden Einstellung um; doch anstatt eine Sequenz abzuschließen, erzeugt er häufig ein Simile, ein Echo oder einen traumähnlichen Doppelgänger für die narrative Entwicklung, die wir erwarten würden. Wenn das traditionelle Erzählen wie eine elektrische Verkabelung funktioniert, bei der der Strom festgelegte Wege durchläuft, dann franst *Film ist. 7–12* die Isolierung auf und schließt den erwarteten Betrieb mit einem Funkenregen kurz. Bei seinen Rückgriffen auf Archivmaterial geht es Deutsch weniger darum, neue Zusammenhänge zu

dialectic between the pastness of history and the immediacy of the action. These images seem older, that is, more historical: we see their antiquated style not only in clothing and furnishing, but also in filmmaking devices and performance. The historicity of cinema displays itself before us. And yet in the midst of this powerful sense of the past, we also see an intensity of emotion, a compelling presentation of dramatic situations that fill us with curiosity to see what follows—the basic momentum of narrative film—to ask: what comes next? Deutsch both exploits and subverts this energy, withholding the expected satisfaction of narrative outcome by interrupting the story, or diverting our curiosity into other images. Like Kuleshov, Deutsch redefines the meaning of a shot by the shot which follows, but rather than completing a sequence, he often creates a simile, an echo, or a dream-like doppelganger for the narrative development we might expect. If traditional narrative operates like electrical wiring, sending current along determined pathways, Deutsch's *Film ist. 7–12* frays the insulation, short circuiting expected operations with a shower of sparks. Drawing on archival footage, Deutsch cares less about simply making new connections than about awakening energies slumbering in old material. This energy comes from chain reac-

schaffen, als vielmehr Energien zu wecken, die in altem Material schlummern. Diese Energie erwächst aus Kettenreaktionen, das filmische Atom der ursprünglichen Bedeutungen wird gespalten. Über das simple Recyclen von Bildern der Vergangenheit hinaus bringt die Found-Footage-Montage einen wahrhaft neuen Moment hervor – nicht nur ein neues Gefühl von Gegenwärtigkeit, sondern einen prophetischen Sinn für zukünftige Möglichkeiten. Während Kulešovs Lektionen zeigten, wie Filmaufnahmen in Bezug aufeinander Bedeutung erhalten können, indem sie wie Glieder einer Kette ihren Platz innerhalb einer logischer Ordnung finden, führt Deutsch die Einstellungen weniger einem bestimmten Zweck zu, sondern löst eine Reihe von Resonanzen aus, die in anderen Einstellungen ihren Widerhall finden. Wie Kreise, die sich über einen Teich ausbreiten, bringt eine Aufnahme eine weitere zum Schwingen. Kulešov vektorisierte den Schnitt, bei Deutsch hingegen dreht er sich helixförmig ein und aus.

Wenn sich die ersten beiden Teile von *Film ist.* auf Wissenschaftspädagogik und auf die Geschichte der Narration berufen (ohne darauf reduzierbar zu sein), so erforscht das jüngste Kapitel – das die düstere Nummer 13 trägt – die geheimen Kräfte der Kosmologie, der Sexualität

tions, splitting the cinematic atom of original meanings. Beyond simply recycling images of the past, the editing of found footage triggers a truly new moment, not only a new sense of presence, but a prophetic sense of future possibilities. While Kuleshov's lessons demonstrated how shots could be given meaning in relation to each other, finding their place in a logical order like links in a chain, Deutsch more frequently sets off a series of resonances that echo across shots rather than directing them to a specific end. Like ripples expanding across a pond, one shot sets another vibrating. Kuleshov vectorized editing, but Deutsch seems rather to make it twine and untwine in a helix-like pattern.

If the first two sections of *Film ist.* invoke (without being limited to) science pedagogy and the narrative of history respectively, the latest episode—bearing the sinister number 13—probes the secret forces of cosmology, sexuality and the drive towards death. Its title, *A girl & a gun*, refers to a definition of cinema offered by Jean Luc Godard. Godard's phrase identifies sexuality and violence as driving impulses behind the manufacture of moving images. But more than this, the phrase also invokes cinema's fundamental affinity with the dynamic that psychoanalysis calls *displacement*, in which one thing stands in for another. In the movies sex is never

und des Todestriebs. Sein Titel, *A girl & a gun*, ist eine Anspielung auf Jean Luc Godards Definition des Kinos. Der Satz identifiziert Sexualität und Gewalt als die treibenden Impulse hinter der Produktion bewegter Bilder. Darüber hinaus erinnert er aber auch an die fundamentale Affinität des Kinos zu jener Dynamik, die die Psychoanalyse „Verschiebung" nennt, und in der etwas für etwas anderes (ein)steht. Im Film ist Sex niemals nur Sex und Gewalt selten nur Gewalt, tatsächlich substituiert das eine das andere. Die Waffe übt eine phallische Energie aus, aber sexuelles Begehren wird auch in nationale Herrschafts- und Eroberungsfantasien kanalisiert. In Filmen werden Sex und Gewalt nicht nur kombiniert, sondern die Energie des einen wird mit dem anderen verschmolzen. *Film ist. a girl & a gun* geht freilich über eine Kritik der filmischen Ausbeutung von Sex und Gewalt hinaus. Der Film gestaltet mithilfe von Bildern dieser Ur-Energien eine umfassende Mythologie; er erstreckt sich von der Genesis bis zur Apokalypse und verweist auf die Kräfte, die der modernen Geschichte und vielleicht dem gesamten Kosmos zugrunde liegen. Kapitel 13 – gleichzeitig Mythos und Anti-Mythos – inszeniert den Kampf zwischen Thanatos und Eros und kreiert unter Verwendung von Kinobildern eine neue epische Form; das Material dazu

simply sex and violence is rarely simply violence; indeed, one substitutes for the other. The gun exerts a phallic force, but sexual desire is also channeled into national fantasies of dominance and conquest. Movies not only combine sex and violence, but fuse the energy of one with the other. But episode 13 goes beyond a critique of film's exploitation of sex and violence, and fashions an overarching mythology from images of these primal energies. The episode extends from genesis to apocalypse, exposing the forces underlying modern history and perhaps the cosmos as well. Simultaneously a myth and an anti-myth, episode 13 stages the battle of *Thanatos* and *Eros*, using the imagery of cinema to create a new epic form with found footage drawn from pornography, historical documentary, fictional dramas and images of nature. *A girl & a gun* blends these varied modes of filmmaking and their different temporalities in order to fashion a cinematic myth in which the full course of time and history unwinds within an eternal process of union and division.

Episodes 1–12 of *Film ist.* derived a new ambiguity and range of meanings from found footage. Episodes 1–6 loosened the images of scientific films from their intended pedagogic purposes, while sections 7–12 liberated gestures, emotions and incidents from the narratives to

stammt aus der Pornografie, aus historischen Dokumentarfilmen, fiktiven Dramen und Bildern der Natur. *A girl & a gun* mischt diese verschiedenen Filmformen und ihre unterschiedlichen Temporalitäten, um einen filmischen Mythos zu erzeugen, in dem sich der ganze Lauf der Zeit und der Geschichte innerhalb des ewigen Prozesses von Vereinigung und Trennung abspult.

Die Kapitel 1–12 von *Film ist.* haben aus Found Footage eine neue Ambiguität und eine Bandbreite von Bedeutungen abgeleitet. In Kapitel 1–6 lösten sich die Bilder des wissenschaftlichen Films von ihren intendierten pädagogischen Zwecken, während die Abschnitte 7–12 Gesten, Emotionen und Geschehnisse aus jenen Spielfilmen befreiten, zu denen sie ursprünglich gehörten. In Kapitel 13 sind die Bilder jedoch in einen Kontext gestellt, der ihnen gewichtige symbolische Rollen und Bedeutungen zuweist. Bilder, die ursprünglich Muster aus Rauch oder flüssige Lavaströme gezeigt haben, werden zu Verkörperungen der titanischen Kräfte, die zur Erschaffung der Welt führten – der Kräfte des Wachsens und Werdens. Pornografische Filme evozieren kopulierende Gottheiten. Diese Bilder werden zu Trägern von Metaphern, zu Zahnrädern in einem kosmischen Mechanismus. Sexualität tritt hier nicht in Form der erotischen

which they originally belonged. But in episode 13 the images are impressed into a context that endows them with heavily symbolic roles and meanings. Images that may have originally demonstrated the patterns of smoke or the flow of molten magma become embodiments of the titanic forces of world creation, the energies of growth and genesis. Pornographic films evoke copulating deities. These images become the vehicles of metaphor, cogs within a cosmic mechanism. Sexuality does not appear here as the erotic gags or double meanings that enlivened the previous sections, but rather as the force that moves the sun and all the other stars, the momentum that fuses images into metaphors, triggering explosions and transformations. The cultural weight of the intertitles that quote religious and philosophical texts in this episode (as contrasted with the laconic section titles of the previous episodes) gives this succession of images a profundity that contrasts with the light-hearted puns and random associations the previous sections often reveled in. Repetition, formal similarities, and actions that seem to flow across the cuts create a Tsunami of

Gags oder Doppeldeutigkeiten auf, die frühere Kapitel belebt haben, sondern eher als eine Kraft, die die Sonne und alle anderen Sterne in Bewegung versetzt, als Momentum, das Bilder zu Metaphern fügt und Explosionen und Transformationen auslöst. Die kulturelle Bedeutung der Zwischentitel, die hier – im Gegensatz zur lakonischen Betitelung früherer Kapitel – aus religiösen und philosophischen Texten stammen, gibt dieser Bilderfolge eine Tiefgründigkeit, die sich stark von den unbeschwerten Ironien und zufälligen Assoziationen unterscheidet, in denen manche früheren Abschnitte schwelgten. Wiederholungen, formale Ähnlichkeiten und Handlungen, die über die Schnitte hinweg zu fließen scheinen, erzeugen einen Sturm von Bedeutungen, der den ganzen Film überrollt. Eine Abfolge verschlungener Körper wird unterschnitten mit der Erzählung aus Platons *Symposion* über die ursprüngliche Trennung der androgynen Menschen in zwei unterschiedliche Geschlechter (die sich dann ein ganzes Leben lang bemühen, ihren Zwilling zu finden und sich wieder zu vereinigen). Diese Folge von Spiegelbildern scheint eher eine Illustration für die mythische Erzählung von Eros zu sein als ein Beleg für das Ur-Begehren, eine ursprüngliche Ganzheit wiederzuerlangen. Der Kampf dieser Körper, ihr Versuch, miteinander

meaning that sweeps across the film. A series of twined bodies are intercut with the tale from Plato's Symposium of the primal separation of the original androgynous human into separate sexes (which then strive their entire lives to find their twin and reunite). The series of mirror images seem like an illustration for this mythic account of Eros, rather than to document the primal desire to recover a primal wholeness. The struggle of these bodies to merge rehearses the film's logic of juxtaposition, portraying the energy of editing itself, making visible the rhythm of a fission both nuclear and cinematic. Deutsch forces Kuleshov's montage beyond the simple creation of meaning to reveal a primal desire of images to unite and generate new figures of significance. The archive of cinema supplies the matrix of a new mythology, as the process of editing becomes a process of mythopoesis, manifesting the struggle between contraries and the conjunction of opposites.

A girl & a gun may not be the final episode of *Film ist.*, but it does constitute its alpha and omega, as these orphaned images unite to form a new cosmology of cinema. In the Kabbalah of Isaac Luria, creation began with a disaster, as the vessels of the cosmos shattered when divine energy streamed into them. This divine tragedy caused fragments of the transcendent energy

Film ist. a girl & a gun (2009)

zu verschmelzen, erscheint wie eine Allegorie der gesamten Montage-Logik des Films; die Energie des Schnittprozesses selbst bildet sich darin ab, die Rhythmik einer nuklearen wie kinematografischen Spaltung wird sichtbar. Deutsch treibt die Kulešovsche Montage über die einfache Bedeutungsgebung hinaus und enthüllt ein Ur-Begehren der Bilder: sich zu vereinigen und neue Bedeutungsfiguren zu generieren. Das Archiv des Kinos gibt uns die Matrix für eine neue Mythologie. Der Schnittprozess wird zu einem Prozess der Mythopoesis, in dem sich der Kampf zwischen Gegensätzen und die Verbindung von Gegenteiligem manifestiert.

A girl & a gun ist vielleicht nicht das letzte Kapitel von *Film ist.*, stellt aber in der Art, wie sich diese „verwaisten" Bilder vereinigen, um eine neue Kosmologie des Kinos zu formen, das Alpha und Omega des gesamten Projekts dar. In der Kabbalah von Isaac Luria beginnt die Schöpfung mit einer Katastrophe: Die Gefäße des Kosmos zerspringen, als göttliche Energie in sie einströmt. Diese göttliche Tragödie ließ Fragmente der transzendenten Energie in eine Welt der Materie fallen und besprenkelte sie mit Funken aus dem himmlischen Reich. Religiöse Meditation und Rituale versuchen, diese göttliche Einheit wiederherzustellen und den Bruch zu heilen, indem sie die gefangenen Funken aus ihren welt-

to fall into a world of matter, seeding it with sparks from the heavenly realm. Religious meditation and rituals seek to restore the divine unity and heal this breach, liberating the captive sparks from their earthly container, and allowing them to re-ascend to their original source. I believe this process stands as an ideal metaphor for Deutsch's transformation of found footage, reworking archival material, seeking to release and gather the energy contained within them:

179

lichen Gefäßen befreien und wieder zu ihrer ursprünglichen Quelle hinaufsteigen lassen. Ich denke, dass dieser Vorgang eine ideale Metapher für Gustav Deutschs Transformation von Found Footage darstellt. Seine Wiederverarbeitung von Archivmaterial ist der Versuch, die Energie, die darin enthalten ist, freizusetzen und wieder zu sammeln – von der wissenschaftlichen Erforschung der Bewegungsgesetze über die enigmatischen Konfigurationen von Erzählkunst und Geschichte bis hin zur Expansion und Kontraktion der Energie des Universums selbst in den Rhythmen erotischer Vereinigung und tödlicher Trennung. In *Film ist.* verknüpft und entwirrt sich die Vergangenheit vor unseren Augen und demonstriert, wie durch Spaltung Energie entsteht und aus Katastrophen Welten geschaffen werden. Bilder aus der Vergangenheit werden verwandelt und weiterentwickelt, und sie bringen dabei eine ganze Palette von Zeiterfahrungen hervor; aus Filmfossilien ersteht eine neue Gegenwart; im Aufeinandertreffen von Einstellungen werden schlummernde Bedeutungen wiederbelebt. Die Essenz von Film besteht darin, starren Bildern Bewegung und Leben zu schenken. *Film ist.* rüttelt die Archive der bewegten Bilder zu neuen Entdeckungen auf.

from the scientific exploration of the laws of motion; to the enigmatic configurations of narrative and history; to the expansion and contraction of the energy of the universe itself in the rhythms of erotic union and deadly division. In *Film ist.*, the past knits together and unravels before our eyes, demonstrating the way energy emerges from fission, worlds are created from disasters. Images of the past are refined and transmuted to yield a range of temporal experience, as a new present arises from fossilized films and the conjunctions of shots revitalize slumbering meanings. The essence of film consists in endowing still images with movement and life. *Film ist.* awakes the archives of moving images into new discoveries.

Michael Loebenstein

Conditio humana

Gustav Deutschs dokumentarische Fiktionen Film ist. a girl & a gun *und* Visions of Reality
Gustav Deutsch's Documentary Fictions Film ist. a girl & a gun *and* Visions of Reality

„Jeder von uns ist also ein Stück von einem Menschen, da wir ja, zerschnitten wie die Schollen, aus einem zwei geworden sind. Also sucht nun immer jedes sein anderes Stück. (...) Und wenn, indem sie zusammenliegen, Hephaistos vor sie hinträte, seine Werkzeuge in der Hand, und sie fragte: Was ist es denn eigentlich, was ihr wollt, ihr Leute, voneinander, und wenn sie dann nicht zu antworten wüßten, sie weiter fragte: Begehret ihr etwa dieses, soviel als möglich zusammen zu sein, daß ihr euch Tag und Nacht nicht verlassen dürftet? Denn wenn das euer Begehren ist, so will ich euch zusammenschmelzen und in eins zusammenschweißen, so daß ihr statt zweier einer seid, und solange ihr lebt (...). Dies hörend, das wissen wir gewiß, würde auch nicht einer sich weigern oder zu erkennen geben, daß er etwas anderes wolle, sondern jeder würde eben das gehört zu haben glauben, wonach er immer schon strebte, durch Nahesein und Verschmelzung mit dem Geliebten aus zweien einer zu werden. Hiervon ist nun dies die Ursache, daß unsere ursprüngliche Beschaffenheit diese war und wir ganz waren, und dies Verlangen eben und Trachten nach dem Ganzen heißt Liebe." [1]

Gehen wir mit Aristophanes davon aus, dass die oben beschriebene, ursprüngliche Teilung der „Kugelmenschen" in Mann und Frau a) unge-

"'Let us cut them in two,' Zeus said, 'then they will only have half their strength, and we shall have twice as many sacrifices.' (...) The two halves went about looking for one another, and were ready to die of hunger in one another's arms. (...) Suppose Hephaestus, with his instruments, were to come to the pair, who are lying side by side and say to them: 'What do you people want of one another?' They would be unable to explain. And suppose further, that when he saw their perplexity he said: 'Do you desire to be wholly one, always day and night to be in one another's company? For if this is what you desire, I am ready to melt you into one and let you grow together, so that being two, you shall become one' (...) there is not a man of them who, when he heard the proposal, would deny or would not acknowledge that this meeting and melting in one another's arms, this becoming one instead of two, was the very expression of his ancient need. And the reason is that human nature was originally one, and we were a whole, and the desire and pursuit of the whole is called love." [1]

If we assume, like Aristophanes, that the division of the original 'round, 4-armed human beings' into man and woman was a) unjust, and b) irrevocable, then it is Eros—'the most humane amongst the gods,' both 'doctor and friend' to

1) Aus Aristophanes' Rede in Plato, *Das Gastmahl* (Schleiermacher-Übersetzung, 1807).

1) *Dialogues of Plato*, translated by B. Jowett, Clarendon Press.

181

recht, und b) unwiderrufbar ist, so ist es Eros – der „menschenfreundlichste unter den Göttern" und der Menschen „Arzt und Beistand" – der einen Ausweg aus der Spaltung verheißt.

Bei Gustav Deutsch, dem laut eigener Aussage der Komödiendichter Aristophanes näher steht als der Philosoph Plato, stellt sich dieses Versprechen gebrochener dar. Deutsch glaubt nicht an universelle Erklärungsmodelle – seine Kunst bricht scheinbar hermetische Denkgebäude auf. So auch seine beiden jüngsten Projekte: Der 13. Teil von *Film ist.* sowie das Ausstellungs- und Spielfilmprojekt *Visions of Reality* stellen die Kraft des Eros in den Mittelpunkt; dennoch geht es dem Filmemacher nicht vorrangig um eine Feier der Liebe als „Geleiterin" in die „ursprüngliche Natur" des Menschen, wie es noch in Platons *Gastmahl* heißt. Vielmehr beschäftigt ihn die Beschreibung jener Energien (die „Fissionsenergie", die Tom Gunning in seinem Beitrag in diesem Band beschreibt, als auch die Fusionsenergie), die die Menschen (und die Filme, die sie geschaffen haben) unterwegs in den „Urzustand", auf der Suche nach dem (Gegen)Stück produzieren.

Beide Filme sind Filme über die Liebe, und von beiden kann man als Tragödien sprechen. *Film ist. a girl & a gun* erzählt in 5 Kapiteln – Genesis (Schöpfung), Paradeisos (Paradies),

man, who offers a way out of the dilemma. In the case of Gustav Deutsch, who claims he feels a closer affinity to the playwright Aristophanes than to the philosopher Plato, this promise is partly broken. Deutsch does not believe in universal explanations—his art topples seemingly hermetical ivory towers. This also applies to his two latest projects: the 13th part of *Film ist.* and the installation and feature film project *Visions of Reality*, which focus on the power of *Eros*. Yet the filmmaker is not primarily concerned with a celebration of love to help reveal the 'original nature' of humans, as intended in Plato's *Symposium*. Instead, he is interested in describing those energies (the energy of fission, as described by Tom Gunning in his essay, as well as fusion), produced by human beings and the films made by them while seeking the (better) half of their original state.

Both of the films are about love, and both could be called tragedies. *A girl & a gun* tells the story of man and woman in five chapters—*Genesis* (Creation), *Paradeisos* (Heaven), *Eros* (Love), *Thanatos* (Death) and *Symposion* (Banquet)—as a series of violent separations and no less violent couplings, from the creation of the cosmos, from chaos to the establishment of modern matrimony. The roles of *Gaia, Uranos, Eros, Thanatos* and the *Cyclops* are cast in varying constellations.

Film ist. a girl & a gun (2009)

Eros (Liebe), Thanatos (Tod) und Symposion (Gastmahl) – die Geschichte von Mann und Frau, von der Erschaffung des Kosmos aus dem Chaos bis zur Einrichtung der modernen Ehe, als eine Serie gewaltsamer Spaltungen und nicht minder gewalttätiger Vereinigungen. Die Rollen von Gaia, Uranos, Eros, Thanatos, der Kyklopen werden in wechselnden Konstellationen besetzt; die Konflikte, die aus dem Riss durch die Ganzheit resultieren, entladen sich in lustvoller Vereinigung (kopulierende, tanzende, ringende und gebärende Körper), orgiastischer Zerstörung (Explosionen, Brände, Mord und Totschlag) und einem Maschinenfetisch, den Deutsch (wie Freud) als moderne Ausprägung des Thanatos identifiziert. Wissenschafter und Wissenschafterinnen, die mit kalter Neugier Apparate streicheln, im Petrischälchen die Genesis herausfordern, vor Mikroskop und Kinokamera Pflanzen zergliedern, finden sich am Schneidetisch neben Soldaten wieder, die Fliegerbomben wie Frauen beiwohnen, oder ihre Geschoße im Arm wiegen als wären es Babies.

Tragödie

Seine ProtagonistInnen entlehnt der Filmemacher auch im 13. Kapitel seines Zyklus *Film ist.* aus dem Archiv. Gleich Akteuren der antiken Tragödie tragen manche dieser „Leiharbeiter"

The conflicts, which arise from splitting the integral whole, result in lusty affairs (copulating, dancing, wrestling and birthing bodies), orgiastic destruction (explosions, fires, murder and manslaughter) and a mechanical fetish, which Deutsch (similar to Freud) identifies as the modern manifestation of *Thanatos*. Scholars revering instruments with cold curiosity, trying to recreate genesis in Petri dishes, and dissecting plants under the microscope or in front of the film

183

Michael Loebenstein

Masken (BesucherInnen eines Faschingsballs, die HeldInnen eines Porno-Schmalfilms, englische Soldaten, die in einem Aktualitätenfilm Gasmasken vorführen), und besetzen ihre Rollen gemäß der Aristotelischen Poetik durch *Tun* (Handeln), nicht durch *Berichten* (wie im Epos, von dem Aristoteles die Tragödie klar trennt). Konnte man die vorangegangenen Kapitel von *Film ist.* noch als poetische De-/Rekonstruktionen von naturwissenschaftlichen Klassifikationssystemen, vor allem der Taxonomie (als Prozess der Systematisierung und Klassifikation) verstehen, so ist in *A girl & a gun*, wie Tom Gunning feststellt, die Poesie selbst Untersuchungsgegenstand und Methode zugleich. Alles menschliche Streben – und Deutsch versteht darunter auch den Film – gilt von Anbeginn der Konstitution des Mythos. So bildet sich die Erschaffung der Mutter Erde aus dem Chaos in einem rot kolorierten Archivfund ab, Schutzmasken tragende Frontkrieger verkörpern die einäugigen Zyklopen, schleiertanzende Frauen in Edisons Black Maria-Studio treffen auf pudelnackte BDM-Grazien, die in Nordseedünen Gymnastik treiben. Stärker noch als andere Deutsch-Filme etabliert *A girl & a gun* „Film", „Kino" als mythopoetische Macht. Was Drehli Robnik 2005 über *Welt Spiegel Kino* schrieb, gilt in verstärktem Maß für das neue Werk: „Wenn

camera, are juxtaposed on the editing table with soldiers sleeping with aircraft bombs as though they were their wives, or rocking munition in their arms like babies.

Tragedy

The filmmaker again selects his protagonists from a vast amount of archival films. Like actors in the ancient tragedies, some of these 'borrowed characters' wear masks (the attendees of a carnival, the protagonists of a small-gauge porn film, English soldiers wearing gas masks in a newsreel) and develop their roles according to Aristotle's *Poetics and Rhetoric:* through action (behavior), instead of narration. If we can interpret the previous chapters of *Film ist.* as a poetically deconstructed investigation of scientific classification systems, primarily taxonomy (as a process of systematization and classification); then *A girl & a gun* employs poetry both as the method and as the *object* of examination. All human aspiration—and this includes film according to Deutsch—has been directed towards constituting myth ever since the genesis of the cosmos. Thus Mother Earth is created from chaos in red-colored archival footage. Soldiers wearing gas masks represent the one-eyed Cyclops; and veiled women dancing in Edison's Black Maria Studio contrast with stark-naked

Film ist. a girl & a gun (2009)

alles zusammenhängt, entsteht ein fast paranoider Eindruck von Totalität, von Globalität, nämlich räumlicher Vernetztheit und lebenszeitlicher Alldurchdrungenheit einer Welt, die Film macht, die 'sich aufführt'(...)"². Poesie wird hier als jenes Verfahren verstanden, das aus Vorfällen Fälle macht, aus Zufall mittels Formsetzung Schicksal schafft. Deutschs Montageverfahren arbeiten die in den Ausgangsmaterialien angelegten Gesten und narrativen Verbindungen mittels Anschluß- und Kontrastmontage sowie über das Sound Design in verschärfter und zugespitzter Weise hervor: Auf dem Schneidetisch entsteht das Bild einer naturhaften *conditio humana*.

Monumente

An den ekstatischen Freuden, die der Kinematograph bereitet – die „Schaffung von Leben aus unbelebten Elementen", die Transformation von der „Diskontinuität zur Kontinuität" – hat die Filmwissenschafterin Annette Michelson sowohl spielerische Souveränität als auch die Tendenzen zu kindlichen Omnipotenz-Phantasien diagnostiziert. Ich denke, dass *A girl & a gun* auf dem Feld der Poetik jenes Projekt weitertreibt, das Gustav Deutsch bereits seit *Adria*

2) Drehli Robnik, „Massen vermessen in Masken", in: *kolik.film* 3 / 2005, S. 37.

girls from the Nazi *Bund Deutscher Mädchen* doing gymnastics on the dunes at the North Sea.

Drehli Robnik's comments on *Welt Spiegel Kino* in 2005 are even more applicable to the new film: "If everything is connected, we are presented with an almost paranoid impression of totality, or globality, namely the spatial interconnectedness and 'permanently saturated state' of a world that 'makes film,' that performs itself (...)" ² Here poetry is understood as the process by which incidents become cases, and coincidence becomes fate by way of creating a framework. Deutsch's editing processes bring forth the gestures and narrative interconnections in the original footage in a more focused and pointed manner by means of crosscutting and match cuts, as well as sound design. The image of a natural *conditio humana* is created on the editing table.

Monuments

The ecstatic joy perpetuated by the movie machine—the creation of life from static objects,

2) Drehli Robnik, "Massen vermessen in Masken," in: *kolik.film* 3/2005, p. 37.

verfolgt: die Schönheit, den poetischen Gehalt filmischer Artefakte, des Kinos als Schöpfungsmaschine anzuerkennen und zu feiern, um im gleichen Atemzug jene Ideologien, die in den Bildern arbeiten, freizulegen und zu demonstrieren. Seinen (lustvollen) Zweifel an einer industriell produzierten Mythopoetik teilt er mit Roland Barthes, der in *Mythen des Alltags* (und am Beispiel der Fotoserie *The Family of Man*) von einem Unbehagen, einer „Ungeduld" schrieb, die die (mutwillige und ständige) „Verwechslung von ‚Natur' und ‚Geschichte'" in ihm erzeugte[3].

Die Bilder, die Deutsch montiert, versteht er explizit als *historisch*. Aus ihrem Inhalt, aus den Konstellationen, die sie vorführen, spricht ihre Zeit. Sie sind – im Foucaultschen Sinne – *monumental*, als die „Sprache", welcher sie sich bedienen, bedeutsam wird. Eine (Film-)Archäologie, wie Gustav Deutsch sie betreibt, zeigt auf, welche Verbindungen die in jedem Teilstück enthaltenen Artikulationen zu anderen Wissensformationen unterhalten, welche sozialen Praktiken zu ihrer Herstellung beigetragen haben, anstatt die Footage bloß als „Informationsträger" von Faktenwissen zu betrachten. Jede einzelne dieser filmischen „Scherben" erlaubt es, mannig-

and the transformation of discontinuity into continuity—has been diagnosed by film scholar Annette Michelson in another context as both playful sovereignty and a childlike fantasy of omnipotence. I believe that *A girl & a gun* is a continuation of Gustav Deutsch's project in the field of poetics, which he has pursued since *Adria*: acknowledging and celebrating the beauty and the poetical content of film footage, and of cinema as a creative machine, while simultaneously exposing and demonstrating those ideologies inherent in the images. He shares his (relished) doubt in an industrially produced mythopoesis with Roland Barthes, who in *Mythologies* writes of his "impatience" at "seeing Nature and History confused at every turn" by the media, his example being the exhibition of the much acclaimed *Family of Man* photographic series.[3]

Deutsch understands the images he uses to be explicitly *historical*. The content and constellations they depict are representative of their times. They are *monumental* in the sense of Foucault, since the "language" they use becomes equally important to the content described. (Film) archeology, as carried out by Gustav Deutsch, illustrates how the articulation of each

3) Roland Barthes, „Die große Familie der Menschen", in: *Mythen des Alltags* [1957], Frankfurt/M. 1964.

3) Roland Barthes, "The Great Family of Man," in: *Mythologies* [1957], New York 1970.

faltige historische Assoziationen herzustellen, ohne dabei die oft komischen oder verblüffenden Potentiale der Ausgangsmaterialien gänzlich zu denunzieren. Wenn in einer Sequenz Soldaten vor ihresgleichen und der Filmkamera in einer Sandgrube Blindekuh spielen, so ist das so burlesk wie grausam, Entertainment *und* Drill: Im Kino des Großen Kriegs, aus dem die Aufnahmen stammen, werden die Protagonisten (und das Publikum des Films) auf die Erfahrung vorbereitet, gaskrank und mit zerschossenen Augen den Weg aus dem Niemandsland zu finden.

Kulissendörfer

Man kann auch lieben, was man seziert. Zweifellos liebt Gustav Deutsch jedes Stück Footage, das in seine Filme einfließt. Nicht weniger liebt er – und dieser Text handelt von Liebe, auch wenn der Krieg immer wieder hineinragt – die Ölbilder, Zeichnungen und Drucke des amerikanischen Malers Edward Hopper. In mehrjähriger Arbeit hat Deutsch sich Hoppers Werk erarbeitet, mittels Studium der Bilder in Katalogen und Museen, Sekundärliteratur und Schriften aus dem Nachlass, Skizzen, Architekturmodellen und dem Nachstellen einzelner ikonischer Momente aus dem Hopper-Kosmos. Das Resultat ist wie so oft mehrstufig: In der Kunsthalle

part is connected with other forms of knowledge and the social practices that contributed to their production, instead of footage merely being seen as the 'carrier of information.' Each one of these cinematic 'shards' enables multiple historical associations, without entirely denouncing the often comical or surprising potential of the original footage. When we see soldiers playing 'pin the tail on the donkey' in a sandpit in front of the camera, it is both burlesque and gruesome, entertainment and drill. In the cinema of the Great War, which these scenes come from, the protagonists (and the film audience) are being prepared for the experience of being blinded by mustard gas, or projectiles, and having to find their way in no man's land.

Potemkin Villages

We may even love that which we are dissecting. There is no doubt that Gustav Deutsch loves each piece of footage he uses in his films. He equally loves—and this essay is about love, although war repeatedly raises its ugly head—the paintings, sketches and prints by the American painter Edward Hopper. Over a period of several years Deutsch has delved into Hopper's work, studying his paintings in catalogues and museums, sifting through the literature on Hopper

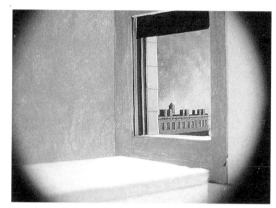

Visions of Reality, Wednesday, 28 August 1957, 6 p.m.,
Pacific Palisades, Arbeitsmodell / *model*,
Kunsthalle Wien (2008)

Visions of Reality, Friday, 29 August 1952, 6 a.m.,
New York, Arbeitsmodell / *model*,
Kunsthalle Wien (2008)

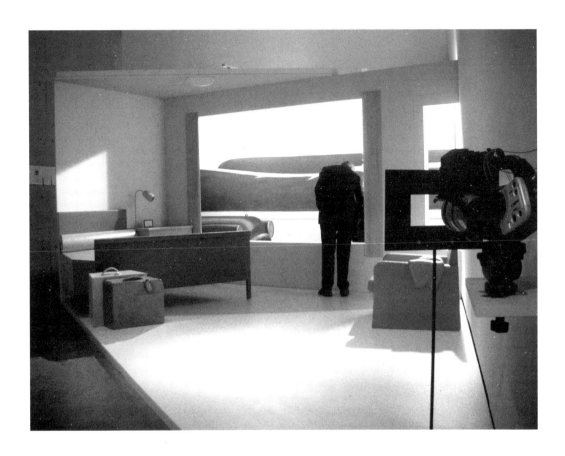

Visions of Reality, Wednesday, 28 August 1957, 6 p.m.,
Pacific Palisades, Filmset — installation,
Kunsthalle Wien (2008)

Michael Loebenstein

Wien waren im Rahmen der Ausstellung *Western Motel. Edward Hopper und die zeitgenössische Kunst* (Oktober 2008 bis Februar 2009) elf Raummodelle nach Gemälden Hoppers zu sehen, eines davon im Originalmaßstab.

Dieses Modell wird nach Ende der Ausstellung als Filmset für eine Szene aus *Visions of Reality* dienen, Gustav Deutschs erstem Spielfilm. *Visions of Reality* erzählt, ausgehend von 15 Hopper-Gemälden, die fiktive Biografie von Shirley, einer Schauspielerin. Die Handlung verläuft zwischen den Jahren 1928 (Shirley wird 18 und zieht nach New York) und 1965, als die 55-jährige Frau zwischen Cape Cod und New York einen Pendlerzug betritt. Dazwischen: mehrere Jobs, die Große Depression, Engagements im *Group Theatre* und im *Living Theatre*, Krieg und der konservative Backlash der Fifties; zugleich eine Liebe, ein Lebensmensch (der Photograph Stephen), Krankheit, die Andeutung eines Verlusts. Leerstellen.

An Edward Hopper fasziniert Deutsch weniger jene ins Mythische erhobene amerikanische Ikonografie, die seine Gemälde auf dem Kunstmarkt, in Bildbänden und als Posterreproduktionen so populär gemacht hat. Zum einen interessiert den Architekten und künstlerischen Forscher Deutsch die radikale Konstruiertheit der Hopperschen Bildwelten. Um den Eindruck des

and the artist's own writings, producing sketches, architectural models and reenactments of iconic moments of the Hopper cosmos. Once again, the result is a work-in-progress. In the Vienna Kunsthalle art gallery, eleven architectural models—one in the original scale—based on paintings by Hopper are being shown as part of the exhibition *Western Motel: Edward Hopper and Contemporary Art* (October 2008 – February 2009).

After the exhibition, the full-scale model will be used as the film set for a scene in *Visions of Reality*, Gustav Deutsch's first feature film. Based on fifteen Hopper paintings, *Visions of Reality* tells the fictitious story of Shirley, an actress, between the years of 1928 (when she turns 18 and moves to New York) and 1965, when the 55-year-old woman gets on a commuter train between Cape Cod and New York. Scenes from a life: several jobs, the Great Depression, acting in the *Group Theater* and the *Living Theater*, World War II and the conservative backlash of the 1950s; and at the same time: love, a partner in life (the photographer Stephen); illness, the implication of a loss; several blank pages, gaps in her biography.

Deutsch is less fascinated by the mythical American iconography of Edward Hopper, which has made the paintings so popular in the

Alltäglichen, des Umgangs(bild)sprachlichen herzustellen, bedarf es umfassender Verzerrungen der Perspektive und der menschlichen Proportion. Die Installation in der Kunsthalle Wien macht diese Formsetzungen anschaulich. Die zehn Miniaturmodelle erlauben es, sowohl den von Hopper gewählten Blick (seine „Kameraperspektive") einzunehmen, als auch das Szenarium in Aufsicht zu begutachten. Der Erkenntnisschock ist groß: Betten entpuppen sich als trapezförmig, Fußböden neigen sich in Richtung ihrer Betrachter, Sesselbeine haben unterschiedliche Längen, scheinbar dreidimensionale Objekte entpuppen sich als zweidimensionale *props*. Eines dieser Kulissendörfer macht Deutsch bewohnbar: Die lebensgroße Nachbildung von *Western Motel* (1957) darf und soll vom Publikum betreten werden. Zugleich projiziert eine Videokamera eine Aufnahme des Szenarios, entsprechend dem BetrachterInnenstandpunkt des Gemäldes, zurück in den Ausstellungsraum. Das Resultat ist eine auch räumlich hergestellte, gespaltene Wahrnehmung: Auf der Leinwand ist das „korrekte" Bild zu sehen, während die BesucherInnen im Set den „authentischen" Aufbau erleben. Eine Gleichzeitigkeit beider Erfahrungen ist unmöglich, da die Leinwand von der Installation aus nicht sichtbar ist, und der *live feed* der Videokamera nicht aufgezeichnet wird.

art market, as well as in picture books and poster reproductions.

On the one hand, the architect and 'artistic researcher' Deutsch is interested in the radical constructedness of Hopper's imaginary worlds. To give an impression of the everyday, perspective and human proportions undergo extensive contortions. The installation in Vienna vividly demonstrates these artistic devices. Ten miniature models enable us to see Hopper's chosen view (his 'camera perspective'), as well as examine the scene from above. The shock of recognition is great: beds turn out to be trapezoidal; floors are slanted towards the spectator; the legs of chairs are of different lengths; seemingly three-dimensional objects turn out to be two-dimensional props. Deutsch has made one of these film sets inhabitable: the life-size reconstruction of *Western Motel* (1957) was intended to be open to spectators. At the same time, a video camera projects a recording of the scene, in keeping with the perspective of the painting, into the exhibition space. The result is a spatially manifest, divided perception: on the projection wall we see the 'right' scene, while the spectators on the set experience the 'authentic' set. It is impossible to experience both at the same time, since the screen is not visible from the installation, and the live feed of the

Michael Loebenstein

Wieder einmal: eine Spaltung, ein Riss, der durch die Welt geht; vor allem dann, wenn – als wäre es ein ewiges Gesetz – die Besucherinnen „automatisch" die Pose von Hoppers Modell einnehmen, während ihre Begleiter das Szenario aus der Perspektive des Künstlers studieren.

A Day in the Life
Zum anderen interessiert sich Gustav Deutsch, ausgehend von Hoppers Malerei, für das, was ich eine „dokumentarische Fiktion" nennen würde: einen Film, der aus dem Material der Wirklichkeit ein Drama schöpft, Anschlüsse herstellt, und zugleich die poetischen Gesetzmäßigkeiten, nach denen Geschichte(n) „gebaut" werden, ausstellt. 15 Hoppersche „Szenen" werden von Deutsch als Still verstanden, als Filmstandbild, als Keim von Mikrogeschichten, die sich vor, nach und im Off des von Hopper fixierten Moments ereignet haben (könnten). Das „Material", die dokumentarischen Evidenzen sind jene Spuren, die Hoppers Bilder tragen, ihre *Faktur* [4]: die anamorphotische Verzerrung des Perspektivraums, der Farbauftrag, die Lichtsetzung, und die Ausgestaltung der Räume mit scheinbar zwecklosen Details. Ausgehend davon

video camera is not being recorded. Once again, there is a gap, a schism in our world; particularly when—as though it were an eternal law— female spectators 'automatically' take on the pose of Hopper's model, while their partners study the scene from the artist's perspective.

A Day in the Life
On the other hand, Gustav Deutsch is interested in what I would call a 'documentary fiction' based on Hopper's painting: a film which creates drama from the stuff of reality, making connections in order to illustrate the poetic laws according to which the stories are 'constructed.' The fifteen Hopper scenes are understood by Deutsch to be stationary, like stills, the nuclei of micro-stories, which (may) have taken place before, after, or in the 'off' of the moment created by Hopper. The 'material' or documentary evidence consists of all the traces inherent in Hopper's images, or their 'Faktura' [4]—the anamorphosis of the perspective space, the coloring, the lighting and the seemingly useless details decorating the rooms. Based on these traces, Deutsch designs his own constructions. According to the light in the paintings he devel-

4) Ein Schlüsselbegriff der Avantgarde, der die autonome Ästhetik materieller Spuren und sensorischer Eigenschaften beschreibt, und die „Gemachtheit" von Kunst bloßlegt.

4) A key term of the (Russian) avant-garde, describing the autonomous aesthetics of material traces and sensory qualities, which expose the 'constructedness' of art.

Film ist. a girl & a gun (2009)

entwirft Deutsch seine eigene Konstruktion: Gemäß den Lichtverhältnissen in den Bildern setzt er Schnitte in der Zeit, und entwirft ein Panorama fragmentarischer Momentaufnahmen: 15 Szenen à 6 Minuten, die jeweils an einem Tag – dem 28. August – spielen[5]. „Was wäre, wenn...?" *Visions of Reality* stellt, wie der Titel es ankündigt, *Vorstellungen* von *Wirklichkeit* vor: den Prozess der Erzählung als verbindenden Kitt zwischen scheinbar zufälligen Ereignissen, den mythopoetischen Vorgang, der noch belanglosesten Details Bedeutung verleiht.

Die Szenerie von Hoppers *Western Motel* wird in Deutschs Re-Imaginierung zum Photoshooting zwischen Shirley und Stephen, das Jahre später in der Erinnerung Shirleys wieder aufersteht. Ein nachlässig umgeworfener Damenschuh; ein Textil (Strümpfe? Ein Handtuch?) das beiläufig auf einen Sessel geworfen wurde; Buchrücken, die unscharf bleiben. In einem von Hoppers Bildern, *New York Movie* (1939), ist links, angeschnitten, der Ausschnitt einer Kinoleinwand mit einem Schwarz-Weiß-Film zu sehen. In Deutschs Drehbuch wird

ops a timeline and creates a panorama of fragmentary snapshots: 15 scenes, each 6 minutes long, each taking place on the same day— August 28th.[5] "What would happen if...?" As its title might imply, *Visions of Reality* introduces the process of storytelling as the glue between apparently coincidental events—a mythopoetic process, which gives meaning to the most trivial details. The set of Hopper's *Western Motel* becomes Deutsch's reimagination of a photo session with Shirley and Stephen, which is resurrected in Shirley's memory years later: a ladies' shoe carelessly toppled over; stockings or a towel draped nonchalantly over a chair; bookends, which remain illegible. Hopper's *New York Movie* (1939), shows us the fragment of an on-screen black & white movie in the painting's corner. In Deutsch's film script this becomes William Wyler's *Dead End* (1937)—a film that Shirley might have seen.

5) Das Jahresdatum korrespondiert dabei jeweils mit dem Entstehungsjahr des zitierten Gemäldes. Auch der 28. August ist ein aufgeladenes Datum: die letzte Szene enthält eine Radioübertragung des „March on Washington" aus dem Jahr 1963.

5) The date of the year corresponds with the year in which the respective painting was executed, while the day is referred to as a decisive date in American history: the last scene features a radio broadcast of the 'March on Washington' on August 28, 1963.

daraus William Wylers *Dead End* (1937) – ein Film, den Shirley womöglich gesehen haben könnte.

Unwillkürlich denke ich, bei *Visions of Reality* wie bei *A girl & a gun*, an John Lennons und Paul McCartneys monumentale Meta-Erzählung „A Day in the Life". Zeitungsnotizen, Fragmente des Alltäglichen (ein Autounfall, das Ende eines Krieges, Schlaglöcher in den Straßen Lancashires), die Fragmente zweier Songs (der eine ohne Bridge, der andere ohne Anfang und Ende) werden gleich den Aristophanes-Kugelmenschen von Hephaistos' Hammer zusammengeschmiedet. Es entsteht ein Song, der – von was sonst! – vom Begehren nach Vollständigkeit wie vom Verlust erzählt; zugleich eine Meta-Erzählung seiner eigenen Gemachtheit, wenn das Aufnahmestudio selbst, die Künstlichkeit der Aufnahme über die Einschließung „dokumentarischer" Momente (Regieanweisungen, Sesselknarzen, die Klingel und das Metronom, die den Takt angeben) transparent werden. Mit dem einen Film teilt der Beatles-Song die Tragik des Todes, des Verlusts; mit dem anderen die Kraft des Begehrens. „*I love to turn you on.*"

Both *Visions of Reality* and *A girl & a gun* make me involuntarily think of John Lennon and Paul McCartney's monumental metanarrative "A Day in the Life." News items, fragments of daily life (a car accident, the end of a war, potholes in Lancashire's roads), the fragments of two songs (one of them without a bridge, the other without beginning or end) are fused together, just as Aristophanes' round human beings are joined together by Hephaestus' hammer. A song comes into being, it tells of longing, of completeness, and loss—what else! At the same time it is a metanarrative of its own creation, as the recording studio and the artificiality of the takes are made transparent via 'documentary moments' (director's cues, chairs scraping on the floor, the bell and the metronome, indicating the tempo). With one of the films, the Beatles song shares the tragedy of death and loss; its bond with the other is the power of desire: "*I love to turn you on.*"

Burkhard Stangl

Meine liebste Nation ist mir die Faszination

Notate zur Rolle der Musik bei Gustav Deutsch

My Favorite Nation Is Fascination

Notes on the Role of Music in the Work of Gustav Deutsch

Komponist (1) Die Wichtigkeit der Musik in Gustav Deutschs Filmœuvre erfährt meines Erachtens viel zu wenig Würdigung. Das liegt auch an Gustav Deutsch selbst. Klar ist, welche Bedeutung er der Musik für seine Filme zumisst. Er weiß auch, denke ich, wie fundamental entscheidend sein eigener Anteil an der Formung der Filmmusik ist. Schließlich wählt er die Musikstücke aus, gibt den Komponisten Hinweise, verlangt bisweilen, will, baut, probiert, stellt zusammen, verbindet, komponiert. Aber es ist möglicherweise seiner Bescheidenheit geschuldet, die ihn hindert, den Aspekt der Musik in seinem Filmschaffen medial zu forcieren. Eben weil er den für die beteiligten Komponisten vorgesehenen Raum nicht mitbesetzen und nicht einengen will.

Kollektiv Für die Mehrzahl seiner abendfüllenden Filme hat Gustav Deutsch bisher zumeist mit Musikern zusammengearbeitet. Achtung: Mehrzahl. Deutsch bringt es zu Stande, ausgeprägte Musikerpersönlichkeiten zusammenzuführen und daraus ein *Film ist. Ensemble* zu formen. Gustav Deutsch ist, um es salopp zu sagen, ein begnadeter Bandleader.

Geschichte Gustav Deutsch hat sich von der Geschichte befreit, weil er sie zum zentralen

Composer (1) In my opinion, the importance of music in Gustav Deutsch's œuvre is not adequately appreciated. This is partially due to Gustav Deutsch himself. It is clear he considers music meaningful to his film work. I also think he knows how fundamentally decisive his contribution is to the creation of music for his films. After all it is he who selects the music, giving instructions to his composers, making occasional demands, willfully proceeding, constructing, experimenting, assembling, joining and composing. Perhaps his humility hinders him from pushing the musical aspect of his filmmaking into the foreground—precisely because he does not want to preoccupy and cramp the creative space intended for participating composers.

Collective Gustav Deutsch has collaborated with composers (plural) on almost all of his feature length films to date. He has succeeded in bringing a distinctive collection of musical personalities together to form the *Film ist. Ensemble*. He is an exceptionally gifted band leader, informally speaking.

History Gustav Deutsch has liberated himself from history by making it central to his work, allowing him to rethink and 'film' history anew.

Burkhard Stangl:
Transkriptionsskizzen von „Wiener Lieder" für /
musical sketches of "Viennese folk songs" for
Welt Spiegel Kino (2004)

Thema seiner Arbeit gemacht hat. Deshalb kann er sie neu denken und neu „filmen". Im Umgang mit Musik findet diese seine Wesensart ihren unbestechlichen Widerhall.

Vertrauen Interdependenzen zwischen Filmschnitt und Musik. Schon in der Planungsphase eines Films von Gustav Deutsch sind die Komponisten in das Filmprojekt involviert. Ein ausführliches Exposé und ausführliche Gespräche fungieren als erste Inspirationsquelle, als erster Input für die Musiker. Erste Ahnungen, in welche Richtung es gehen könnte. Während Deutsch/Schimek in den Filmarchiven aberhunderte von Filmen sichten und von den ausgewählten Filmsequenzen Videokopien anfertigen lassen, arbeiten die Komponisten – sozusagen „blind" – an ihren ersten musikalischen Skizzen. Diese werden von Deutsch entweder schon während oder nach dem Erstellen der ersten Filmentwürfe im Computer angelegt. Die Musik kann in dieser ersten Phase schon mitbestimmend für den Filmschnitt sein. Parallel dazu erhalten die Komponisten Videokopien seiner bisherigen Arbeit, oftmals unfertig, roh und rau. Die Bildsequenzen wiederum nehmen Einfluss auf den kompositorischen Gestaltungsprozess. Dabei spielen die klaren Vorstellungen des Filmemachers *die* entscheidende Rolle, gleichzeitig

This disposition finds unadulterated repercussions in his work with music.

Trust Film editing and music are interdependent. Gustav Deutsch engages composers at the outset of the film, already during preproduction stages of the project. The initial input and source of inspiration is provided by an extensive project synopsis as well as in-depth conversations. These convey the first inklings as to what direction the project is going to take. Deutsch and Hanna Schimek view hundreds of films and organize video copies of chosen sequences while the composers execute their first musical sketches 'blindly'. Deutsch downloads this music into his editing program during or immediately subsequent to his first rough cut of the video. Music can co-determine the montage of the film at this preliminary stage. Meanwhile the composers receive a video copy of Deutsch's work, which is often in an incomplete, rough and unpolished state at this time. Sequences of images in turn influence the creative process of composing. The articulate intentions of the filmmaker play a most decisive role at this juncture, while musical stimulus is also desired and welcomed. Music thereby shapes the dramaturgy of the film on a 'subterranean' level.

sind Anregungen von Musikerseite erwünscht und willkommen – und formen damit die Dramaturgie des Films „unterirdisch" leise mit.

Verdichtung (1) Wien im Februar 2002. *Film ist. 7–12* hatte gerade seine Premiere in Rotterdam erlebt. Dafeldecker, Fennesz, Siewert, Stangl zeichnen für den Soundtrack des 90minütigen Films verantwortlich. Treffen mit Gustav Deutsch in Wien. Auf seinem Arbeitsplatz stapeln sich 42 Audio-CDs mit unserer Originalmusik, natürlich in verschiedensten Fassungen. 42 Arbeits-CDs für *Film ist. 7–12*. Nimmt man eine durchschnittliche Spieldauer von 20 Minuten pro CD an, ergibt dies eine Gesamtspieldauer von 840 Minuten, das sind 14 Stunden. Gustav Deutsch hat sie alle gehört, davon nur einen Prozentsatz verwendet. Die Parallele zu seiner filmischen Arbeitsmethode ist evident.

Komponist (2) Der Ton macht die Musik? Nicht nur. Auch die Auswahl macht die Musik. Gustav

Compression (1) Vienna in February, 2002: *Film ist. 7–12* has just had its premiere in Rotterdam. Dafeldecker, Fennesz, Siewert, Stangl are responsible for the 90 minute soundtrack. A meeting with Gustav Deutsch in Vienna: 42 Audio CD's of our original music stacked up on his desk, naturally in a great variety of versions — 42 working CDs for *Film ist. 7–12*. If you estimate an average running time of 20 minutes per CD, you reach a total running time of 840 minutes, equivalent to 14 hours. Gustav Deutsch has listened to them all. He used only one percent of the total material. This method finds obvious parallels in how he works on film.

Composer (2) Sound makes the music, right? Not really: choices also make the music. Gustav Deutsch is not only a filmmaker without a camera he is also a composer without an instrument. It is striking how his way of handling contemporary musical material corresponds to his method of working with found footage.

Deutsch ist nicht nur Filmemacher ohne Kamera, er ist auch Komponist ohne Instrument. Frappant, wie Deutschs Umgang mit zeitgenössischem Musikmaterial seiner Found-Footage-Filmmethode entspricht.

Weiss-Sagung „Im Stummfilm war man gezwungen, das unhörbare Gerede auf ein Minimum herabzusetzen und zwischen den Dialogtexten die Bilder allein sprechen zu lassen – heute wird fast nur geredet, die Schauspieler reden und reden, um dem Zuschauer – oder besser: Zuhörer – verständlich zu machen, wovon der Film handelt. Das Bewusstsein, daß der Film eine visuelle Kunst ist, kann dabei kaum aufkommen." (Peter Weiss, *Avantgarde Film*, 1956). Die Bilder allein sprechen lassen. Nicht nur, dass heutzutage die Schauspieler „reden und reden" – auch da, wo nicht (oder zusätzlich auch) geredet wird, wird das Bild zumeist von „Musik und Geräuschkulissen aller Art" zugekleistert. Aktuelles Filmschaffen beansprucht, auf der Höhe der Zeit zu sein. Das musikalische Niveau der meisten Filmmusiken hingegen befindet sich – wiewohl auf höchstem technischen Standard stehend – in den tiefsten Niederungen der Zeit. Gustav Deutsch zählt zu jenen Filmemachern, in deren Werken die Musik dem Film nicht hinterdrein hinkt.

Wise words...Weiss' words "Silent film demanded that inaudible dialogue be kept to a minimum and images alone be given to speak between intertitles. Today there is constant talking—the actors talk and talk in order to make it clear to the viewer—or rather listener—what the film is about. The understanding that film is a visual art form barely has a chance to emerge." (Peter Weiss, *Avantgarde Film*, 1956). Allow images to speak by themselves... It is not only that nowadays the actors "talk and talk". The image is obscured by "music, and a backdrop of noise in a variety of forms"—with or without talk. Current filmmaking claims to be state-of-the-art. The musical standard of most film scores, however, while fully up-to-date on a technical level, reaches for the shallowest depths of our time. Only in rare cases, such as the work of Gustav Deutsch, the musical score does not limp behind the film.

Premiere *Welt Spiegel Kino* first seen and heard at the cinema aroused astonishment. At home an emphatic journal entry: "My favorite nation is fascination."

Caution Deutsch's elegant interweaving of film and music... simultaneously, his unwavering respect for the vulnerable sovereignty of the

Welt Spiegel Kino: Live,
Live Act mit / *feat.* Christian Fennesz, Jean Paul Dessy
und / *and* Burkhard Stangl,
Österreichisches Filmmuseum, 19. 11. 2005

Premiere *Welt Spiegel Kino* das erste Mal öffentlich im Kino gesehen und gehört – Begeisterung. Zuhause der emphatische Eintrag ins Cahier: „Meine liebste Nation ist mir die Faszination."

Behutsamkeit Deutschs elegante Film-und-Musik-Verwebungen... Zugleich bei ihm die unbedingte Bedachtnahme auf die verletzbare Souveränität des jeweilig anderen Kunstfeldes. Nur was sich neugierig fremd bleibt, kann sich verstehen.

Konzert Welche Person macht Filme, in deren Interesse es steht, dass die an der Filmmusik beteiligten Komponisten / Musiker zu den Filmen bzw. zu den extra für den Live-Event neu zusammengestellten Filmextrakten live auftreten? Das Konzert ist ein integraler Bestandteil von Gustav Deutschs Kunstauffassung, er belohnt die aus den Archiven in die Öffentlichkeit, ins Offene gezerrten Bilder mit einem Geschenk. Er lässt sie gemeinsam mit den Musikern (die dadurch ebenso beschenkt werden) live in Interaktion treten. Dabei kann es sich um eine „klassische" Film-und-Musik-Situation handeln, genauso wie um eine „live bespielte" Installation im Kontext der Bildenden Kunst. So haben Gustav Deutschs stumme beredte Bilder nicht nur Konzerte im Rahmen von Filmfestivals

respective field of art: To comprehend one another, it is advisable to remain curiously foreign to each other.

Concert What filmmaker is interested in calling composers and musicians together who co-collaborated on a soundtrack in order to accompany the film or a collection of extracts newly compiled for a live event?

The concert is integral to Gustav Deutsch's concept of art. He rewards images torn from archives and forced into public with a special gift. He invites them to interact live with musicians who are thereby equally rewarded. This might take place at a 'classical' site for film and music or in an art venue as part of a 'live installation'. So it comes to pass that Gustav Deutsch's silent, eloquent images have not only performed for concerts at film festivals but are also known to frequent the occasional music festival.

Running Time Deutsch's experimental film œuvre consists primarily of feature length films. The filmmaker engages the 90-minute feature length format, thereby engaging everything that

erlebt, sondern sogar auch das eine oder andere Musikfestival besuchen können.

Filmlänge Bei Deutschs experimentellem Film-œuvre dreht es sich vornehmlich um abendfüllende Werke. Der Filmemacher legt sich mit dem 90minütigen Spielfilmformat an – und legt sich damit mit allem an, was Film ist. *Film ist. 1–6, Film ist. 7–12, Welt Spiegel Kino, Film ist. a girl & a gun.* Eineinhalb Stunden Film, eineinhalb Stunden Musik. Pur.
Wer sonst noch?

Verdichtung (2) Deutschs Filme sind fast durchwegs sprachlos, wie aus einer Zeit, als Bild und Klang noch keine gemeinsame Sprache hatten, keine Rede von einem Reden, das uns sagt, worum es sich handelt. Handlung ohne Sprachlaut. Komprimierter Sinn aus Bild und Musik als Reinheit, die allem Radikalen anhaftet.

Ein Blick „.... schwer von Geduld, Heiterkeit und gegenseitigem Verzeihen, den ein unwillkürliches Einverständnis zuweilen auszutauschen gestattet mit einer Katze." (Claude Lévi-Strauss, *Traurige Tropen*)

film is. *Film ist. 1–6, Film ist. 7–12, Welt Spiegel Kino, Film ist. a girl & a gun.* One and a half hours of film, one and a half hours of music—pure. Who else?

Compression (2) Deutsch's films are almost entirely speechless, as if from a time when image and sound didn't share a common language—no talk about what the story is about. There is action without verbal utterances. A compressed meaning constituted by image and sound—a purity that is at the heart of everything radical.

A Brief Glance *"...*heavy with patience, serenity and mutual forgiveness, that, through some involuntary understanding, one can sometimes exchange with a cat." (Claude Lévi-Strauss, *Tristes Tropiques*)

Beate Hofstadler

All you need to make a movie is a girl and a gun – All you need is love

Film ist. 13, *mit psychoanalytischen Augen betrachtet*
Film ist. 13 *seen through psychoanalytic eyes*

Am Anfang war *A girl and a gun*. Am Ende ein Loch und A (cow)boy and a gun. Schuss – Gegenschuss. „All you need to make a movie is a girl and a gun" meint David W. Griffith. Meint Jean-Luc Godard. Meint Gustav Deutsch? Meint man? Von dem immerhin aktiv schießenden *girl* bleibt ein befremdlich zur Schau gestelltes Loch, in dessen Richtung ein Cowboy seine Schüsse abfeuert. *Wird fortgesetzt*[1].

Diese dichte Kette aus Metonymien / Verschiebungen und Metaphern / Verdichtungen, mit denen uns Gustav Deutsch durch seine Entstehungsgeschichte der Menschheit führt, ist keine leichte Augenkost. *Zuerst nun war das Chaos.* So haben manche sich aus sich selbst heraus geboren. Genesis, Paradeisos, Eros, Thanatos und Gastmahl sind die Stationen auf denen wir einkehren, wenn wir uns durch *A girl & a gun* bewegen. Found Footage aus Pornographie, Kriegsbildern und Naturaufnahmen werden zu einer explosiven, teils gewaltvollen Textur verwoben. Männer fallen für die Ehre. Eindringend. Eindringlich ... und bist du nicht willig. Ein wiederkehrender Kreislauf.

Es scheint, als ob die Geschichte / der Film

In the beginning there was *A girl and a gun*. In the end a hole and A (cow)boy and a gun. Shot —countershot. „All you need to make a movie is a girl and a gun" says David W. Griffith; says Jean-Luc Godard; says Gustav Deutsch? Says everyone? What's left of the girl, who after all is actively shooting, is a disconcerting hole. A cowboy fires his shots in its direction. *To be continued.*[1]

This dense string of metonymics / shifts and metaphors / compressions with which Gustav Deutsch guides us through his history of origins of humanity is not easy on the eyes. *Verily at the first Chaos came to be.* Thus some have given birth to themselves. On our way through *A girl & a gun* we put in stops at Genesis, Paradeisos, Eros, Thanatos and Symposium. Found footage from porn and images of war and nature are woven into an explosive, and partly violent texture. Men die for honor. Forced. Forcingly... and if thou'rt unwilling. A recurring cycle.

It seems as if history / the film is running backwards. An active woman successively turns into a passive object—displayed in all her lavish varieties, or making herself see. *Stand to face me, my beloved and open out the grace of your eyes.*

[1] Kursiv werden hier und im Folgenden Originalzwischentitel aus Gustav Deutschs *Film ist. a girl & a gun* zitiert. Diese Zwischentitel stammen aus antiken Texten von Hesiod, Sappho und Platon.

[1] Direct quotes from the intertitles of Gustav Deutsch's *Film ist. a girl & a gun* are put in italics throughout this essay. These intertitles derive from ancient texts by Hesiod, Sappho, and Plato.

Beate Hofstadler

rückwärts läuft. Eine aktive Frau verwandelt sich zunehmend in ein passives Blickobjekt. Zur Schau gestellt in all ihren verschwenderischen Spielformen. Oder sich schauen machend. *Stelle dich hin mein Freund und lass die Augen aufschlagen ihren Reiz.*

Zur Entstehung der Menschheit gehört auch ihre zunehmende Sexualisierung, die sich in der praktizierten Sexualität als Schwierigkeit erweist. *Heute liebt man nur ganz flüchtig und das Herz ist nicht so wichtig.*[2] Zahlreiches pornografisches Material ist Verweis. Vielleicht. Am Anfang war eine Geschlossenheit, der Kugelmensch bei Platon. Drei Geschlechter von Menschen gab es. *Die 3 Geschlechter gab es deshalb, weil das männliche von der Sonne abstammte, das weibliche von der Erde und das männlich-weibliche vom Mond. Zeus halbierte die Kugelmenschen, da sie ihm gefährlich wurden. „Wie man Quitten zum Einmachen durchschneidet."*[3] *Nun sehnte sich eine jede Hälfte nach der zugehörigen anderen und versuchte mit ihr zusammenzukommen.* Eros soll für die nötige sexuelle Attraktion sorgen, um die ursprüngliche Einheit und Ganzheit in der Vereinigung wieder herzustellen. *Weiter entstand Eros, der schönste der unsterblichen Göt-*

Increasing sexualization is part of the origins of humanity, which proves difficult in practiced sexuality. *Love today is fleeting and the heart is less regarded.*[2] The amount of pornographic material is a reference. Possibly. In the beginning there was wholeness, Plato's round man. According to him, there were 3 sexes. *Now the sexes were three, because the man was originally the child of the sun, the woman of the earth, and the man-woman of the moon.* Zeus cut the round men in half as they became too dangerous for him. "Cut men in two, like a sorb-apple."[3] *After the division the two parts of man, each were desiring his other half.* Eros is responsible for sexual attraction to recreate the original oneness and wholeness in copulation. *Eros, fairest among the deathless gods.* Searching often is yearning for something lost, some think for love, but desire and love can never find one another. Sexual reproduction is also attached to mortality. Creatures meander around, since fulfilling sexuality and ideal love will never make a round whole. *She bare also the fruitless deep with his raging swell (...) without sweet union of love.* The *Real* in Lacan. In the end there was a split, a disruption. A lack. Lack derives from irreconcilable

2) Liedzeile aus *Nocturno* (Gustav Machatý, 1934).

3) Sigmund Freud, *Jenseits des Lustprinzips* [1920], in: GW XIII, Frankfurt/M. 1999, S. 63.

2) A line from a song in *Nocturno* (Gustav Machatý, 1934).

3) Sigmund Freud, *Beyond the Pleasure Principle* [1922], New York 1961, p. 52.

202

Film ist. a girl & a gun,
Zwischentitel / intertitle

ter. Das Suchen ist häufig ein Sehnen nach etwas Verlorenem. Manche meinen nach der Liebe. Allein Begehren und Liebe können niemals zueinander finden. Die geschlechtliche Fortpflanzung ist auch mit Sterblichkeit verbunden. Die Wesen irren umher, da erfüllte Sexualität und vollkommene Liebe nicht unter eine Kugel zu bringen sind. *Das unwirtliche Meer, das anschwillt und stürmt (...) doch ohne verlangende Liebe.* Das Reale bei Lacan. Am Ende war eine Spaltung, eine Zerrissenheit. Ein Mangel. Mangel entsteht aus einer unüberwindbaren Differenz: Der Mensch verlässt einen geschlossenen Zustand, und tritt in eine Mangelsituation. Er braucht den Anderen, der Bedürfnisse gewährt oder auch verwehrt. Resultierender Mangel schafft das Begehren. Das Begehren bleibt unerfüllbar, schafft stets neues Begehren. Bleibt als Druck spürbar. Diesen Mangel zu beheben, Ganzheit und Ungeteiltheit wiederherzustellen, wird fortan das Bestreben sein. *Und ich sehn mich und ich begehr...* Das Phantasma der Vollkommenheit täuscht über die Begrenztheit hinweg. Scheinbar. Der frühere Zustand der Vollkommenheit und Geschlossenheit (das Reale) soll erneut hergestellt werden: Vollkommenheit vor Mangel. Sattheit vor Hunger. Zentrierung vor Dezentrierung. Kugelmensch vor Zweibeinern. Das Leben ein ewiger Rückgriff in die Zukunft.

differences: one is born too early—leaving an enclosed condition and entering a state of lacking. We need the *Other,* who grants or refuses our needs.

Desire cannot be completely satisfied and that creates new desire. It lingers as a force, and then yearning begins. From this point on, the striving will be to fix this state of lacking, to recreate wholeness and unbrokenness. *I long and seek after...* The phantasm of completeness deceives us from the limitations, or so it seems. The original state of completeness and wholeness (the *Real*) shall be restored again: Completeness over lack, satiation over hunger, centre over decentre, round man over biped. Life is a perpetual recourse to the future. *And the desire and pursuit of the whole is called Eros.* Man's refusal to accept the lack leads to misunderstanding. The most privileged form of denial of human incompleteness is not distinguishing the phallus from the penis[4]. This deceit or interchange of penis and phallus is also evident in the assumption that one is supposedly (more) complete by possessing the phallus; a completeness shown in the ability to satisfy every woman. Back to sexual reality though, which demonstrates that "nothing assures that every man / the

4) see August Ruhs, "Mangel / Differenz / Geschlecht", in *texte*, Heft 1, Vienna 1995, p. 59.

...diesem Verlangen und Trachten
nach Ganzheit
eignet nun der Name Liebe...

...aber mich
hast du vergessen —
oder hast du
einen anderen Menschen lieber?

Film ist. a girl & a gun,
Zwischentitel / *intertitle*

Diesem Verlangen und Trachten nach Ganzheit eignet nun der Name Liebe. Sträubt sich der Mensch, den Mangel zu akzeptieren kommt es zu Verwechslungen. Die Materialisierungserscheinungen des Phallus, dessen Gleichsetzung mit dem männlichen Geschlechtsorgan, stellt die privilegierteste Form der Verleugnung menschlicher Unvollkommenheit dar.[4] Diese Täuschung oder Vertauschung von Penis und Phallus zeigt sich ferner in der Annahme, durch den vermeintlichen Besitz des Phallus vollkommen(er) zu sein. Die Vollkommenheit, die sich darin kundtut, jede Frau befriedigen zu können. Doch zurück zur sexuellen Realität: Sie äußert sich dadurch, (...) dass nichts dafür sorgt, dass jeder Mann / der ganze Mann (tout homme) (...) so beschaffen sei, dass er jede Frau befriedigen kann. Der Mann (...) muss sich damit begnügen, davon zu träumen".[5] So wird eine „Verschiedenartigkeit zur Verschiedenwertigkeit"[6], das in der Andersartigkeit als ein Nicht-Ganzes symbolisiert wird. Verleugnet wird der Mangel, dass weder Mann noch Frau den Phallus besitzen kann, weil jener nur als Symbol des Mangels zu fungieren ver-

whole man (tout homme) (...) is conditioned to satisfy every woman. Man (...) needs to content himself by dreaming about it."[5] And so the "variety of forms becomes a variety of values,"[6] which in its otherness is symbolized as incomplete. This lack is denied: No one can possess the phallus, neither man nor woman, because it can only serve as a signifier of lack. It represents the void, cannot be located, and signifies what one could have.[7] The subjunctive life, the phallus as an empty promise.

The second half of the round man finds a correlation: If the woman as "man's dream" equals a phantasm, then she assumes the complete man, Prince Charming. *But me you have forgotten, or you love some man more than me?* The woman trusts in the illusion, that there is indeed the one, the perfect one. This leads to the phantasm of virginity: Sleeping Beauty is saving herself. She waits for the one and wants no other. This illusion of perfection leads to "women ultimately always cheating on their husbands with a divinity."[8]

4) vgl. August Ruhs, „Mangel / Differenz / Geschlecht",
 in *texte*, Heft 1, Wien 1995, S. 59.

5) Jacques Lacan, „Rede in Genf über das Symptom",
 in: *Riss*, Heft 1, Zürich 1985, S. 25.

6) August Ruhs, op.cit., S. 54.

5) Jacques Lacan, "Rede in Genf über das Symptom",
 in: *Riss*, Heft 1, Zurich 1985, p. 25.

6) August Ruhs, op.cit., p. 54.

7) see August Ruhs, "a-nalyse und/oder A-nalyse", in:
 *Der Vorhang des Parrhasios. Schriften zur Kulturtheorie
 der Psychoanalyse*, Vienna 2003, p. 196.

mag. Er repräsentiert das Nichts, lässt sich nirgends verorten, steht als Zeichen dafür, dass man etwas haben könnte.[7] Ein Leben im Konjunktiv. Der Phallus, ein leeres Versprechen.

Die zweite Seite des Kugelmenschen findet eine Entsprechung: Wenn die Frau wiederum als „Traum des Mannes" einem Phantasma gleicht, geht sie vom vollkommenen Mann, vom Märchenprinzen aus. *Aber mich hast du vergessen – oder hast du einen anderen Menschen lieber?* Die Frau wiegt sich in der Illusion, dass es den Einen, den Vollständigen tatsächlich gibt. Dies mündet in das Phantasma der Jungfräulichkeit: Dornröschen hebt sich auf. So wartet sie auf den Einen und will sonst Keinen. Diese Illusion der Vollkommenheit führt dazu, dass die Frauen ihre Männer „letztlich immer mit einem Gott betrügen".[8]

Eros und Thanatos auf dem Weg. „Bedürfnis nach Wiederherstellung eines früheren Zustandes".[9] Natur, geht es nach Freud. Kultur, geht es nach Lacan: Thanatos als Maske der symbolischen Ordnung. Begehren, Triebe und Sprache

Eros and Thanatos on their way; "the desire to recreate original conditions."[9] That is, nature, according to Freud; culture, according to Lacan: Thanatos as a mask of the symbolic order. Desire, drive and language belong to the realm of the *Other*. They come from outside. *Each of us when separated is but the tally-half of a man.* This is the unconscious desire, therefore desire is sexual. Only in language is desire recognized, but its articulation is limited because desire and language are inherently incongruent. It's the lack inside the chain of signifiers left from the original split. Symbolically the heart cannot be located; the word separates. Those who deny the word, deny the lack. *I want to say something but shame prevents me.* Those who deny the lack do not find themselves; lull themselves into a non-existing wholeness; rolling up; a desire heading for obliteration in the moment of fulfillment; Thanatos. Drive is always also a death drive, an attempt to aim beyond the lust principle, but results in pain rather than more lust. It is the point where lust is experienced as suffering; painful lust is pleasure. *In my dripping pain the blamer... may winds and terrors carry him off.* It is the yearning for that, which is lost, the

7) vgl. August Ruhs, „a-nalyse und/oder A-nalyse", in: August Ruhs, *Der Vorhang des Parrhasios, Schriften zur Kulturtheorie der Psychoanalyse*, Wien 2003, S. 196.

8) Jacques Lacan, zitiert nach Ruhs, „Mangel/Differenz/Geschlecht", op.cit., S. 56.

9) Freud, op.cit, S. 62.

8) Jacques Lacan, quoted from Ruhs, "Mangel/Differenz/Geschlecht", op.cit., p. 56.

9) Freud, op.cit, p. 62.

gehören dem Bereich des Anderen an. Kommen von außen. *Jeder von uns ist also das Bruchstück eines Menschen.* Gemeint ist das unbewusste sexuelle Begehren. Im Artikulieren wird das Begehren erst erkannt. Doch die Artikulation ist begrenzt, denn das Begehren und die Sprache sind grundsätzlich nicht vereinbar. Es ist der Mangel in der Signifikantenkette, den die erste Trennung hinterlässt. Das Herz lässt sich symbolisch nicht verorten. Das Wort trennt. Wer das Wort verweigert, verwehrt den Mangel. *Will etwas sagen, aber es hält mich ab die Scham...* Wer den Mangel verwehrt, findet den Weg zu sich nicht. Wiegt sich in nicht vorhandener Geschlossenheit. Kugelt sich ein. Ein Begehren, das im Moment seiner Erfüllung seiner Auslöschung zusteuert. Thanatos. Trieb ist immer auch Todestrieb. Ein Versuch, über das Lustprinzip hinaus zu schießen. Es entsteht nicht ein Mehr an Lust, sondern Schmerz. Dort an jenem Ort, an dem die Lust als Leiden erfahren wird. Diese schmerzhafte Lust ist Genießen. *Wer mich quält, den sollen die Winde treiben und seine Sorgen.* Diese Sehnsucht nach dem Verlorengegangen, dem Urobjekt. Jedoch. Die ewige Suche findet nur Ersetzungen.

Film ist. 13 zeigt viel Bezug bei wenig Beziehung. *Manchmal gibt es ein sich finden, aber selten ein sich binden.*[10] „All you need is love, love..." Die

ur-object, although the eternal search only finds substitutions.

Film ist. 13 shows a lot of relatedness while showing little relationship. *Sometimes we will find another, but we rarely bind another.*[10] "All you need is love, love..." Creatures meander around, elevating feelings, imploding/exploding, opening/closing, showing/unifying; no merging. The longing to return to wholeness (round) leads to the actual lapse of all gentle pursuits; of love. *Their heart turned cold and they dropt their wings.* The round man was cut in two: the subject has to overcome the transgression of having and being and to accept the double alienation (mirroring misconception, symbolic castration) to arrive at lust. "It is possible to sustain a desire, given that the subject takes on this double alienation and accepts it, and given that its living condition allows for recognizing the illusion of an identity of sense and being by resisting the temptation to identify with its representations. The constant desire of the other curbs the short-circuiting of the need for satisfaction and reaches access to love, sexuality and death via this lack."[11] *According to my weeping.*

Can be continued.

10) A line from a song in *Nocturno* (Gustav Machatý, 1934).
11) Ruhs, "Mangel/Differenz/Geschlecht", op.cit., p. 51.

Wesen irren umher. Erhebende Gefühle. Implodieren. Explodieren. Sich öffnen. Sich schließen. Sich zeigen. Sich vereinigen. Sich nicht verbinden. Der Wunsch, die Geschlossenheit (Kugel) wieder zu erreichen, führt zur eigentlichen Verfehlung aller zärtlichen Strebungen. Der Liebe. *Ihnen sind vor Kälte erstarrt die Herzen, senken ihre Flügel.* Der Kugelmensch wurde zertrennt: Das Subjekt muss eine Habens- und Seinsverfehlung bewältigen und die doppelte Entfremdung (spiegelbildliches Verkennen, symbolische Kastration) akzeptieren, um zur Lust zu gelangen. „Sofern das Subjekt diese zweifache Entfremdung auf sich nimmt und akzeptiert, sofern es ihm seine Lebensbedingungen erlauben, die Vermeintlichkeit der Identität von Sinn und Sein zu erkennen, indem es der Versuchung widersteht, sich mit den es repräsentierenden Repräsentanzen zu identifizieren, ist es ihm möglich, ein Begehren aufrechtzuerhalten, das als stetes Begehren des anderen dem Kurzschließen der Bedürfnisbefriedigung Einhalt gebietet, um über den so erlebten Mangel den Zugang zur Liebe, zur Sexualität und zum Tod zu erreichen." [11] *Für meine Tränen.*

Kann fortgesetzt werden.

10) Liedzeile aus *Nocturno* (Gustav Machatý, 1934).

11) Ruhs, „Mangel / Differenz / Geschlecht", op.cit., S. 51.

Hanna Schimek, Gustav Deutsch

Film ist. a girl & a gun

Zeichnungen und Filmstills
Drawings and film stills

Während der Recherche zu *Film ist. a girl & a gun* fertigte Hanna Schimek – wie schon bei vorangegangenen Recherchen – unzählige Standbildzeichnungen von den gesichteten Filmen an. Diese Zeichnungen dienen sowohl der Unterstützung des optischen Gedächtnisses, als auch der internen Kommunikation. Mit diesen sehr schnell und fast automatisch gezeichneten Skizzen versucht sie das Wesentliche der Bildinhalte zu erfassen, und sich so ins Gedächtnis einzuprägen. Das Ergebnis – hunderte Seiten Skizzen und mit Gesprächs- und Gedankennotizen versehene Aufzeichnungen – stellen eine unabdingbare Arbeitsgrundlage für Selektion, Ordnung und Schnitt dar.

Einer thematischen Auswahl und Zusammenstellung dieser Zeichnungen sind im nachfolgenden Bildteil Filmstills aus *Film ist. a girl & a gun* gegenübergestellt.

During the research for *Film ist. a girl & a gun*, Hanna Schimek drew innumerable sketches of single frames from the films viewed—as she had done before during previous research. These sketches serve both the purpose of supporting the optical memory as well as internal communication. With these quick, almost automatic sketches, she tries to document the essential characteristics of the images, thereby etching them into her memory. The results—hundreds of pages of notes and sketches—form the necessary basis for the process of selecting, arranging and editing.

A thematic assortment and compilation of these sketches has been set in contrast to film stills from *Film ist. a girl & a gun* in the following section of images.

▨ UTILITY SERVICE DE LUXE (1938-40)

▨ VARIATIONS OF CURING (1926)

▨ VARIATIONS OF GAY WORMING UP (1937)

▨ WEEKEND OF LOVE I (1938)

▨ " II 1938 GLEICHER FILM.....

▨ WHAT THE ARTIST MISSED (1932) ✓ FUCK A DUCK FILM PRODUCTION

HÄNDE ZWISCHEN SCHENKEL!
IHRE - SEINE
DIRECTOR OSCAR LOVENUT.

SOUND:
RUDOLF TWITCHTWAT

"SCHÖNSCHÖNE!
FLECKEN

STERMA-
LIKE...

8:35
8:55
3

19sec
1

EXTASE | MASKENHAFT 35sec
GESCHMINKT 35

2 —36sec SIE DREHT SICH
SIE GREIFT SEINEN SCHWANZ - BLICKE!

▨ WHEN POP IS AWAY MOM WILL PLAY (1934-37) PROSTEN!
DER KAMERA 20...

SNAPPY BRUSIMAN

BEIDE
HABEN
MASKEN
1'07sec

0:55
1:35
3

ER KOMMT
ZUR TÜR HEREIN...

LIEST PORNO
AUF PARKBANK

2 — 28sec ✓

SIE LIEST... KEYHOLE MAGAZIN ZUHAUSE
AUF COUCH

▨ WONDERS OF THE UNSEEN WORLD (1923) MR. EVIL MINDED

▨ FULLER BRUSH MAN (1930)

▨ MENAGE MODERNE DE MADAME BUTTERFLY (NEGATIVE...)

▨ THE HYPNOTIST (1931)

▨ VARIATIONS OF THE GAY NINETIES

▨ THREE COMRADES (1928-30) SCHWULENFILM 2...

▨ KKK NIGHTRIDER

▨ A NIGHT WITH A BROADWAY BABY

▨ POT POURRI FROM THE 50TH

▨ A COUNTRY STUD HORSE PEEP SHOW MIT KINETOSKOPE! (1920)

15

Film ist. a girl & a gun – Genesis.
Ausschnitt aus / *excerpt from*: *What the Artist Missed* (1932)

Film ist. a girl & a gun – Genesis.
Ausschnitt aus / *excerpt from: Three Graces* (1930)

v. l. n. r. / f. l. t. r.:
Darkie Rhythm (1928–30) / *Massages* (1920–25) / *Darkie Rhythm* (1928–30)
Naked Truth (1925–1931) / *Re-United Foursome* (1921–23) / *Busy Lesbian Club* (1930–33)
Darkie Rhythm (1928–30) / *Jazz Mania* (1936–38) / *Gay Count* (1925)

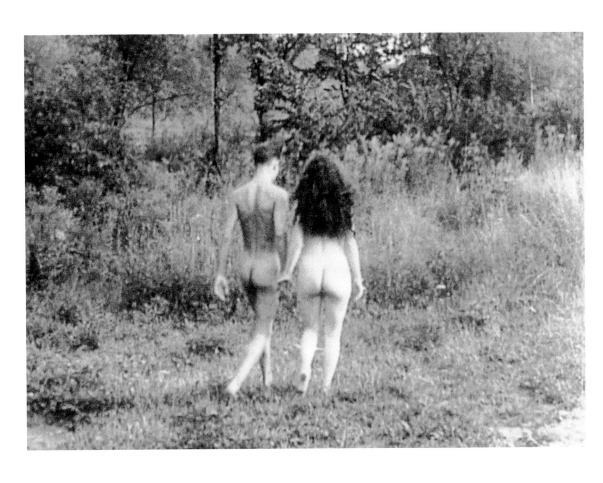

Film ist. a girl & a gun – Paradeisos.
Ausschnitt aus / *excerpt from: L'île des Nudistes* (1936)

v. l. n. r. / f. l. t. r.:
L'île des Nudistes (1936) / *L'île des Nudistes* (1936) / *Lachen des Lebens* (1932)
L'île des Nudistes (1936) / *Rodeo* (1923) / *Lachen des Lebens* (1932)
Lachen des Lebens (1932) / *L'île des Nudistes* (1936) / *Ewiger Wald* (Rolf von Sonjevski-Jamrowski, 1936)

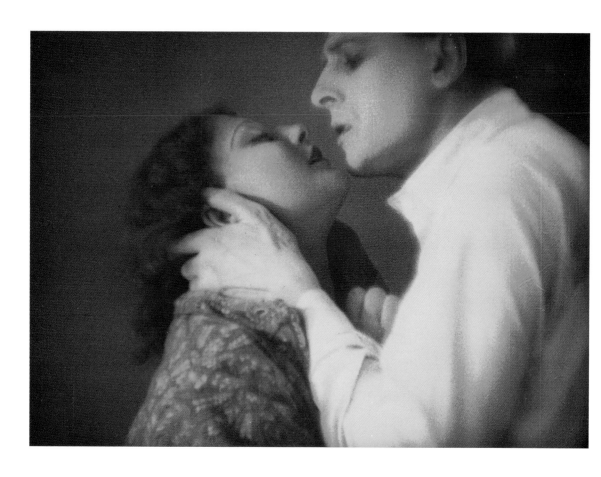

Film ist. a girl & a gun – Eros.
Ausschnitt aus / *excerpt from: Erotikon* (Gustav Machatý, 1929)

La Nave (Gabriellino D'Annunzio, Mario Roncoroni, 1921) / *Scampolo* (Augusto Genina, 1928) / *La Piovra* (Edoardo Bencivenga, 1919)

La Contessa Sara (Roberto Roberti, 1919) / *La Storia di una Donna* (Eugenio Perego, 1920) / *Maciste all' Inferno* (Guido Brignone, 1926)

Die Büchse der Pandora (Georg Wilhelm Pabst, 1929) / *Fleur d'amour* (Marcel Vandal, 1927) / *La Storia di una Donna* (Eugenio Perego, 1920)

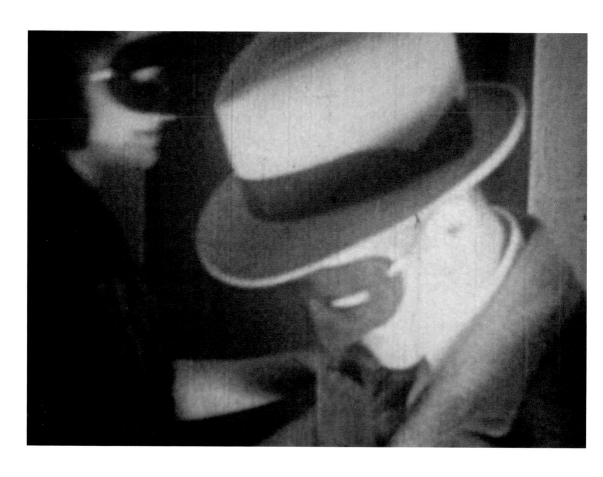

Film ist. a girl & a gun – Thanatos.
Ausschnitt aus / *excerpt from: When Dad is Away, Mom Will Play* (1934–37)

v. l. n. r. / f. l. t. r.:
The Masked Rape (1936) / *One Sunday Morning* (1930–32) / *Mardi Gras Orgy* (1930)
When Dad is Away, Mom Will Play (1934–37) / *When Dad is Away, Mom Will Play* (1934–37) / *Mardi Gras Orgy* (1930)
Gas Masks of World War I (1917) / *Flame Thrower* (1916) / *Gaumont Graphic 436* (1915)

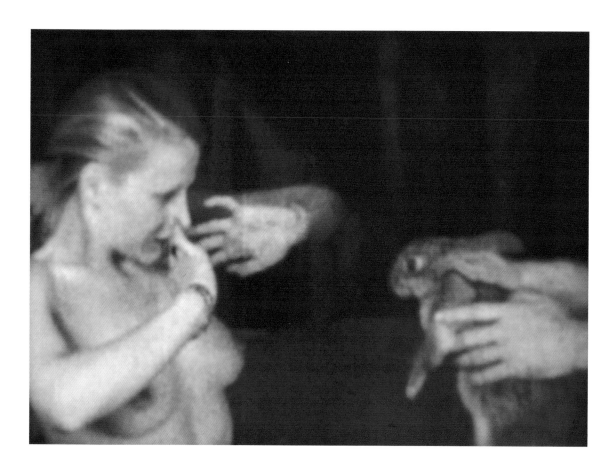

Film ist. a girl & a gun – Symposion.
Auschnitt aus / *excerpt from: The Modern Magician* (1933)

v. l. n. r. / *f.l.t.r.*:
Eugene Sandow (William Dickson, 1894) / *The Modern Magician* (1933) / *English Tragedy* (1936)
Matinee Idol (1937) / *Mexican Honeymoon*, (1935–40) / *The Modern Magician* (1933)
Sexy Sixteen (1938–42) / *La Femme au Portrait 2* (1940) / *Chinese Love Life* (1921)

Film ist. a girl & a gun – Symposion.
Ausschnitt aus / *excerpt from*: *Sons of the Empire, Part 1* (J.B. McDowell, H.C. Raymond, 1917)

v. l. n. r. / f.l.t.r.:

Scene di guerra alpina (1917) / *Flashes of Action, Part 3* (1919) / *Flashes of Action, Part 3* (1919)
Flashes of Action, Part 3 (1919) / *Flashes of Action, Part 2* (1919) / *Sons of the Empire, Part 5* (J.B. McDowell, H.C. Raymond, 1917)
Sons of the Empire, Part 1 (J.B. McDowell, H.C. Raymond, 1917) / *With British Monster Guns in Action* (1918)
Sons of the Empire, Part 4 (J.B. McDowell, H.C. Raymond, 1917)

Film ist. a girl & a gun – letztes Bild des Films / *last frame of the film*.
Ausschnitt aus / *excerpt from: The Great Train Robbery* (Edwin S. Porter, 1903)

Anhang / Appendix

Biografie / Biography

1952 geboren in Wien

1958–62 Volksschule in Wien

1962–70 Gymnasium in Wien, Matura in Bildnerischer Erziehung über das *Bauhaus*

1970–79 Diplomstudium Architektur an der Technischen Universität Wien; Foto- und Super-8-Arbeiten sowie kollektive soziale und politische Arbeit.

1980–83 Mitglied der Medienwerkstatt Wien, Videoarbeiten

seit 1983 Mitglied der internationalen Künstlergruppe „Der Blaue Kompressor – Floating & Stomping Company" (DBK)

seit 1985 Arbeit mit Hanna Schimek, Partnerin in Leben und Kunst, unter dem Label D&S

seit 1989 Filmarbeit

seit 1996 Mitglied von sixpackfilm (www.sixpackfilm.com)

seit 2002 Mitglied von After Image Productions (www.afterimage.at)

seit 2003 Künstlerischer Leiter der Aegina Akademie, Aegina/Griechenland (mit Hanna Schimek)

Gustav Deutsch lebt in Wien und Aegina.

Nichtfilmische Werke, Projekte und Ausstellungen (Auswahl) 1983–2008

Eine komplette Filmografie und ausgewählte audiovisuelle Installationen sind auf Seite 228–241 zu finden.

1983–87 *Jardin de Wiltz*, Konzept und Realisierung eines öffentlichen Gartens, als Kooperation scheinbar nicht-behinderter mit behinderten Menschen, Wiltz/Luxemburg (mit DBK)

1984 *Son et Lumiere Vienna*, ein Landschafts-, Klang- und Lichtspektakel (D&S)

1985–94 *Das Wasser, die Pflanzen, die Grenzen der Wüste*, künstlerisches Forschungsprojekt in der Saharaoase Figuig/Marokko, Ausstellung (D&S)

1985–91 *Die Kunst der Reise*, Konzept und Realisierung von Ausstellungen und Veranstaltungen in Wien (Luftbad, 1986/87), Frankfurt (1988/89) und London (1991, in Kooperation mit Battersea Arts Center, Watermans Arts Center, Chisenhale Gallery, London Filmmakers Cooperative) (D&S)

1993 *Son et Lumiere Frankfurt*, ein Schau-, Hör- und Lichtspiel zum Thema: Nacht/Stadt/Tag (D&S)

1995 *Die Kunst der Reise – Die Athen Konferenz*, Konzeption und Realisation einer Ausstellungs- und Veranstaltungsreihe in Zusammenarbeit mit dem Goethe Institut und dem Fournos Theater/Athen (D&S) *Taschenkino*, Wien (siehe *Installationen*)

1996 *Taschenkino – US Tour*, Art Institute/San Francisco, Walter Reade Theatre/New York, MIT/Boston, Art Gallery Windsor/Ontario *Terrain Vague*, künstlerische Forschung und Plakataktion, Frankfurt/Main 1.7.–7.7.1996 (D&S)

1997 *Karamustafa Import – Export*, österreichisch-türkisches Kunstaustauschprojekt in Zusammenarbeit mit Gülsün Karamustafa, Ausstellungen in Wien (echoraum und Völkerkundemuseum) und im Kabataş Kültür Merkezi, Istanbul (D&S)

1999 *Odyssey Today – CD ROM*, Multimedia-Publikation des Langzeitprojekts *Die Kunst der Reise* (D&S)

1998–2006 Verschiedene installative Arbeiten auf Grundlage der *Film ist.*-Serie im In- und Ausland (siehe *Installationen*)

2003–2008 Verschiedene Installationsprojekte von D&S in Aegina, Wien, Linz, Köln und Karlsruhe; Entwurf und Bau (mit Franz Berzl) eines Camera-Obscura-Gebäudes in Perdika/Aegina (siehe *Installationen*)

2006–2009 Arbeit an *Visions of Reality* (siehe *Installationen*) und *Film ist. a girl & a gun*

2008 *Café Melange*, Ausstellungs- und Veranstaltungsprojekt für das Europäische Jahr des interkulturellen Dialogs in Wien; ein mobiles Kulturcafé mit Diskussionen, Veranstaltungen, Ausstellungen und einer Mediathek (D&S)

2009 Retrospektive im Österreichischen Filmmuseum, Wien

2009 Künstlerischer Partner des interdisziplinären Forschungsprojekts *Film.Stadt.Wien. A Transdisciplinary Exploration of Vienna as a Cinematic City*, gemeinsam mit dem Ludwig Boltzmann Institut für Geschichte und Gesellschaft und dem Österreichischen Filmmuseum, gefördert vom WWTF (D&S)

1952 Born in Vienna

1958–62 Primary School in Vienna

1962–70 Secondary School in Vienna; A-levels include examinations in art (special topic: the *Bauhaus*)

1970–79 Studies in Architecture, Technical University Vienna (graduate engineer); photo works and Super-8 films, collaborative social and political work.

1980–83 Member of Medienwerkstatt Wien, video works

since 1983 Member of the international artists group "Der Blaue Kompressor – Floating & Stomping Company"(DBK)

since 1985 Works with Hanna Schimek, his partner in life and art, under the label D&S

since 1989 Film works

since 1996 Member of sixpackfilm (www.sixpackfilm.com)

since 2002 Member of After Image Productions (www.afterimage.at)

since 2003 Artistic director of Aegina Academy, Aegina / Greece (with Hanna Schimek)

Gustav Deutsch lives in Vienna, Austria and Aegina, Greece.

Selected non-film works, projects and exhibitions 1983–2008

For a complete filmography and a selection of audiovisual installations see page 228–241.

1983–87 *Jardin de Wiltz*, concept and realization of a public garden, in cooperation with people with special needs, Wiltz / Luxemburg (with DBK)

1984 *Son et Lumiere Vienna*, a landscape-, sound-, and light-spectacle (D&S)

1985–94 *The Water, The Plants, The Borders of the Desert*, artistic research works in the Sahara desert oasis Figuig/Marocco, exhibitions in the oasis (D&S)

1985–86 *The Art of Travelling – Archive Vienna*, concept and realization of an exhibition and a series of events in Vienna (D&S)

1989 *The Art of Travelling – Archive Frankfurt*, concept and realisation of an exhibition and a series of events in Frankfurt am Main, Germany (D&S)

1991 *The Art of Travelling – Archive London*, concept and realisation of an exhibition and a series of events in London, in cooperation with: Battersea Arts Center, Watermans Arts Center, Chisenhale Gallery, London Filmmakers Cooperative (D&S)

1993 *Son et Lumiere Frankfurt*, an audio-, visual-, light-spectacle on the theme „Night / City / Day" (D&S)

1995 *The Art of Travelling – The Athens Conference*, concept and realisation of an exhibition and a series of events in cooperation with Goethe Institute and Fournos Theater, Athens (D&S)
Taschenkino (*Pocket Cinema*), Vienna (see *Installations*).

1996 *Pocket Cinema – US Tour*, Art Institute/San Francisco, Walter Reade Theatre / New York, MIT / Boston, Art Gallery Windsor / Ontario
Terrain Vague, artistic research and performance, Frankfurt / Main 1. 7. – 7. 7. 1996 (D&S)

1997 *Karamustafa Import – Export*, Austrian-Turkish Art exchange project, in cooperation with Gülsün Karamustafa. Exhibitions in Vienna (echoraum and Museum of Ethnography) and in Istanbul (Kabataş Kültür Merkezi) (D&S)

1999 *Odyssey Today—CD ROM*, multimedia publication of the long term project *The Art of Travelling* (D&S)

1998–2006 Various installation works based on the *Film ist.* series (see *Installations*)

2003–2008 Various installation projects with D&S in Aegina, Vienna, Linz, Cologne and Karlsruhe; construction (with Franz Berzl) of a camera obscura building in Perdika / Aegina (see *Installations*)

2006–2009 Work on *Visions of Reality* (see *Installations*) and *Film ist. a girl & a gun*

2008 *Café Melange*, concept and realization of a mobile café presenting lectures, discussions, music and a mediatheque. Realized in the course of the European Year of Intercultural Dialogue in Vienna (D&S)

2009 Retrospective at the Austrian Film Museum, Vienna

2009 Artistic partner of the interdisciplinary research project *Film.Stadt.Wien. A Transdisciplinary Exploration of Vienna as a Cinematic City*, with Ludwig Boltzmann Institut für Geschichte und Gesellschaft and the Austrian Film Museum, funded by the WWTF (D&S)

Filme und Videos / Films and Videos

Wenn nicht anders angegeben, wurden alle Filme von Gustav Deutsch realisiert (Konzept, Produktion, Regie, Kamera, Ton, Schnitt).
Unless otherwise noted all films shot, edited, produced and directed by Gustav Deutsch.

Für die Creditangaben wurden die folgenden englischen Bezeichnungen gewählt:
CO-DIRECTOR (Ko-Regie), **PRODUCTION** (Produktion), **PRODUCER** (Produzent) **CAMERA** (Kamera), **SOUND** (Ton), **EDITOR** (Schnitt), **MUSIC** (Musik).
Unter **WITH** finden sich diverse Mitwirkende (Funktion in Klammern); **FEATURING** gibt DarstellerInnen an.

Alle Filme werden, so nicht explizit ein Vertrieb (*Distributor*) angegeben ist, von sixpackfilm (Wien) verliehen: www.sixpackfilm.com
Unless a distributor is noted all films are distributed by sixpackfilm (Vienna, Austria): www.sixpackfilm.com

Rituale

[Rituals]
1982, Video, b/w, 35 min
CO-DIRECTOR Ernst Kopper
DISTRIBUTOR Medienwerkstatt Wien

Eine Videodokumentation über die Festkultur im niederösterreichischen Weinviertel. „Unterstreicht üblicherweise bei solchen Anlässen die Filmkamera nicht ohne Bosheit in der Optik unbeabsichtigte Komik, so weichen die *Rituale* zwar ihr auch nicht aus; aber anstatt lächerlich zu wirken, rührt sie, stimmt feierlich! (...) Mit dem exemplarischen Mut zu breitem Ausspielen lassen diese Rituale in ihrem Pluralismus ihr Gemeinsames erkennen, in unserem Bedürfnis nach Kommunikation, unbeschadet aller ihrer Unzulänglichkeit, weil man sonst erfröre." (Fritz Walden)
A video documentary on social rituals in the rural Weinviertel region in Lower Austria. Gustav Deutsch: "I began working with Medienwerkstatt *in 1981, on a collaborative project with another architect—Ernst Kopper—who had founded a collective with three other architects. They had applied for a grant for an alternative media project focusing on life in the countryside. (...) We worked together for two years, shooting video, and recording the cultural behavior and rituals of people in the countryside during the cycle of a year. We visited all the feasts and all openings of schools and roads and whatever."*

Fulkur

1982, Video, b/w, 20 min
CO-DIRECTOR Ernst Kopper
DISTRIBUTOR Medienwerkstatt Wien

Das Partnervideo zu *Rituale* ergründet in einer dichten Montage den Kulturbegriff der BewohnerInnen des Weinviertels. Zugleich parodiert das Video die herablassende Art, mit der das Fernsehen einem „rückständigen" ländlichen Kulturverständnis begegnet.
Fulkur was the second video produced from material shot in the Weinviertel region. It sheds a light on people's opinions on culture and art, and parodies the prejudices manifest in the style of conventional TV documentaries. Deutsch: „In those days, we saw collaborative work as political, as collaboration not only among artists, but with the people in the areas where we filmed."

Asuma

1982, Video, color, 35 min
CO-DIRECTORS Gerda Lampalzer, Manfred Neuwirth
DISTRIBUTOR Medienwerkstatt Wien

Der Versuch von scheinbar nichtbehinderten Menschen (internationalen Künstlern und Künstlerinnen), mit Behinderten zusammenzuarbeiten. Gearbeitet wurde in den geschützten Werkstätten des *Centre de Réadaptation* in Capellen (Luxemburg). In sechs Monaten entstanden nach den Ideen jedes einzelnen Mitarbeiters Objekte, Bilder, Klangkörper, Texte usw. Dieser Versuch der Zusammenarbeit von Menschen verschiedener Bewusstseinszustände stellte keine Therapie dar, sondern

die Suche nach der persönlichen und der gemeinsamen Kreativität. (Medienwerkstatt Wien)

A collage of images and sound put together from the impression of visitors to a project in which people of different states of awareness (mentally handicapped and artists) attempt to work together. Conceived and shot as a collective project at the workshops of the Centre de Réadaptation *in Capellen, Luxembourg.*

Wossea Mtotom

1984, Video, color & b/w, 70 min
CO-DIRECTORS Gerda Lampalzer, Manfred Neuwirth
DISTRIBUTOR Medienwerkstatt Wien

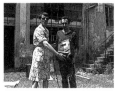

In einem weiteren kollektiven Projekt wurde, 2 Jahre nach den Dreharbeiten zu *Asuma*, ein kleiner Park, der „Garten von Wiltz", entworfen. „*Wossea Mtotom* dokumentiert diese Zusammenarbeit: Als lose Folge von Momentaufnahmen, die das gelassene Zusammenspiel der Gruppe unterstreichen; und als Versuch, das Medium Video weniger als Dokumentations- denn als Kommunikationsmittel zu gebrauchen. ‚Kein Bericht über das Projekt', wie die Realisatoren schreiben, ‚sondern ein Teil desselben'". (Constantin Wulff)

In a follow-up project to the one shown in Asuma *a public garden, "The Garden of Wiltz", was built in the Luxemburg community of Wiltz.* Wossea Mtotom *is a largely associative documentary collage showing this collaborative effort.*

Non, je ne regrette rien / Der Himmel über Paris

[Non, je ne regrette rien / The Sky over Paris]
1988, 16mm (Blow-up von/from S-8), color, 2 min

Der Himmel über der Pariser Ringautobahn, im Ausschnitt der Heckscheibe eines fahrenden Autos. Mit jedem Kameraschnitt beginnt Edith Piaf ihr Chanson immer wieder von vorne. (Gustav Deutsch)

The sky over the motorway circling Paris, seen through the back window of a moving car. With each bridge over the carriageway, Edith Piaf begins her chanson anew... (Gustav Deutsch)

Prince Albert fährt vorbei

[Prince Albert Passes By]
1988, 16mm (Blow-up von/from S-8), color, 1 min

Die regenverhangene Skyline von Oostende über dem bleiernen Meer. Langsam kommt Prince Albert zu den Klängen einer Hymne von links ins Bild ... (Gustav Deutsch)

The rain darkened skyline from Ostende out over the leaden sea. Slowly Prince Albert enters the picture from the left to the sound of a hymn... (Gustav Deutsch)

Adria – Urlaubsfilme 1954–68
(Film – Schule des Sehens I)

[Adria—Holiday Films 1954–68 (Film—School of Seeing I)]
1989, 16mm (Blow-up von/from S-8), Color & b/w, 37 min
DISTRIBUTOR sixpackfilm, Lightcone, Canyon Cinema

Um das *naive* Hinschauen, das gegebenenfalls mehr sichtbar machen kann als das raffinierte Filmemachen, geht es auch in Deutschs wissenschaftlich-erheiternder Urlaubsfilmanalyse *Adria*. Deutsch geht dem nach, was der anonyme Reisende als *erinnernswert* ansieht, und stellt erstaunliche Regularitäten, optische Wiederholungstaten im Umgang mit Architektur, Familie und Freizeit fest; *Adria*: ein reiner Found-Footage-Film, der – in charakteristischer Systematik – nach Kamerabewegungen geordnet ist. (Stefan Grissemann)

Deutsch's first major found footage film, a milestone in his 'archeology' of amateur filmmaking. "I decided to categorize the films into 'actions', meaning the activities of the filmmakers as they made the films; and 'reactions,'

meaning the reactions of the people in front of the camera. Then I devised a more detailed formal organization that I followed very carefully. The decision to make such formal categories derived from my attempt to see the home movies not so much as the individual products of particular families, but as records of a particular social group at a specific historical moment." (Gustav Deutsch)

Sa. 29. Juni / Arctic Circle

[Sat., 29th of June / Arctic Circle]
1990, 16mm (Blow-up von / from S-8), color, 3 min

Ein Found-Footage-Film, in dem Deutsch Aufnahmen einer Reisegruppe nach strukturellen Prinzipien umordnet. „Zwei Ehepaare auf der Fahrt von Wien zum Nordkap und zurück. Am Samstag, dem 29. Juni passieren sie den Polarkreis und bleiben bei dem Schild mit der Aufschrift ‚Polarzirkel' stehen ..."
(Gustav Deutsch)
One of Deutsch's funniest found footage films—a structural reworking of an anonymous filmmaker's road trip to the polar circle. Deutsch: "Two married couples on a journey from Vienna to the North Cape and back. On Saturday, 29th of June they cross the polar circle and stop by the sign which says 'Arctic Circle'..."

Welt / Zeit 25812 min

[World / Time 25812 min]
1990, 16mm (Blow-up von / from S-8), b/w, 37 min
CO-DIRECTOR Ernst Kopper
CAMERA Ernst Kopper

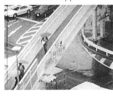

Wien, Singapur, Hongkong, Taipeh, Tokio, Kioto, Osaka, Los Angeles, New York, Wien: Auf einer 18-tägigen Weltreise macht die Kamera jede Minute automatisch ein Bild: am Tag, in der Nacht, im Koffer, im Flug-

zeug, in der Bahn, im Bus, im Hotelzimmer, ... 25812 Bilder, rund um die Erde. Ein Film-Dokument der Welt / Zeit. (Gustav Deutsch)
Vienna, Singapore, Hong Kong, Taipei, Tokyo, Kyoto, Los Angeles, New York, Vienna. On an eighteen-day round-the-world-trip, the camera shot one frame every minute. During the day, during the night, in suitcases, on the airplane, train, bus and in the hotel room ... 25812 pictures round the world. A film document of world time. (Gustav Deutsch)

Augenzeugen der Fremde

[Eyewitnesses in Foreign Countries]
1993, 16mm, color, 35 min
CO-DIRECTOR Mostafa Tabbou
CAMERA Gustav Deutsch, Mostafa Tabbou

Gemeinsam mit dem Marokkaner Mostafa Tabbou dreht Deutsch 1992–93 in Figuig und Wien den Essayfilm *Augenzeugen der Fremde*. Zwei Filmemacher blicken in die Fremde: ein Europäer in Afrika und ein Afrikaner in Europa. Der von Deutsch fotografierte afrikanische Teil des Films steht in fast spiegelbildlichem Gegensatz zu der von Tabbou umgesetzten Wiener Hälfte: Hitze gegen Kälte, Licht gegen Dunkelheit, Profi- gegen Amateurfilmemacher.
Nur in einem sehen sich Deutsch und Tabbou geeint: in der Distanz, die sie zur Welt halten, die sie filmen. Auf die Fremde kann man nur aus der Ferne blicken. (Stefan Grissemann)
1992–93, Deutsch directed an essay film in Vienna and Figuig with Morrocan Mostafa Tabbou. Two filmmakers gaze on foreign territory: one is a European in Africa, the other an African in Europe. The African part directed by Deutsch inversely mirrors the Viennese part realized by Tabbou: heat versus cold, light versus darkness, professional versus amateur filmmaker. Deutsch and Tabbou only see eye to eye in terms of the distance they keep to the world they are shooting: One can only view the foreign from afar. (Stefan Grissemann)

55/95

1994, 16mm, b/w, Loop & 35mm, b/w, 1 min
SOUND Christoph Amann

Trailer für die Filmschau *Austrian Avant-Garde Cinema 1955–1993*, ausgehend von der Filmaufnahme der Unterzeichnung des Staatsvertrags 1955, die Deutsch im Mistkübel eines Kopierwerks fand. „Ein Fundstück aus der österreichischen Vergangenheit, bearbeitet im Hinblick auf die Zukunft." (Gustav Deutsch)
The one minute film consists of a single shot from the 1955 newsreel in which Foreign Minister Figl declares Austria's post-war independence. At a time when Austria has become a member of the EU and the right wing dreams of a third republic, the re-working of an amusing trifle becomes a serious commentary on the way in which Austrian neutrality and independence is dealt with. (Thomas Korschil)

Am laufenden Band

[On the Conveyor Band]
1994, 16mm, b/w, Loop & 3 min version
Found-Footage-Film: „Spezialisierung und Rationalisierung bei der Tortenherstellung."
Found footage film about "specialization and rationalization for the production of cakes." (Gustav Deutsch)

Film / Spricht / Viele / Sprachen

[Film / Speaks / Many / Languages]
1995, 35mm, color, 1 min
PRODUCTION Viennale, Gustav Deutsch
DISTRIBUTOR sixpackfilm, Viennale

Gustav Deutsch, der Analytik nicht mit Schwere verwechselt, lässt im Viennale-Trailer 1995 manche Fährten aufblitzen. Auf einem Boulevard in Casablanca findet er verstreut 39 Fragmente eines indischen

Spielfilms. Witterung, Passanten und Fahrzeuge haben an ihnen ihre Spuren hinterlassen. Deutsch wählt 21 der aufgehobenen Fragmente aus und „(re-)konstruiert" eine knapp einminütige Geschichte. (...) Eine Minute Kino der Farben, des Materials, der Emotionen, des Marktes, der kulturellen Verschränkungen. (Elisabeth Büttner)
39 fragments of an Indian feature film with French and Arabic subtitles were found on Boulevard Sidi Mohamed Ben Abdallah. Of these, 21 were used to (re)construct a one minute story comprising 4 parts which take place in 4 locations dictated by the original material. (...) The length of each fragment is as found, the sequences re-ordered and separated from each other by a single monochromatic frame. Each of the four headings has a color and a word assigned to it. (...) The words (in white letters) cover the whole area of the screen, with the appropriate color as background. The pieces are preserved as found and seen as a film object—the accumulated damage, dirt, sound track and perforation are all visible. (Gustav Deutsch)

Taschenkino

[Pocket Cinema]
1995, S-8, color, no sound, 100 Loops
PHOTOS Hans Labler
FEATURING Wilbirg Donnenberg, Werner Kodytek, Hanna Schimek, Günther Seher, Irene Strobl, Geri Weber and others
SUPPORTED BY hundertjahrekino

Taschenkino – der Katalog

[Pocket Cinema – The Catalogue]
1996, 16mm (Blow-up von/from S-8), b/w, 30 min
FEATURING Wilbirg Donnenberg, Werner Kodytek, Hanna Schimek, Günther Seher, Irene Strobl, Geri Weber and others
SUPPORTED BY hundertjahrekino
Ein Expanded-Cinema-Projekt, realisiert zum 100. Geburtstag des Kinos. Stefan Grissemann: „Deutsch denkt das Kino weit über dessen traditionelle Grenzen hinaus: Für sein *Taschenkino* etwa lässt er 1995 100 Spielzeugfilmbetrachter, so genannte *Microviewer*, im Zuschauerraum kreisen, auf denen je eine kurze

Filmschleife zu sehen ist: das Auge eines Pferds, die Ohren eines Esels, der Schwanz eines Zebras, Blitze, Feuer, Wolken, Wasseroberflächen. Schwenks seit- und auf- und abwärts. (...) Rituelle Handlungen, ein Kuss, ein Shakehands, gedrehte Daumen und übereinander geschlagene Beine." Ein Jahr später wurden die 100 Loops auf 16mm aufgeblasen und als Rolle neu zusammengestellt.

An Expanded Cinema *project staged in 1995 for the centennial of cinema. Stefan Grissemann: "Deutsch thinks of Cinema far beyond its traditional boundaries. In 1995 he circulated 100 toy movie-viewers or 'micro-viewers' among the audience for his* Pocket Cinema *project. Each device ran a short strip of film displaying individual motifs: the eye of a horse, the ears of a donkey, the tail of a zebra, lightning, fire, clouds, bodies of water; pans and tilts (...)." One year later the 100 film loops where blown up to 16mm and assembled into a linear reel.*

Film ist mehr als Film

[Film Is More Than Film]
1996, 35mm, color & b/w, 1 min
PRODUCTION Viennale, Gustav Deutsch
CAMERA Georg Eisnecker
SOUND Gustav Deutsch, Dietmar Schipek
FEATURING Regina Schlagnitweit

Der Trailer für die Viennale 1996 zeigt 25 Kader aus der Großaufnahme eines Auges, dazwischengeschnitten 24 Begriffe als Schriftinserts, auf der Tonspur unterlegt mit Filmzitaten.
The festival trailer for the Viennale 1996 is made up of 25 frames of a close-up shot of an eye, 24 intertitles, and short bursts of cinematic sounds lifted out of a variety of films. "Compressed cinephilia." (Stefan Grissemann)

Mariage blanc

[White Marriage]
1996, 16mm, color, 5 min
CO-DIRECTOR Mostafa Tabbou
FEATURING Mostafa Tabbou

Beitrag zur Filmrolle *Filmart Takes Position 1996: ALIEN/NATION,* von sixpackfilm. „Als ‚Mariage blanc' bezeichnet man in Marokko eine Schein- hochzeit zwischen einem Marokkaner und einer Europäerin, zum Zwecke der Erlangung einer Aufent- haltsgenehmigung in Europa. Der Film thematisiert diese sehr intime Form der versuchten Immigration und ist für Mostafa Tabbou Fiktion und Realität zugleich. *Mariage blanc* wurde an drei Tagen im Juli 1996 im Hotel de Paris in Casablanca in Marokko aufgenommen." (Gustav Deutsch)

'Mariage blanc' in Morocco means a sham marriage between a Moroccan man and a European woman in order to obtain a residence permit in Europe. The theme of Mariage blanc *is this very intimate form of attempted immigration which is, for Mostafa Tabbou, simultaneously fiction and reality. The film was shot in three days in July of 1996 at the Hotel de Paris in Casablanca, Morocco. (Gustav Deutsch)*

no comment – minimundus Austria

1996, 35mm, b/w, 13 min
PRODUCTION polyfilm
PRODUCER Alexander Dumreicher-Ivanceanu
SOUND Gustav Deutsch, Dietmar Schipek
FOUND FOOTAGE BY Hans Holzinger, Heinrich Stahl, anonym
SUPPORTED BY hundertjahrekino

Beitrag zur Filmrolle *Eine Geschichte der Bilder,* im Rahmen von *hundertjahrekino.* „Privatmaterial aus den Jahren 1953 bis 1956 lässt Gustav Deutsch zum Schauplatz einer denkwürdigen Kollision zweier Systeme von Nachrichten- und Identitätsvermittlung werden. Die gute alte Schwarzweiß-Kino-Wochenschau begegnet Seitenschienen der Kabel-Euro News, in denen unter dem Logo

,no comment' Impressionen von allen erdenklichen Weltschauplätzen und Krisenherden für sich stehen." (Claus Philipp) *A found footage film produced on the occasion of the centennial of cinema.*

"A picture of Austria by Austrians with selected public views taken from home movies from the fifties. A fictional, private newsreel in TV news style without commentary, featuring original soundtrack material from the archives." (Gustav Deutsch)

Film ist. 1–6

1998, 16mm, color & b/w, 60 min
PRODUCTION loop media
PRODUCER Manfred Neuwirth
SOUND Gustav Deutsch, Dietmar Schipek
DISTRIBUTOR sixpackfilm, Lightcone, Canyon Cinema

Tableaufilm zur Phänomenologie des Mediums Film. Die ersten sechs Kapitel sind dem wissenschaftlichen Labor als Geburtsstätte des Films gewidmet:
1. Bewegung und Zeit /
2. Licht und Dunkelheit /
3. Ein Instrument /
4. Material / 5. Ein Augenblick / 6. Ein Spiegel.
„Ein einschlagender Blitz teilt Ganzes, Deutschs Verfahren ist dem ähnlich; es spaltet die Darstellungsschichten des wissenschaftlichen Materials und stattet sie mit neuen Sinnschichten aus. Das gelingt durch die teilweise Neugestaltung des Tons und der Musik, die dem (scheinbar) über objektive Beweiskraft verfügenden Material fiktionale Gestalt verleiht. (...) Imposant sind die Materialien selbst und Deutschs Rechercheleistung, sie aus den Archiven des Schweigens herauszuholen; Lehrfilme, die Generationen von Auszubildenden öd rezipierten, werden befreit aus ihrer hilflosen Pädagogik und durch das Verfahren von Reihung und Neuordnung mit jener Kraft ausgestattet, die ihnen prinzipiell innewohnt." (Bernhard Sallmann)
1. Movement and Time / 2. Light and Darkness / 3. An Instrument / 4. Material / 5. A Blink of an Eye / 6. A Mirror.
"Film ist. *consists almost exclusively of sequences from existing scientific films. These films are about the acrobatic flights of pigeons, the intelligence testing of apes; about 'reversed worlds' and stereoscopic vision; hurricanes and impact waves in the air. How glass breaks, children walk and how a Mercedes crashes into a wall in slow motion. The contempt with which scientific films are received is not directed against the content, but rather against their conventional, unimaginative, ridiculous and commentary-contaminated appearance. Similarly, the fascination with some of the educational films can be attributed almost exclusively to the power of their images—images which one has never seen, even in the cinema." (Alexander Horwath)*

Tradition ist die Weitergabe des Feuers und nicht die Anbetung der Asche
[Tradition is the Handing on of Fire, not the Worship of Ashes]
1999, 35mm, color, 1 min
CO-DIRECTOR Christian Fennesz
PRODUCTION Filmarchiv Austria
SOUND Christian Fennesz

Trailer für das Filmarchiv Austria. Deutsch: „Ein Filmfundstück – aus Nitrocellulose – als Material. Das Feuer – die Bedrohung des Nitrofilms – als Motiv. Ein Zitat – von Gustav Mahler – als Botschaft. Der Soundtrack – von Christian Fennesz – als Brücke."
Trailer for the Filmarchiv Austria. "Some found footage—made of cellulose nitrate—the material. Fire—a threat to nitrate film—its theme. A quote—from Gustav Mahler—its message. The soundtrack—by Christian Fennesz—as the bridge." (Gustav Deutsch)

233

K & K & K

1999, Video, color, 12 min
FEATURING Kurt Kren
DISTRIBUTOR Gustav Deutsch

Deutschs dokumentarische Erzählung *K & K & K* ist eine filmische Paradoxie: ein selbst gedrehter Found-Footage-Film, ein cleveres Spiel mit verschwundenem oder nie belichtetem Material. Die Videoarbeit ist dem Wiener Avantgardefilmpionier Kurt Kren (1929–98) gewidmet und versteht sich als eine Art doppelter Erinnerungsfilm: Deutsch denkt mit dem Material, das er an einem Mittwoch im August des Jahres 1997 gedreht hat, an seinen Freund Kren zurück, der sich darin seinerseits an seinen verstorbenen Freund Robert Klemmer erinnert. Schon darin spiegelt sich das Wesen der Arbeit mit gefundenem Filmmaterial: Sie ist nichts anderes als rekontextualisierte Erinnerung. (Stefan Grissemann)

Deutsch's documentary narrative K & K & K *is an example of a filmic paradox. It is a found footage film that was directed by its maker, cleverly playing with film material that disappeared, or actually never was exposed. The video project is dedicated to Viennese avant-garde film pioneer Kurt Kren (1929–98), and can be understood as a kind of two-fold film of remembrance. Deutsch thinks back upon his friend using material he literally shot from the hip on a Wednesday in August of 1997, showing Kren remembering his late friend Robert Klemmer. The essence of working with found footage is already reflected in the very concept of the project: It is nothing other than the re-contextualizing of memory. (Stefan Grissemann)*

Film ist. 7 – 12

2002, 35mm, color & b/w, 94 min
WITH Hanna Schimek (Artistic Supervisor, Research)
PRODUCTION loop media
PRODUCER Manfred Neuwirth
MUSIC Werner Dafeldecker, Christian Fennesz, Martin Siewert, Burkhard Stangl
IN COOPERATION WITH Centre National de la Cinématographie, Cinemateca Portuguesa, Cineteca di Bologna, Filmarchiv Austria, Nederlands Filmmuseum
DISTRIBUTOR sixpackfilm, Nederlands Filmmuseum, Lightcone

Während sich die ersten 6 Kapitel des Tableaufilms *Film ist.* mit dem wissenschaftlichen Labor als Geburtsstätte des Mediums beschäftigten, sind die nächsten 6 Kapitel dem Jahrmarkt, dem Varieté und dem Studio, als Wiege der Kinematographie gewidmet: 7. Komisch / 8. Magie / 9. Eroberung / 10. Schrift und Sprache / 11. Gefühl und Leidenschaft / 12. Erinnerung und Dokument. „Ich glaube, dass wir im 21. Jahrhundert endlich lernen werden, das bewegte Bild zu verstehen, indem wir das Staunen des frühen Publikums wiederentdecken, aber auch, indem wir ein breites Bezugsfeld gewinnen, in dem alle diese verschiedenen Gesten, Momente, Handlungen, Ausdrücke, rätselhaften Objekte und flackernden Erleuchtungen nicht ein wahres Lexikon bilden werden, sondern ein Spektrum von Möglichkeiten, eine Tabelle von Verbindungen, den Stoff einer neuen Kunstform der Collage und Montage. Die Surrealisten evozierten den Traumvorgang durch die zufällige Zusammenstellung von Gegenständen und Bildern, die eine neue Massenkultur ihnen als ihren Abfall anbot. Eine neue Wissenschaft könnte von diesem ständig wachsenden Aschehaufen weggeworfener Bilder und visueller Amnesie aufsteigen. Deutschs Film ist jedoch mehr als nur die letzte Folge im surrealistischen Spiel. Er erinnert nicht so sehr an ein Wörterbuch als an ein reich illustriertes ABC für Kinder, eine Fibel, die uns das Sehen wieder beibringen wird, indem sie uns durch das Dickicht der Bildermassen schneidet, mit der Durchschlagskraft einer Vision, die wachsam dafür ist, was am Film noch lebendig ist und uns den Prozess der Wiederentdeckung lehrt, der – Film ist." (Tom Gunning)

7. Comic / 8. Magic / 9. Conquest / 10. Writing and
Language / 11. Emotions and Passion / 12. Memory and
Document.
*"I believe that in the twenty-first century we will finally
learn how to understand the moving image, rediscovering
the wonder of first audiences, but also gaining a broad field
of reference in which all these diverse gestures, moments,
actions, expressions, enigmatic objects and wavering illumi-
nations will form, not a true lexicon, but a range of possi-
bilities, a table of combinations, the stuff of a new art form
of collage and montage. The surrealists evoked the dream
process through the chance assembly of the objects and im-
ages which a new mass culture offered them as its discards.
A new scholarship might spring up on this ever-widening
ash heap of discarded images and visual amnesia. This ever-
spreading overgrowth of images tends to blind us, rather
than aid our sight. Deutsch´s film is more than the latest
installment in the surrealist game. Rather than a verbal
lexicon, it recalls a child´s spelling book, amply illustrated,
a primer which will instruct us how again to see, cutting
through the thicket of the mass of images with the
penetration of a vision alert for what still is alive in film,
teaching us the process of rediscovery that—film is."*
(Tom Gunning)

Spectrum
2003, 35mm / 16mm / Video, color, 49 sec
CO-DIRECTOR Martin Siewert
PRODUCTION sixpackfilm, Gustav Deutsch
SOUND Martin Siewert
Trailer für sixpackfilm. „Das Licht erzeugt das Bild.
Die Farben des Lichts erzeugen die Farben des Bildes.
Die Übergänge der Farben erzeugen die Bewegung des
Bildes. Die Dauer der Farben und Übergänge erzeugt
die Geschwindigkeit der Bewegung. Die Reduktion der
Dauer erzeugt die Symbiose der Farben. Die Symbiose
der Farben erzeugt das weiße Licht. Der Ton erzeugt die
Stimmung des Bildes." (Gustav Deutsch / Martin Siewert)
*Trailer for sixpackfilm. "Light produces the image. The
light's colors produce the colors of the image. The trans-
itions between the colors produce the movement within the
image. The colors' durations and the transitions between*

*them produce the speed of the movement. The reduction
in duration produces the colors' symbiosis. The colors'
symbiosis produces white light. The soundtrack produces
the atmosphere." (Gustav Deutsch / Martin Siewert)*

Welt Spiegel Kino – Episode 1–3
[World Mirror Cinema. Episode 1–3]
2005, 35mm, b/w, 93 min
WITH Hanna Schimek (Artistic Supervisor, Research)
PRODUCTION loop media, Nederlands Filmmuseum
PRODUCER Manfred Neuwirth, Frank Roumen
MUSIC/SOUND Christian Fennesz, Burkhard Stangl, Cello
played by Jean Paul Dessy
IN COOPERATION WITH Cinemateca Portuguesa, Det Danske
Filminstitut, Filmarchiv Austria, Nederlands Filmmuseum,
Österreichisches Filmmuseum
DISTRIBUTOR sixpackfilm, Nederlands Filmmuseum

Die drei Episoden von *Welt
Spiegel Kino* beginnen mit
einem Schwenk und weit-
eren Ansichten einer Straße
mit Lichtspielhaus, davor
urbanes Gewimmel, im
Herumstehen wie auch in
Bewegung: Kinematograf
Theater Erdberg, Wien 1912;
Apollo Theater, Surabaya
1929; Cinema São Mamede
Infesta, Porto 1930. Zuerst
Found Footage von ausge-
suchter Beliebigkeit, dann
Zeitlupe und zoomende
Fokussierung von Details,
zumal Individuen. Anders als in *Tom Tom the Piper's Son*,
Ken Jacobs' Klassiker der vergrößernden Abtastung
des Gewusels früher Filmbilder, öffnen sich isolierte Bild-
zonen hier auf andere, in ihnen implizierte Bilder. Diese
fungieren als Entfaltung eines imaginären Innen, in dem
sich das mediale Außen ablagert, als Fortspinnen mög-
licher, wunschklischeedurchwirkter Biografien. (...)
Was oder wen die Zooms und Freezes zum Überblenden
auswählen, ist spannend und überraschend, denn jeder

beliebige Punkt im Bild kann Öffnung auf weitere Bilder werden, ohne dass diese Links einer externen Ordnung bedürften. Filmografische Daten zum montierten Material stehen im Abspann, nicht etwa am Bildrand, und ein Sounddesign aus alten Schlagern und neuer Kompositorik legt ein Gewebe aus Stimmungen, Akzenten, nachhallenden Erinnerungen aus, anstatt als Gefühlsanleitung zu fungieren. (...) *Welt Spiegel Kino*, das hängt zusammen, insofern Kino Welt spiegeln, ein Bild von Allerweltsmenschen (und seien sie Kaiser) geben kann, von allem an ihnen, ihrer gelebten Aktualität, ihren Lebensmöglichkeiten und deren Bedingungen. (Drehli Robnik)
In Gustav Deutsch's most recent found footage film the masses "absorb" (Walter Benjamin) the artwork. Three historical camera pans across the streets and squares of Vienna, Surabaya, and Porto provide a starting point for reflection on the relationship of everyday stories and cinematic machinery. The film's steadfast piercing of the dynamic of this relationship is astounding. Each of the three pans—taken between 1912 and 1930—shows a cinema; in the montage, the passersby become chance protagonists in a series of micro-tales, which report on both cinematic and world history. Deutsch's method for connecting archival material is highly hypertextual: every person in the film refers to a multitude of socio-cultural contexts, similar to the hyperlinks in the interactive CD-Rom Odyssey Today made by Deutsch and his partner Hanna Schimek. For Gustav Deutsch, the cinema (and pars pro toto every similarly 'insignificant' artefact) is a mirror to the world. And conversely, the cinema belongs to these 'infamous people', the secondary characters of history. Their being-in-the-world creates its photochemical process; the twentieth century person is reflected (and discovered) in the eye of the camera. (Michael Loebenstein)

Die Mozarts
[The Mozarts]
2006, 35mm (Transfer von / from Video), color, 1 min
CO-DIRECTOR Hanna Schimek
CAMERA Manfred Neuwirth
PRODUCTION Wiener Mozartjahr 2006

Wolfgang Amadeus Mozart – die Ikone der Österreich-werbung – wird auf einer täglich im Wiener Stadtraum stattfindenden Performance von einer multiethnischen Darstellergemeinde wieder zum Leben erweckt. Konzertkartenverkäufer in historischen Kostümen und Perücken stehen am Stephansplatz, bei der Oper, beim Mozartdenkmal, vor dem Burgtheater... und versuchen vorbeigehende Touristen zum Kauf eines Tickets zu verführen. Neun von ihnen stellen sich vor: Limani Mozart, Amari Mozart, Jordansky Mozart, Alin Mozart ... (Gustav Deutsch / Hanna Schimek)
Commissioned by the Vienna Mozart Year 2006. "Wolfgang Amadeus Mozart—the advertising icon for the country of Austria—is brought to life in Vienna's urban space every day by a multiethnic group of actors. Sellers of concert tickets in historic costumes and wigs stand around St. Stephen's Square, at the State Opera House, at the Mozart monument, in front of the Burgtheater, trying to convince passing tourists to buy one. Nine of them introduce themselves: Limani Mozart, Amari Mozart, Jordansky Mozart, Alin Mozart, etc." (Gustav Deutsch / Hanna Schimek)

Film ist. a girl & a gun
2009, 35mm, color, 93min
WITH Hanna Schimek (Artistic Supervisor, Research)
PRODUCTION loop media
PRODUCER Manfred Neuwirth
MUSIC Christian Fennesz, Martin Siewert, Burkhard Stangl
ADDITIONAL MUSIC BY Bohren und der Club of Gore, David Grubbs, Olga Neuwirth, Lucia Pulido, Eva Reiter, Soap & Skin
PRODUCTION PARTNERS Nederlands Filmmuseum, Imperial War Museum, Filmarchiv Austria, Österreichisches Filmmuseum

IN COOPERATION WITH Bundesarchiv Filmarchiv, Centre National de la Cinématographie, Cinémathèque de Toulouse, Cineteca di Bologna, Friedrich Wilhelm Murnau Stiftung, Museo Nazionale del Cinema di Torino, Národní Filmový Archiv, The Kinsey Institute for Research in Sex, Gender and Reproduction.

Der dritte Teil von *Film ist.* erzählt in 5 Kapiteln – Genesis (Schöpfung), Paradeisos (Paradies), Eros (Liebe), Thanatos (Tod) und Symposion (Gastmahl) – die Geschichte von Mann und Frau, von der Erschaffung des Kosmos aus dem Chaos bis zur Einrichtung der modernen Ehe, als einer Serie gewaltsamer Spaltungen und nicht minder gewalttätiger Vereinigungen. Auch hier verwendet Deutsch ausschließlich Found Footage aus diversen europäischen Archiven, sowie erstmals Material aus dem Kinsey-Insitut in Bloomington, Indiana. (Michael Loebenstein)
Die Konfrontation der Geschlechter, Liebe und Hass, Erotik und Pornografie, Leidenschaft und Gewalt, waren von Anbeginn der Kinematografie, sowie mit jeder weiteren neuen Entwicklung von optischen und optisch-akustischen Medien, Motivationsgeber und Hauptthemen der medialen Produktionen. Voyeurismus und Exhibitionismus sind dem Medium Film und allen weiteren Medien inhärente Begriffe. In diesem Kapitel – das in seinem Aufbau und seiner inhaltlichen Konzeption einem fünfaktigen griechischem Drama entspricht – werden jedoch nicht nur die eindeutigen Gattungen und Genres erfasst und bearbeitet, sondern auch der wissenschaftliche Film, der Lehrfilm, der Kriegsfilm oder der ethnographische Film. Die Konfrontation der Geschlechter durchzieht – mehr oder weniger versteckt – all diese Gattungen und Genres, und soll durch die Montage verdeutlicht und in neue Bedeutungszusammenhänge gebracht werden. (Gustav Deutsch)

The 13th chapter of Film ist. *is dedicated to the universal theme of the battle of the sexes, and is composed from archival footage discovered during research in European archives, as well as in the Kinsey Institute in Bloomington, Indiana. "Using images from the first four and a half decades of cinematography," taken from 11 archives across the world, Gustav Deutsch has constructed a musical "film drama in five acts." In detail, the editing is again based on visual analogies, the external similarity of bodies, objects, movements and narratives. The film constructs its own amazing attractions from the juxtaposition of documentary, fictional, pornographic, scientific and propaganda images that are literally alien to their original purpose. In other words, they are images that do not necessarily belong together, though they create visual contexts. The central thread is supplied by ancient mythology, fragmentary quotes of Hesiod, Sappho and Plato. And a line leads from the ancients to the mythical stories that cinema is still telling. Film is: a girl and a gun. (Isabella Reicher)*

Verleih und Verkauf
Distribution and sales

Distribution, sales and information
on films by Gustav Deutsch: sixpackfilm
office@sixpackfilm.com

Die CD / *the Audio-CD*
Film ist. Musik / *phonographics*,
Werner Dafeldecker, Christian Fennesz,
Martin Siewert, Burkhard Stangl,
is available from: durian records:
durian@durian.at

Die CD / *the Audio-CD*
Film ist. Musik / *dialogue & variations*,
Hannes Löschel & Velvet Lounge, Gustav Deutsch,
is available from: Loewenhertz:
www.loewenhertz.at

Filme und Videos: „Fundus"
Films and Videos from the "Fund"

Den ‚kanonischen' Arbeiten Gustav Deutschs steht eine
Vielzahl von Filmen und Videos gegenüber, in denen die
Motive, Themen und Strategien seiner künstlerischen
Praxis in ‚kleiner', oft privater Form verhandelt werden.
Mit Ausnahme seiner ersten Videoarbeit, *Jugendzen-
trum/Per Albin Hansson Siedlung Ost*, die während
seines Technikstudiums auf 1 Zoll C Videoband entstand,
sowie einiger Found-Footage-Filme sind es filmische
Studien, Skizzen, filmische Selbstbeobachtungen und
Tagebuchaufzeichnungen, die überwiegend auf Super-8
gedreht wurden und nicht in Distribution sind. Als „Fun-
dus" für seine ‚rekombinierende' Arbeitsweise werden
sie immer wieder für einzelne Veranstaltungen umgear-
beitet (z.B. vertont), nach thematischen Gesichtspunk-
ten zusammengestellt oder mit den längeren Arbeiten
kombiniert.

*What Gustav Deutsch calls "films from the fund" are the
various 'smaller' film and video works that pursue the
themes and topics of his canonical films, albeit in a more
private and playful fashion. With the exception of a couple
of found footage films and* Jugendzentrum / Per Albin
Hansson Siedlung Ost *[Youth Center Per Albin Hansson
Estate East], an early documentary shot on 1 inch video
during his architectural studies, all these films and videos
are sketches, studies, self observations or film diaries,
mostly shot on Super-8 and never distributed. As a 'pool'
for his method of recombinant programming they never-
theless are regularly reworked, compiled into reels and
combined with more canonical films for screenings and
lectures.*

Jugendzentrum / Per Albin Hansson Siedlung Ost
1977, Video, b/w, 35 min
no answer
1982, S-8, color, no sound, 5 min
Parasol
1982, S-8, color, no sound, 3 min
love my cow
1982, S-8, color, no sound, 1 min
The ceremony of the whirling dance
1983, Video, b/w, 80 min
As time goes by Maria / 83
1983, Video, b/w, 60 min
Listomist
*1984, 16mm (Found Footage), color & b/w,
Rohmaterial / raw footage*
As time goes by Maria / 84
1984, S-8, color, 15 min
Landen
1986, 8mm (Found Footage), no sound, Loop
Trepini da Treporti
1986, S-8, no sound, Loop
The bruxelles trip / 86
1986, S-8 color, no sound, 3 min
Leo Africanus le voyageur
1986, S-8, color, no sound, 30 min
3 min aus der Ewigkeit / Feuer
1986, S-8, color, no sound, 3 min
3 min aus der Ewigkeit / Meer
1986, S-8, color, no sound, 3 min
Walzer Nr. 18
1988, 16mm (Found Footage), b/w, Loop
3 min aus der Ewigkeit / Nachtgewitter
1988, S-8, color, no sound, 3 min
360° v.l.n.r. tägl. 1.1. – 31.1.1988
1988, S-8, color, no sound, 20 min
**Der Blaue Kompressor & Das Geschenk des
Jahrhunderts**
1988, S-8, color, no sound, Rohmaterial / raw footage
Die Dame / Das Dromedar / Der Araber
*1988, 8mm (Found Footage), b/w, no sound, Loop
Video, color, 4 min*
Minutentagebuch 20. 3.1989
1989, S-8, color, no sound, 1 min

Kamelführer
1989, S-8 (Found Footage), color, Loop
Kurzer unruhiger Schlaf
1989, S-8, color, no sound, Loop
Das Blaue Zimmer – 48 Std
1989, S-8, color, no sound, 2 min
Kristallnacht / Maingas
1989, S-8 & 16mm, color, 1 min
Fenster nach Mekka 1 / Figuig
1990, S-8, color, no sound, 2 min 30 sek
100 Schritte tägl. 1.1. – 31.1.1990
1990, S-8, color, no sound, 20 min
Fenster nach Mekka 2 / London
1991, S-8, color, no sound, 3 min
Feininger in Moskau
1991, 8mm, color, no sound, Loop
International Observations 1 – Paris / Monsieur Delouit
1992, S-8, color, no sound, 1 min
Minutentagebuch 15.10.1992
1992, S-8, color, no sound, 1 min
Fensterdschungel
1994, S-8, color, no sound, 3 min
Küchenbiotop
1994, S-8, color, no sound, 3 min
Tanz des Lebens
1994, 16mm, b/w, Loop
God is in the detail – Mies van der Rohe antwortet Frank Lloyd Wright
1994, 16mm, b/w, work in progress
International Observations 2 – Athen / Argos
1995, S-8, color, no sound, 3 min

Mit/*with* Ernst Kopper

Die drei Videobänder über die niederösterreichische Region Weinviertel entstanden 1980–1981 parallel zu den Filmen *Rituale* und *Fulkur* im Rahmen des Projekts *Filme aus Niederösterreich* und werden über die Medienwerkstatt Wien vertrieben. Deutsch und Kopper kompilierten für *Weinland/Himmelsfrieden* Interviews mit politischen Repräsentanten vom Bürgermeister bis zum Nationalratsabgeordneten; *Portraitskizzen* zeigt regionale

Kulturschaffende bei der Arbeit oder im Interview. *Weinlandpotpourri* wurde als erster Rohschnitt für die Fördergeber montiert. Die Bänder sind im Unterschied zu ihren „Partnerfilmen" mehr als Zeitdokument denn als künstlerische Dokumentationen konzipiert.

These three videos about the Weinviertel, a rural region in Lower Austria, were shot back to back with the more poetic videos Rituale *and* Fulkur *in 1980–81. For* Weinland/Himmelsfrieden *Deutsch and Kopper compiled interviews with a range of regional politicians, from mayors to members of the national council.* Portraitskizzen *presents regional artists and cultural associations at work, and* Weinlandpotpourri *is an early rough cut produced for the funding agencies. Unlike the two canonical videos from the series these tapes where not conceived as artworks, but rather as a historical document of the region and its inhabitants. The tapes are distributed by the Medienwerkstatt Wien.*

Weinlandpotpourri
1982, Video, b/w, 55 min
Weinland / Himmelsfrieden
1982, Video, b/w, 60 min
Portraitskizzen
1982, Video, b/w, 30 min

Mit/*with* Hanna Schimek

Die filmischen Miniaturen, die Deutsch gemeinsam mit Hanna Schimek hergestellt hat sind überwiegend gegenseitige Studien (Protagonist und Beobachter) in zwei Serien: Studien über Tanz (die *H. tanzt*-Serie), und Filme über Essen (die *H. isst Tiere*-Serie). Alle Filme außer *Greifzug*, der aus vier in der Kamera geschnittenen Rollen besteht, und *100 Steine / 100 Schritte*, der als eine Doppelprojektion aus 100 Loops konzipiert wurde, bestehen aus jeweils einer, eine Rolle langen Einstellung auf Super-8. *She* wurde auf Video produziert; Hanna Schimek filmte, ähnlich den *Screen Tests* von Andy Warhol, die Gesichter von Freundinnen; Gustav Deutsch versah die Tonspur mit Charles Aznavours Song „She".

239

Installationen (Auswahl)
Installations (Selection)

Since 1984 Gustav Deutsch and Hanna Schimek have pro-
duced a number of collaborative films and videos, mostly
experimental one-shot studies and observational minia-
tures. One series shows Hanna Schimek dancing (the H.
tanzt series), others are films about eating (f.e. H. isst ...).
100 Steine / 100 Schritte (100 rocks / 100 footsteps) was
shot in the desert and is conceived as a double projection
of 100 Loops, depicting Gustav Deutsch carrying rocks;
She consists of video close-ups Schimek shot of her female
friends, and features a Charles Aznavour song ("She")
that Deutsch added to the soundtrack.

Exercises aux Baguette
1984, S-8, color, 2 min
She
1984, Video, b/w, 9 min
H. tanzt im Luftbad
1986, S-8, color, no sound, 3 min
H. tanzt bei H.K. I + II
1986, S-8, sw, no sound, 2 x 3 min
100 Steine / 100 Schritte
1988, S-8, double projection, no sound, Loop
H. tanzt in der Wüste
1988, S-8, color, no sound, 3 min
Rocktiger
1989, S-8, color, 3 min
H. isst Tiere 1 / Kücken
1991, S-8, color, no sound, 3 min
H. isst Tiere 2 / Pinguin
1991, S-8, color, no sound, 2 min
Greifzug
1993, S-8, color, 12min.
Featuring: Dagmar Frühwald, Hanna Schimek
H. isst Tiere 3 / Hase
1993, S-8, color, no sound, 3 min
H. isst Tiere 4 / Schwein
1994, S-8, color, no sound, 3 min
G.D. Architekt
1994, S-8, color, no sound, 3 min
Alpenglühen / 10000 Watt – links
1998, S-8, color, no sound, 2 min 30 sek
Alpenglühen / 10000 Watt – rechts
1998, S-8, color, no sound, 2 min 30 sek

Internationaler Sendeschluß – transmission endings
of 48 stations from 20 countries all over the world.
48 channel video installation, Grundig Messestand,
 Messe Wien, 1992
Single channel video installation, Dominikanerkloster
 Frankfurt, in the context of *Nacht Stadt Tag*,
 15. 6. – 23. 7. 1993
9 channel video installation, Künstlerhaus Wien,
 in the context of *Kunst und Diktatur*, 28. 3. – 15. 8. 1994
4 channel video installation, Galeria de Arte Cinemática
 SOLAR, Vila do Conde / Porto, part of the solo
 exhibition *Reflections*, 11. 11. 2006 – 14. 1. 2007
Adria / life
16 channel video installation in the context of
 schräg.SPUREN, Tage zeitgenössischer Videokunst in
 Klagenfurt, organized by UNIKUM and Kulturabteilung
 der Stadt Klagenfurt. Hauptbahnhof Klagenfurt,
 31. 5. – 8. 6. 1996
Film – Schule des Sehens I /
Adria – Urlaubsfilme 1954 – 1968
Interactive video installation at Westbahnhof Wien in
 the context of *ART at RAIL*, Kunsthalle Wien, 2000
Taschenkino
Interactive film screening, 17. 11. and 18. 11. 1995,
 Filmhauskino Wien
Installation in the context of *Kino wie noch nie*, Generali
 Foundation Wien, 20. 1. – 23. 4. 2006, and Akademie der
 Künste, Berlin 12. 5. – 8. 7. 2007
Film ist. 1 – 6
Single channel DVD installation, in the context of
 Postmediale Kondition, Neue Galerie Graz, 16. 11. 2005 –
 15. 1. 2006 and ARCO Madrid, 7. 2. – 16. 4. 2006
Film ist. 1 – 12
8 channel DVD installation in the context of the *Interna-*
 tional Film Festival Rotterdam, Rotterdamse Schouwburg,
 25. 1. – 2. 2. 2002
4 channel DVD installation in the context of *Flanders*
 International Film Festival, Ghent, 8. – 19. 10. 2002.
8 channel DVD installation in the context of *Wien Modern*,
 Künstlerhaus Wien, 10. 11. – 23. 11. 2002
8 channel DVD installation Galeria Solar, part of
 the solo exhibition *Reflections*, Vila do Conde,
 11. 11. 2006 – 14. 1. 2007

8 channel DVD installation in the context of *That's Not Entertainment: el cinema respon al cinema* CCCB, Centre de Cultura Contemporània de Barcelona, 12.12.2006 – 18.3.2007

4 channel DVD installation in the context of *That's Not Entertainment: el cinema respon al cinema*, Centro cultural Fundación Bancaja, Valencia, 13.12.2007 – 24.3.2008

Film ist. Stimme und Gesang / Voice and Song
4 channel DVD installation in the context of *Phonorama*, ZKM Karlsruhe, 19.9.2004 – 30.1.2005

Tatort Migration 1–10
10 channel DVD installation in the context of *Projekt Migration*, Kölnischer Kunstverein, 1.10.2005 – 15.1.2006

2 channel DVD installation in the context of *Vertrautes Terrain – Aktuelle Kunst in & über Deutschland*, ZKM Karlsruhe, 22.5. – 21.9.2008

Welt Spiegel Kino – Tryptichon
3 channel DVD-installation, Galeria Solar, part of the solo exhibition *Reflections*, Vila do Conde, 11.11.2006 – 14.1.2007

Wednesday, 28 August 1957, 6 p.m., Pacific Palisades
Multimedia installation in the context of *Western Motel. Edward Hopper und die zeitgenössische Kunst*, Kunsthalle Wien, 3.10.2008 – 15.2.2009

Mit /*with* Hanna Schimek

Alpenglühen / 10000 Watt
Light installation, in the context of the first *Silvrettatelier*, Bielerhöhe, Vorarlberg, 26.8. – 27.8.1998

5th Decree of 22nd January 1828
Light installation, in the context of *Licht | Bild | Realität*, Aegina Akademie 2003, 9.5 – 18.5.2003

Licht | Bild | Realität – Atlas
Museo Laografico, *Aegina Akademie*, 2003
Lentos Museum, Linz, 14.5. – 16.8.2004

Licht | Bild | Illusion – Atlas, 26 Panoramas
Slide installation, Kunsthalle Wien project space, 8.6. – 3.7.2005

Licht | Bild | Illusion – Atlas, 2 Lichtbildschauen
Markellos Tower, *Aegina Akademie*, 2005

Mit /*with* Hanna Schimek und /*and* Franz Berzl

Light Columns – a reconstruction of the Apollo Temple of ancient Aegina by light
Light installation in the context of *Licht | Bild | Illusion*, Aegina Akademie 2005 (project presentation)

Mit /*with* Franz Berzl

Camera Obscura Building
In the context of *Licht | Bild | Realität*, Aegina Akademie 2003, 9.5. – 18.5.2003 (still in function)

241

Filme mit Livemusik
Films with live music

Österreichisches Filmmuseum, Wien (A)
A girl & a gun: Live. Selected film material from the collaborating archives, with live music by: Christian Fennesz, Martin Siewert, Burkhard Stangl, 19. 2. 2009

Auditorio Municipal Vila do Conde (P)
Film ist. 7 / 10 / 12, and selected original material from the Nederlands Filmmuseum, with live music by: Werner Dafeldecker, Christian Fennesz, Martin Siewert and Burkhard Stangl, 11. 11. 2006

Österreichisches Filmmuseum / Wien Modern (A)
Welt Spiegel Kino: Live, 3 acts with the three episodes and original material from the archives, with live music by: Christian Fennesz, Burkhard Stangl and Jean Paul Dessy, 19. 11. 2005

50th Cork Film Festival Overture / Millenium Hall, Cork (IR)
Film ist. 1–12, 4 channel DVD installation with live music by: Werner Dafeldecker, Christian Fennesz, Martin Siewert and Burkhard Stangl, 9. 10. 2005

Dundee Contemporary Arts (UK)
Film ist. 1–12, 4 channel DVD installation with live music by: Werner Dafeldecker, Christian Fennesz, Martin Siewert and Burkhard Stangl, 19. 10. 2003

Rocket Cinema, Paradiso Amsterdam (NL)
Film ist. 7–12, four part, parallel DVD presentation with four different live soundtracks: DJ Alec Smart, Dox Orchestra, Renson & Heleen and The Amazing Jukebox, 18. 1. 2003

Wien Modern, Konzerthaus (A)
Film ist. Music – Dialogue and Variations, film loops from *Film ist. 1–6*, live sound track by: Hannes Löschel and Velvet Lounge, 14. 11. 2002

Wien Modern, Künstlerhaus (A)
Film ist. 1–12, 8 channel DVD installation with two live acts by: Werner Dafeldecker, Christian Fennesz, Martin Siewert and Burkhard Stangl, 11. 11. & 12. 11. 2002

Musikprotokolle 2002, Graz (A)
Film ist. 7/10/12, and selected original material from the Nederlands Filmmuseum, with live music by: Werner Dafeldecker, Christian Fennesz, Martin Siewert and Burkhard Stangl, 1. 11. 2002

International Short film Festival Vila do Conde (P)
Film ist. 1–6 with live soundtrack by: (des) integração + Alex Fx, 6. 7. 2002

Diagonale 2002, Dom im Berg, Graz (A)
Film ist. Musik – phonographics, 4 channel DVD installation, with live act by: Werner Dafeldecker, Christian Fennesz, Martin Siewert and Burkhard Stangl, 21. 3. 2002

Jeunesse – Fast Forward Zyklus, Porgy & Bess, Wien (A)
Film ist. Music – Dialogue and Variations, film loops from *Film ist. 1–6*, live sound track by: Hannes Löschel and Velvet Lounge, 11. 1. 2002

Minoriten, Graz (A)
Film ist. Music – Dialogue and Variations, film loops from *Film ist. 1–6*, live sound track by: Hannes Löschel and Velvet Lounge, 16. 11. 2001

The Boxhead Ensemble Tour 2001
(Amsterdam, Harlem, Bruxelles, Paris, London, Brighton, Manchester, Dublin)
Michael Krassner, David Michael Curry, Fred Lonberg-Holm, Tim Rutili, Scott Tuma and Jim White Music inspired by selected works from international filmmakers: Gustav Deutsch (Vienna, Austria – *Film ist.1*) Guy Sherwin (London, UK); Paula M Froehle (Chicago, USA); Grant Lee (Brighton, UK); Phil Solomon (Boulder, USA); Gerard Holthuis (Den Haag, Netherlands); Julie Murray (New York, USA); Jem Cohen (New York)

Werkschauen, Tourneen
Retrospectives, Tours

Österreichisches Filmmuseum, Wien (A)
Retrospektive, 19.– 26. 2.2009

Centre Pompidou, Paris (F)
Presentations in the context of FILM & CO:
Film ist. 1–6, 9.1.2008
Film ist. 7–12, 16.1.2008
Welt Spiegel Kino Episode 1–3, 23.1.2008

Bergen – Borealis, Contemp. Music Festival (S)
Tribute Gustav Deutsch, March 2005

ZKM / Zentrum für Kunst und Medien, Karlsruhe (D)
Gustav Deutsch-Evening, 12.3.2003

Museo Nacional Reina Sofia, Madrid (E)
Conferencia de Gustav Deutsch, 21.11. 2002

Centre Pompidou, Paris (F)
Rendez-vous avec Gustav Deutsch, 5.10.2002

Internationales Kurzfilmfestival Hamburg (D)
Workshop Gustav Deutsch, 8.6.2002

Diagonale 2002 (A)
Tribute Gustav Deutsch, 19.– 24. 3.2002

6. Regensburger Kurzfilmwoche (D)
Werkschau Gustav Deutsch, 12.– 20.11.1999

Popifilm, Rotterdam (NL)
Organisation of a tour of *Film ist. 1–6*
Cinema de Balle, Amsterdam, 22. & 23.10.1999
Popifilm, Rotterdam, 25.10.1999
Vera, Groningen, 26.10.1999
Filmhuis Keizer Deventer, 28. & 31.10.1999
Movie, Wageningen, 2. & 3.11.1999

44th Cork Film Festival, Cork (IR)
Tribute Gustav Deutsch, 10.– 17.10.1999

Belluard Bollwerk International 1999, Fribourg (CH)
Gustav Deutsch – deux programmes des films et
une conférence, 25.6.– 10.7.1999

**12èmes Rencontres vidéo art plastique,
Centre d'Art Contemporain Basse Normandie,
Hérouville Saint-Clair** (F)
Tribute Gustav Deutsch, workshop "on repetition
in life and in film", 18.11.– 21.11.1998

**L'immagine leggera, Palermo International Videoart
Film & Media Festival** (I)
Omaggio a Gustav Deutsch, 26.9.– 4.10.1997

Lectures & Workshops
(Auswahl / Selection)

1996 San Francisco Art Institute (Cinematheque),
San Francisco, USA
MIT (Media Lab), Boston, USA
1998 12th Rencontres Vidéo Art Plastique,
Herouville Saint-Clair / Caen, F
1999 University of Nijmeegen, NL
University of Liege, Liege, BE
2000 Athens School of Fine Arts
(Digital Media Department), Athens, GR
Bard College (Film Department), New York, USA
Cinemateca Portuguesa, Lisboa, PT
2002 Diagonale – Festival des Österreichischen Films,
Graz, A
Museo Nacional Centro de Arte Reina Sofia,
Madrid, ES
Österreichisches Filmmuseum, Wien, A
Universität für Musik und darstellende Kunst,
Wien, A
2003 Nederlands Filmmuseum, Amsterdam, NL
2004 Österreichisches Filmmuseum, Wien, A
Tampere Film School, Tampere, FI
2005 Österreichisches Filmmuseum, Wien, A
2006 Orphans Film Symposium, Columbia,
South Carolina, USA
Kunsthøgskolen i Bergen (Kunsthochschule /
National Academy of the Arts), Bergen, N
University of Helsinki (Faculty of Arts), Helsinki, FI
University of Binghamton (Film Department),
New York, USA
Instituto Politécnico do Porto, Porto, PT
Nederlands Filmmuseum, Amsterdam, NL
Hochschule für Gestaltung, Abteilung Film
(Film Department), Linz, A
Schule für unabhängigen Film, Wien, A
2007 CINECITY Film Festival, Brighton, UK
2008 Deutsche Kinemathek – Museum für Film und
Fernsehen, Berlin, D
2009 Österreichisches Filmmuseum, Wien, A

Auszeichnungen
und Preise (Auswahl)
Awards (Selection)

1995
Anerkennungspreis des Landes Niederösterreich für
künstlerischen Film / *Award for Film Art, granted by the
state of Lower Austria*
1999
Österreichischer Würdigungspreis für Filmkunst /
National award for Film Art, Republic of Austria

Asuma
(mit / *with* Gerda Lampalzer, Manfed Neuwirth):
Preis des Belgischen Fernsehens RTBF / *RTBF television
award* 1984
Augenzeugen der Fremde
Hauptpreis Dokumentart Neubrandenburg (D) / *main
award at Dokumentart, Neubrandenburg / Germany* 1994
Taschenkino und / and **Film ist mehr als Film**
Preis Neues Kino, Viennale 1996, Wien / *Viennale Award
for innovative cinema, Vienna* 1996
Mariage blanc
Team Work Award, Stuttgarter Filmwinter (D) / *Stuttgart
Filmwinter festival, Germany* 1997
Odyssey Today – CD ROM (mit / *with* Hanna Schimek)
Hauptpreis / *Main Award*, VIPER International Festival,
Basel, CH 2000
Film ist. 1–6
Main Prize, Mediacity Film Festival, Windsor / Ontario,
CA 1999; Silver Spire Award, International Film Festival
San Francisco, USA 2000; Main Prize, Ann Arbor Film
Festival, USA 2000
Film ist. 7–12
Curator's Award, Cinematexas, Austin, USA 2002;
Best Editing Award, Ann Arbor Film Festival 2003
Welt Spiegel Kino – Episode 1–3
Best Film, EXiS (Experimental Film & Video Festival),
Seoul, KR 2005

Bibliographie (Auswahl)
Bibliography (Selection)

Eine erweiterte Bibliografie, sowie Volltextversionen
einzelner Texte unter www.gustavdeutsch.net
*Most of the entries below are in German only. For more
bibliographical entries, as well as downloadable articles
visit* www.gustavdeutsch.net *and*
www.sixpackfilm.com

Publikationen herausgegeben von / *Publications edited by* Gustav Deutsch and Hanna Schimek

Film ist. 1–6
Begleitheft zum Film, mit einem Essay von Alexander
Horwath. 30 Seiten, dt/engl, 13 ganzseitige Abbildungen,
sw, Eigenverlag, 1998

Film ist. 7–12
Begleitheft zum Film, mit einem Essay von Stefan
Grissemann. 34 Seiten, dt/engl, 13 ganzseitige
Abbildungen, Farbe, Eigenverlag, 2002

Film ist. Recherche
Gustav Deutsch / Hanna Schimek (eds.), mit Beiträgen
von Marianne Kubaczek / Wolfgang Pircher, Nico de
Klerk, Hanna Schimek und Gustav Deutsch, 120 Seiten,
72 Abbildungen, sw/Farbe, sonderzahl 2002

Welt Spiegel Kino – Episode 1–3
Begleitheft zum Film, mit Beiträgen von Tom Gunning,
Michael Loebenstein, Nico de Klerk und Regina
Guimarães. 34 Seiten, dt/engl, 15 ganzseitige
Abbildungen, sw, Eigenverlag, 2005

Licht | Bild | Illusion – Atlas / 26 Panoramen
Begleitbroschüre zur Installation im Kunsthalle-
Projectspace. Gustav Deutsch / Hanna Schimek,
52 Seiten, 26 Abbildungen, Farbe, Eigenverlag, 2005

Publikationen über / *Publications on* Gustav Deutsch

Rituale
Fritz Walden, „Rituale," *Arbeiter Zeitung*, 2.10.1982

Drei Minuten aus der Ewigkeit
Elisabeth Büttner / Christian Dewald, „Gustav Deutsch
über die Fort / Bewegung und ihre vielfältige Praxis,"
in: Filmbühne Mödling (eds.), *Filmbrunch* 26 / 1993

Kunst / Spur
Silvia Miklin-Knifacz, „Die ‚Kunst / Spur' – eine
Spurensuche aus konservatorischer Sicht," *Materialien
zur Gesamtkultur* Nr. 76, Ein Magazin von „Der Blaue
Kompressor" 1993. Monika Schwärzler, „Spurenlese –
Über den Umgang von Kunst mit Spuren," *Materialien
zur Gesamtkultur* Nr. 76, Ein Magazin von „Der Blaue
Kompressor" 1993

Internationaler Sendeschluß
Karlheinz A. Geißler, „Internationaler Sendeschluß,"
Universitas 12/1994

Endless Repetition
Bert Rebhandl, „Hypnotische Schleifen," *Der Standard*,
17.12.1994

Augenzeugen der Fremde
Irene Rudolf, „Dunkel des Bildes," *Multimedia* 22/1994
Conny E. Voester, „Duisburger Filmwoche: Ein Forum
für den Nachwuchs," *epd Film* 1/1995

Adria
Stefan Grissemann, „Das taktlose Kino. Notizen zu den
jüngsten Vertretern der österreichischen Avantgarde.
Ein Spaziergang, nahe der Sonne", in: Alexander Horwath,
Lisl Ponger, Gottfried Schlemmer (eds.): *Avantgardefilm
Österreich 1950 bis heute,* Wien 1995

Film / Spricht / Viele / Sprachen
Elisabeth Büttner, „Diese Augen kenn' ich doch,"
Falter 40/1995

Taschenkino
Markus Wailand, „Nur keine Witze," *Falter* 46/1995
Claus Philipp, „Erweiterung des Horizonts – mit
Augenklappen," *Der Standard*, 20.11.1995
Ilse Retzek, „Einfach lustiges Kino," *Oberösterreichische
Nachrichten*, 6.12.1995
Dineke de Zwaan, „Taschenkino: Met een gif groen
viewertje in de Bioscoop," *homepage
iffrotterdam*.nl / FFR/96, Rotterdam Film Festival 1996
Remke de Lange, „Gustav Deutsch: Taschenkino is
uiteindelijk mijn persoonlijke viering van hoderd jaar
film geworden," *Daily Tiger* Rotterdam 1/1996
Gertjan Zuilhof, "Zakbioskoopjes," *De Groene
Amsterdamer*, 14.2.1996
Leonor Amarante, "Cinema de Bolso: sessões de
anarquia e humor," *Jornal da Tarde Sao Paolo*, 21.5.1996

245

Isabel Healy, "Discret charm of the pocket cinema,"
The Examiner, 11.18.1996
Thierry Jobin, "Passez le film à votre voisin,"
Le Nouveau Quotidien, 25.10.1996

no comment – minimundus AUSTRIA
Claus Philipp, „Man hat Töne," in: polyfilm Verleih (eds.):
Eine Geschichte der Bilder, Wien 1996

Das Wasser, die Pflanzen, die Wege der Wüste
Paolo Bianchi, „Wüste-Welt-Oase, Gustav Deutsch &
Hanna Schimek," *Kunstforum* Bd. 137, Juni – August 1997

Film ist. 1 – 6
Alexander Horwath, „Blitz (Energie-Umwandlung
beim modernen Kinematographen)," in: *Film ist. 1 – 6*,
Begleitheft, 1998
Claus Philipp, „Spielformen eines Sammlers",
Der Standard, 22.10.1998
Stefan Grissemann, „Das wunderbare Chaos:
Was das Kino-Auge sieht," *Die Presse*, 8.11.1998
Bernhard Sallmann, „Diagonale," *Filmforum* Heft Nr. 17,
Mai / Juni 1999

K & K & K
Bernhard Sallmann, „Diagonale," *Filmforum* Heft Nr. 17,
Mai / Juni 1999

**Tradition ist die Weitergabe des Feuers und nicht
die Anbetung der Asche**
Alexander Horwath, „Die Weitergabe des Feuers,"
profil, 11.10.1999

Odyssey Today – CD ROM
Stefan Grissemann, „Zerbeulte Teekannen in Marokko,"
Die Presse, 4.8.2000

Film ist. 7 – 12
Tom Gunning, „*Film ist*. Eine Fibel für eine sichtbare
Welt," *Stadtkino Zeitung* Nr.379, April 2002
Stefan Grissemann, „Das Schweigen erklärt nichts,"
in: *Film ist. 7 – 12*, Begleitheft, 2002
Stefan Grissemann, „Kommen, sehen und sichten:
Die Welt im Brennglas des Kinos," *Die Presse*, 18.3.2002
Michael Omasta, Michael Loebenstein, „Der Mann ohne
Kamera," *Falter* 15 / 2002
Michael Loebenstein, „*Film ist*. Die Freuden des
Schneidetischs," *Falter* 15 / 2002
Claus Philipp, „Auf der Suche nach dem unverdorbenen
Blick," *Der Standard*, 13./14. April 2002

Christoph Huber, „Die Straße taumelt, und das Zimmer
gleich mit: Eine unendliche Archäologie von Kinowun-
dern," *Die Presse*, 13.4.2002
Dieter Pichler, „*Film ist. 7–12*," *RAY Kinomagazin*, April 2002
Sebastian Feldmann, „Ordnung gestiftet in der Welt als
Scherbenhaufen," *Rheinische Post*, 9.4.2002

Film ist. 1–12, DVD Installation
Alexandra Seibel, „Unter der Haube," *Kurier*, 13.11.2002
Stefan Grissemann, „*Film ist*. DVD Installation im
Künstlerhaus," *profil*, 18.11.2002
Geoffrey Macnab, „Eye-to-eye with history,"
Daily Tiger Rotterdam Nr. 5, 31.1.2005

Light | Image | Reality – The Aegina Academy
Isabella Reicher, „Panoramablick aufs Lichtspiel,"
Der Standard, 22.5.2003
Stella Rollig, „Prinzipiell kann man sagen, dass wir uns
gerne an Orten aufhalten, die Un-Orte im Sinn der zeit-
genössischen Kunst sind," Gustav Deutsch und Hanna
Schimek im Gespräch mit Stella Rollig, *Kunstforum*
Bd.167, November – Dezember 2003

Camera Obscura Aegina
Matthias Boeckl, „Camera Obscura auf Aegina,
Griechenland," *architektur.aktuell* Nr.284,
November 2003
Sam Lubell, "Camera Obscura: ancient technique,
modern art," *Architectural Record*, May 2004
Suzanne Trocmé, "Focal Hero – A modern take on
the Camera Obscura," *Wallpaper magazine*, Issue 68,
May 2004
Phyllis Richardson, "Panoramic Projections, Camera
Obscura, Aegina Greece," in: Phyllis Richardson,
XS Green, Big Ideas, Small Buildings, London 2007

**Light | Image | Illusion – The Aegina Academy 2005,
and Camera Obscura**
Martha Blassnigg, "The Aegina Academy, A Forum
for Art and Science: Light | Image | Illusion,"
Leonardo, Journal of the International Society for the
Arts, Sciences and Technology, Vol. 39, No. 3 (2006),
MIT Press

Film ist. Stimme und Gesang
Stefan Grissemann, „Vox Acuta," in: Brigitte Felderer
(ed.), *Phonorama, eine Kulturgeschichte der Stimme als
Medium*, Berlin, 2005

Welt Spiegel Kino – Episode 1–3

Tom Gunning, „Lebendige Spiegel: Deutschs Monado-
logie des Kinos," in: *Welt Spiegel Kino – Episode 1–3*,
Begleitheft 2006

Drehli Robnik, „Massen, vermessen in Masken,"
kolik.film 3/2005, März 2005

Michael Loebenstein, „Der Nabel der Welt," in:
Welt Spiegel Kino – Episode 1–3, Begleitheft 2006

Nico de Klerk, „Enter the Dragon," in: *Welt Spiegel
Kino – Episode 1–3*, Begleitheft 2006

Regina Guimaraes, „Das Kino als Spiegel der Welt,"
in: *Welt Spiegel Kino – Episode 1–3*, Begleitheft 2006

Claus Philipp, „Die ‚kleinsten Zellen' und der Rest
der Welt," *Der Standard*, 4.4.2006

Michael Omasta, „Die Menschen des Kinos" und
„Fantasie des Unmöglichen", *Falter* 13/2006

Christoph Huber, „Archäologie in der Alptraum-
Herberge," *Die Presse*, 5.4.2006

Nina Schedlmayer, „Welt Spiegel Kino – Episode 1–3,"
RAY Kinomagazin, April 2005

Dana Linssen, „Antieke film nieuw leven ingeblazen,"
NRC Handelsblad, 18.1.2006

Kos van der Burg, „*Welt Spiegel Kino* wekt de
doden tot leven," *Het Parool,* 18.1.2006

Belinda van de Graaf, „Vergeten filmbeelden uit
een ver verleden," *Trouw,* 19.1.2006

Allgemeine Artikel / General topics

Luis Miguel Oliveira, „Cineasta Gustav Deutsch
em Portugal," *Publico*, 9.11.2006

Marcos Cruz, „Gustav Deutsch e a visao cinéfila da
realidade mundial", *Diario de Noticias*, 17.11.2006

Liana Leandro, „Reflexos e reflexoes na Solar,"
O Primeiro de Janeiro, 17.11.2006

Oscar Faria, „O filme é um filme é um filme,"
Publico, 20.12.2006

Gareth Buckell, "24 frames a second. Peter Tscherkassky,
Gustav Deutsch and the Austrian Avant-Garde,"
Filmwaves 34, 11.4.2008

Das Langzeitprojekt FILM IST. von Gustav Deutsch
Diplomarbeit von Alexandra Rotter, Universität Wien,
Institut für Kunstgeschichte, Univ.-Prof. Dr. Martina
Pippal, Wien 2008

AutorInnen und HerausgeberInnen
Contributors and editors

NICO DE KLERK

ist wissenschaftlicher Mitarbeiter des Nederlands Filmmuseum in Amsterdam. Sein Forschungsfeld sind jene Aspekte der Sammlungen, die aus dem Kanon der Filmgeschichte fallen: frühe nicht-fiktionale Filme, 'koloniales' Kino, sowie das Programmformat des frühen Kinos. Er ist (Co-)Herausgeber unter anderem von *Nonfiction from the Teens* (1994) und *Unchartered Territory: Essays on Early Nonfiction Film* (1997) und publiziert regelmäßig Artikel in niederländischen und internationalen filmhistorischen Periodika.

Nico de Klerk is a researcher at the Nederlands Filmmuseum in Amsterdam. His work focuses on the 'orphaned' aspects of the Filmmuseum's collections and of film history, e.g. early non-fiction, 'colonial' cinema, the 'programme' format. Books he has edited are (among others) Nonfiction from the Teens *(1994) and* Unchartered Territory: Essays on Early Nonfiction Film *(1997) and he has written articles and reviews for various Dutch and international film historical publications.*

STEFAN GRISSEMANN

ist Filmkritiker und Leiter des Kulturressorts des österreichischen Nachrichtenmagazins *profil*. Er hat Bücher zu Arbeiten von Michael Haneke, Elfriede Jelinek und Robert Frank veröffentlicht und eine Biografie des mysteriösen B-Picture-Regisseurs Edgar G. Ulmer verfasst. Jüngste Publikation: *Sündenfall. Die Grenzüberschreitungen*

des Filmemachers Ulrich Seidl, erschienen im Herbst 2007.

Stefan Grissemann has published books on Edgar G. Ulmer, Michael Haneke, Elfriede Jelinek and Robert Frank. A film critic since 1988 in various international publications, he currently works as head of the arts section of profil *magazine in Vienna, Austria. His latest publication is* Sündenfall (Original Sin), *a study of Ulrich Seidl's life and career.*

TOM GUNNING

hat mit seiner Lehrtätigkeit und unzähligen Publikationen maßgeblich zur „Wiederentdeckung" und Neuinterpretation des frühen Kinos beigetragen. Er forscht und publiziert zum Kino und dessen Verhältnis zur Moderne, zur Kunst-, und Kulturgeschichte des 19. und 20. Jahrhunderts, sowie zum Avantgardefilm. Er ist Professor am Department of Art History und Vorsitzender des Committee on Cinema & Media Studies an der University of Chicago.

Tom Gunning has, in his work as a scholar and author, greatly shaped our understanding of Early Cinema and the culture of Modernity surrounding it. He is the author of numerous publications on early film, art history, the popular culture of the 19th and 20th century. He is the Edwin A. and Betty L. Bergman Distinguished Service Professor at the Department of Art History and Chair of the Committee on Cinema & Media Studies at the University of Chicago.

BEATE HOFSTADLER

ist Psychoanalytikerin in freier Praxis in Wien. Studium der Psychologie (Salzburg), Theater-Film- und Medienwissenschaften (Wien); sozialwissenschaftliche Forschungstätigkeiten; Lektorin an der Johannes Kepler Universität Linz, Institut für Frauen- und Geschlechterforschung. Ausgewählte Publikationen: *Stielaugen oder scheue Blicke. Psychoanalytische Erhebungen zum Verhältnis von Frauen zu Pornographie* (Co-Autorin Ulrike Körbitz), Frankfurt 1996; *KörperNormen – KörperFormen. Männer über Körper, Geschlecht und Sexualität;* (Co-Autorin Birgit Buchinger) Wien 2001; *Lesarten von Geschlecht. Pedro Almodóvars Film „Alles über meine Mutter",* Wien 2007.

Beate Hofstadler is a psychoanalyst practicing in Vienna. She studied psychology and Theater, Film and Media Studies in Salzburg and Vienna, and teaches at the Institute for Women's and Gender Studies at Johannes Kepler University in Linz. She has published on the relationship of gender, psychoanalysis and film, e.g. on pornographic film and Pedro Almodóvar's Todo sobre mi madre.

ALEXANDER HORWATH

arbeitet seit 1985 als Filmkritiker, Autor und Kurator. 1992–97 war er Direktor der Viennale – Vienna International Film Festival, seit 2002 ist er Direktor des österreichischen Filmmuseums. Er ist Autor und (Co-)Herausgeber von Publikationen zum amerikanischen Kino der 1960er und

1970er Jahr, zum Avantgardefilm und über Filmemacher wie Josef von Sternberg, Michael Haneke und Peter Tscherkassky.

Alexander Horwath has worked as a film critic, writer, and curator since 1985. He was director of the Viennale— Vienna International Film Festival from 1992–97 and has been director of the Austrian Film Museum since 2002. He is the author and (co-)editor of publications on the American Cinema of the 1960s and 70s, Austrian avant-garde film, and filmmakers such as Josef von Sternberg, Michael Haneke, and Peter Tscherkassky.

WOLFGANG KOS

ist Historiker und arbeitet seit den späten 1960er Jahren theoretisch und praktisch zu Populärkultur und Kulturgeschichte, sowie über das Verhältnis Kunst-Gesellschaft. Von 1968–2003 war er als Radiojournalist maßgeblich an der Erfindung innovativer Formate für den Österreichischen Rundfunk ORF beteiligt. Seit 2003 ist er Direktor des *Wien Museum*, dem ehemaligen Historischen Museum der Stadt Wien. Er ist Autor zahlreicher Schriften und Kurator vieler Ausstellungen und Veranstaltungen.

Wolfgang Kos is a historian and has been working as a writer, radio journalist and curator since the late 1960s. Topics of his research include popular culture and society, urban studies, music and the arts. From 1968–2003 he developed a series of innovative radio programs for the Austrian na-

tional public service broadcaster ORF. Since 2003 he has been the director of the Wien Museum, the metropolitan museum of the City of Vienna.

SCOTT MACDONALD

forscht, lehrt und publiziert seit 30 Jahren zum internationalen Avantgardefilm. Seine Interviewserie mit unabhängigen FilmemacherInnen, *Critical Cinema*, liegt mittlerweile in 5 Bänden vor. Jüngste Publikationen sind u.a. *Art in Cinema: Documents Toward a History of the Film Society* (2006) und *Canyon Cinema: The Life and Times of an Independent Film Distributor* (2008); ein neues Buch, *Adventures of Perception: Cinema As Exploration* ist in Arbeit. Er ist Gastprofessor für Filmgeschichte am Hamilton College und der Harvard University.

Scott MacDonald has been programming, teaching, and writing about avant-garde cinema for 30 years. His Critical Cinema *series of interviews with independent filmmakers is now in five volumes. Recent books include* Art in Cinema: Documents Toward a History of the Film Society *(2006),* Canyon Cinema: The Life and Times of an Independent Film Distributor *(2008), and* Adventures of Perception: Cinema As Exploration *(forthcoming). He is a Visiting Professor of Film History at Hamilton College and Harvard University.*

HANNA SCHIMEK

ist Künstlerin mit den Schwerpunkten Fotografie, Film, Installationskunst und interdisziplinäre künstlerische Forschung; ihre Arbeiten sind im In- und Ausland ausgestellt und präsentiert worden. Sie studierte an der Grafischen Lehr- und Versuchsanstalt in Wien und an der École Supérieure des Beaux Arts, Paris. Seit 1983 ist sie Mitglied von „Der Blaue Kompressor"; seit 1985 realisierte sie zahlreiche Projekte gemeinsam mit Gustav Deutsch unter dem Label D&S, darunter *Licht | Bild – Die Aegina Akademie, Tatort Migration, Café Melange*. Sie war Artistic Supervisor und Researcher für *Film ist. 7–12, Welt Spiegel Kino* und *A girl & a gun* und ist Ko-Autorin zahlreicher kurzer Filmarbeiten (siehe Filmografie).

Hanna Schimek is an artist whose field of work includes photography, film, installation art, graphic design and artistic, interdisciplinary research. She studied photography at the Grafische Lehr- und Versuchsanstalt in Vienna and painting at the École Nationale Supérieure des Beaux Arts, Paris. Since 1983 she is a member of "Der Blaue Kompressor." Since 1985 she has realized numerous collaborative projects with Gustav Deutsch under the label D&S, among others Light | Image – The Aegina Academy, Tatort Migration *and* Café Melange. *She worked as artistic supervisor and researcher on Gustav Deutsch's feature-length* Film ist. 7–12, Welt Spiegel Kino *and* A girl & a gun *and is the co-director of numerous experimental short films (see filmography*

for details). Her art has been presented and exhibited in Austria and internationally.

BURKHARD STANGL

ist composer / performer im Bereich experimentelle Improvisation, elektronische und neue Musik. Zahlreiche CD-Veröffentlichungen; Film u. Videomusiken u.a. für Ernst Schmidt jr., Billy Roisz und Gustav Deutsch. Neuvertonung von G.W Pabsts *Die freudlose Gasse* (Filmarchiv Austria DVD, 2008) Publikationen: *Ethnologie im Ohr* (Wien 2000), Artikel, Essays. Lehrauftrag an der Universität für Musik und darstellende Kunst in Wien (Schwerpunkt neue Musik und Improvisation). Internationale Konzerttätigkeit. http://stangl.klingt.org

Burkhard Stangl is a composer and performer working in the field of non-ideomatic improvisation, electronica and contemporary classical music. A busy performer and recording artist, he has contributed music to the films of, among others, Ernst Schmidt Jr., Billy Roisz and Gustav Deutsch. In 2008 he composed and recorded a new score for G.W. Pabst's Die freudlose Gasse *(Filmarchiv Austria, DVD). He teaches at the University of Music and Performing Arts Vienna.* http://stangl.klingt.org

Die HerausgeberInnen
The editors

WILBIRG BRAININ-DONNENBERG

Studium der Psychologie und Soziologie in Salzburg, Paris und Wien. Freie Filmkuratorin (z.B. *Wissenschafterinnen im Film*, Wien 2008, *Unter dem Vesuv. Neapel im Film*, Wien 2007), *Frauen und Wahnsinn im Film*, Wien 1998) und Filmvermittlerin, u.a. für sixpackfilm (1993–2004), Viennale, Diagonale und Synema. Konzeption von Filmveranstaltungen und Symposien, zuletzt *Sollst die Stadt meiner Filme sein. Perspektiven für eine Filmstadt Wien*. gem. mit Barbara Pichler, Wien 2008; *Psynema – Licht in dunklen Räumen. Psychoanalyse, Film und Kino*, gem. mit Synema und der Wiener Psychoanalytischen Akademie, Wien 2008; *Hunde I Welt I Bild*, gem. mit Hanna Schimek, Wien 2009. Filmpublizistische Arbeiten u.a. für Falter, Diagonale. Lebt in Wien.

Wilbirg Brainin-Donnenberg is a film curator and educator. She studied psychology and sociology in Salzburg, Paris and Vienna, and has been the curator and manager of several conferences and film retrospectives on the topics of Women's filmmaking, gender and the media, psychoanalysis and film. From 1993-2004 she worked for sixpackfilm, since 2004 she has been working freelance for (among others) Viennale, Diagonale, The Austrian Film Museum and SYNEMA.

MICHAEL LOEBENSTEIN

arbeitet seit 1999 als freier Kurator, Filmkritiker, Autor und Mediengestalter. Seit 2004 ist er Mitarbeiter des Österreichischen Filmmuseums und an dessen Vermittlungs- und Forschungsprogrammen beteiligt. Er ist (Co-)Herausgeber einiger Publikationen des Filmmuseums, zuletzt *Film Curatorship. Archives, Museums, and the Digital Marketplace* (2008), sowie der DVD-Editionen des Filmmuseums.

Michael Loebenstein has worked as a freelance writer and critic, curator and DVD author since 1999. From 2004 on he has worked as a curator and researcher at the Austrian Film Museum. His most recent publication is Film Curatorship. Archives, Museums, and the Digital Marketplace *(2008, with Paolo Cherchi Usai, David Francis, and Alexander Horwath). He is the Supervising Editor of the Film Museum's DVD editions.*

Text- und Bildnachweis
Acknowledgements

Abbildungen S. 96–112
Illustrations p. 96–112

Wenn nicht anders angeben / *Unless otherwise noted*
© Gustav Deutsch

Taschenkino, Interaktive Filmvorführung / *Interactive film screening*, Filmhauskino, Wien, 17.11. / 18.11.1995
© Hans Labler

Film ist. 1–12, 8 channel DVD installation, im Rahmen von / *in the context of* Wien Modern, Künstlerhaus Wien, 10.11. – 23.11. 2002 © Hans Labler

Film ist. 1–12, 8 channel DVD installation, Galeria Solar, Vila do Conde, 11.11. 2006–14.1. 2007

Film ist. Stimme und Gesang, 4 channel DVD installation, im Rahmen der Ausstellung / *in the context of Phonorama*, ZKM Karlsruhe, 19.9. 2004–30.1. 2005

Welt Spiegel Kino – Tryptichon, Galeria Solar, Vila do Conde, 11.11. 2006 – 14.1. 2007

Tatort Migration 1–10, 10 channel DVD installation im Rahmen der Ausstellung / *in the context of Projekt Migration*, Kölnischer Kunstverein, 1.10. 2005 – 15.1. 2006 © Kölnischer Kunstverein

Wednesday, 28 August 1957, 6 p.m., Pacific Palisades, Multimedia Installation, im Rahmen der Ausstellung / *in the context of Western Motel. Edward Hopper und die zeitgenössische Kunst*, Kunsthalle Wien, 3.10. 2008 – 15.2. 2009 © Stephan Wyckoff

Licht | Bild | Realität – Atlas, Gustav Deutsch, Hanna Schimek, Lentos Museum, Linz, 14.5. – 16.8. 2004

Licht | Bild | Realität – Atlas, Gustav Deutsch, Hanna Schimek, Lentos Museum, Linz, 14.5. – 16.8. 2004

Light Columns – a reconstruction of the Apollo Temple of ancient Aegina by light, Gustav Deutsch, Hanna Schimek, Franz Berzl, im Rahmen von / *in the context of Licht | Bild | Illusion*, Aegina Akademie 2005 © Franz Berzl

5th Decree of 22nd January 1828, Lichtinstallation, Gustav Deutsch, Hanna Schimek, im Rahmen von / *in the context of Licht | Bild | Realität*, Aegina Akademie 2003, 9.5. – 18.5. 2003 © Hans Labler

Camera Obscura Building, Gustav Deutsch, Franz Berzl, im Rahmen von / *in the context of Licht | Bild | Realität*, Aegina Akademie 2003, 9.5. – 18.5. 2003

Camera Obscura Building, Gustav Deutsch, Franz Berzl, im Rahmen von / *in the context of Licht | Bild | Realität*, Aegina Akademie 2003, 9.5. – 18.5. 2003

Licht | Bild | Illusion – Atlas, 26 Panoramas, Gustav Deutsch, Hanna Schimek, Diainstallation / *slide installation*, Kunsthalle Wien project space, 8.6. – 3.7. 2005

Alpenglühen / 10000 Watt, Gustav Deutsch, Hanna Schimek, Lichtinstallation im Rahmen des ersten / *light installation in the context of the first* Silvrettateliers, Bielerhöhe, Vorarlberg, 26.8. – 27.8.1998,

Abbildungsnachweis
Image credits

S. 8 / *p. 8* © Hanna Schimek, 1998
S. 14 / *p.14* (oben / *top*) © Hanna Schimek, 2003
S. 14 / *p.14* (unten / *bottom*) © Hanna Schimek, 2005
S. 17 / *p.17* (oben / *top*) © Hans Labler, 1995
S. 17 / *p.17* (unten / *bottom*) © Hans Labler, 2002
S. 18 / *p.18* © M. Loebenstein, 2008
S. 50 / *p.50* (oben / *top*) © Hendrik Ewert, 1984
S. 50 / *p.50* (unten / *bottom*) © Studio L'Oasis, 1992
S. 63 / *p.63* © Rick Prelinger, 2008
S. 135 / *p.135* © Hanna Schimek, 2004
S. 188 / *p.188* © M. Loebenstein, 2008
S. 189 / *p.189* © M. Loebenstein, 2008
S. 197 / *p.197* © Burkhard Stangl, 2004
S. 199 / *p.199* © Hanna Schimek, 2005

Sämtliche Textbeiträge in diesem Buch sind Erstveröffentlichungen; Alexander Horwaths „Kino(s) der Geschichte" (S. 123 ff.) enthält kurze Passagen aus einem älteren Text von Alexander Horwath, der 1998 im Begleitheft zu Gustav Deutschs *Film ist. 1–6* publiziert worden ist: „Blitz (Energie-Umwandlung beim modernen Kinematographen)".

All texts in this book are published here for the first time. Alexander Horwath's "Cinéma(s) de l'histoire" (pp..123) incorporates short passages from an older text, which was published in 1998 to accompany Gustav Deutsch's Film ist. 1–6: „Blitz (Energie-Umwandlung beim modernen Kinematographen)." [Energy Conversion in Modern Cinematography]

Übersetzungen / *Translations*

The essays by Alexander Horwath (123–143), Wolfgang Kos (49–62) and Michael Loebenstein (181–194), as well as the foreword and pages 26 and 208 were translated from German into English by Renée von Paschen. The essays by Wilbirg Brainin-Donnenberg (9–18), Stefan Grissemann (19–48) and Burkhard Stangl (195–200) were translated from German into English by Eve Heller. Beate Hofstadler's essay (201–207) was translated from German into English by Natascha Unkart.

Übersetzungen aus dem Englischen ins Deutsche von / *Translations from English into German by* Hina Berau: Scott MacDonald (63–94, 145–162), Nico de Klerk (113–122). Der Text von Tom Gunning (163–180) wurde von Petra Metelko ins Deutsche übersetzt (Mitarbeit: Hina Berau) *Tom Gunning's essay (p. 163–180) was translated by Petra Metelko and Hina Berau.*

Dank an / *Thanks to*

Gustav Deutsch & Hanna Schimek; Karl Ulbl, Iris Buchholz; Andrea Glawogger, Alexander Horwath, Regina Schlagnitweit, Raoul Schmidt, Georg Wasner (Österreichisches Filmmuseum); Brigitte Mayr, Michael Omasta (Synema); Brigitta Burger-Utzer, Gerald Weber (sixpackfilm); Gabi Adebisi-Schuster, Franz Berzl, Anna Brainin, Josef Brainin, Rosemarie Donnenberg, Hans Labler, Manfred Neuwirth, Barbara Pichler, Rick Prelinger, Arturo Silva, Linda Williams, Stephan Wyckoff, sowie allen AutorInnen und ÜbersetzerInnen dieses Buchs / *and to all the authors and translators who have contributed to this book.*

FilmmuseumSynemaPublikationen

Seit einigen Jahren arbeiten das Österreichische Filmmuseum und SYNEMA in vielfältiger Weise zusammen. All diese kooperativen Projekte sind von der Überzeugung getragen, dass die Wahrnehmung von Filmen und das Nachdenken darüber zusammengehören: dass die konkrete Anschauung, die „Lektüre" von Filmen im Kino der unverzichtbare Ausgangspunkt jeder Beschäftigung mit dem Medium ist – und dass umgekehrt eine „reine" Anschauung weder wünschenswert noch möglich ist, da die Artikulationsweisen des Films stets andere, ästhetische und gesellschaftliche Artikulationen nach sich ziehen.

Das Ziel, die Vermittlungsarbeit zu vertiefen und über die Veranstaltungen hinaus präsent zu halten, führte zur Idee einer gemeinsamen Buchreihe, in der die inhaltlichen Positionen, die Forschungsschwerpunkte und die Sammlungsbestände zum Ausdruck kommen sollen: FilmmuseumSynemaPublikationen.

Österreichisches Filmmuseum
Augustinerstraße 1, A-1010 Wien
Tel.: +43/1/533 70 54, www.filmmuseum.at

Synema – Gesellschaft für Film und Medien
Neubaugasse 36/1/1/1, A-1070 Wien
Tel.: +43/1/523 37 97, www.synema.at

FilmmuseumSynemaPublikationen sind zu beziehen im gut sortierten Buchhandel oder direkt bei office@synema.at

Band 1
CLAIRE DENIS. TROUBLE EVERY DAY
Herausgegeben von
Michael Omasta, Isabella Reicher
Wien 2005, 160 Seiten
ISBN 3-901644-15-6
Das erste deutschsprachige Buch über die französische Regisseurin (*Nénette et Boni, Beau travail, L'Intrus*). Mit Beiträgen von Peter Baxter, Martine Beugnet, Christine N. Brinckmann, Ralph Eue, Ekkehard Knörer, Jean-Luc Nancy, Vrääth Öhner, einem ausführlichen Gespräch und einer kommentierten Filmografie. Vorwort von Jim Jarmusch

Band 2
PETER TSCHERKASSKY
Herausgegeben von
Alexander Horwath, Michael Loebenstein
Wien 2005, 256 Seiten
ISBN 3-901644-16-4
Das vielfältige Œuvre von Peter Tscherkassky spielt eine zentrale Rolle beim international wieder erwachten Interesse am Avantgardefilm. Ein reich illustriertes Werkverzeichnis mit Essays von Alexander Horwath, Drehli Robnik und Peter Tscherkassky sowie umfassender Bio-Bibliografie. Text englisch/deutsch

Band 3
JOHN COOK. VIENNESE BY CHOICE,
FILMEMACHER VON BERUF
Herausgegeben von
Michael Omasta, Olaf Möller
Wien 2006, 252 Seiten
ISBN 3-901644-17-2
John Cook, ein kanadischer Fotograf und Filmemacher im Wien der siebziger Jahre, spürte mit unbändiger Lust am Geschichtenerzählen dem Geschmack des Lebens nach. Eine Wiederentdeckung in Essays, Gesprächen, einer Filmografie sowie durch Cooks hier erstmals veröffentlichter Autobiografie „The Life".

Band 4
DZIGA VERTOV. DIE VERTOV-SAMMLUNG
IM ÖSTERREICHISCHEN FILMMUSEUM /
THE VERTOV COLLECTION
AT THE AUSTRIAN FILM MUSEUM
Herausgegeben von
Österreichisches Filmmuseum,
Thomas Tode, Barbara Wurm
Wien 2006, 288 Seiten, ISBN 3-901644-19-9
In beispielhafter Weise stellt der Band die umfangreiche Sammlung des Österreichischen Filmmuseums zu dem russischen Filmemacher und -theoretiker Dziga Vertov vor: Filme, Fotos, Plakate, Briefe sowie eine Vielzahl bislang unpublizierter Schriften, Entwürfe und Skizzen. Text englisch/deutsch

Band 5

JOSEF VON STERNBERG.
THE CASE OF LENA SMITH
Herausgegeben von
Alexander Horwath, Michael Omasta
Wien 2007, 304 Seiten
ISBN 978-3-901644-22-1

Entlang hunderter Originalfotos und Dokumente, einer Reihe literarischer Blitzlichter sowie Essays internationaler Autoren und Autorinnen rekonstruiert dieser Band Josef von Sternbergs verlorengegangenes Filmdrama über eine junge Frau in der Wiener Klassengesellschaft um 1900. Text englisch/deutsch

Band 6

JAMES BENNING
Herausgegeben von
Barbara Pichler, Claudia Slanar
Wien 2007, 264 Seiten
ISBN 978-3-901644-23-8

Die weltweit erste umfassende Würdigung einer der faszinierendsten Persönlichkeiten des unabhängigen US-Kinos. Mit Beiträgen von Julie Ault, James Benning, Sadie Benning, Dick Hebdige, Sharon Lockhart, Scott MacDonald, Volker Pantenburg, Michael Pisaro, Nils Plath, Allan Sekula, Amanda Yates. Text englisch

Band 7

JEAN EPSTEIN. BONJOUR CINÉMA UND
ANDERE SCHRIFTEN ZUM KINO
Herausgegeben von
Nicole Brenez, Ralph Eue,
übersetzt aus dem Französischen
von Ralph Eue, Wien 2008, 160 Seiten

ISBN 978-3-901644-25-2

Jean Epstein, der große Unbekannte unter den Größten des Films, gehört zur Handvoll jener Autoren, die in ihren Reflexionen über das Kino wie in ihren künstlerischen Arbeiten das moderne Filmdenken miterfunden haben. Der vorliegende Band macht eine Auswahl seiner mitreißenden Schriften erstmals auch in deutscher Sprache zugänglich.

Band 8

LACHENDE KÖRPER. KOMIKERINNEN
IM KINO DER 1910ER JAHRE
Claudia Preschl
Wien 2008, 208 Seiten
ISBN 978-3-901644-27-6

Dieses Buch trägt, mit Blick auf die kurzen Serien- und Lustspielfilme, zur Wiederentdeckung eines frühen, sehr direkten, „anderen" Kinos bei, in dem Komikerinnen eine große Rolle spielten. Der vielfältige Fundus ihrer grotestk-körperlichen Überschreitungen und anarchischen Rebellion bietet heute Aufschlussreiches zu Geschlechter- wie Handlungskonzepten.

Band 9

FILM CURATORSHIP. ARCHIVES, MUSEUMS,
AND THE DIGITAL MARKETPLACE
Herausgegeben von Paolo Cherchi Usai,
David Francis, Alexander Horwath,
Michael Loebenstein. Wien 2008,
240 Seiten, ISBN 978-3-901644-24-5

Das Buch diskutiert – in Form von Dialogen zwischen Kuratoren und Archivaren dreier Generationen – das Medium Film und seine Vermittlung im Kontext von Museen und Cinémathèquen, Fragen von Kuratorenschaft sowie die Zukunft des filmischen Erbes und sucht eine Form der Auseinandersetzung jenseits des Medienpurismus oder der Zwänge des Marktes. Text englisch

Band 10

MICHAEL PILZ. AUGE KAMERA HERZ
Herausgegeben von Olaf Möller
und Michael Omasta. Wien 2008,
288 Seiten, ISBN 978-3-901644-29-0

Michael Pilz, Regisseur von *Himmel und Erde*, einem der zentralen Werke im internationalen Kino der 1980er Jahre, ist einer der großen Unbekannten der österreichischen Filmgeschichte: ein Solitär, der sich konsequent seit vier Jahrzehnten jeglicher Kategorisierung verwehrt. Diese erste, in enger Zusammenarbeit mit dem Künstler entstandene Monografie enthält Essays zu seinem Schaffen, ein ausführliches Gespräch, ausgewählte Texte und Dokumente zu seiner Arbeit sowie eine umfassende Filmografie.